Elsy Leuzinger The Art of
Black Africa

New York
Graphic Society Ltd.
Greenwich
Connecticut

Translated by R. A. Wilson
Standard Book No. 8212-0468-8
Library of Congress Catalog Card
No. 70-186806

Original German edition
© 1972 by Verlag Aurel Bongers
English language edition
© 1972 by Studio Vista Publishers
English language edition first published
in the United States of America by
New York Graphic Society Ltd., 1972
Printed and bound in West Germany

Introduction

We are becoming more and more clearly aware of the range and importance of African art. This has not always been the case. Even by the beginning of the present century interest in it was confined to a handful of enthusiasts, mostly painters, who discovered it in museums of ethnology and curio cabinets, and drew inspiration from it: Picasso, Vlaminck, Derain, Modigliani, Matisse and Braque in Paris, or Nolde, Kirchner and Pechstein in Germany.

Nowadays, however, there is an established place in the collections of our museums and art galleries for a critically assembled selection from the outstanding examples of African art. For since then we have learnt new ways of looking at things and new standards of judgement. We no longer measure art by the Greek ideal of beauty, or by the degree to which it is true to life. The first thing we look for today is the expression of spiritual ideas in an artistically convincing form. From the very first, African artists have fulfilled this requirement to an astonishing extent.

To an African, completely enclosed within his ancient tribal tradition, there seems no point in imitating nature, even though he is an extremely accurate observer. In his view, the very closest representation of a girl would be inadequate, because it would have neither life nor odour. What the African is trying to conceive is a new form, a tangible image, for the many spiritual beings which inhabit his environment: he is trying to create something spiritual, something transcendent.

Where is this art produced?

Just as we constantly try nowadays to achieve a better understanding of people of civilizations other than our own, we are also concerned to go beyond super-

ficial appearances and obtain a more profound insight into their art. We like to have a clearly defined picture of a particular situation and to be able to assess all the factors which have gone to form the cultural pattern of the community — the influence of the environment, the thoughts and feelings of individual groups and persons. In the case of Africa this is an extremely difficult undertaking. The cultural pattern of present day Africa is extremely complex and difficult to elucidate, and its sources go back to the period before recorded history. Interpretations which are not backed by research in the field are questionable. Theories break down in the face of a complex and living reality. What may be true of a single village can be completely different in the case of the next village. Thus I must ask the reader always to add to my account the tacit, sceptical 'perhaps' or 'as a rule' — and not to forget that, in Africa as well as anywhere, there are no rules without exceptions.

When we approach the African continent from the north, we first encounter White Africa, with a largely pale-skinned population, looking towards the Mediterranean. For our purpose it is almost of no significance, because it is an Islamic culture which has not produced any representative sculpture.

In the case of the so-called black races, a distinction must be made between the genuine Negroes and the races of an Ethiopian type and Hamitic culture. The Hamites — tall and slim with delicate features — inhabit the steppe. They are stock-raisers whose way of life is often nomadic, such as the Massai in the semi-deserts of East Africa, the Tuareg of the Sahara, the Fulani in the dry savannah of West Africa. They are too proud to undertake agriculture or manual work, and they treat with con-

tempt the Negro smiths who supply their weapons. Naturally these nomads are restricted by their migrations to the bare minimum of domestic equipment, with the result that they have not been able to develop any representative sculpture. But in the decoration of their garments, vessels and weapons they often display a highly developed aesthetic sense.

The Negroes, who practise agriculture and manual work, can be divided into four main groups:

1 The Sudanic peoples of the Western Sudan and neighbouring countries;
2 The Bantu peoples in the southern and eastern part of the continent and in the Congo region;
3 The Nilotic peoples of the Eastern Sudan, with a considerable inmixture of Ethiopic blood;
4 The Palaenegrides, sturdy in stature, the Negroes of the tropical forests, who often live in symbiosis with the Pygmies of the jungle.

The Pygmies, like the Bushmen of the deserts of South Africa, are not Negroes, but fair-skinned races of short stature. They are the real primitives of Africa, who have remained in the hunting and collecting stage and have no representative sculpture. The Bushmen, however, contributed to the rock paintings of prehistoric times.

Plastic art of a high standard has flourished above all amongst the settled agricultural peoples of the western side of the continent from Senegal and the Western Sudan, through the countries of the Atlantic coast into the Congo, with offshoots into the region of the Rovuma river of the east coast. Here, where dry steppe turns into the fertile moist savannah, which in many places runs deep into the tropical forest, are found the places where the Sudanic and Bantu

peoples cultivate their fields and bury their dead. Because they remain in the place where the dead are buried, their faith in their ancestors and spirits is constantly nourished, so much so that it has largely been able to maintain itself even against Islam.

Not only does the savannah provide the most favourable conditions for life; as extensive open country it is also accessible and open to new immigrations, new ideas and new influences. For thousands of years the Negroes have accepted ideas and beliefs from outside; they have integrated new ideas into their own lives and made use of them to develop a higher culture.

The history of Black Africa, recorded for us in ancient chronicles, travellers' accounts and archaeological discoveries, teaches us that there have always been considerable population movements in Africa. It is known that non-Negro groups from the Mediterranean region, from Asia Minor, Mesopotamia, Persia, Egypt and Arabia penetrated Africa, followed the courses of the great rivers and used the caravan routes to reach the interior of Africa.

The most important impulse towards the development of the higher Negro civilizations unquestionably came by way of the Nile valley. In his essay 'African Sculpture and Sacral Kingship', 1969, Hermann Baumann showed that the spread of iron-using culture in Black Africa, and the sacral kingship associated with it bears overwhelmingly convincing signs of an origin in the ancient Near East. The main role of cultural mediation was played by the Nubian kingdom, the ancient Cush on the middle Nile, in the present day region of Dongola. As early as the first millennium B.C. Cush was a powerful kingdom, and had even ruled Egypt as the twenty-fifth dynasty (751—656 B.C.). Its first impor-

tant capital was Napata, and its second — from 440 B.C., on — Meroë. Because of its fortunate position at the junction of the caravan routes and its highly developed cotton and iron industries, Meroë achieved riches and glory. The deified rulers of Cush surrounded themselves with the pomp of ancient Egypt. Here all the races of the ancient Near East met. In particular, Greek, Roman, Coptic-Byzantine and Persian influences were at work. About the fourth century A.D., the power of Meroë was broken by the first Christian king of Axum in Ethiopia, and the people became Christian shortly after.

It is more than likely that when political crises and revolutions took place the defeated ruling class — kings, officials and priests — would have fled from Napata and Meroë to Black Africa. Although there are no records of the course taken by their flight, the traces of their cultural influence on the usages and regalia of the Black African kingdoms is unmistakable. One of the routes followed by the sacral kingship led out of the Nile valley towards the Sudan, through Ethiopia and the lake region to south-east Africa. Evidence of this can be found in the ruins of Zimbabwe and the kingdom of Monomotapa. Yet another route left the former on the Ubangi river and led far into the Congo (Bakuba, Baluba, Balunda, Bakongo etc.). The migrations towards the west across the central Sudan — by way of Kordofan, Darfur and Wadai — led on the one hand through the western Sudan to the countries of the Atlantic coast (Futa Djalon, the Temne-Bullom kingdom, etc.), and on the other hand towards Lake Chad and along the Benue to the region of the lower Niger (Ife, Benin), extending as far as the grasslands of Cameroon.

The kingdoms which were founded through the influence of the intellectually and technically superior immigrants, shared with Napata-Meroë and Egypt the institution of divine kingship, with the remarkable customs of their royal courts, even though they differed in details. For example, a practice common to them all was that of the ritual murder of the king: the king, regarded as the incarnation of the god, had to die when there were signs that his bodily strength was declining, because his good health was identified with the prosperity of the country. The death of the king was kept secret for a long time, and a great retinue had always to die with him. While alive the king had neither to touch the ground, nor reveal his face to the people, and no-one was allowed to see him eat. He was held to be related to the moon and the cattle, and the holy fire of the nation was never allowed to go out. Certain marks of majesty, such as a crown and a throne, the artificial beard, drums, cloaks of lion and leopard skin, are as typical of this complex as the custom of matrilineal inheritance, the marriage of brother and sister in the royal house, and the high status of the king's mother. Many of these customs are so unusual that their occurrence cannot be regarded as accidental, but rather as a sign of definite wider connections and a common historical origin. Hermann Baumann has also shown that certain decorative features, such as the twisted band and the figure-of-eight loop, were associated with the sacral kingship, and that also 'hollow-bottom pottery' — so called because of the indentation of the bottom of the vessel — can also be related to the rise of iron-using civilization in Black Africa.

A very early date can be placed on the introduction of iron-using civilization into Nigeria, thanks to the geologically authenticated discovery of terracotta figures of the Nok civilization: a carbon-14 dating points to 360 B.C. These are the earliest known sculptures of Black Africa. In the course of the Bantu migrations, iron-using civilization was also introduced to southern Africa about 300 A.D. In general, the iron age reached its full development in western and southern Africa in the first half of the second millennium A.D.

In addition to iron-using civilization, there were in antiquity innumerable other stimulating influences. Stimuli from North Africa and the southernmost tip of Arabia were of importance in advancing civilization. By way of the Sahara caravan routes, Carthage and the Libyco-Berber states associated with it brought foreign cultural elements from the ancient Mediterranean sphere deep into Negro territory, and South Arabian culture from the 'land of incense' played a decisive part in the rise of the Ethiopian kingdom. One can imagine that immigrant groups, usually small but intellectually gifted, who imposed themselves as masters upon the indigenous Negroes and set up states with marked class distinctions, would modify the previous world view and introduce more advanced technical achievements. This largely took place in a peaceful way. In the Negro myths, the conquerors appear as gods and civilizing heroes, bringers of important techniques and cultural elements, and they still enjoy veneration in the cult.

The degree to which the Negroes submitted to the outside influences which swept in upon them varied greatly. There is no doubt that a great deal was ignored, while other elements disappeared after a time. But where the Negroes were able to accept the outside stimulus, to adapt it and to make it their own, their standard of living rose

considerably. Improvements in agriculture — the building of terraces and artificial irrigation — and the use of metals gave them greater control over their environment. The special rules of a life in a society with marked class divisions enabled them to develop greater political power, and active commerce brought them riches and strength. From the sixteenth century on, there were contacts with Western Europe. Travel and the exchange of teachers, craftsmen and messengers, and also increasing trade and riches, made a vital contribution to the development of African civilization. But in the sphere of art, the European presence left almost no trace (with the exception of Benin and Sherbro). The reason why the Europeans took a long time to establish themselves in Africa was that they had considerable respect for the power of the West African states.

History tells us that Black Africa was also shaken by wars, by ambitious conquests, by slave hunts, by fanatical wars of religion — especially amongst the Moslems — and by endless tribal feuds. These drove the tribes from their homelands and intermingled them. Many tribes moved into mountain or forest regions where defence was easier than in the open savannah. They were threatened by new dangers in the forest; but by fierce endeavours they succeeded in wresting a space for their homes and fields from the rampant jungle. In the isolation of these places of retreat they were able to preserve many traditional practices.

The function and meaning of African art

Africans create their art largely as an instrument by which to make contact with supernatural forces; it helps them to overcome the dangers of their environment; it is the expression of their religion. In general Negroes believe in a universal life force, which an omnipotent creator God pours into the world, and which gives life to every created thing, human beings and animals, plants and stones. Even the dead retain their living force. The divine power is manifested in partial aspects as 'sons of God'; but it is also present in the ancestral father and mother of the tribe and in the great heroes of tribal mythology. It is at work in the elemental forces of nature or in the powerful animals of the wilds, which are particularly imbued with this creative force (*see* P. Tempels).

Africans conceive of the life force as something dynamic which can be controlled, so that it is worthwhile to amass it in large quantities. This can come about through good deeds and sacrifices; whereas through sins the life force is taken away and misfortune is brought down. Sickness, fires, conflict and premature death are regarded as the consequence of evil actions, such as lies, deceit, theft or sexual abuse. Then the magicians and witches, with their sinister activities, have free play, and the village community devotes all its efforts to restoring the sacred order, and thereby the prosperity of the community, by cultic actions, spells and atoning sacrifices. Everyone shares a responsibility for the prosperity or ruin of his village with the result that cultic actions are of the utmost importance for the life of the tribe. With real devotion and inward commitment, the African places himself under the protection of the divine powers.

Every new phase of human life is inaugurated by magical practices. These are most lengthy and most detailed at the time of death, which is regarded as particularly dangerous and sinister. Africans are afraid of the souls of the

dead, because they believe that the powers of the soul of someone to whom injury was done during his life, powers which are now released in death, are now intent on doing harm as *nyama* or avenging force. Through the ritual of burial they attempt to exorcize the uncanny comings and goings of the ancestral spirits, while they call on souls who are favourably inclined towards them for counsel and help (*see* H. Baumann, 1969).

The *nyama* of beasts of prey which have been killed also pursues men in various disguises, as a spirit or a kind of werewolf; and this too must be warded off by magical actions.

The responsible task of understanding the operation of the forces flowing from the divine power, and of controlling them in a meaningful way, lies in the hands of the priest or the medicine man. The latter is not a charlatan, as we have been conditioned to believe, but a person marked out for this task by special sensibility and intelligence. A medicine man undergoes a long period of training, studies practical means of healing, and tests the effectiveness of plants and minerals. As an acute psychologist he knows how to make convincing use of his methods and to make his appearance in a mysterious and even uncanny form. In so doing, he makes use of the experience preserved in traditional customs which teaches him how to deal with the spirits which bestow or threaten the life force. A medicine man has a recipe for every circumstance of life; and belief in its effectiveness creates confidence and dispels fear — at least, until new signs of danger call for more magic. Since everyone who is in difficulties turns to him, the priest is aware of all the troubles of the village. This gives him sufficient knowledge and power to be able to give genuine advice,

warning and help. The force of his precepts is strengthened by the use of oracles. In many parts of Africa the priest is assisted by a secret society. This is a society of men (women's secret societies are rare) who are united by a special initiation, tests, rituals and oaths of secrecy. The societies carry out the ritual sacrifices handed down from the past, in order to ensure the favour of powerful protecting spirits, and to enforce authority and obedience with their aid.

The secret societies are authoritarian. They supervise morality and the keeping of the tribal tradition, which alone guarantees the sacred order; they dispense justice, and in special camps in the bush educate the young men to be fit for the struggle of life and to show respect to the spirit world. The conclusion of this period of training, initiation as a member of the society, and promotion from one grade to another, are all the object of festivals.

But Africans also like these invisible spirits to be tangible. For this reason, they create a sculpture which serves as a medium giving access to the spirit world: the figures of ancestors and spirits, masks and other cult objects. The ancestor figures, dignified and solemn symbols of the tribal hero, imbued with power, or of the first mother of the tribe and the ultimate dwelling place of the tribe's soul, provide a link between God and man. They have all kinds of special characteristics: the pattern of tribal scars, *coiffures* and emblems. They have to follow all the regulations exactly, and must be so beautiful that they please the spirit and invite him to make his dwelling in the figure. And if earnest prayer is made to the spirit and sacrifice offered to him — the first fruits of the harvest, the blood of animals, Kola nut or beer — he takes part in the life of the com-

munity. If the figure is imbued with power, it mediates fertility, riches and the blessing of children, and makes its advice and will known by certain signs. Such ideas are expressed differently in particular cases. Some tribes believe that the spirit of the ancestor is present in the image only during the ritual, while others conceive the figure as being constantly indwelt by the soul of the tribe, as long as sacrifice and worship is offered at regular intervals. If this is neglected the spirit departs, and all that is left is the empty piece of wood.

The same is true of spirit and animal figures and of fetishes. The large statues are usually the common possession of a village, a family or a society. They are kept and cared for by a priest, and brought out and worshipped only for important ceremonies which are for the common good. Smaller figures may belong to individuals as personal protective spirits. They are given an honoured place in the house and recharged with psychic force at periodic cultic celebrations.

The fetish is an object enriched with magical substances, usually of indeterminate form, manufactured and consecrated by the medicine man himself. It protects the person who calls upon it in every imaginable situation, and from all dangers. But amongst the fetishes can occasionally be found some with the features of the sacred tribal ancestors or a powerful and dynamic political leader, and these can be counted as works of art.

Masks are produced in order to enable the souls of the dead, or the protective spirits of the village or society, to make their appearance in tangible or visible form, or for the dramatic representation of mythical actions. Depending upon their role, they have to be as unreal and weird or as terrifying as possible, a non-existent being, neither man or beast, but containing elements of both. The animal features symbolize the forces of the bush and the water. The origin of the mask may well go back to a vision in a dream, which, once given shape, proved to be so effective that thereafter it was preserved and constantly reproduced.

Masks may be made in such a way that they either cover only the face or enclose the entire head like a helmet; or again they may be placed as a head-dress upon the head. In addition to this there are also masks which are not worn, but are only venerated as sacred objects or, in a miniature form, serve as the badge of the societies and spirits. A fantastic costume conceals the person who wears the mask.

Like the ancestor figures, the masks are also consecrated and imbued with power by sacrifices on the part of the priests and societies. They are inviolable, and to do them harm would bring mortal danger. The moment the initiate conceals himself within the mask costume, he is no longer a human being with limited powers. He is now imbued with divine power, like an electric current pulsing through his body. The dancer behaves like a spirit, speaks in a disguised voice, and comes forth with a solemn gait, sometimes on stilts, or in a dynamic whirling dance to the exciting rhythm of drums, rattles, flutes and singing. The appearance of the masks is like an impressively staged theatrical spectacle, at which the awestruck spectators share the experience of the appearing of the spirits and, under the impression that they make, willingly submit themselves to everything they command. The concept of being the bearer of the divine power so overwhelms those who wear the masks that they fearlessly undertake any struggle with the demons.

Those who have carried out field studies, such as G. W. Harley, E. Donner, H. Himmelheber, E. Fischer, or B. Holas have described how much the masks signify and can effect. There is a whole hierarchy of masks, extending from the highest 'great spirit masks' which appear only in the decisive moments of the life of the tribe, through smaller masks which may act, for example, as judges, peace-makers, debt collectors, policemen, nocturnal expellers of witches, the souls of the dead, or personal protective spirits, right down to the masks which act as entertaining buffoons, though without wholly abandoning the weirdness of the spirit world.

Thus the masks have important sociological, political and psychological functions, not the least of which is that they reduce people's tension from time to time and relieve their fear.

Tribes who like carving also give as beautiful and effective a form as possible to other cult objects, and even simple objects of everyday use. By the symbols of the holy, of ancestors and spirits, and animal motifs on fans and staffs, on drums, bells, harps and rattles, on spoons and sacrificial knives, on goblets and bowls, and also on oracles, or on loom heddle pulleys, Africans ensure constant contact with the forces which protect and strengthen life.

This does not mean, however, that every little sign has the same powerful symbolic content. Of course Africans sometimes give free reign to their delight in ornamentation, without thinking of magic and the cult of the gods.

In the choice of decorative motifs they restrict themselves to a relatively small range of forms. There are geometrical patterns, into which the representations are fitted. Whether these patterns have any particular significance is difficult to say. Thus one is often not certain whether a zig-zag line symbolizes lightning, water, a snake or the antelope, or even grinning teeth, or whether it is merely a decorative element. Plant motifs are uncommon. The twisted band and the loop motif can be seen as an indication of the sacral kingship, as has been shown by Hermann Baumann in his studies.

Human motifs have undisputed priority. They form an analogy to particular divine forces and myths. Thus the navel and genitals signify the continuance of mankind. A large navel is a sign that a powerful spirit has left the womb. A large head with exaggerated eyes and a strongly formed chin is a sign of great intellect and willpower. A Janus head is a reference to the dualism of forces.

Animal motifs are less frequent. They probably refer to mythological conceptions. Animals like the antelope, the chameleon, the spider and the bird appear as saviours or tribal ancestors, or as the bearers of a power which is meant to be conjured up by their particular characteristics: bodily strength by the buffalo, elephant, hippopotamus, boar, crocodile, ram; long life by the tortoise; life-giving water by the fish, frog or snake. A bird serves as mediator between this world and the world beyond, the monkey as the jester or as the judge of the souls of the dead. Even individual features such as horns, fangs or claws can suffice as a symbol, the part representing the whole.

The artist

Only in recent years has intensive research sought to explain the nature and mode of work of African artists. The studies of H. Himmelheber, W. Fagg, P. Harter and E. Fischer have shown that powerful artistic personalities can be identified from their works, although they

respect the formal canons of their group, e. g. Shankadi, Bamileke, Yoruba, Dan, the master of Buli. Master sculptors are highly regarded and honoured by their fellow tribesmen. The reputation of a famous sculptor can spread far into the outside world and bring him commissions from miles away.

The social position of an African artist depends upon the form of culture to which his village belongs. In the circumstances of a village, amongst the agricultural peoples of West Africa and the Congo, he is usually a farmer, who carves in his leisure time. But it can happen, if there is a particular demand for his work, that he is released from his share of labour in the fields and his work paid for with food and produce. Thus, for example, amongst the Ngere as much as three goats can be paid for a mask; in Cameroon a carver should receive a girl for a mask, girls being regarded as desirable workers for the fields. At any rate, remuneration for a work of art is always very generous and quite out of proportion to the amount of time spent by the artist on its production.

In many regions of Africa cult objects are produced by the smith. He has a special and quite distinctive status and importance. As a powerful, fearless man who strikes sparks and controls the glowing fire, he is bound to be in alliance with the occult forces. On the basis of this belief he can build a position of power which allows him to achieve a position of dominance over his fellow tribesmen as leader of the secret society or as a priest. Amongst the Bantu of the Congo and the Bantoid peoples of West Africa, a smith may sometimes even become a prince, an immediate adviser of the king, and may even rise to the position of sacred ruler himself.

In the Hamitic language region of the West Sudan, where the masters despise manual labour, the smith belongs to a pariah caste, which is recruited from an ancient stratum of Nigritic culture. Nevertheless, he is treated even there with a certain awe and respect, for no-one wishes to incur the displeasure of occult forces. In many myths the smith appears as the bringer of civilization (Dogon); sometimes the production of pottery is the task of the smith's wives.

There are also places where whole groups of professional sculptors have been formed. They work in public and concentrate on a speciality which they then offer for sale. At the royal courts a particularly lively business is carried on in workshops. There the laws applied to the sculptors are different from those in agricultural communities. The kings and princes, with their need for display and prestige, for beauty and a sophisticated mode of life, provided a powerful stimulus to artistic creation, especially in the secular sphere. These royal patrons of the arts got artists to compete; they stipulated their wishes and rewarded original inspiration, magnificent decoration and careful execution with honours, titles and gifts. A memorial of the king had to be set up with naturalistic portrait heads, and impressive royal insignia had to be manufactured, all the drums, sceptres, ceremonial axes and tobacco pipes. The nature and size of the thrones of the kings and princes were precisely laid down. The royal court possessed a monopoly of materials, such as gold, bronze, jewels and ivory.

Professional sculptors today are increasingly willing to work for the tourist market, although this has caused many artists to decline into routine and careless work and to put vapid novelties on the market.

The finest works are produced by an artist with a genuine tribal tradition, working in awareness of his responsibility and duty and in the service of religion, with the aim of giving form to a mighty spiritual being. To this end he retreats into solitude and devotes himself with undivided concentration to his work. He has to observe a series of ordinances and taboos, for it is dangerous to have anything to do with spirits, and it is important for a wood carver to adopt a conciliatory attitude to the soul of the felled tree. The whole work is accompanied by sacrifices and incantations; rhythmic sounds accompanying the blows of the adze bring his mind into harmony with the great act of creation. The carving becomes a cultic act.

Thanks to the researches of Hans Himmelheber, we know a good deal about the artists of the Dan region. Himmelheber succeeded in visiting the carver who was regarded by people over a wide region as the most important. This artist is called Sra, and he is a Kran, who was called by the chiefs of the Dan to their capital and worked for both tribes. Sra means 'god', and the name is meant as an honour, because Sra creates such beautiful objects.

He has a dignified face with a spiritual quality about it. His father, says Sra, was also a carver, but died early. He now appears to him in dreams and teaches him to carve. In order to have these dreams, Sra takes a medicine. Even as a boy he carved manioc tubers, and then produced rice bowls, rice spoons, gaming boards, figures and masks.

For a large carved drum Sra receives a cow, and for a mask about three goats. With the payment for his work he buys wives, who together with his pupils work in the fields. He has twenty or thirty pupils, sent to him by the chiefs of other villages to be taught. But he accepts only really talented boys and shows them what is good and what is not. He will not tolerate bunglers and onlookers. His fame is considerable and universally recognized, so that he has no need to fear competition from his successors. Sra carves for his own genuine pleasure, and when purchasers come to him, they can select something for themselves in his house. The Dan are familiar with the carving methods of each artist, but most of all with the simple, powerful works of Sra.

Amongst the Dan a master artist on his death leaves his tool to his favourite pupil. The latter steps three times over the body, bows deeply towards the dead man and says, 'Master, give me your gifts.' At the same time he makes a movement with his arms, as if he wished to place something from his master upon his own shoulders.

The artist has within himself the basic pattern of the figure or mask which he plans. What he has experienced in awe in the cultic acts he now seeks to reproduce in a new and more intense form by the work of his hands. An African artist who is capable of concentration and devotion is not hindered by religious pressure and standard forms from varying and enriching his work by his own creative imagination and from influencing the existing style. Every work is a unique creation, and yet it departs only a little from the conceptions and feeling for style of his tribe. This may be one of the reasons why the styles are often so well defined and pure, even though there are slight differences between one work and another: it is in these nuances and details that the true master is revealed. Thus the artist has always a very close link with his community and is never in opposition to it or in reaction against it. Its customs and images are

also his own, for he has grown up with them, and they have trained him. The carver is filled with genuine reverence and responsibility, and indeed is possessed by his mission. This devotion is essential if the form and content of a work of art are to combine to form a perfect unity. If a tribe loses its religious faith, the artist's power fails, the fundamental essence of his work is removed, and for all the outward mastery, only an empty shell remains. That Negroes above all excel in representational sculpture may be related to their extraordinary capacity for intense experience. Both the Bantu and the Sudanic Negroes are extrovert types, who can be spontaneously and violently seized by an idea and feel themselves, in the violent rush of their experience, compelled to work. Their depth of experience jumps like a spark from the work of art to the observer, and is one of the mysteries of their power.

Materials and technique

Wood
This is the African's favourite material. Wood — recalling ancient tree trunks and massive tree tops in which spirits dwell, a living material with a soul — is especially appropriate for receiving 'life force'.

Especial hard, termite-resistant wood are preferred for sculpture: iroko wood *(chlorophora excelsa),* and also woods of the mahogany and ebony varieties, which are suitable for extremely delicate carving. For the large masks lighter woods are chosen, which do not weigh so heavy when worn. The carver works without any vice. His main tool is the cross-cutting axe, the adze. He first marks out the outline by a number of marks on each side. Then, with accurate blows, he cuts out the form, constantly turning and rotating the block to preserve the round shape. Finally, he takes hold of the blade of the adze and uses it like a knife, to cut out the details of the surface. Often he also uses a small knife for this purpose. At this stage, he can give expression to his own aesthetic feeling by fine nuances.

A striking feature of African sculpture is that the artist almost always goes to the trouble of cutting figures and masks from a single piece of wood, instead of making them up from separate parts, which would save him a great deal of trouble. Long horns are not simply attached, but allowed for from the first, when the sculpture is conceived, by the carver's choice of a sufficiently long tree trunk, which he then patiently hollows out. Many carvers leave the marks of the adze strokes showing, a kind of craftsmanship we appreciate with great pleasure; others, however, — and especially those who prefer the round style — polish the surface with wet, coarse leaves or fragments of stone, and then leave the work for a time steeped in mud or in an etching bath of leaves; many again burn them with red hot iron or paint them with soot, resin and oil. In the Congo region, pulverized *tukula,* a red termite-resistant wood, is rubbed in, in order to give the sculpture a beautiful colour. All these processes produce an inimitable, dark shining patina on the masks and figures, the beauty of which is increased even more by their subsequent use in cultic actions.

Many masks, though fewer figures, are painted in colour, most frequently with black and white. White, the colour of spirits, places one in the protection of the spirits, and the sick and those who mourn also paint themselves white. Red, on the other hand, is used to express joy and happiness. Other colours

are rare or of recent date. Some tribes do not add to the original dark bronze colour of their wooden figures and masks, while others adorn them richly, like a beloved living being, with loin cloths, bracelets and chains of metal, glass beads, seeds and kernels. Animal teeth, cowrie shells, leather or horns are meant to increase the magical effect of the figure or mask.

When other materials besides wood are used, such as copper nails and cowrie shells for the eyes, or fibre for the hair and beard, this is by no means a cheap effect, because the African is not endeavouring to imitate nature, but is indicating significant focal points or emphasizing how precious the object is.

Because African sculpture in wood is subject to rapid decay through the climate and termites, it is rarely more than two hundred years old, unless the works have been so carefully preserved that they have been able to last for several centuries. None of the wooden figures mentioned in the ancient chronicles have lasted down to our own time.

Metal

Black Africa has possessed metals for centuries. The Nok culture already possessed iron. The advanced cultures of antiquity also conveyed to West Africa the practice of casting in copper alloys (bronze and other copper alloys including brass), with the lost wax technique. In the setting of the royal courts, marvellous works were produced by casting. One thinks in particular of the bronzes of Ife and Benin, of the *kuduos* and gold weights of the Ashanti and Baule, and of the magnificent ornamental rings, sometimes associated with carved figures, in the West Sudan and on the Ivory Coast. In the complicated lost wax technique, the figure is first formed in wax, in the case of larger works round a core of clay. Decorations and details are added by means of threads of wax. The model is then surrounded with clay, which is forced into the slightest markings in the wax original. When the clay covering has set, it is heated, so that the wax melts and runs out: this is why it is called lost wax *(cire-perdue)*. The molten metal is now poured into the hollow mould. In order to release the casting, the clay mould must be broken: so it is also known as the 'lost mould' technique. Every piece is a single casting. And when the work stands complete before us, its surface polished, we can only be astonished at the ability of these metal founders who, with skill, patience and endurance, struggle with the limited possibilities of their primitive tools to produce works of genius.

The wax and the twisted or rolled threads are responsible for the characteristic spiral and herringbone patterns of the bronze castings of various regions, as well as for their supple appearance.

In addition to the lost wax process, Black Africa is also acquainted with casting in solid moulds and many other methods of metal working, such as chiselling and embossing, filigree and the application of gold leaf. Unfortunately very little has been preserved of the golden treasures of the ancient kingdoms.

Finally, we must mention the iron sculptures of the Dogon, Bambara, Senufo, Yoruba, Bakuba and of the Karagwe of East Africa, which are undoubtedly of some importance.

Stone

Now and again one finds stone sculptures in Africa, most of which are centuries old.

The most important finds come from the regions of the ancient kingdoms;

there are representational stone sculptures, and also pillars merely hinting at the human form.

The stone figures of Nigeria (Yoruba, Esie) and the *nomoli* and *pomtan* of Sierra Leone and Guinea, seem to be related to the round style. The *mintadi,* seated or kneeling ancestor figures from the lower Congo, also fall into this category, as do the dignified stone eagles of Zimbabwe.

Stone figures, of phallic significance or decorated with abstract ancestor figures, are found in Ethiopia (Sidamo, Darassa), amongst the Ekoi and in Tundidaro on the Upper Niger, about ninety miles south of Timbuktu. The stone circles and upright stone stelae, which are found in various regions of the West Sudan and West Africa, are relics of an older megalithic culture.

Terracotta

Clay which has been only lightly fired is fragile, and consequently very little of it is found in museums, although one must realize that clay modelling takes place everywhere in Africa, mostly in a cheerful primary style. On the other hand, as a result of its resistance to climate and insects, terracotta objects are now the most important evidence of prehistoric sculpture. The Nok discoveries, more than two thousand years old, which already display the characteristic stylistic forms of Negro sculpture, the magnificent memorial heads of Ife, the ancient figures of the mysterious Sao, or the great figures of the Ashanti and Agni, are outstanding examples of this material. It is puzzling why clay sculpture, so popular in the recent period, has produced so little that is of value. The effigy vases of the Mangbetu, the clay figures of the Minianka and the tobacco pipes of Cameroon etc., and a few roof ornaments and fetishes are pleasing exceptions.

It would take too long to catalogue here the application and range of all other materials and techniques used in works of art. Some others will be mentioned later in the context of a particular region: e. g. basketwork and weaving, with special methods of decoration; carving in ivory, horn, bone and hippopotamus tooth; and the working of leather and gourds. Clothing and decoration, and the painting and engraving of hut walls and cult objects, can also be given only a limited mention.

The division of work

Within any community there are strict rules as to which work should be carried out by men and which by women. To take over the work of the other sex would be regarded as a profound insult. Building houses, blacksmith's work, bronze casting, basketwork, leather work and carving are left entirely to men. Women spin and make pottery, but the production of clay sculptures for the cult is left to men, who usually monopolize everything which concerns the cult. Where women weave, as for example in the Congo and in parts of West Africa, no man is allowed to touch their broad, upright weaving stools; on the other hand, in the West Sudan only men sit on the narrow-band treadle loom.

Form

Why has African sculpture exercised so profound a fascination upon our artists ever since its discovery? The main reasons are certainly the high degree of abstraction, the expression in concrete forms of immaterial conceptions, the formal unity and the particular power of expression and directness of its statement. Reminiscences of every stage in the development of art in the present

century can be found in Black Africa (*see* Fagg and Plass, 1964): cubism or concretism in the building up of sculptures from stereometric-cubic basic forms (Dogon), surrealism in the fantastic combination of elements suggesting power (the *banda* masks of the Baga), realism or expressionism with exaggerated natural forms (Ekoi, Batchokwe). Every style gives the impression that the artists constantly felt the urge to express something spiritual, by formal means, as intensely and convincingly as possible. Attempts to establish rules which are of general application are questionable in the light of the large number of styles that exist; a student of art would find every stage from harsh realism to the ultimate degree of abstraction in cubist sculpture.

It is possible to make with some confidence the following observations concerning African wood sculpture:

— the tree trunk remains more or less effective as the basic form, with a strong vertical axis and restrained features, which give it its static appearance, balanced verticality and monumentality; but at the same time, within the compact form of a vertical post, there dominates a distinctive rhythm which sets the material in motion and sometimes even breaks out of it;

— for the sake of an idea, a natural form can be transformed, seized in its essentials, transcended, doubled or paralleled, and inessential features of it left out;

— highly arbitrary proportions, which to our perception are specifically African, replace anatomical proportions; we may call them 'proportions of significance';

— spiritual conceptions are given shape by means of cubist forms;

— the African artist is guided by an astonishingly sure feeling for the material and the clear three-dimensional form, for movement and counter-movement and the effect of light and shade, for the tension created by the interplay of surfaces, lines and values in a balance of meaning and form which often approaches the level of genius;

— the African artist has an exact knowledge of the expression value of the forms he uses, whether they are taken from the natural sphere or from the available body of stereometric forms.

The African also experiences sharp curves and angles and deep shadows as aggressive and powerful, and he always uses them when he is seeking to make an impression, to terrify or to cast a spell. On the other hand, gentle curves and delicately balanced surfaces, and an economy of decoration and colour, proclaim the helping, conciliatory and friendly element which beauty and harmony are intended to spread abroad. It is obvious that the rigidity of the cubist wooden face in the movement of the dancer produces a remarkable expression of unreality. Hollow cheeks, a hard chin or white painting is understood by the whole tribe as an apparition of the spirit of the dead. A powerful head dominated by large eyes above a body of regular symmetry, suggests dignity and restrained power.

Of course there are many other means of expression. Sometimes the human form will be reduced to a geometrical figure to such an extent that it becomes an ornament, while again it may be so overlaid by ornaments that it seems to have disappeared completely. These ornaments are sometimes elaborated from a sheer love of decoration, and sometimes for symbolic reasons. For the initiate the meaning of the symbol remains even when it is reduced to a form that is abstract in the extreme. He uses the symbols with a creative love of decoration to satisfy his aesthetic sense.

Although the different styles of Africa, a good thousand in number, vary greatly, we can perhaps distinguish the following two basic tendencies, proposed by Hermann Baumann: the 'round style' as abstraction in a realist and expressive direction, and the 'pole style' as abstraction in a cubist direction. Each of these tendencies has its centre in a particular region, while both types meet and overlap in border regions, or contain enclaves of the other style.

The pole style, which is found in its purest form in the West Sudan, works boldly with stereometric elements and achieves a distinctive balanced rhythm in the image within the compact form of a narrow, tall tree trunk. It is best adapted to giving visible power to an intellectual conception.

The round style, with its centre in the southern Congo and the more easterly kingdoms of the Atlantic coast, a style which reproduces naturalistic living elements with great sensitivity and interpretative power, instantly transforms, exaggerates, changes and abstracts from natural forms in order to achieve a more concentrated form and more intense expression. In Cameroon this style is particularly vital, and amongst the Baluba, Baule and Dan is graceful and poetic. Where sculpture is produced in the service of the sacral kingship and for the glorification of the ruler, there is a particular endeavour to achieve truth to nature. The marvellous heads and figures of Ife and the earlier Benin in Nigeria are idealized portraits, with a trueness to life which is quite uncanny. Although they seem to be hardly African in style at all, it is by Negroes that they were made.

It is interesting to compare a map of the distribution of patriarchal and matriarchal social organization with the map of the different styles. It is clear that there is an astonishing degree of agreement between them; the severe 'pole style' is largely found in areas with a patriarchal social organization, where women are excluded from the life of the cult, while the heart of the 'round style' area is found in the matriarchal Congo region, where women have many privileges and a particularly close connection with growth and the fertility of the fields. Here the image of the earth mother has a particular significance. But we must not overlook the fact that matriarchal organization finds a counterpart in the sacral kingship and its 'round style' of sculpture, so close to nature.

While we constantly stress the beauty of African art, we are well aware that this is a judgement about a selection from the best of a mass of mediocre material. Whereas tourist and souvenir articles relapse into primitivism, the classical style in its pure form in no sense deserves to be dismissed with the word 'primitive', which is unfortunately so often applied. The classical styles are far from being spontaneous, naive, crude or unskilled. For the category of undifferentiated and truly primitive objects Felix Speiser has coined the concept 'primary art', a concept which we shall adopt here. By contrast, the classical styles display skilled planning and conceptual force: they are beautiful in their simplicity, overcome technical difficulties with care and patience, and form a new, logical and tense unity on the basis of an idea. By virtue of the faith experience which underlies them, they possess an almost magical radiance.

Thus we find here an almost limitless profusion of styles of sculpture, and we know that the present period of turmoil and breakdown will bring yet more to light, styles which at the present day are still concealed under the protection of the secret societies. Taken as a whole,

they are the result of the openness of the African Negro to outsiders, the skilful choice of elements which seem adequate to him, and ultimately of the way in which they fit harmoniously into the inherent law of tribal life in the silence of the bush. The sure touch with which the artists have brought their own creative will into harmony with the conditions imposed by the village community is marvellous.

It would only lead to confusion if we were to specify and characterize all the major styles and the smaller stylistic groups which result from the combination of major styles. Thus we shall limit ourselves to the principal styles and the larger groups, and will list under the heading of a characteristic style similar smaller styles and sub-styles. In fact in reality they are very nearly indistinguishable. Peoples of different races and cultured levels are intermingled, and the distribution of styles is not always identical with that of tribal groups. There have been mutual borrowings, and it has also happened that a particular tribe which has practised carving will have worked for a number of other tribes, and sold its speciality far beyond its own tribal borders. It is even more impossible to trace all folk movements and the progress of ideas through the complicated past of Black Africa. Even the documentation of the works found in museums and collections is often erroneous, for in most cases only the place of purchase has been noted, and this is not necessarily the same as the place where the objects were produced. For thousands of years Black Africa has produced art. What has remained of it? A few excavated objects in bronze, stone and terracotta, a few rock paintings. Almost everything made from perishable wood more than two hundred years ago — about which one can read in ancient

chronicles — is lost for ever through decay. No African museum preserved these wooden sculptures. Thus we are at the very final stage of an immeasurable past: a terrifying thought. For in spite of the strength of tradition and the force of convention, the styles continue their constant process of change. One must accept that numerous styles had already disappeared centuries ago, or at best now exist only in their final phases. This is an irreplaceable loss, particularly as the African art we possess displays such a fundamental and fascinating variety of forms. The preservation of the remains of African art has been due not least to European museums which have protected and cared for them. It has been collectors, too, who have saved the most magnificent objects, often at the last minute before their destruction by fanatical breakers and smashers of idols.

When we talk of a final stage, we are naturally referring only to the ancient tribal art. For when as at the present day the ordinances of faith waver and change, and where the formal tribal order collapses, new and possibly less strict rules are set up, and the art of Black Africa will take on a new appearance.

A particular kind of superficial decoration may continue to adorn household objects, in so far as they are not replaced by industrial products; the so-called 'ancient art' will be fabricated in a watered-down form for tourists. But the talented African artist will look for new ways to give expression to his emotions and to satisfy his deep-rooted sense of beauty.

Stylistic regions

West Sudan 22—79

A The Dogon 26—39
B The Bambara 40—53
C Upper Volta 54—65
D The Senufo (Siena) 66—79

From Senegal to the western Ivory Coast 80—107

E The Bijogo and Baga 82—93
F Sierra Leone and Dan-Ngere 94—107

From the Ivory Coast to Dahomey 108—137

G The Baule and Guro 110—123
H Ghana and Dahomey 124—137

Nigeria 138—221

J Early Nigeria: Nok, Ife, etc. 140—151
K Benin 152—169
L The Yoruba in the recent period 170—187
M The tribal art of the lower Niger 188—203
N South-eastern, eastern and northern Nigeria 204—221

Cameroon 222—247

O North and south Cameroon 224—233
P The Cameroon grasslands 234—247

Gabon and neighbouring countries 248—275

Q The Pangwe (Fang) and Bakwele 250—261
R The Bakota, Mitsogho, Bapunu, Kuyu, etc. 262—275

The Congo (Zaïre) 276—361

S The lower Congo 280—289
T The south-western Congo 290—299
U The southern Congo 300—311
V The central Congo 312—323
W The south-eastern Congo: the Baluba 324—335
X The northern Congo 336—347

Z *East and South Africa* 348—361

West Sudan

West Sudan is the geographical name for the green savannah country, the moist steppe, which stretches from the southern edge of the Sahara and the Sahel across the hinterland of the states of the Guinea coast to the forest region. As far as the styles of art which we must mention are concerned, West Sudan can be taken as a smaller region: the term refers to the Dogon, Bambara, Marka and Bozo in Mali; the Kurumba, the Mossi, Bobo-Fing, Bobo-Ule (Tara), Lobi, and Gurunsi in Upper Volta, and finally to the Senufo of southern Mali and the northern Ivory Coast, to mention only the most important.

This broad open country has had a troubled past. The transition to the iron age took place here in the first millenium A.D. From ancient times both people and foreign cultural materials, ideas and trade goods found their way to inner Africa from the Nile valley and the Mediterranean region across the long-established caravan routes. There is no doubt that when Carthage, Cyrene and Rome were at their height, a lively and varied life flourished here too, with a regular exchange of slaves, gold and ivory for copper, glass beads and magnificent textiles. Even at the present day the caravans laden with salt make their way along the desert tracks of ancient times.

In the West Sudan, too, kingdoms were founded which flourished and then collapsed. We learn of these kingdoms from the reliable accounts of Arab and Berber historians and geographers. Thus Al-Bakri (eleventh century) is the first to mention the magnificent empire of Ghana, which from the fourth to the thirteenth centuries extended from Senegal to the Upper Niger. The royal capital of ancient Ghana, with its abundance of gold, became a byword for size and magnificence amongst Africans. In the twelfth century Ghana was supplanted by the

A 1
Rock painting of a dancer wearing a bird mask; fragment of a circumcision seat.
Dogon, Bandiagara.
Stone, 17 cm.
Musée de l'Homme, Paris.

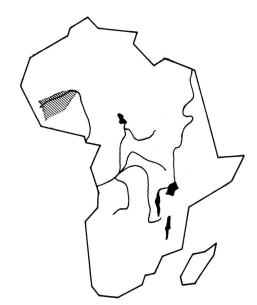

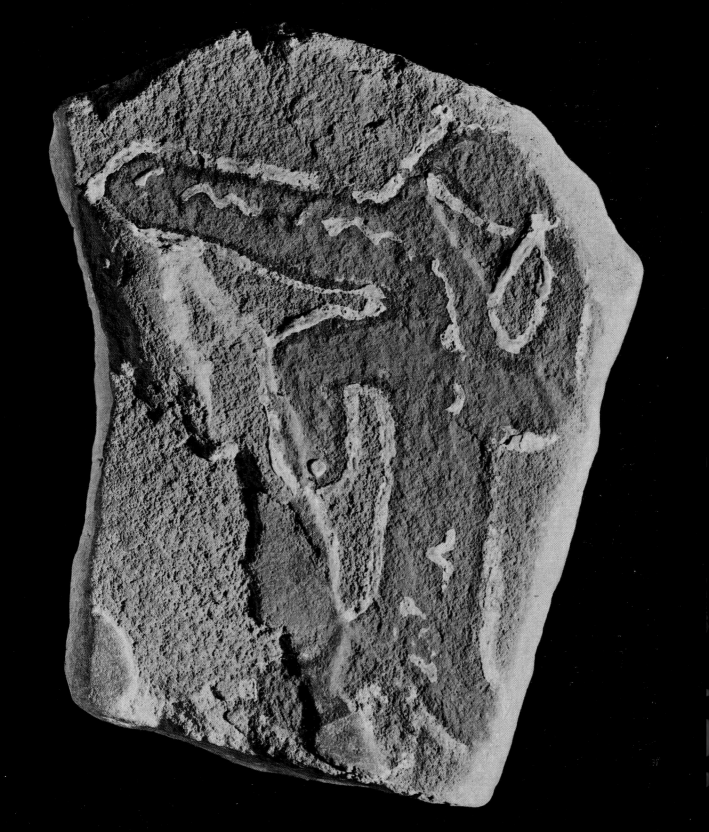

kingdom of Mali, while in the sixteenth century the latter in its turn was destroyed by Songhai, Segu and Kaarta. In Upper Volta the kingdoms of Mossi and Dagomba were formed. In these chronicles sculptures are also mentioned: Ibn Batûta saw masked dances in the fourteenth century; Al-Bakri, about 1050, describes bronzes from the Gundam district. In some graves in the Lobi area, brass castings have also been discovered, which must have been produced before the twelfth century. All that remain to us of these treasures are a few stone, earthenware and metal sculptures, e. g. the polished sandstone pillars of Tundidaro, a hundred miles south of Timbuktu, or terracotta figures from tumuli near Mopti and Djenne. In the eleventh century Islam reached the courts of the kingdoms of West Sudan. The chroniclers Ibn Batûta and Ibn Khaldûn were profoundly impressed by the high standard of living of the kingdom of Mali, which extended from the Atlantic as far as Niamey on the Niger, with four hundred cities with an Islamic intellectual culture. Timbuktu was the seat of an important university for the study of Greek and Arabic writers. Magnificent pilgrimages constantly crossed the Sudan towards Mecca.

It is known that the indigenous population reacted in different ways to these outside influences, either assimilating them wholly or in part, or rejecting them out of hand. We read of audacious conquerors and despots, of population movements and tribal feuds, but also of peaceful colonization and of harmony between different levels of civilization in close contact: on the one hand the autochthonous stratum of Old Sudanic or Nigritic culture with the smiths and first divine kings, and on the other hand Neo-Sudanic culture with the late oriental despotic kingdoms of the late iron age, and Islam. The Neo-Sudanic Islamic culture with its centralized monarchy remained restricted on the whole to the larger settlements. There we find mosques with their characteristic minarets. There are the magnificent, colourful markets with people in long robes and golden ornaments, and the horsemen with armour of quilt and chain mail, and metal helmets. There too we find varied and sophisticated products such as decorative leather work, indigo dyeing, embroidery, the drawing of silver wire, embossed work and pewter casting. Characteristic of this civilization is the widespread use of mud or clay, not only for the flat-roofed houses, but also for vessels and tools; so much mud, that one can almost speak of a 'mud complex'.

But immediately upon leaving the centres at which the royal court was located, one arrives in the midst of the ancient indigenous Negro culture. Here the patriarchal extended family in a walled hamlet of round huts is dominant; here the princes and elders have to give way to the authority of the 'lord of the soil'. Across wide regions the peasants, with their roots in the villages, were able to maintain their inherited belief in ancestors and spirits in the face of Islam, down to the present day.

It is they who continued to produce sculpture in wood down the centuries to the present time. Only the high degree of abstraction which characterizes their sculpture suggests the influence of Islam, with its hostility to images.

A 2
Eleven-headed female figure. Dogon, found near Sanga. Encrusted wood, 36.8 cm. Coll. Prof. W. Münsterberger, New York.

A 3
Mounted ancestor figure. Dogon. Wood, 82 cm. Coll. Henri A. Kamer, New York.

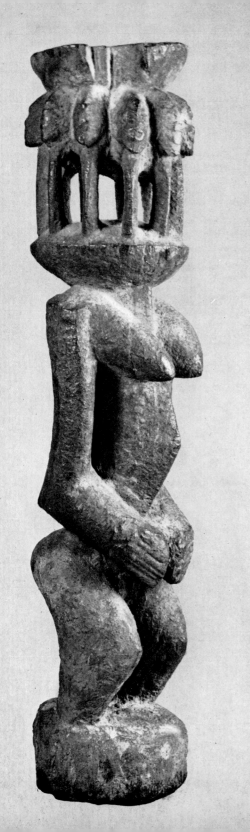
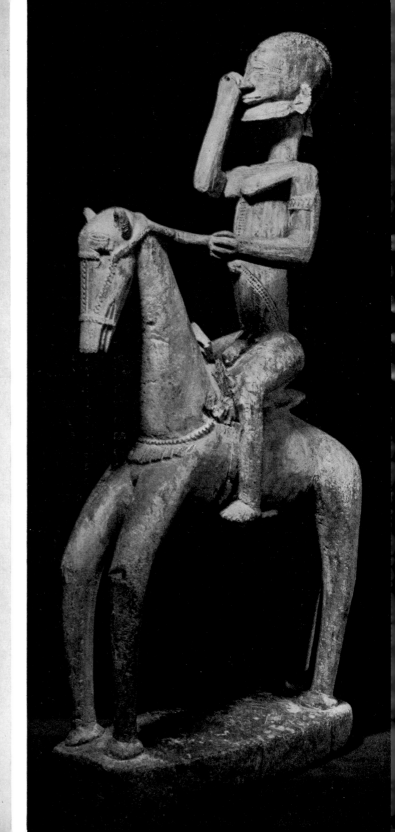

A The Dogon

The Dogon, in northern Mali, are called Habbe ('unbelievers') by the Fulani, because they resisted Islam. They live in the bend of the Niger, in the rocky high plateau round Bandiagara and the Hombori mountains. At some time in the period between the twelfth and fourteenth centuries they seemed to have migrated here under pressure from the Mossi kingdom, to seek refuge in this inaccessible rocky country. With the aid of artificial irrigation, the industrious Dogon wrested their little fields from the dry ground at the foot of the rocky cliffs and planted them with vegetables and millet.

The carving of the Dogon is of great variety and interest. Thanks to the researches of French scholars, and especially of Marcel Griaule, we know a good deal about the ancient myths to which these sculptures refer: about the creator god *Amma* and the eight *Nommo,* who are regarded as his messengers and as incarnations of his life force. It was also the *Nommo* who became men. The smith, the *Nommo* who had become the seventh man, came down to earth either on horseback or in an ark, bringing with him important cultural materials and techniques. As the *hogon,* the smith exercises the high priesthood, and is the mediator responsible for contact between heaven and earth, between the living and the dead. The myths also tell of the incest of *Dyugu Seru* and *Yasigi,* a sin which upset the great cosmic order and was atoned for by the sacrifice of one of the *Nommo.* The pieces of the sacrifice were scattered to the four points of the compass, and one piece came to lie in the middle of the water as the sacred crocodile. The Dogon believe that a very long time ago they were immortal, and that the ancients turned themselves into snakes in order to go on living in the spirit kingdom. Because they failed to observe the divine commandments they suffered death, and could not even find peace as the souls of the dead. But the Dogon, on the advice of the oracle, carved a great snake and offered it to the wandering soul as a place of rest. The myths also tell how the *Nommo* sacrificed on the earth cleansed the fields in the form of the snake *Leba,* and that from the *nyama,* the power of his soul, two twins, brother and sister, came into being as the first Dogon. These mythical events form the content of the cult which the Dogon continually practise to bring about atonement and to preserve the sacred order. Figures and masks play an important part in it.

The carving of the figures which form the vessels for the life force of the *Nommo* and the souls of the ancestors is in the hands of the smith. The cult figures are kept in sanctuaries cared for only by the *hogon,* the priest, who places sacrificial gifts before them in little bowls. If an important member of the secret society dies, his body is laid against the ancestor statue for a certain time, so that his soul may be united with it. Thus the ancient figures are reservoirs of life force. At the annual festival of the dead the *hogon* brings them out in order to ask them for a good harvest and healthy children.

A remarkable find, discovered in hidden caves in the rock, were the bundles of figures joined together with iron chains, often in a naturalistic style and made of wood as hard as stone, encrusted with a red or grey covering made of ashes, animals' blood and millet beer. There is no doubt that these figures are centuries old: a carbon — 14 dating places them in the thirteenth century. The Dogon treat them with reverence, but state that they were not

A 4
Female ancestor figure with child. Dogon. Wood with red patina, 75 cm .
Coll. Nicaud, Paris.

A 5
Female ancestor figure with child. Dogon. Encrusted wood, 69 cm.
Coll. Hélène Kamer, Paris.

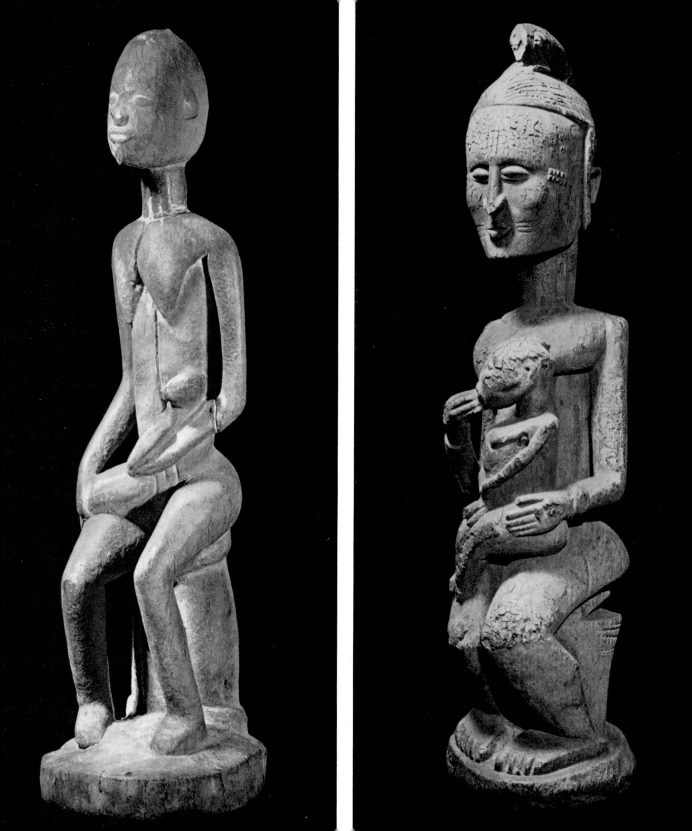

made by their tribe, but come from the previous population, the Tellem. These mysterious Tellem seem to have been a branch of the Kurumba, an ancient people still living in Upper Volta, whose smiths were famous for their art. For the Kurumba also call themselves Tellem.

The genuine Dogon style is very far from naturalistic. It is symmetrical and firm in outline, built up of clearly defined stereometric elements. The slim, lengthy bodies, in which the tree trunk can still be detected, form the very archetype of the pole style. The arrangement of the hair is such that it continues the line of the profile in a semicircle running back in the centre of the head. The breasts are balanced by the heavy shoulder blades: in this style, the basic requisite is balance. The face is completely unrealistic, with a nose like a straight arrowhead, a short horizontal chin, and the ears drawn as a semicircle. The large hands often lie on the thighs or the knees. The Dogon statues, with their thoroughgoing simplification, produce a solemn and monumental effect.

Abstract to the ultimate degree, and reduced as it were to a sign, these figures are found on cult objects, doors, door locks, butter dishes, loom heddle pulleys and other tools.

The themes refer to the events of mythology and to the laws of life and growth. Thus we find the smith as the seventh Nommo and the first hogon, with a ribbed cap and a beard, or as a rider. Figures set one upon the other recall Aru, the cunning usurper of the country, and his brother. We see Yasigi who committed incest, or Dyugu Seru, who hides his face from shame. Raised arms signify entreaty for the protection of the mythical creative forces, or an invocation to the rain clouds to pour rain upon the dry land. The original ancestor couple, the androgynous ancestor on the pedestal, and the stool with the four pairs of figures of the eight Nommo, as well as other rarer compositions with several heads, are a symbol of the universe, and manifest the eternally valid order of the cosmos to which man must subject himself. An important cult object, used in testing the novices of the men's secret society, is the trough with the reliefs of the Nommo and crocodiles. It refers to the myth which tells how the smith, as the bringer of civilization, travelled down the rainbow to earth in a boat. Because the horse was the first creature to climb out of the boat, the trough usually carries a horse's head. The crocodile recalls the sacrificing of one of the Nommo to save the world. The boat's spiral course as it rushed down is represented by zig-zag lines. They also refer to the vibration in the cosmos, and especially to rain, water and life. The finest cult objects, with symbols of the myth, are possessed by the hogon. The door of his millet granary is covered with reliefs of rows of male and female ancestors, because the first thing that happens in the ritual is the scattering of the seeds from his granary to ensure the fruitfulness of the land. In his food bowl in the form of a ball (the world egg), decorated with the zig-zag lines of cosmic energy and crowned with the mythical Nommo horsemen, the hogon offers the sacrificial meat.

The smith also manufactures ritual objects from brass or wrought iron, which have a connection with the spirits and heroes: the primordial smith is said to have used a glowing piece of iron to carry off a piece of the sun and bring it down to man.

Masks are not made by the smith, but by the novices of the men's secret society, and the wood used is the light wood of the kapok tree. They have the same cubic structure as the statues:

A 6
Head of the Great Mother mask Imina-na.
Dogon. Wood, 98.5 cm.
Musée de l'Homme, Paris.

A 7
Monkey mask.
Dogon. Wood, 36 cm.
Private collection, Paris.

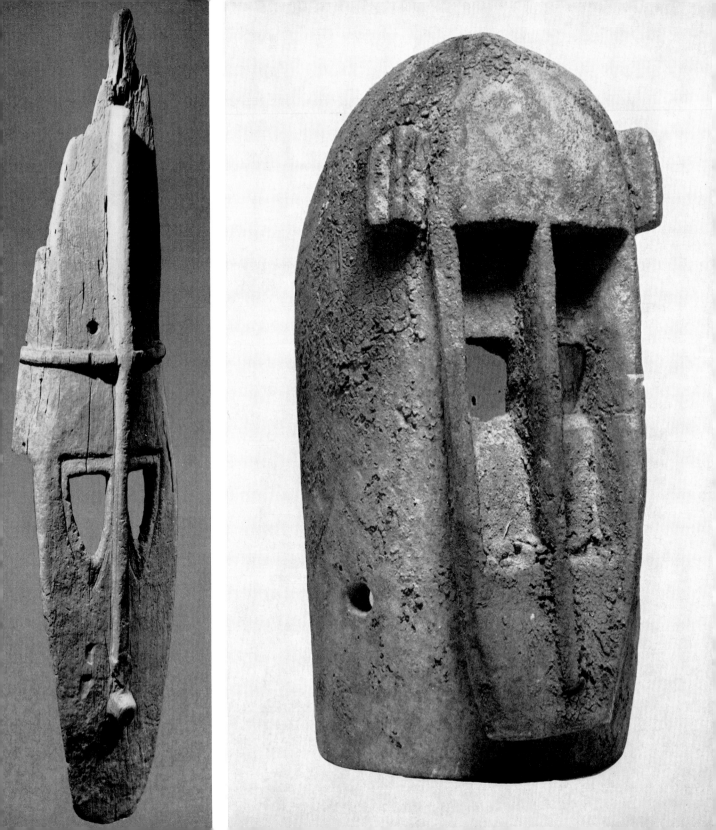

always starkly rectangular, sometimes shaped into a point at the top, with eyes, carved out as triangles or rectangles, lying in deep vertical grooves beside the sharp arrowhead ridge of the narrow nose. The nose may also be broken by zig-zag marks. The mouth is shown in abstract form, or else projects forward like a plug. This basic form is painted in various ways, adorned with horns, animal ears and other features, to show what kind of creature is meant, and whether a *Nommo,* a human being or an animal is being represented. In the case of human beings age, race or calling is shown, e. g. priest, hunter, robber, magician or a girl of the Fulani. The most common animals are the crocodile, the antelope, the hare, the buffalo, the monkey, the snake and the hyena. There are red fibre costumes and emblems to go with them. Every type of mask has its own distinctive dance step. The storeyed *sigiri* masks carry a decorative plank about five yards tall above the abstract face of the mask, as a symbol of the journey to earth taken in the ark by the hero who brought civilization. The *kanaga* mask, called 'the hand of God', with its headdress in the form of a cross of Lorraine, indicates — according to Griaule — a bird in flight, while others interpret it as the crocodile. The circular movements described by the dancers who wear these masks are meant to symbolize the gestures of the god *Amma* in creating the cosmos. At the very top of this mask we find once again the first human couple.

All these various types of mask, more than a hundred in number, are derived from the one great *imina-na* mother mask, which is conceived in the form of a snake. It is ten yards long, and is therefore much too large to be worn. But it is a cultic object to which the greatest veneration is paid. At the death of an important member of the society the mother mask is set up for six days in the house in which he died. But every sixty years, at the great *sigi* feast — *sigi* means forgiveness — it is renovated and set up in the open square. Then its mask-children appear and in a dramatic display, often with acrobatic dances, enact the creation myths, in order to portray in visible form the bond with *Amma* and the spirits. They entreat the goodwill of the spirits with atoning sacrifices. The new members of the society are also initiated at the *sigi* feast. By contrast to the statues, which are kept hidden, the masks are open to public view. Always in moments of danger and especially when someone has died, the society of the *Awa* masks comes out. They dance on the terraced fields of the dead man and conclude the funeral ceremonies, in order to exorcise the souls of the dead. Animal masks are used to appease the *nyama* of a slain animal, whose revenge is feared; and masks may be put on to drive away robbers from the fields.

In the place where the circumcision of the boys takes place the rock walls and seats are covered with painted signs of a symbolic nature. Charcoal, iron oxide, bird droppings and lime are used as colours. The figures are intended to exorcise the 'life force' of the dead.

A 8
Ancestor figure with staff.
Dogon. Wood, 54 cm.
Coll. Max and Berthe Kofler-Erni, Basel.

A 9
Kneeling five-headed figure.
Dogon. Wood, 32 cm.
Coll. Rasmussen, Paris.

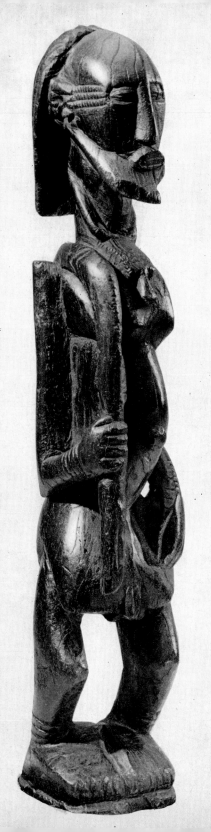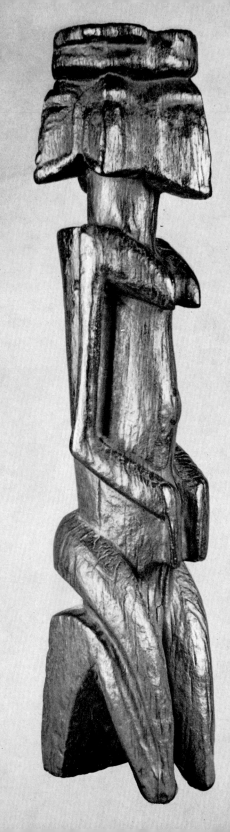

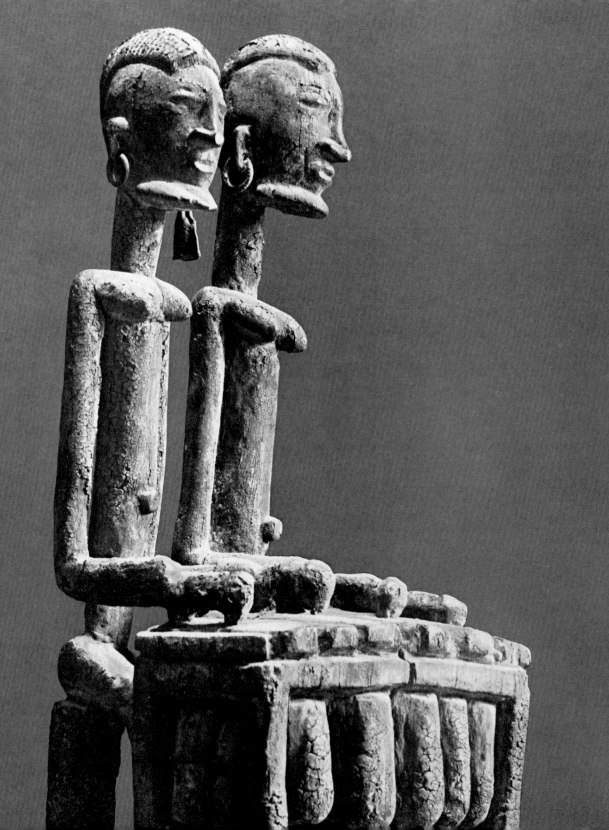

A 10
Two xylophone players.
Dogon. Wood, 44 cm.
Coll. Hélène **Kamer, Paris.**

A 11
Head. Dogon.
Weathered wood, 50 cm.
Coll. J. Kerchache, Paris.

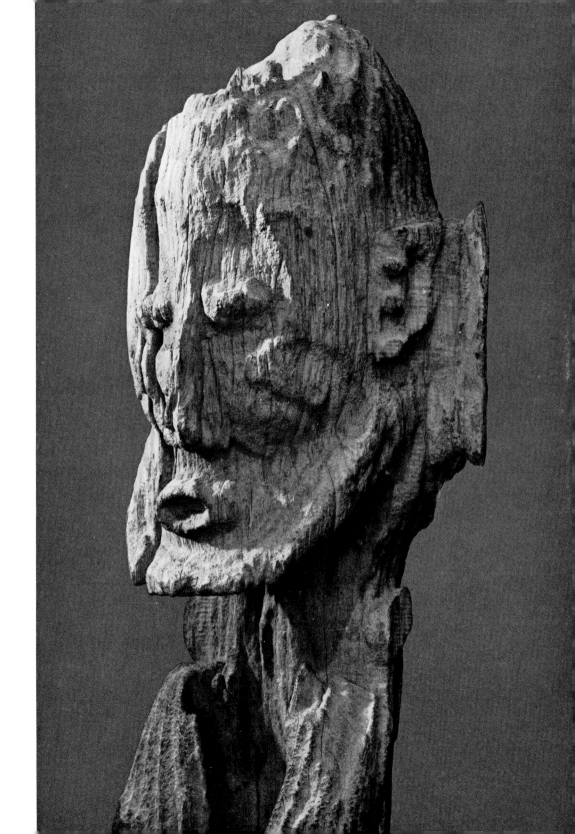

A 12
Kneeling female figure.
Mali, prehistoric. Found near Djenne on the upper
Niger. Terracotta, 30 cm.
Musée I. F. A. N., Dakar.

A 13
Priest, *tellem.* Dogon. Encrusted wood, 45 cm.
Rietberg Museum, Zurich.

A 14
Tellem, female figure with arms raised.
Dogon. Encrusted wood, 60 cm.
Coll. J. Kerchache, Paris.

A 15
Post-like figure. Dogon. Wood, 86 cm.
Coll. Simone de Monbrison, Paris.

A 16
Statue in pole style. Dogon. Wood, 156 cm.
Coll. Mr and Mrs Deschiron, Paris.

A 17
Horseman. Dogon. Wood, 55 cm.
Coll. J. Kerchache, Paris.

A 18
Throned ancestor figure. Dogon. Wood, 63 cm.
Coll. P. Verité, Paris.

A 19
Hunchback. Dogon. Wood, 43 cm.
Private collection, Paris.

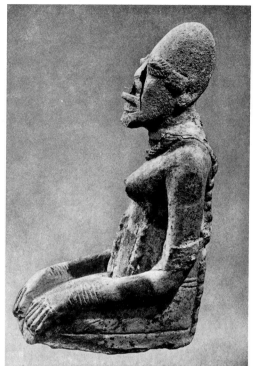

A 12

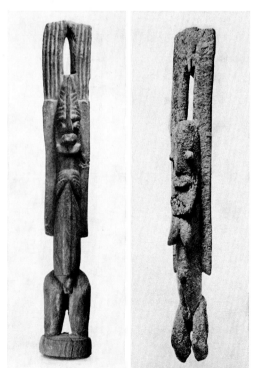

A 13
A 14

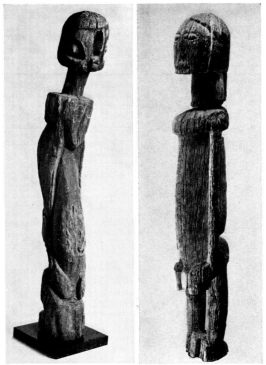

A 15
A 16

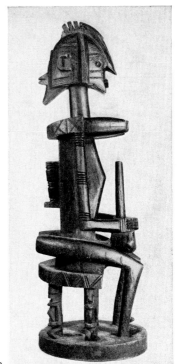

A 18

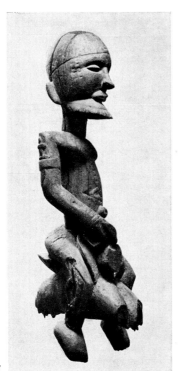

A 17

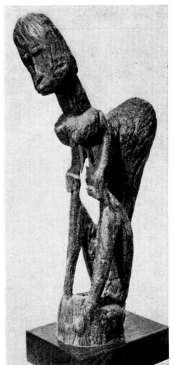

A 19

A 20
Ancestor pair. Dogon. Wood, 66.5 cm.
Rietberg Museum, Zurich.

A 21
Ancestor pair. Dogon. Wood, 65 and 64 cm.
Coll. J. Kerchache, Paris.

A 22
Ancestor pair. Dogon. Wood, 65 cm.
Coll. Nicaud, Paris.

A 23
Ritual trough with *tellem* relief. Dogon.
Wood, l. 160 cm.
Coll. J. Müller, Solothurn, Switzerland.

A 24
Ancestor figure with lip-plug of the so called
Master of Ngol. Dogon. Wood, 63 cm.
Rietberg Museum, Zurich.

A 25
Ritual seat with pairs of figures. Dogon. Wood, 28 cm.
Coll. Max and Berthe Kofler-Erni, Basel.

A 26
Granary door with animals and riders.
Dogon. Wood, 37 cm.
Coll. Nicaud, Paris.

A 27
Ritual bowl with horse and rider. Dogon. Wood, 68 cm.
Coll. E. Leuzinger, Zurich.

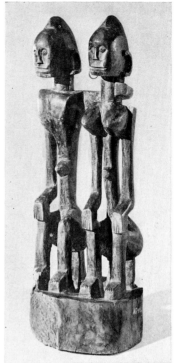

A 20

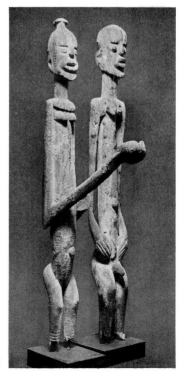

A 21

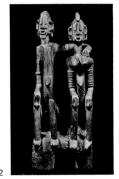

A 22

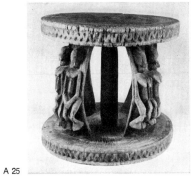

A 25

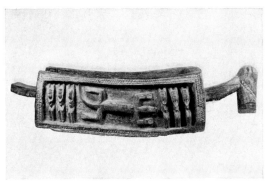

A 23

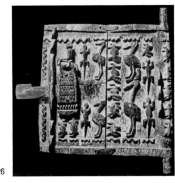

A 26

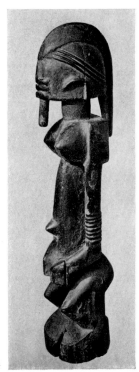

A 24

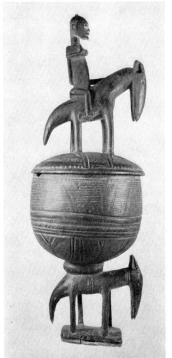

A 27

A 28
Small kneeling figure. Dogon. Brass, 6 cm.
Coll. George Ortiz, Geneva.

A 29
Pendant. Standing figure.
Dogon. Brass, 11.5 cm.
Coll. George Ortiz, Paris.

A 30
Posts from a religious building; pair of figures, plus
symbols, in relief. Dogon. Wood, 280 and 260 cm.
Coll. Hélène Kamer, Paris.

A 31
Kanaga mask. Dogon. Painted wood, 104 cm.
Coll. Edith Hafter, Zurich.

A 32
Tellem door with relief. Dogon.
Encrusted wood, 66 cm.
Private collection, Paris.

A 33
Antelope mask. Dogon. Painted wood, 111 cm.
Coll. A. Mabille. Brussels.

A 34
Mask with deep eye sockets, open mouth and
visible teeth. Dogon. Wood, 47 cm.
Coll. Koenig, Ganslberg/Lower Bavaria, Germany.

A 35
Mask with curved horns. Dogon. Wood, 60 cm.
Coll. Robert Poupion, Neuilly, France.

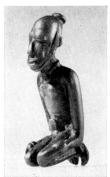

A 28

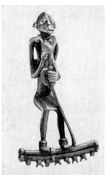

A 29

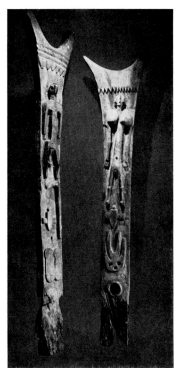

A 30

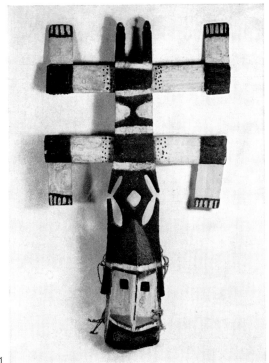

A 31

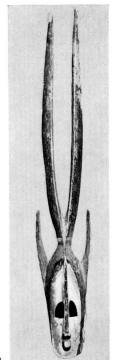

A 33

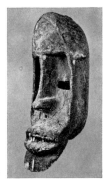

A 34

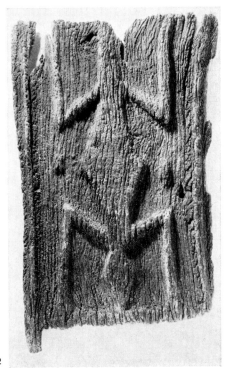

A 32

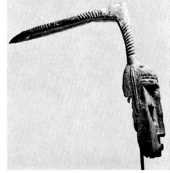

A 35

B The Bambara

The Bambara, who live in Mali, on the Bani river and on both sides of the Upper Niger, are an important Mande-speaking tribe, almost a million in number. They are the heirs of two kingdoms: Segu (1660—1881) and Kaarta (1670—1851). An advanced Islamic intellectual culture is found above all in the cities, amongst which Bamako is a particularly lively, colourful and active centre of trade and commerce.

The life of the farmers in the villages is quieter. Here Old Nigritic customs and carving in many forms have been maintained. The Bambara believe in the great light and creator god *Faro,* a kind of redeemer and organizer of the universe, who is enthroned in the seventh heaven and sends the rain which brings fertility. His sacred colour is white. All white things can be used as gifts to *Faro,* such as eggs and cowrie shells. According to the myth *Faro* bestowed upon men their conscience, order and purity, as well as a sense of responsibility. He brought them corn and cotton and taught them to work. At one time the most beautiful girl, richly adorned, was sacrificed to him every year at the riverside as his bride. *Faro* also created the female twins. Through his messenger, the swallow, he made them pregnant with his vital power, and so brought into being the first Bambara. For this reason twins are particularly regarded as bringing good fortune: they have received life direct from *Faro.* The omnipresence of this god and his incarnations in the form of all kinds of spirits can always be sensed. The Bambara undertake nothing without first asking the will of *Faro* through an oracle.

Life in the village is ruled by secret societies to which the male Bambara belong. Each of the six societies has a particular function in the life of the tribe. The boys awaiting initiation belong from the seventh year of life to the *N'tomo* society, which protects them from danger and teaches them correct behaviour. The boys who at any one time go through the bush school together, and receive circumcision and initiation into the men's society, form an age group which remains united in mutual loyalty throughout life. The most powerful authority is the *Komo* society. With the smith as its leader, it exercises judicial power.

The smiths *(numu)* are, in true Hamitic spirit, a respected, feared and at the same time despised caste, who live in their own villages, or in isolated quarters of the village, and marry among themselves. The same caste provides those who carve the sacred masks and figures. Besides them there are also the *kule,* a caste of carvers who likewise live apart. The *numu* and *kule* wander around the country and accept commissions, so that it sometimes happens that the same carver, depending upon who gives him the commission, may produce quite different objects. But they are always guided by a powerful feeling for tradition. The *kule* say that the wood comes to them itself from the bush to be worked by them, and that they know how to deal with the spirits without being harmed by them. The sculptures, carved from the kapok tree, are blackened with red hot iron, shea butter is rubbed into them, and they are finally decorated with little rings, glass beads, cowrie shells or red jequirity beans. It is rare for them to be painted.

The carvings of the Bambara present a great number of types and varieties and are in general of a severe monumental but elegant style. The figures are composed of cubist forms, with thin

B 1
Antelope dance headdress
Chi wara, hind with kid.
Minianka type, Bambara.
Wood with brass strips, 71 cm.
Musée I. F. A. N., Dakar.

B 2
Mask. Marka.
Wood with brass sheeting, 36 cm.
Ethnological collection, Zurich.

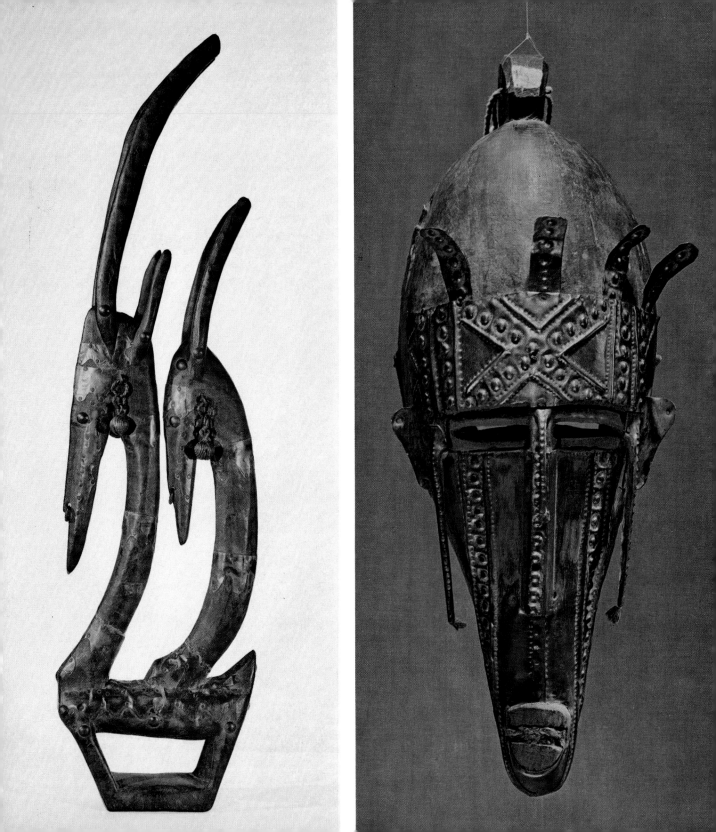

pillar-like bodies. The breasts project forward as heavy sharp cones, while the arms hang down at the sides. A characteristic of female figures is the transverse hair style, based on the short ringlets that project sharply sideways on the heads of their living models. Patterns of notches imitate the tribal scars. The Bambara have a large number of female figures which are used in the fertility cult. These rigorously stylized female figures are also found on cult objects such as harps, flutes, and stools, or on door latches. Figures also decorate the bowls in which shea butter is kept, butter used as ritual ointment after the bath of purification.

The statues can be divided into three main groups of styles:

1. The figures of the northern Segu style are characterized by a prominent hooked nose, protruding eyes, breasts placed high on the body, large hands like paddles and large, stable feet.

2. The southern style, found round Bamako, is more severe. The figures have a straight profile, the breasts are often placed low.

3. The third group, from the region between Buguni and Dioïla, has only become known in recent years. Surprisingly, these statues have softer lines and sensitive features. These imposing figures are crowned by a tall cap with bands falling away at each side, and they are shown standing, riding or seated on a chair. The surface of the figures is considerably decayed throughout.

A separate group is formed by the *boli*. This term is applied to primitive figures of various kinds. The *boli* house the magical forces of powerful nature spirits and are used by the secret societies. Their form is usually encrusted with a sacrificial deposit of ashes, animals' blood and beer, which ensures the magical power of the *boli*.

The term '*chi wara*' refers in the first instance to the *chi wara* headdresses for the antelope dance, for which the Bambara have become world famous. The *chi wara* are amongst the most beautiful and ingenious works of African sculpture. The proud eland, the emanation of the creator god *Faro,* is the tribal animal of the Bambara and the mythical spirit of work; for it once taught men how to cultivate grain. Its growth-bringing powers are invoked in every situation in life. The young men who are members of the *Flankuru* society appear and, before the clearing of land, seed time or harvest, to the accompaniment of drum beats, begin a distinctive slowly weaving circular dance, with constant respectful genuflections. The male and female antelopes always form a pair, and the great spirit would kill anyone who tried to separate them in the rite. They also dance after the conclusion of their puberty celebration before the nubile girls, who are richly adorned with cowrie shells. With the characteristic movements, leaps and vibrations of the antelope they display his magical relationship to the fertility of their fields and women.

The *chi wara* headdresses are made in numerous brilliant variations, differing according to place and time, and never alike. Sometimes they reach high into the air, sometimes they project far to each side. They may be smooth or angular, close to nature or abstract to the ultimate degree. Only the zig-zag lines of the mane and horns must remain recognizable in order to be effective as a symbol of the mythical power, as the part representing the whole.

Three main groups of *chi wara* can be distinguished:

1. The 'Segu-Minianka type' of the eastern Bambara region, between Sikasso, Kutiala, Segu and Dioïla, including the Minianka, an enclave of the Senufo

B 3
Statue of woman carrying a pot.
Bambara. Wood, 135 cm.
Coll. Henri A. Kamer, New York.

B 4
Female ancestor figure, seated.
Bambara. Wood, 102.2 cm.
The Museum of Primitive Art, New York.

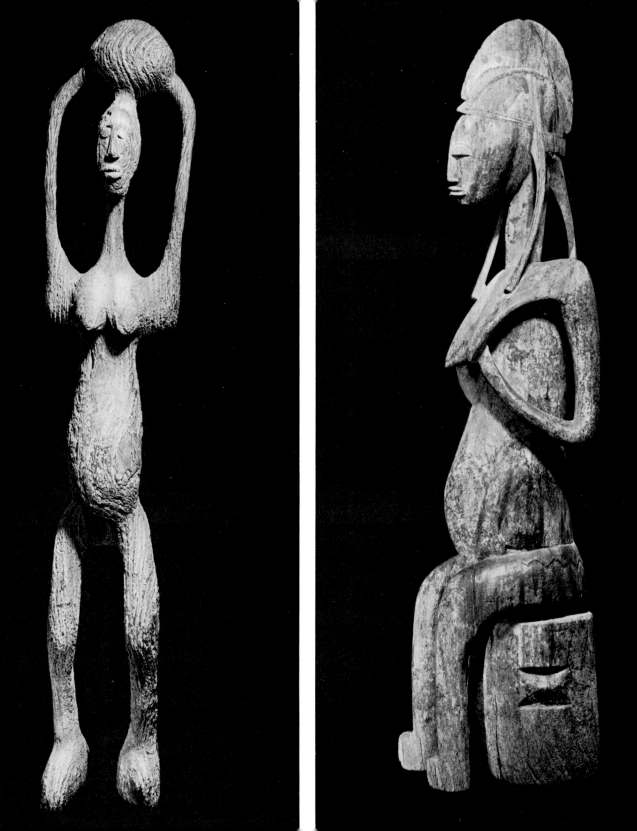

in the Bambara region. The structure of this type is vertical: above a small body rises a powerful curved neck with a broad mane of decorative openwork, a firm, narrow head and slightly curved horns riding majestically above. The hind which belongs to this type has no mane; instead, it bears a small kid upon its back and has straight horns. These are formed with powerful spiral curves.

2. The 'horizontal type' of the north-western region round Bamako. There the antelope, its horns bearing spiral curves, leaps across horizontally. It is formed in two parts, which are joined together at the neck with a metal ring. Regardless of zoological accuracy it may have several pairs of horns; or the bodies of the antelopes may be combined with all kinds of elements of other animals, so that they appeared to one well known scholar as *monstres harmonieux*. A tail rolled in a circle, for example, may be derived from the chameleon which, as one of the first animals of the creation, is said to have been meant to bring immortality to the Bambara, but was overtaken by another animal who brought death. The surface of many of the *chi wara* is completely smooth, but that of others is entirely covered with a delicate pattern of curves, representing the pattern of the animal's coat.

3. The 'Suguni type' found in the villages around Buguni in the south-western Bambara region. Here we find a vertical, abstract type. The interplay of forms between the zig-zag pattern, the horns and the curve of the neck, with the head growing to a point and the strange bodies, is extraordinarily attractive and imaginative. The body of the antelope is sometimes arbitrarily joined to that of another animal (horse, chameleon, lizard, tortoise or gazelle). When there is also the figure of a woman on top this may — in the view of Jacqueline Delange —

refer to the myth in which the jealous twin brought evil.

The dance for which the Suguni type is used is more wild than in the case of other types.

A similar richness of ideas and a high capacity for abstraction is also displayed by many objects worked in iron, mostly representing riders, women and animals. They form part of the family treasure of the chief, who makes use of them at ceremonies.

Depending upon its form, each mask is meant for one of the great secret societies, and has strictly regulated functions in conveying magical power. Most of them are in animal form and are highly abstract. The shapes worn by the *Kono* society as a headdress, made of wood, bristles, cowrie shells, teeth, thorns and a thick encrustation from sacrifices, can only marginally be regarded as art. But this is not true of the vast flat masks used by the *Kono* society, with their long animal ears, the form of which is often concealed under the deposit from sacrifices.

The most important group of masks is used by the *Kore* society. The masks are worn when the water spirit has to be called upon for rain and growth. This always happens at the beginning of the important stages in the agricultural process, and also at the great ceremony of the initiation of new members of the society which takes place every seven years. But the masks can also be brought out before and after these occasions, such as when rain has been absent for too long a time. Then an exceedingly strange troupe of animal masks makes its way down to the river with leaps and bounds, constantly bowing the knee respectfully to the spirit to which due tribute has to be paid. The form of the *Kore* masks is unrealistic, so much so that the type of animal which they repre-

B 5
Standing female figure.
Bambara. Wood, 55 cm.
Coll. Hélène Kamer, Paris.

B 6
Female fertility figure.
Malinke. Wood, 37.5 cm.
Danish National Museum,
Ethnographical Department,
Copenhagen.

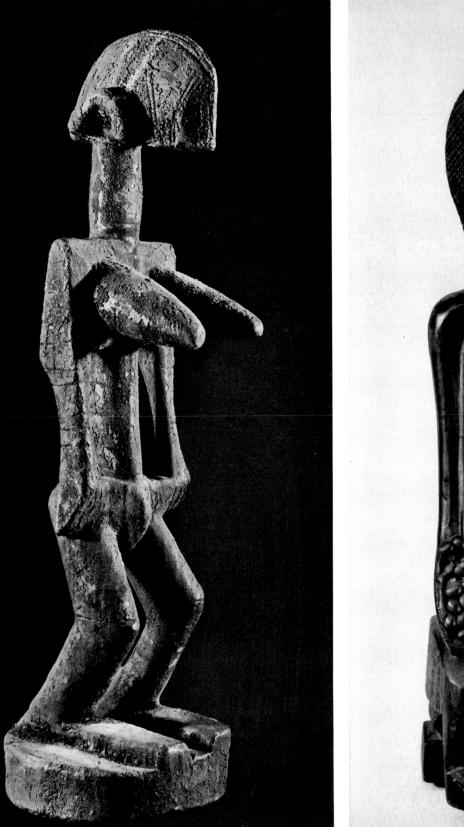
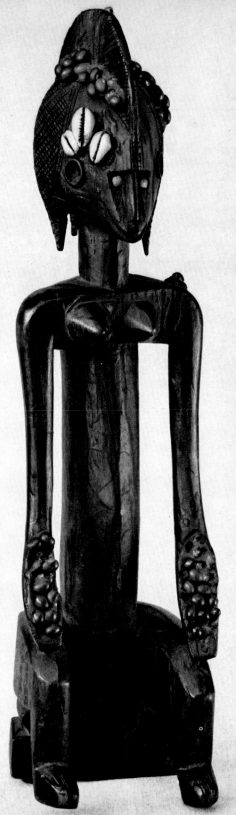

sent is almost unrecognizable. They are mainly hyenas, monkeys, lions, antelopes and horses. The lion head is round with short ears. The hyena has an oval face with long ears and an open mouth; its forehead is often sharply protruding.

Only the *N'tomo* mask, the protecting spirit of the boys, is given human features, though there are always from two to ten small vertical horns above it, which refer to a particular myth. The *N'tomo* masks of the Segu type have a bold hooked profile, while those of the southern type have an angular austere form, thus corresponding to the figures of each region. Sometimes they are set with cowrie shells and jequirity beans, while they are sometimes also combined with human and animal figures.

The cotton textiles of the Bambara are also decorated with symbolic ornaments. The zig-zag on a cloth worn by one particular Bambara woman was explained to me as an antelope. The patterns are produced by a method of etching with soap and mud.

Some of the neighbours of the Bambara also fall within their sphere of influence. These include the Khassonke, Malinke, Marka, as well as the Minianka sub-tribe of the Senufo, which has already been mentioned.

The masks of the Malinke (southern Mali and upper Guinea) are particularly heavy and monumental, and their figures are very lively. Amongst the Minianka the clay figures which are used in the temple worship possess vital force. The masks of the Marka, a fishing people in the San district, are narrow and austere, with a sharp chin. They are brightly painted or coated with metal foil with raised ornamentation, achieving a fine decorative effect. The men of the Marka, clad in costumes of colourful cloth, always appear in pairs, to represent man's wooing of woman. The same stern, metal-plated Marka face can also be found staring out from the cloth of the little marionettes manipulated by a man hidden under a covered frame, and performing fables and burlesques.

It has only recently been realized that the small and very ancient fishing people, the Bozo, living around the confluence of the Bani and Niger, produce works of art. The form of the rare, brightly coloured animal masks is resembling that of the Bobo-Fing animal mask; they share the decorative plating of metal foil with their neighbours the Marka.

B 7
Antelope dance headdress *Chi wara,* female Minianka type. Bambara. Wood, 64 cm. Coll. P. Verité, Paris.

B 8
Antelope dance headdress *Chi wara,* male Minianka type, Bambara. Wood, 81 cm. Coll. Max and Berthe Kofler-Erni, Basel.

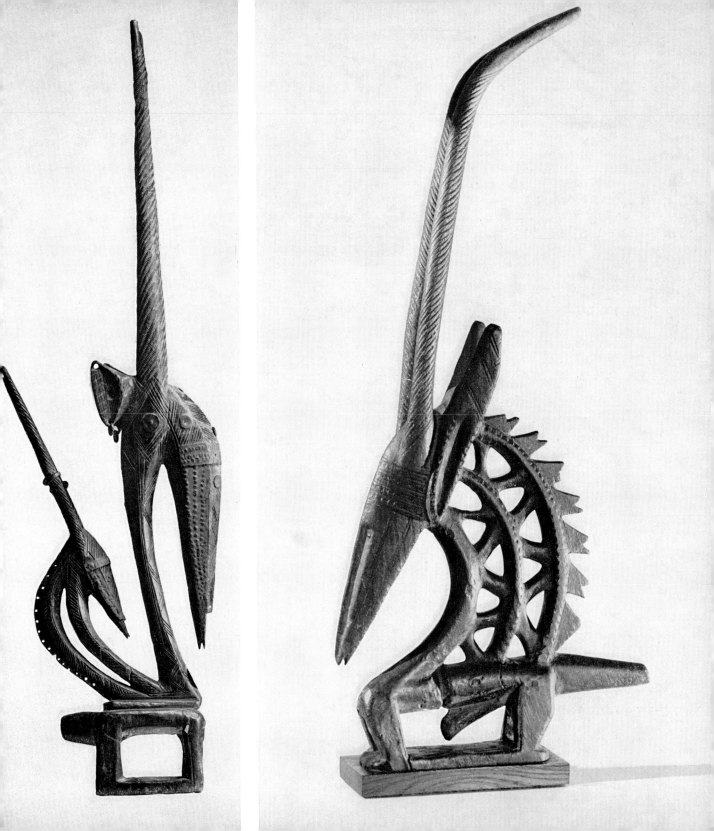

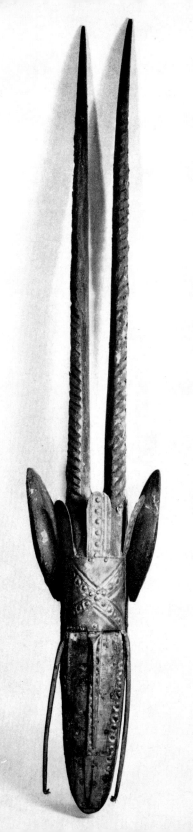

B 9
Antelope mask. Marka.
Wood covered with metal,
76 cm.
Coll. J. Müller, Solothurn,
Switzerland.

B 10
N'tomo mask with figure.
Bambara. Wood, 69 cm.
Coll. P. Verité, Paris.

B 11
Animal mask. Malinke, Mali.
Wood and cowrie shells,
54.5 cm.
Coll. Helmut Gernsheim,
Castagnola, Switzerland.

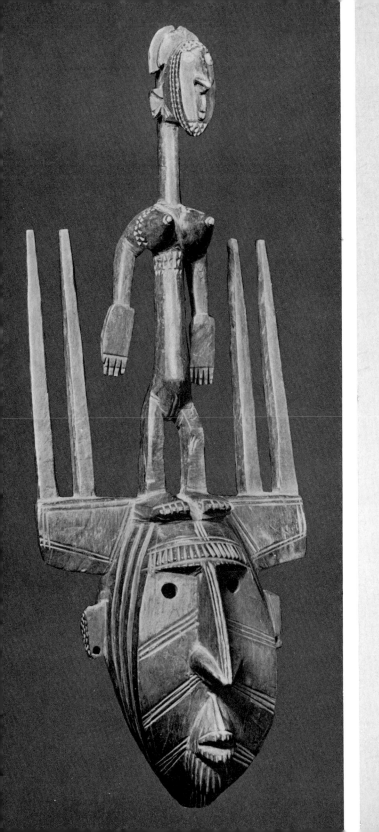
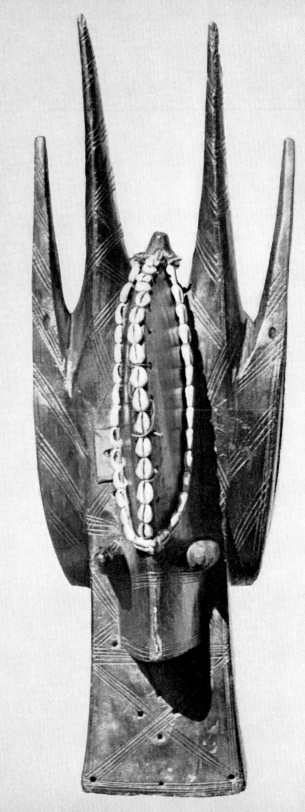

B 12
Female figure. Bambara. Wood, 78 cm.
Coll. Simone de Monbrison, Paris.

B 13
Bowl and lid with female figure. Bambara.
Wood, 46 cm.
Coll. Max and Berthe Kofler-Erni, Basel.

B 14
Antelope staff. Bambara. Wood, 77 cm.
Coll. E. Storrer, Zurich.

B 15
Female figure. Segu type. Bambara. Wood, 62 cm.
Náprstek Museum, Prague.

B 16
Antelope dance headdress. Suguni type. Bambara.
Wood, 61 cm.
Ethnological Collection, Zurich.

B 17
Dance mask. Marka.
Wood with brass and iron strips, 42 cm.
Coll. Dr. Edmund Müller, Beromünster.

B 18
Temple figure. Minianka. Terracotta, 51 cm.
Coll. E. Storrer, Zurich.

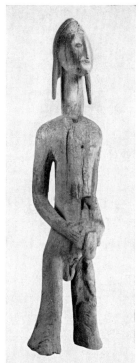

B 12

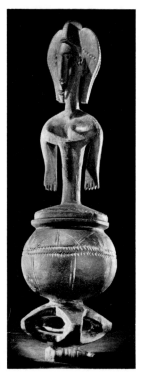

B 13

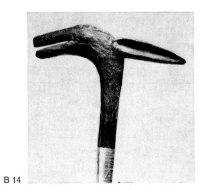

B 14

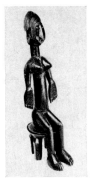

B 15

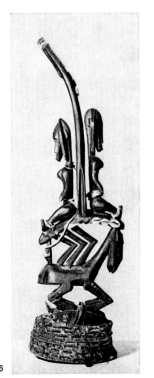

B 16

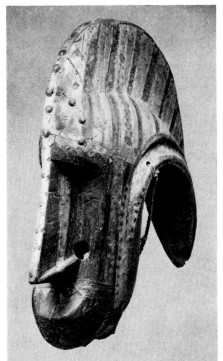

B 17

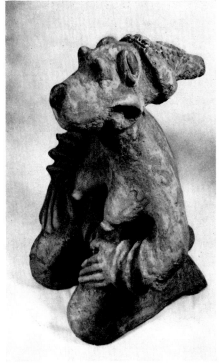

B 18

B 19
Ritual staff with antelope head. Bambara.
Iron, 23.5 cm.
Coll. Winizki, Zurich.

B 20
Ritual staff with equestrian figure. Bambara.
Iron, staff 126 cm., figure 18 cm.
Coll. Winizki, Zurich.

B 21
Boli, animal figure of the Kono society. Bambara.
Rattan framework covered with mud, honey and
dried blood, 55 cm.
Coll. Comte Baudouin de Grunne,
Wezembeek-Oppem, Belgium.

B 22
Ancestor figure. Bambara. Wood, 65 and 57 cm.
Rietberg Museum, Zurich.

B 23
Dance mask. Marka.
Wood covered with copper sheeting, 41 cm.
Coll. L.-P. Guerre, Marseilles, France.

B 24
Antelope mask. Bambara. Wood, 78 cm.
Rietberg Museum, Zurich.

B 25
Aardvark mask. Bambara. Wood, 47 cm.
Rietberg Museum, Zurich.

B 26
Antelope dance headdress, female *chi wara.*
Bambara. Wood, l. 54 cm.
Coll. E. Leuzinger, Zurich.

B 27
Antelope dance headdress *chi wara.*
Bambara, near Bamako.
Wood, brass eyes, 34 cm.
Rietberg Museum, Zurich.

B 19
B 20

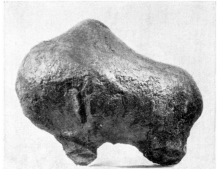

B 21

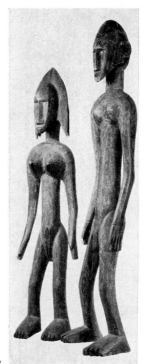

B 22

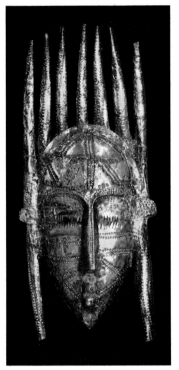

B 23

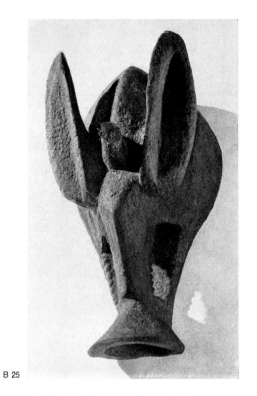

B 25

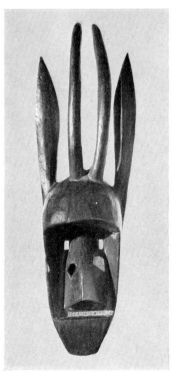

B 24

B 26

B 27

C Upper Volta

The Mossi

A harmonious symbiosis of the Old Nigritic and the Neo-Sudanic civilizations has been established by the various populations of Upper Volta. The kingdoms of Mossi-Yatenga and Mossi-Wagadugu, with their sacral monarchy, flourished from the eleventh to the fifteenth century. At the head of society, which was organized into castes, stood the chief minister and the aristocracy. The king, the Moro-Naba, still lives in his capital at Wagadugu. In accordance with the commandment of Islam, there is no place for sculptural art at his court, with the exception of a few portrait masks which his predecessors seem to have had cast in bronze. Instead, arts and crafts in metal, leather and textiles are developed to a considerable degree.

In spite of the power of the courts and of Islam, a large number of the tribes of Upper Volta have succeeded in maintaining the ancient Sudanic civilization, and with it a belief in the 'lord of the soil' as the ultimate authority, and the art of carving, nourished by the cult of the spirits and ancestors. Every tribe has its own stylistic variant, although a connection with other ideas in the West Sudan is unmistakable.

What is usually known as the Mossi style is the work of the smiths of the ancient Kurumba tribe of the Yatenga region. The Mossi call them the Fulse, but they call themselves Nioniosse ('Not Mossi'). Their masks have an oval, abstract spirit face with no mouth or chin, toothed decoration along the line of the nose, triangular eye holes and short antelope horns which, depending upon whether it is a female or a male mask, are straight or curved. The mask face is crowned by a lofty superstructure either in the form of a human being — in accordance with the practice of dancing with figures on the head at the funeral procession of a king — or in the form of a long pierced plank decorated with geometrical designs, similar to the storeyed *sigiri* mask of the Dogon. The masks are kept by the 'lord of the soil', and women are not allowed to look at them. The masks that belong to the *Wango* society appear at funerals or in other protective capacities. They sing in a secret language to the accompaniment of drums and flutes.

The Kurumba

There is no absolute connection between the Kurumba tribe and the Kurumba style. The style which is usually known by the name of 'Kurumba' is a different one. The term refers to the sculptures of the branch of the Kurumba who dwell in the Aribinda and Belehede region of northernmost Upper Volta and the adjacent part of Mali. They also refer to themselves as Tellem and may possibly be connected with the ancient Tellem to whom the Dogon refer. If this is so it would not be surprising that the Kurumba and Dogon sculptures show an underlying relationship, which is visible particularly in the *kanaga* (the storeyed mask) and the sculptures used as gable posts amongst the Dogon, and in the corresponding Kurumba sculptures (*see* Schweeger-Hefel).

Amongst the Kurumba carvings the elegant antelope dance headdresses are outstanding. They are used only at funerals, are addressed as honoured persons, are cherished and cared for, and finally buried like a chief. For every festival they are repainted with their typical geometrical pattern. This distinguishes them from the *chi wara* of the

C 1
Antelope dance headdress.
Kurumba, Aribinda region.
Painted wood decorated with seeds and jequirity beans, 70 cm.
Musée de l'Homme, Paris.

54

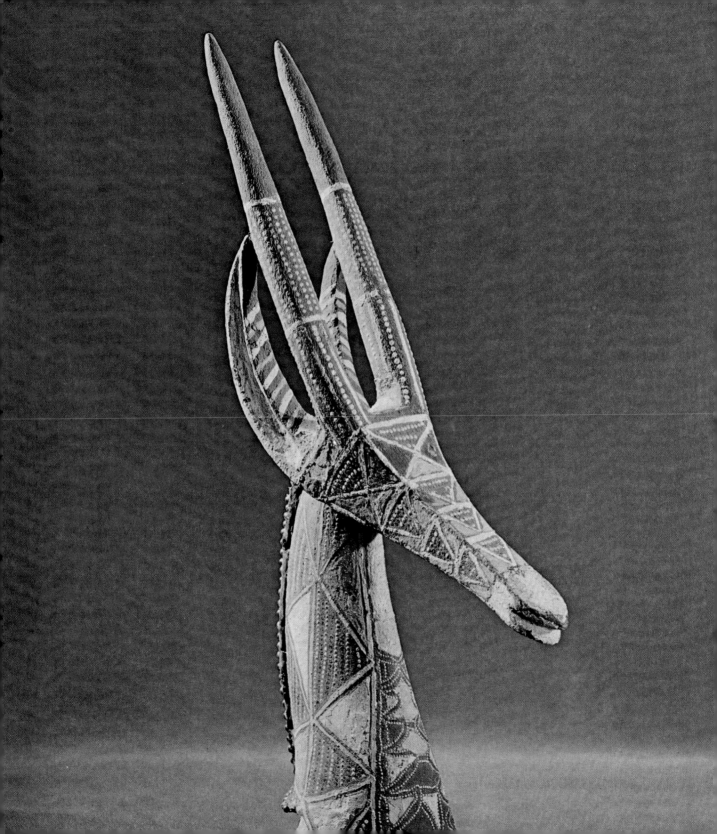

Bambara, which they resemble in their total outward appearance. The Kurumba antelope heads are so attractive that they have become a frequently copied tourist article.

Annemarie Schweeger-Hefel has recorded the following account from the Kurumba about the production of the mask: 'The carver first goes into the bush and looks for a particular very heavy wood which is suitable for making a mask. Since each mask is carved out of a single piece, it must be a comparatively large piece of wood. Before he begins his search and his work, he must sacrifice a three-coloured cock to the ancestors and on the last night before he sets out, he is not allowed to sleep with a woman. He remains all alone in the bush, in a hidden place, until he has completed the mask. He must abstain from sexual intercourse the whole time he is there. When the new mask is finished, he returns with it to the village and once again sacrifices a cock to the ancestors, this time a red one.' When a mask is sold it is handled like a dead body, wrapped in a mat of bast and honoured with a sacrifice of cocks.

The Bobo

Two main style groups can also be found amongst the Old Nigritic Bobo peasants:
1. The Bobo-Fing style, that of the Black Bobo, who live in the region north of Bobo Diulasso and south of Nuna. Some of them also live in Mali round San and Kutiala.

The masks are painted and emphatically three-dimensional. The human faces have sharp protruding noses and a rounded mouth. There are animal masks, buffaloes and rams with marvellously curved horns and muzzles. The smiths who make the masks always wear them themselves at the burial of important persons and at the initiation of new members of the secret society.
2. The northern style of the Bobo-Ule, i.e. the Red Bobo (also called Tara), found particularly in the region round Hunde. Their style is the same as that of the Nuna and Gurunsi. The characteristic feature is the rather coarse painting in geometric patterns of white, red and black. A common type has a flat board-like headdress which is decorated with circle, zig-zag, rhombus or chess board patterns and is topped by a half-moon or a series of figures. The face of the mask has eyes in concentric circles, a diamond- or disc-shaped mouth and the protruding aggressive beak of the hornbill. Every quarter of the village and every clan has its own special form of mask, which is intended for decorative display. The chess board patterns recall the mourning garments of the Bobo. Amongst the masks we also find birds, butterflies, cows, antelopes and chameleons; some are flat, and others three-dimensional. The masked dancers of the *Do* society march on in costumes of red fibre, with whips, sticks, or bundles of leaves as weapons, particularly at the memorial festivals of the dead and in fertility rites.

The numerous attractive pendants, amulets and ornamental rings of brass which are found amongst the Bobo are largely manufactured by the founders of the Senufo.

The Gurunsi (Grunshi) etc.

It is the Gurunsi who make for themselves and for their neighbours the Bobo and the Nuna the board-like multi-coloured *Do* masks. The Gurunsi, Nafana, Abron, Kulango and the Diula in the border region between west central Ghana, southern Upper Volta and Bon-

C 2
Prisoner.
Lobi. Wood, 77 cm.
Private collection, Paris.

C 3
Head. Lobi. Wood, 71 cm.
Private collection, Paris.

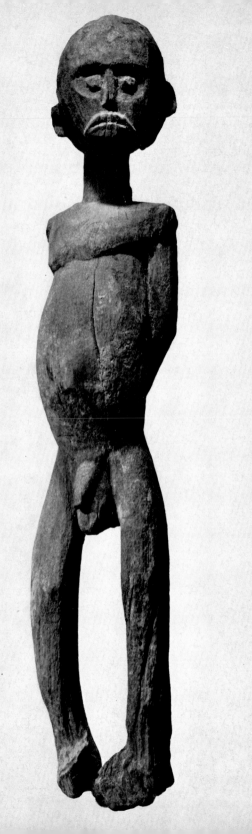
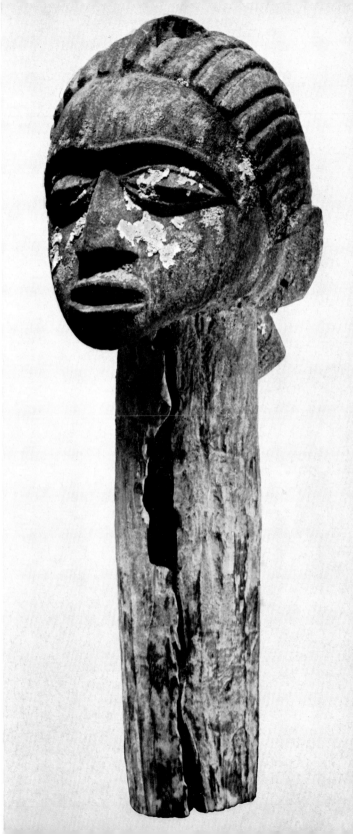

duku in the northern Ivory Coast have also brought on to the market powerful shield-like horned masks. They are made from the soft wood of the *bombax cornui*. Their quality as three-dimensional forms is usually slight, their effect depending upon the decorative pattern of brightly coloured formal elements and sometimes upon the addition of cowrie shells and jequirity beans. The male masks have horns, while the larger female masks, more than three metres high, are topped by a disc-like form.

These masks are seen only once a year during the month of December and then only at night, for during the day the spirits who dwell in them would escape. In the light of the full moon they dance in pairs with leaps and sudden genuflections or with fluttering movements before the vast singing audience in an atmosphere excited by the beating of drums. In this way they cleanse every house from all evil. Throughout the year the masks remain in a special hut. It is the privilege of one particular family to wear them and look after them; old women of this family have the task of bathing the masks in oil and egg and of painting them before the festival.

The masks of the Zavara sub-tribe of the Gurunsi show a very different type of style.

The Lobi

Whereas amongst the Bobo, Mossi and Kurumba masks predominate, the Old Nigritic Lobi and numerous neighbouring tribes such as the Kulango, Birifor, etc., restrict themselves to carved heads and figures made of hard wood. The artistic importance of their works lies in an enduring simplicity, in the fine, lyrical expression of the mouth, which harmonizes with the large, three-dimensional eyes in the shape of coffee beans. Sometimes a

cap of hair with a central knot running from back to front is portrayed. These figures can be seen on the roofs, inside the house or before the entrance. When sacrifices are offered lavishly to them, the figures strengthen the faithfulness of wives, assure the growth of the fields, protect against illness and theft and give their advice through the voice of the oracle.

Typical of the Lobi are three-legged stools with a head carved on the handle. They are used by the old men at the *dyoro* festival, and are also used as clubs. The *dyoro* is celebrated every seven years on the bank of the river in honour of the water spirits.

C 4
Antelope mask with female figure. Mossi. Wood, painted red and white, 109 cm. Rietberg Museum, Zurich.

C 5
Do mask; owl face and geometric motifs; a crocodile on the reverse. Bobo, Bobo Diulasso. Wood, painted red, white and black, 199 cm. Coll. Maurice Bonnefoy / D'Arcy Galleries, Geneva.

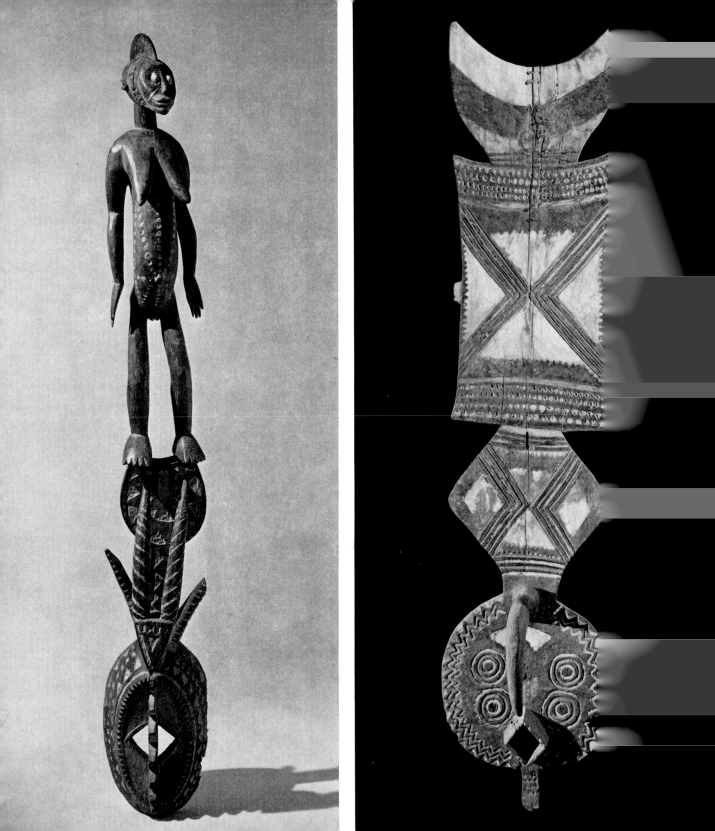

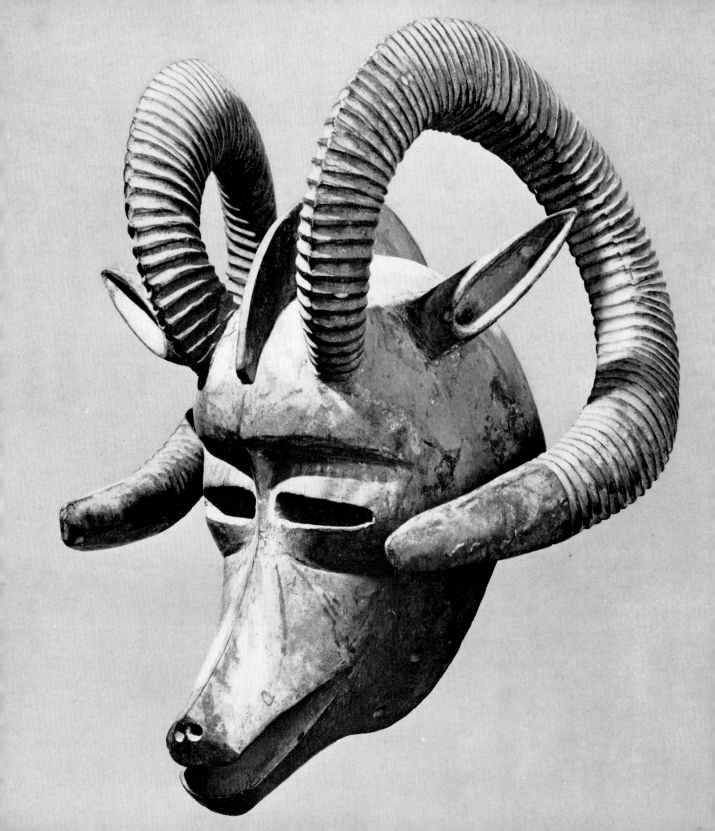

C 6
Ram mask. Bobo-Fing.
Wood, with traces of red,
white and blue, 48 cm.
Coll. Delenne, Brussels.

C 7
Animal mask. Bobo-Fing.
Painted wood decorated
with jequirity beans, 67 cm.
Coll. W. Kaiser, Stuttgart,
Germany.

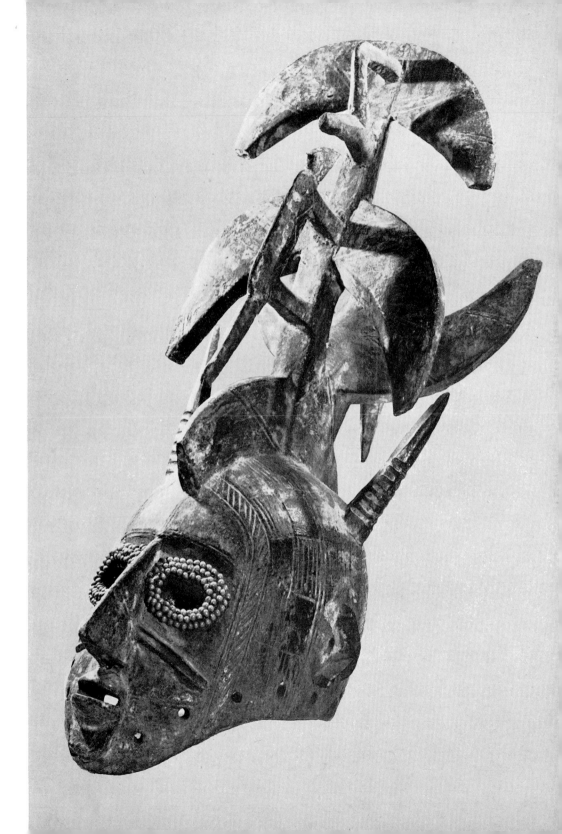

C 8
Buffalo mask, *Do* guardian spirit. Bobo.
Wood painted red, white and black, 75 cm.
Rietberg Museum, Zurich.

C 9
Forked post with female figure. Mossi. Wood, 172 cm.
Musée des Arts Africains et Océaniens, Paris.

C 10
Ram mask. Kurumba. Painted wood, 75 cm.
Coll. E. Storrer, Zurich.

C 11
Pendant, crescent shaped with figure. Bobo.
Brass, 10 cm.
Coll. Max and Berthe Kofler-Erni, Basel.

C 12
Antelope mask. Bobo.
Wood painted red, white and black, 55.3 cm.
Coll. W. Kaiser, Stuttgart, Germany.

C 13
Bird figure. Lobi. Wood, 56 cm.
Private collection, Paris.

C 14
Antelope mask. Bobo-Fing.
Painted wood, 110 cm.
Coll. Nicaud, Paris.

C 15
Three-legged stool of elegant, abstract design.
Lobi. Wood, 81 cm.
Musée I. F. A. N., Dakar.

C 16
Ceremonial collar with two heads. Bobo.
Brass, 20.5 cm.
Coll. Maurice Bonnefoy / D'Arcy Galleries.

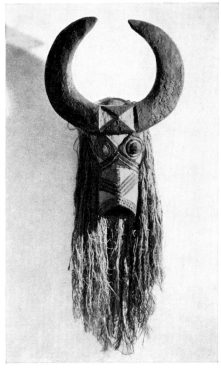

C 8

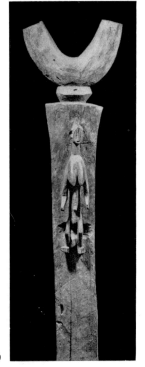

C 9

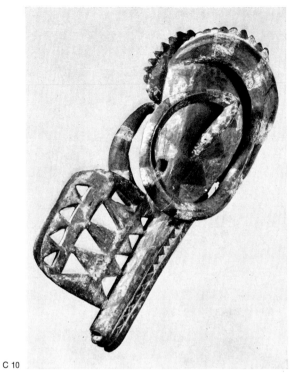

C 10

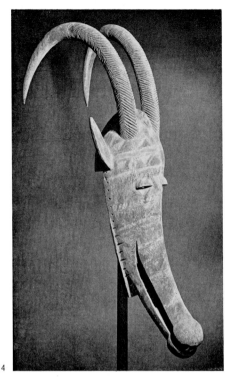

C 14

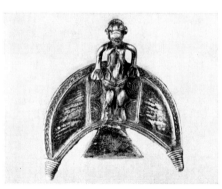

C 11

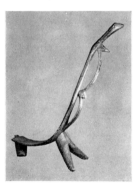

C 15

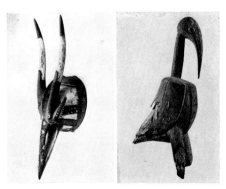

C 12
C 13

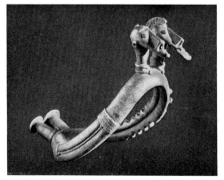

C 16

C 17
Head. Lobi. Wood, 39 cm.
Coll. André Held, Ecublens.

C 18
Marionette. Lobi. Weathered wood, 22.5 cm.
Musée des Arts Africains et Océaniens, Paris.

C 19 a + b
Pair of figures. Lobi. Wood, 67 cm.
Coll. E. Storrer, Zurich.

C 20
Ancestor figure. Lobi. Wood, 70 cm.
Coll. Monique and Jean-Paul Barbier, Geneva.

C 21
Mother and child. Lobi. Wood, 26.5 cm.
Coll. Nicaud, Paris.

C 22
Head. Lobi. Wood, 40 cm.
Private collection, Paris.

C 23
Bird mask, highly abstract design. Gurunsi.
Wood, 86 cm.
Musée National de Haute-Volta, Wagadugu.

C 24
Male dance mask. Gurunsi.
Wood painted red, black and white, 130 cm.
Coll. Simone de Monbrison, Paris.

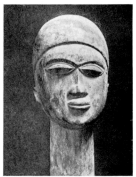

C 17

C 18

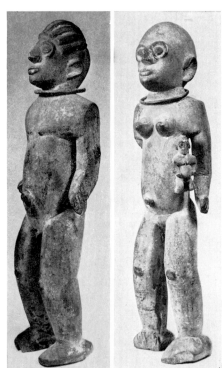

C 19 a + b

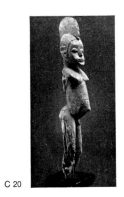

C 20

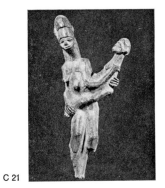

C 21

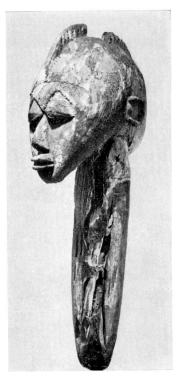

C 22

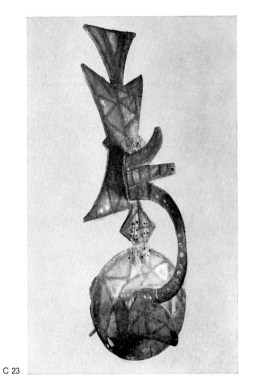

C 23

C 24

D The Senufo (Siena)

The Senufo, who live in the region of the northern Ivory Coast between Korhogo, Ferkessedugu, Bundiali, and Sikasso, and also parts of Mali and Upper Volta, call themselves the Siena. They claim to have migrated from the north two or three hundred years ago.

Their whole religious and social life is governed by the *Lo* society. This society hands on the creation myths with all their consequences, keeps in force the ancient customs which are necessary to overcome the dangers of the environment, and dictates the moral norms of the community. The *Poro* or *Lo* society is divided into three age groups: boys, youths and adults. Every seven years the Senufo, after having undergone lengthy tests, can be promoted into the higher ranks of the society. Each initiation is carried out with ceremonies and mask dances, and the masks are also used for the last rites for an important member of the society. The common bond between the members of an age group is very strong; in cases of real need, every member must be ready for any sacrifice. The meeting place of the *Lo* is the *sinzanga,* the sacred grove outside the village. There too is the place where the cult objects are stored. Women are not allowed to enter the *sinzanga,* but have their own secret *Lo* shrine. There the education of the girls takes place, their training as wives and mothers and their circumcision. Through the medium of female wooden statues the women pray to the great mother goddess *Katieleo* for a successful pregnancy. The prophetesses of the *Sandago* society call on the ancestors who give rain, because the women look after the fields, plant the yams and sow millet. The great *Porgaga* bird figures are also to be found in the women's sacred precinct. The Senufo carvers are the *Kule,* who belong to the Old Nigritic caste of smiths. They form a secret society of their own which is greatly feared, and see to the manufacture of all cult figures. Their statues are called 'the smiths little men'. In recent decades, however, all these rules have been relaxed. Unqualified persons who exercise the ancient craft of carving are more and more numerous, particularly when it is a question of providing for the tourist market.

Statues and reliefs

The highly distinctive style of the Senufo varies according to the district and the clan, and in addition has absorbed certain influences from the Bambara and Baule. The nearer one comes to the Bambara country, the more marked is the influence of the pole style. One of the main centres is to be found round Korhogo and Sinematiali. Its characteristics are unmistakable: a strict stylization, although the underlying organic feeling is preserved, vitality, the hair arranged in a high bird-like crest with a tip coming down over the brow, a semioval, narrow face with a long straight nose ending in a cross-piece representing the nostrils; and in addition, the very characteristic feature of an extremely prognathous jaw, often with a curved chin line, broad shoulders, heavy breasts coming to a sharp point, long arms and a back with fine curved lines. The forms from which the body is constructed spring three-dimensionally into space from the central axis of the narrow body pillar. The navel, which has a magical relationship to fertility, is often decorated with a pattern of rays. Hard woods are used for the figures. Only fifteen years ago the magnificent sculptures of the Senufo were still being kept from view, and indeed were unknown. They were kept in

D 1
Kāgba, head of a tent-like mask framework.
Senufo. Painted wood, 81 cm.
Rietberg Museum, Zurich.

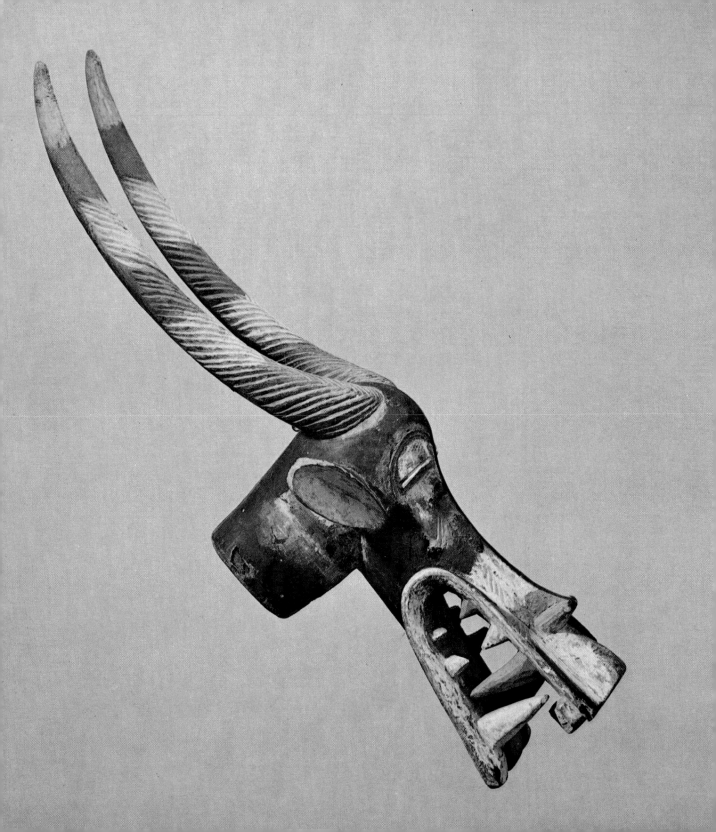

strict secrecy in the *Lo* sanctuary —
until the fatal day when 'Massa' appeared, a fantastic prophet who attracted hundreds of thousands of the Senufo to his fetish cult and ordered them to burn the ancient sculptures. It was fortunately possible to save some of the finest figures from the flames. From them we can judge the extraordinary degree of creative power of which the Senufo were capable. We have selected from their sculptures the most important *deble* and *degele*. The rhythm-beating statues, the *deble,* the most important cult object of the *Lo,* find their principal function at the burial of important members of the society. On such an occasion they appear four times: at the entry into the house where he died on the evening of the day of death, at the burial, at the concluding celebration on the following day, and finally at the sacrificial ritual at which the soul finally takes its leave of the living. But there are also other important occasions on which the *deble* must appear. The young members of the society come forward on these occasions in lines, each carrying a *deble* before him, which he holds by the arms, striking the ground with its pedestal. The dull rhythmic blows, accompanied by the sounds of heavy wooden trumpets, rattles made from gourds and the mourning song in the secret language of the *Lo,* invoke the souls of the dead which dwell in the heart of the earth, and pray to them to take part and give their help. The mystical presence of the mother goddess *Katieleo* is also called upon to purify the earth and make it fruitful.

Even more exclusive are the *degele,* visor masks with a headdress in the form of a figure on top. They are put into use only at night, and are worn by high dignitaries of the *Lo* at the funerals and memorial ceremonies of their leaders. The rings carved on to the necks show

the rank and power of each *degele.* They have no arms, which is not by chance, but, as always, has a deeper meaning. The man carries a quiver with the magical lightning arrows. The *degele* are powerful and well-balanced compositions of a high artistic quality and intensity.

The following common types of figure are to be found:
— a rider with a lance (symbol of the ruling power of the founding ancestors who brought civilization); the horse brings rain;
— the ancestor couple and the mother and child;
— women seated on little stools (a reward for the winner in the farming competition);
— women carrying a vessel on their head (for a fertility rite, in which the woman carries one of these figures on her head to the place of the cult, while other women dance round her with gurgling sounds and throw cowrie money into the bowl);
— the *daleu* figure staff (the mark of a high grade in the *Poro* society, and the emblem of the mother goddess *Katieleo;* used at solemn celebrations and as a taboo sign of the newly circumcised girls);
— statues carrying on their head a pierced dish with esoteric signs (in exactly the same way as the important members of the *Lo* society wear the headdress masks on their heads at their celebrations);
— the large, board-like decoratively pierced headdress masks of the *Kwonro,* an intermediate grade of the *Lo:* the whole cosmology and the emblems of power which are important to the Senufo can be read in them;
— *Porgaga,* the great mythical bird, a representation of the *calao,* the hornbill, *bucorvus abyssinicus,* an important cult object of the *Lo.* According to the myth the hornbill was one of the first creatures

D 2/3
Deble, pair of rhythm-pounding statues. Senufo, Lataha village, Cercle de Korhogo, northern Ivory Coast.
Wood. Man 108 cm.
The Museum of Primitive Art, New York.
Woman 95 cm.
Rietberg Museum, Zurich.

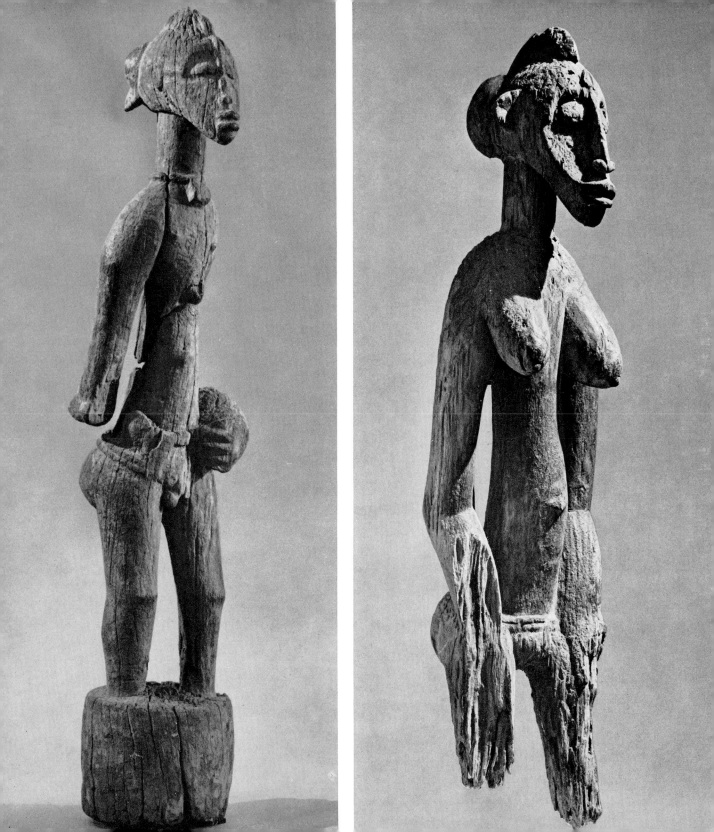

created by God and the first to be killed to feed man. Its swollen body and vast curved beak refer to copulation and numerous offspring. Thus *Porgaga* is an allegory of the continuance of mankind as such. Many of these bird figures are joined to a dome-shaped helmet, so that one can wear them on the head and so represent the creation myth.

Also worthy of a mention are the sacred *plievo* drums, which either stand on human legs or are carried by a female figure (in just the same way as the girls carry the drums on their heads in the rite), and also the doors of the houses of the priests and leading personalities, which are decorated with figures in relief. The themes on them are symbols of power of various kinds. The hornbill, the chameleon, the tortoise, the crocodile, the python and the antelope are symbolic animals, while riders and chains are signs of a ruler. The *kpelie* masks recall the initiation of the boys and the creation myth; the sun or a spider in the centre signify the world's navel or the *sinzanga,* hunters and women pounding corn refer to daily nourishment, etc.

Masks

The masks fall into fundamentally different categories. In addition to the delicate *kpelie* face masks, made from hardwood, there are also large helmet masks in animal form made from the softwood of the kapok tree *(ceiba petendra, Bombax cornui).* This is the category of *wabele* masks with the following particular types:

a) *Kponiugo* with horns, sometimes with two heads, an allegory of the first mythical animals of creation; when it is joined to the small *wa* bowl it is called *waniugo. Kponiugo* means 'head of the *Lo*'.

b) *Korubla* and *kanamto* without horns (baboon or hyena).

c) *Kâgba* and *nassolo; kâgba* is the wooden head of an image, the body of which consists of a roof-like frame covered with painted raffia, which is worn by a masked dancer.

The *wabele* are terrifying images of a fantastic kind. They are demoniac bush spirits and are not meant to be ordinary animals. To make them as grotesque, vigorous and ghostly as possible, their creators combined elements from the powerful symbolic animals: chameleon, wild boar, buffalo, antelope, crocodile and vulture; from horns, feathers, teeth, quills or the spotted colouring of the panther. When the *wabele* go on a witch hunt at funerals and agricultural festivals, wielding their whips and axes and roaring horribly, scattering fire with burning bundles of grass, no woman is allowed to be present, because the masks would frighten them to death. The *wabele* masks are worn exclusively by the men of the *Lo* society.

The *kpelie* masks of the south-western Senufo are of a particularly fine type. They too are worn only by the men of the *Lo* society. From the pleasing form of one of these masks one would not suppose that it represents a greatly feared force. It is the face of the dead man, whom the mask dance is intended to help to find a final place of rest. The characteristics of these masks are a narrow oval face with a rounded forehead and scar marks, eyebrows in the form of a semi-circle, half sunken eyes, a delicate, straight nose, a cross-piece representing the nostrils, and a small, protruding oval mouth. The face is surrounded by all kinds of geometrical decorations and small projections like legs, which the Senufo themselves interpret in quite different ways. They may be horns, boar's tusks or cheek bones, or else the representation of a coiffure with plaits and combs, or else, as Hans Himmelheber conjectures, simply reminis-

D 4
Double mask *Waniugo*.
Senufo. Painted wood, 40 cm.
Coll. J. Müller, Solothurn,
Switzerland.

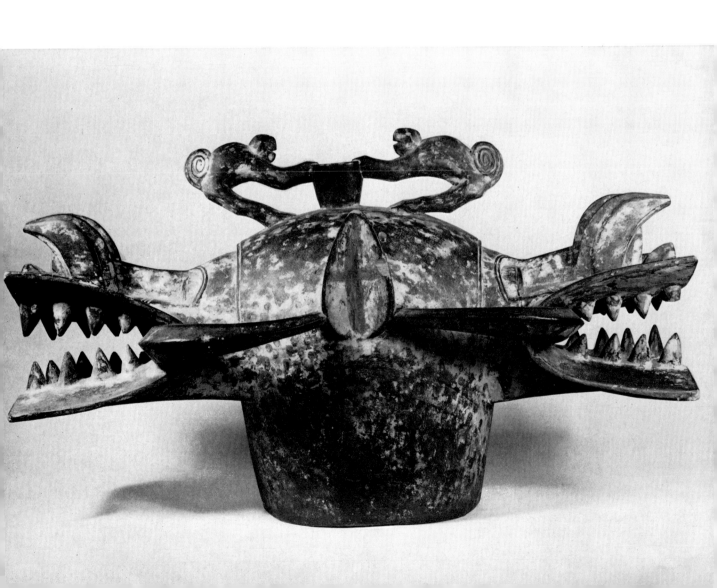

cences of the sacred bird. Different superstructures may be heraldic signs or signs of the person's profession. Thus the crested form represents agriculture, the palm nut the carver, the bird the smith, and the human figure the Diula merchant. Two faces united in a single mask refer to the dualism of the cosmic powers and guarantee fertility. It is obvious that the *kpelie* are no earthly beings. The fact that the masks are small is not a disadvantage: it is precisely because they are so small that they produce a particularly ghostly effect in the dance.

Most of the *kpelie* masks are of a particularly subdued and formal nature. But this depends upon whether they are made by a talented artist, a man with sensitivity and a feeling for proportion. Really good ancient examples are difficult to find: all too often their attractive form, pleasing to tourists, has led the carver to go in for mass production.

Brass casting

The metal work of the Senufo is also worth our attention, both the cult figures of wrought iron and the works in cast brass. They are produced by the *Lorho* caste, by the lost wax method. Of particular magnificence are the so-called 'gagging rings', with their powerfully stylized buffalo heads. The novices of the *Lo* clamp the rings between their teeth when they take part in funerals or return to their family after their initiation: they must not betray the secrets of the *Lo*. The 'medicine' of the powerful buffalo gives them the necessary strength for this.

Small cast human figures, singly or in pairs, are held in the mouth by the women of the prophetesses' society when they have to find out which bush spirits are doing harm.

The Diula, a tribe living in the region of Korhogo, have adopted the *kpelie*

form for the masks of cast brass which they wear during dance ceremonies.

Painted figures on cloth

At the present day one can buy in the market of Korhogo painted cotton cloth with comic figures on it. Originally they were intended for the dancing and hunting garments of the secret society of a guild of hunters; the mythological animals and masked dancers in the pictures had magical protective power.

The technique used is that of acid dyeing. The pattern is painted on to the cloth with plant dyes and then fixed and turned a deep black by painting with a layer of pulp made from root scrapings which contain a tanning material and iron compounds. The cloth was formerly more coarse and the figures smaller than they are today.

The Ligbi-Jimini

In connection with the Senufo another type of mask should be mentioned which is usually known by the name Jimini. It is a somewhat softer, more fleshy variant of the fine *kpelie* masks of the Senufo, and reached Europe as early as the end of the nineteenth century. It comes from the region between Bonduku and the Black Volta, a border region between the Ivory Coast and Ghana. There live the Jimini, a sub-tribe of the Senufo, as well as the Ligbi, amongst them Roy Sieber saw such masks, and the Kulango whom B. Holas photographed wearing similar masks.

D 5
Degele, headdress mask with male figure carrying a quiver for arrows of lightning. Senufo. Wood, 99 cm. Rietberg Museum, Zurich.

D 6
Deble, ritual statue. Senufo. Wood, 105 cm. Coll. J. Kerchache, Paris.

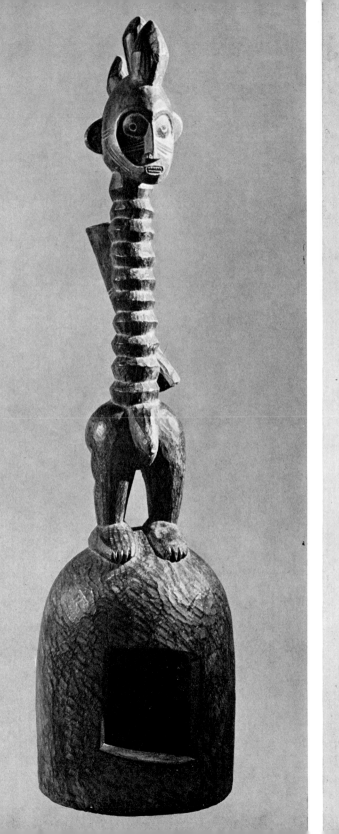
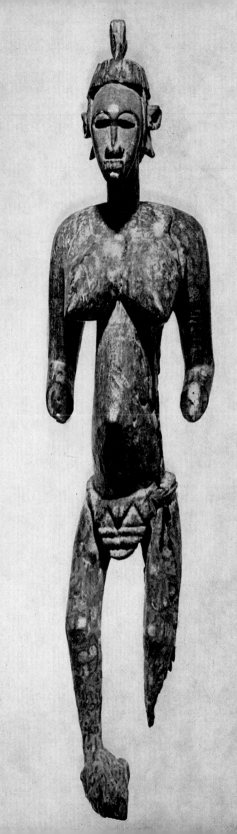

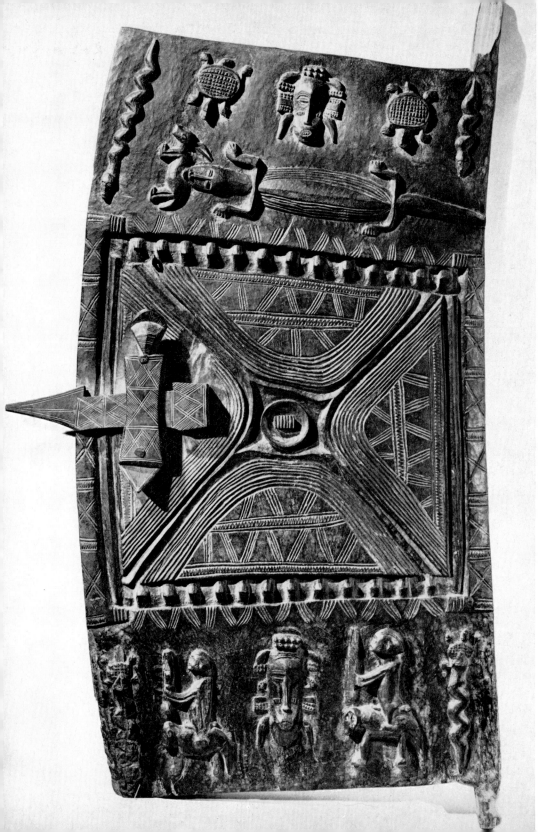

D 7
Door with symbolic relief:
rider, crocodile with prey,
Kpelie mask, tortoise, snakes,
the world's navel, with lined
curves representing currents.
Senufo. Wood, 148 cm.
Coll. J. Müller, Solothurn,
Switzerland.

D 8
Ritual ring with buffalo head.
Senufo, Fondono sub-tribe,
Tyembara, Cercle de Korhogo.
Brass, 9.5 cm.
Coll. E. Storrer, Zurich.

D 9
Double *Kpelie* mask.
Senufo. Wood, 25 cm.
Coll. E. Storrer, Zurich.

D 10
Fire-spitting mask.
Senufo. Wood, 90 cm.
Coll. Charles Ratton, Paris.

D 11
Small horseman.
Senufo. Iron, 15 cm.
Coll. E. Storrer, Zurich.

D 12
Plievo, drum for burial ceremonies, with
mythological motifs.
Senufo-Niene, Tuvere village, northern Ivory Coast.
Wood and leather, 87.5 cm.
Etnografisch Museum, Antwerp.

D 13
Deble, rhythm-pounding statue (detail).
Senufo. Wood, 108 cm.
Coll. E. Leuzinger, Zurich.

D 14
Animal mask with tiny human figure. Senufo.
Wood painted red, white and black, 46 cm.
Rietberg Museum, Zurich.

D 15
Headdress mask with antelope head, human and
animal figures.
Senufo. Wood, double-sided, 133.5 cm.
Coll. André Held, Ecublens.

D 16
Female statuette. Senufo or Turuka. Wood, 33 cm.
Rietberg Museum, Zurich.

D 17
Tribal bird, *Porgaga.* Senufo. Wood, 110 cm.
Rietberg Museum, Zurich.

D 18
Seated woman with pot. Senufo. Wood, 30 cm.
Coll. R. Salanon, Paris.

D 19
Deble, ritual statue. Senufo. Wood, 125 cm.
Coll. E. Storrer, Zurich.

D 20
Large bird, *Porgaga.* Senufo. Wood, 223 cm.
Coll. E. Storrer, Zurich.

D 21
Mask with bird's head. Jimini.
Varnished wood, 35 cm.
Coll. Nicaud, Paris.

D 22
Rider. Senufo. Wood, 36 cm.
Coll. Max and Berthe Kofler-Erni, Basel.

D 12

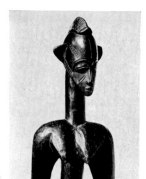

D 13

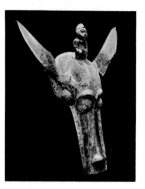

D 14

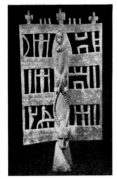

D 15

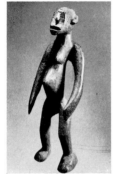

D 16

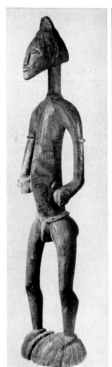

D 19
D 20

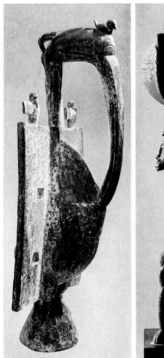

D 17
D 18

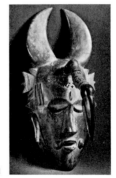

D 21

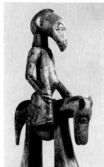

D 22

From Senegal to the western Ivory Coast

The African countries on the Atlantic coast can be divided into a western Atlantic group (from Senegal to the river Bandama on the Ivory Coast) and an eastern Atlantic group (from the Bandama to Gabon). They are largely covered with rain forest, which grows thinner further away from the coast and eventually merges into the savannah of the West Sudan. There are wide stretches of mangrove swamp on the coasts.

Although the rain forest with its hot, wet climate holds many terrors and dangers, isolated groups of Negroes have constantly taken refuge there and wrested a few acres of poor farming land from the jungle by a laborious process of clearance. Ideas of every kind from the Sudan seep down into the forest regions, and the contact of Old Nigritic and Neo-Sudanic influences with West African culture have led to the numerous hybrid forms of a new civilization. In the field of art, the 'pole' and 'round' styles enter into harmonious combinations, giving rise to a rich mosaic of fine masks and figures. Within the western Atlantic group a chain of small kingdoms, chiefdoms and monarchies stretches along the coast. Conditions of life are approximately the same in all these states: the inhabitants all grow rice, fish, and obey a powerful organization of secret societies. The result is that across all boundaries, and in spite of all differences of race and language, their culture presents a more or less unified picture.

The Islamic culture which is dominant in the hinterlands of Guinea and Senegal has very little foothold in the forest region. Here the cult of ancestors and spirits, together with its art, maintains all its force, and a number of important styles are apparent.

E 1
Banda mask for the highest grade of the *Simo* secret society. Nalu.
Wood, painted red, white and black, 142 cm.
Rietberg Museum, Zurich.

E 2
Snake, *Banjonyi.*
Baga-Landuma.
Painted wood, 2 m.
Coll. M et Mme Lazard, Paris.

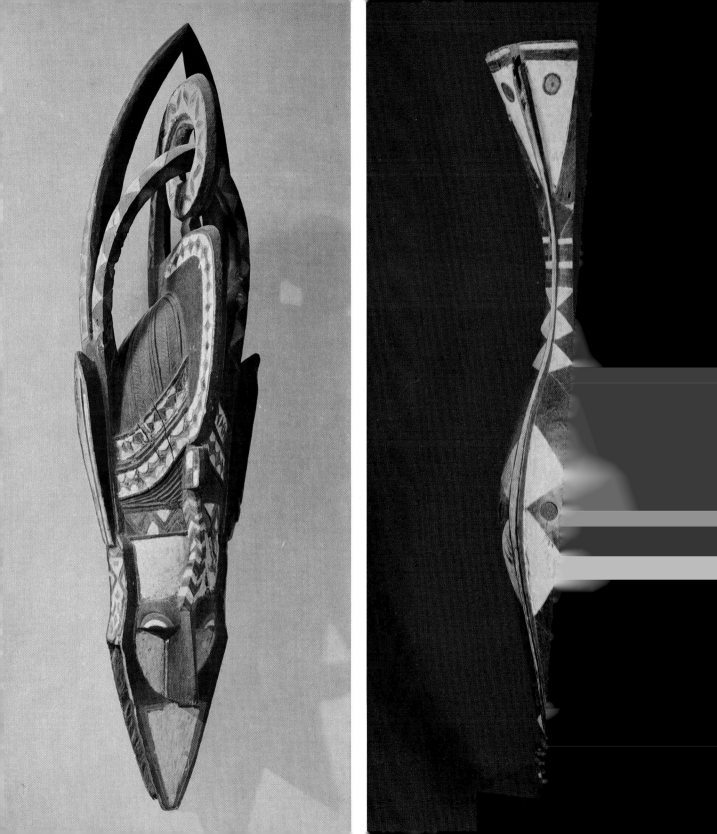

E The Bijogo and Baga

If we approach the countries of the coast from the north, we encounter abstract forms as long as the rule of Islam prevails. Not until we come to the Dyola and Banyun, between Gambia and Casamanca, do we find the first masks: comic, basketwork helmet masks with tube-like eyes, decorated with animal horns, cowrie shells and red jequirity beans. The young men wear them at the circumcision celebrations and when gathering in their tribute in the surrounding villages.

The Bijogo

The first important style of carving is that found in the Bissagos Islands and their hinterland. The art of carving here, however, was at its highest peak about a hundred years ago. The population, decimated by catastrophies and disease, neglected their art and allowed it to decay.

The Bijogo are a matriarchal society. A woman could attain the rank of chief. This explains the many figures of women on the family altars. Their sculpture also reveals their admiration and veneration of the powerful buffalo. The departure of the royal war boats with their mighty buffalo heads on the prow must have provided a magnificent spectacle.

In the case of figures representing souls we find not only the soft round style, but also more severe types. Of particular interest is the large figure with splayed legs, carried by women who wish for children. The spoons and lidded bowls, on which figures and animals are very cunningly combined with the functional form, are unusually charming. Characteristics of the style are a rounded form, a horizontally flattened head,

a low brow, a pageboy hair style, a short skirt carved as part of the figure, and short plump legs. The Bijogo have also a reputation as painters: the mud walls of their huts carry paintings in red and black, sometimes geometrical Islamic patterns, and sometimes figures and scenes in a naive anecdotal style.

The Baga group

The Baga in the Konakry district, the Nalu on the lower Rio Nuñez and the Landuma on the upper Rio Nuñez are the three main tribes which, with some others in south-western Guinea, can be regarded as a single group, because they have the same culture and used to exchange formal elements with each other. They may have migrated two or three hundred years ago from regions on the upper course of the Niger in the West Sudan. Their powerful and often abstract style of sculpture suggests this, for in many respects it is reminiscent of Bambara form.

The powerful *Simo* secret society dominates the life of the Baga and determines the masks and cult objects which are used at birth, circumcision and the death of members of the society, and also at agricultural rites.

The most impressive works are as follows:
— *Nimba,* goddess of fertility, a massive mask borne on the shoulders, which can weigh as much as ten stone. The four supports are covered during the dance by a garment made of fibre. The immense head, with its hawk-like nose, projects far forward and is supported by arms with no hands. It is decorated with geometrical patterns. The ears form two half-circles, while the chin is cut off short. As a full length figure the *Nimba* has a similar head, a barrel-like body and short legs. The *Nimba* are used to

E 3
Buffalo mask, *Ja-rê*. Bidyogo,
Roxa Island. Wood painted
red, white and black, 56.5 cm.
Museu d'Etnologia do
Ultramar, Lisbon.

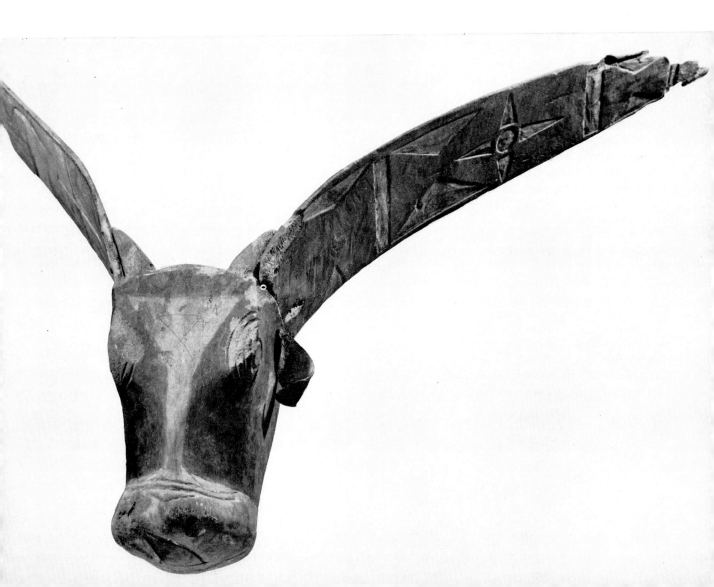

bring fertility, either of a woman, a rice field or a palm grove. *Nimba* gives particular protection to the pregnant mother.

A type of *Nimba* with an extremely small head is also found: this is the girl '*Nimba péfète*'. When it goes through the bush, held high above the bearer's head, its very smallness produces an effect of particular unreality.

— *Banda,* a mask almost six feet long, carried diagonally and horizontally on top of the head, is the symbol of a high rank in the *Simo* society, and consists of a surrealist conglomeration of elements suggesting power: the human face, the crocodile, the antelope, and the chameleon, all painted in colour.

— *Anok (Elek* or *Atyol),* the protecting spirit of the *Simo* society, an abstract, heavy head with a bird's beak on a pedestal, a combination of human and animal features.

— *Banjonyi (Kakilambe),* the powerful, steeply upright miracle snake, two or three yards high, with zig-zag painting following the swellings of its body. This protective spirit, inspired by the python, plays a part in the fire ordeal at the initiation of the boys. On this occasion the two halves of the village compete with their *Banjonyi.*

— *Foho*, the sacred bird, a fantastic, elegantly painted carving.

— The *Simo* ceremonial drum, carried by a female figure and heavily decorated.

— Abstract masks, like a buffalo's head, but referred to as a tortoise, complementing the snake which is thought of as male: the dualism of water and earth.

E 4
Lidded bowl with figures.
Bijogo. Wood, 43.5 cm.
Etnografiska Museet,
Stockholm.

84

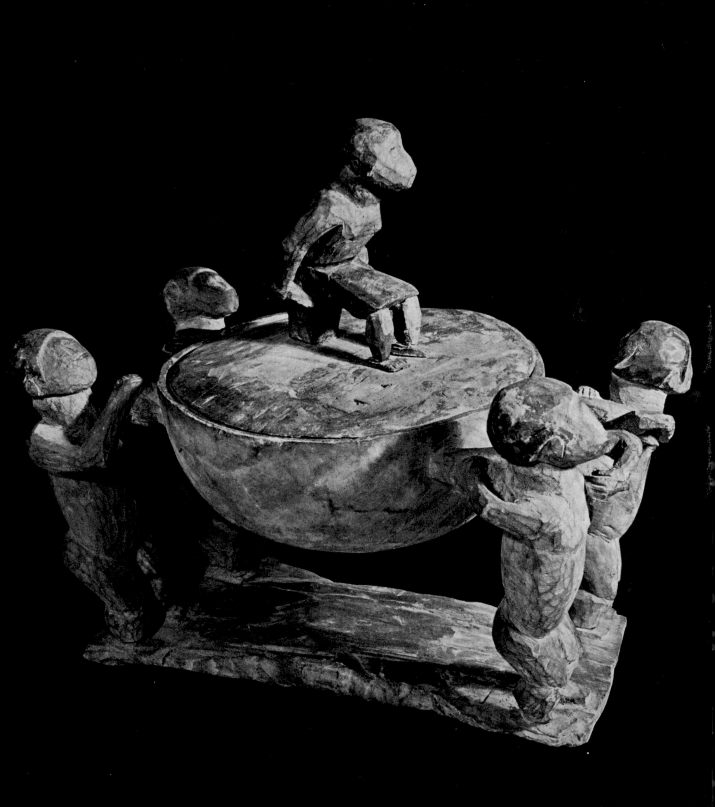

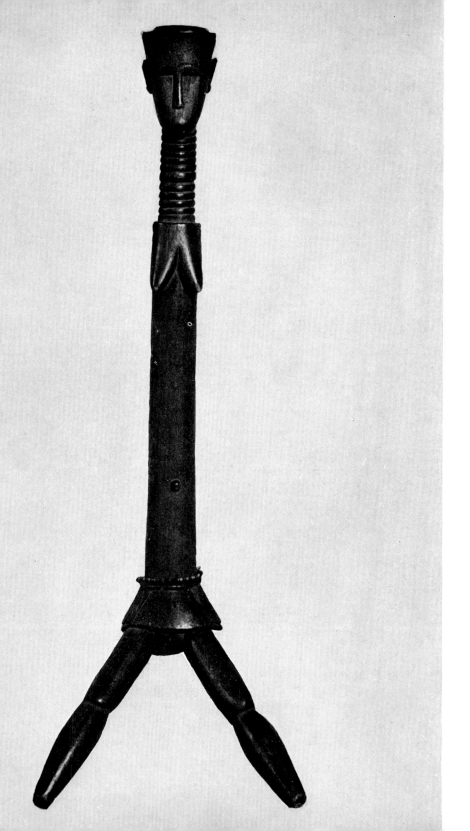

E 5
Fertility figure. Bijogo.
Wood and glass beads, 71 cm.
Náprstek Museum, Prague.

E 6
Large drum with kneeling
mother and other figures.
Baga. Wood, 111 cm.
Coll. Nicaud, Paris.

E 7
Bird for the rice
ceremonies. Baga.
Wood, 65 cm.
Coll. R. Rasmussen, Paris.

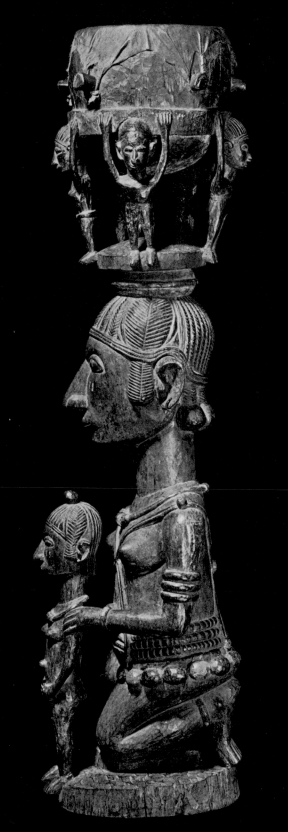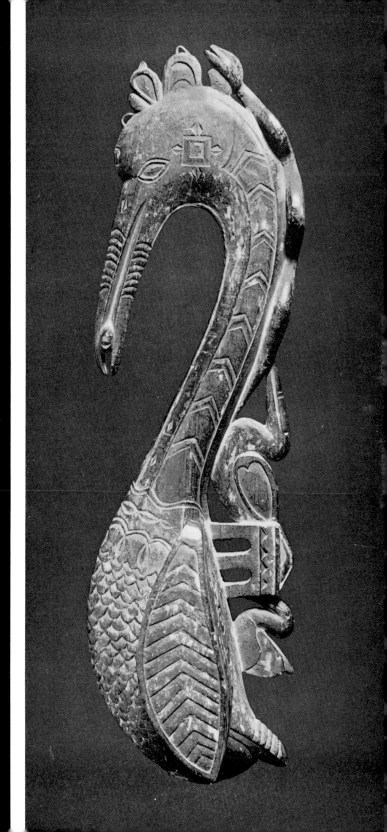

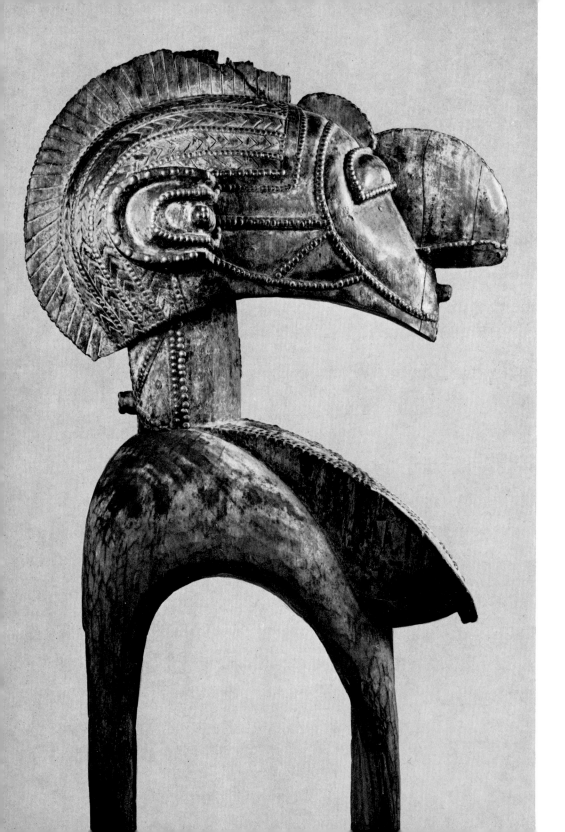

E 8
Nimba dance headdress.
Fertility symbol. Baga.
Wood, 128 cm.
Coll. Max and Berthe Kofler-
Erni, Basel.

E 9
Nimba dance headdress,
the girl *péfète*. Baga.
Wood with copper eyes, 64 cm.
Rietberg Museum, Zurich.

E 10
Nimba dance headdress,
Baga. Wood, 109 cm.
Rietberg Museum, Zurich.

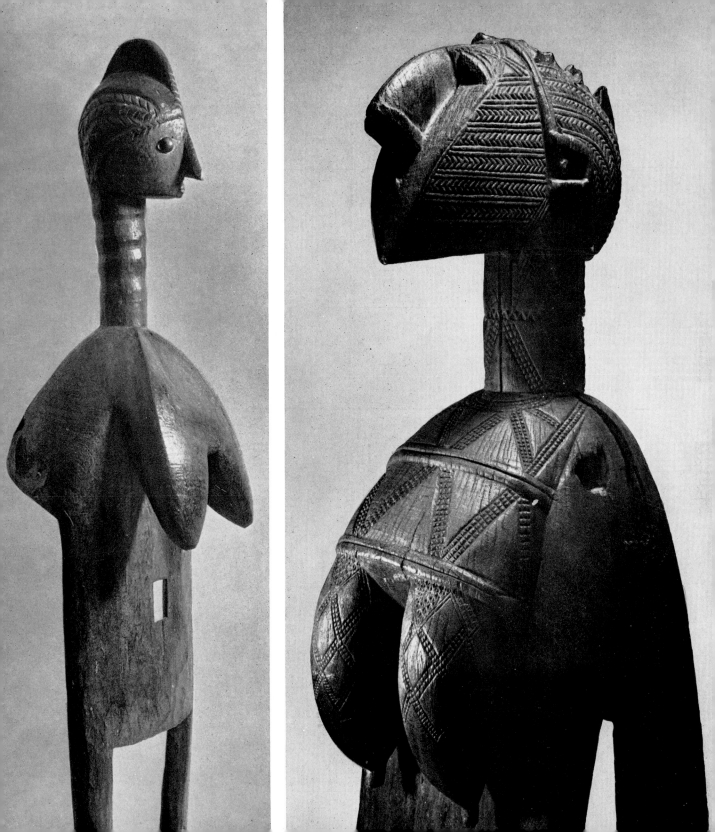

E 11
Ceremonial spoon with female figure.
Bijogo, Orango Grande Island. Wood, 45 cm.
Museu d'Etnologia do Ultramar, Lisbon.

E 12
Staff with figure. Bijogo, Orango Grande Island.
Wood, 59 cm.
Museu d'Etnologia do Ultramar, Lisbon.

E 13
Female figure. Bijogo. Wood, 19 cm.
Danish National Museum,
Ethnographical Department, Copenhagen.

E 14
Ceremonial chair. Senegal. Wood, I. 110 cm.
Museum of the Philadelphia Civic Center,
Philadelphia.

E 15
Lidded bowl with figures. Bijogo. Wood, 40 cm.
Coll. Bernatzik, Vienna.

E 16
Small rider. Soninke, Portuguese Guinea.
Bronze, 95 cm; figure 10 cm.
Coll. Winizki, Zurich.

E 17
Lidded bowl with figures. Bijogo. Wood, 40 cm.
Baga, Portuguese Guinea. Wood, I. 55 cm.
Rietberg Museum, Zurich.

E 18
Saw-fish mask, *Kaissi*. Bijogo, Uno Island.
Wood, painted red and white, 140 cm.
Museu d'Etnologia do Ultramar, Lisbon.

E 19
Anok, ritual object. Baga. Encrusted wood, I. 76 cm.
Rietberg Museum, Zurich.

E 20
Abstract mask. Baga-Landuma. Wood, 95 cm.
Coll. Edith Hafter, Zurich.

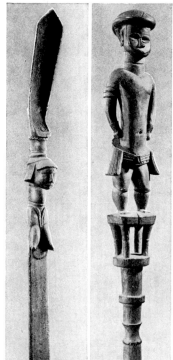

E 11
E 12

E 13

E 14

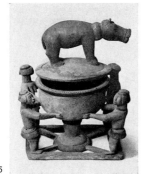

E 15

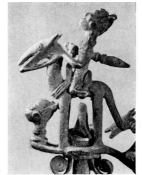

E 16

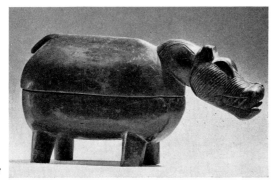

E 17

E 18

E 19

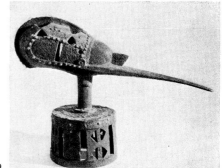

E 20

E 21
Spirit figure. Bijogo. Wood, 37.5 cm.
Coll. Hans Coray, Zurich.

E 22
Female figure. Baga. Wood, 81 cm.
Coll. E. Storrer, Zurich.

E 23
Banda mask. Nalu-Baga, Wood and raffia, 170 cm.
Ethnological collection, Zurich.

E 24
Anok, ritual figure. Baga.
Wood painted in red, black and white, 141 cm.
Coll. Nicaud, Paris.

E 25
Drum with kneeling woman. Baga. Wood, 114 cm.
Private collection, Paris.

E 26
Fertility statue. Baga. Wood, 63 and 61 cm.
Rietberg Museum, Zurich.

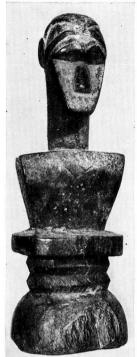

E 21

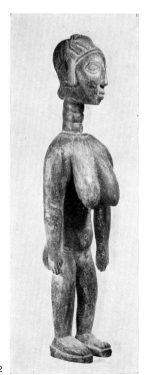

E 22

E 23

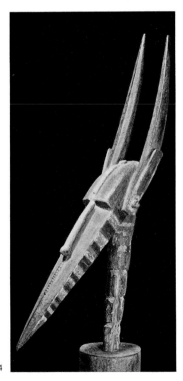

E 24

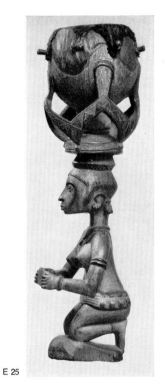

E 25

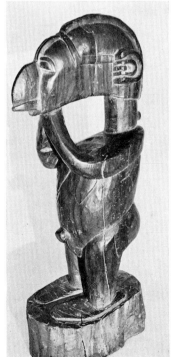

E 26

F Sierra Leone and Dan-Ngere

Sierra Leone

In Sierra Leone we have the rare good fortune to possess not only the wooden sculpture of the recent past — from the Mende, Temne, Vai etc., but also objects which have been preserved from earlier centuries. These consist of stone figures in various styles, both the *nomoli* of the Sherbro-Bullom and Temne, and also the *pomtan* of the Kissi.

History tells of two great kingdoms, the kingdom of Bullom on Sherbro Island with the adjacent mainland, and the Temne kingdom further north. Both already existed in the fifteenth century, and both had a sacral kingship. The Temne king Bai Farama, who seems to have come from the north-east, underwent a forced ritual death. The status and dignity of these kingdoms made a profound impression upon the first Europeans who exchanged gold for cotton here.

In the country in which the Bullom and Temne settled we find not only metal objects but also the *nomoli:* expressive figures and heads from steatite, chlorite slate, granite or other stone. These were memorial figures for dead nobles, used in the royal ancestor cult.

Their characteristics are expressive and realistic negroid faces with large protruding eyes, broad lips and a broad nose, and inflated nostrils. The protrusion of the lower jaw is so extreme that it carries the head out of the vertical plane and brings it spatially well forward. The attitudes of the body vary: sometimes seated, sometimes kneeling, riding or lying down, with the hands on the beard or the cheeks. The *nomoli* display naturalistic feeling and great power of expression. The twisted band,

the sign of divine kingship, also occurs. The form of the garments, the armour and weapons give an indication of their age, as does the fact that in the sixteenth century the Mende invaded the small kingdoms and brought them to an end.

A further indication of the date of the *nomoli* has been advanced by Kunz Dittmer, and this is their similarity to the Afro-Portuguese ivory carvings which can be shown to have been manufactured in the sixteenth century for Europeans, to whom they were sold. The travel writer Valentin Fernandes wrote in the sixteenth century that the Sherbro people were famous for their ivory. Thus part at least of the Afro-Portuguese ivory carvings, which because of their realistic features were long attributed to the Yoruba, were made by the Sherbro, who in their exaggerated reproduction of the Negro face are certainly a match for the Yoruba.

In the Kissi country — north-eastern Sierra Leone and south-western Guinea — the stone figures are called *pomdo,* and in the plural *pomtan.* They are still revered at the present day as ancestor and prophet figures on family altars. The true Kissi style is more abstract. The figures are tubular in shape and richly adorned, the faces of the figures are much less strongly marked, but more delicate, the eyes are flat and drawn as a curve, and the chin is pointed, often adorned with a beard.

Apart from this main style there are also a number of separate styles in the Kissi country, including the so-called Manes or grinning style. Thes consists mostly of representations of bearded men and armed warriors, which may be connected with the conquest by the Manes people in the sixteenth century. In general they have wide mouths with teeth showing and immense fleshy noses,

F 1
Mask with round eyes and beard.
Dan. Wood and raffia, 24 cm.
Coll. R. Rasmussen, Paris.

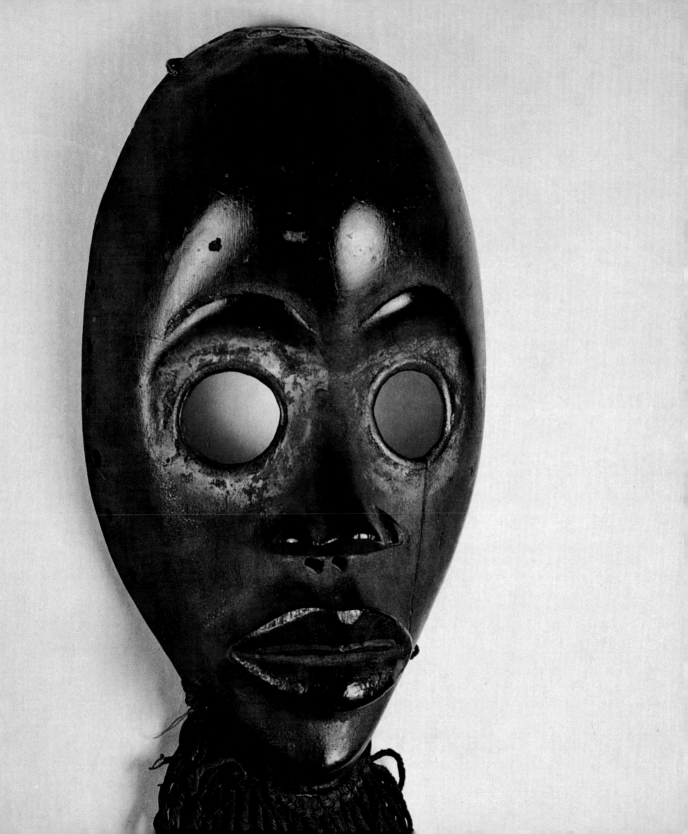

From the mining country in the Kono region of northern Sierra Leone come monumental heads and figures, known as *mahan yafe,* i. e. 'Spirit of the chief'. They are greatly venerated. The heads are like a modified version of the *nomoli,* with a rather less pronounced protrusion of the lower jaw, high curving eyebrows, heavy upper eyelids and only a slit below them. The rings in the lobes of the ear are mentioned by Portuguese accounts in the fifteenth century: they report that among the natives the nobles wore gold rings. Dittmer describes this as an 'early *nomoli* style' and places it in the thirteenth century. By contrast to the Sherbro, the Kissi continued to produce their *pomtan* until the very recent past, and indeed still produce them for tourists in an altered, feeble and decadent style. The Kissi have never practised wood carving.

The Mende

Here we return to the art of wood carving. The Mende, whose language is Mande, entered Sierra Leone in the sixteenth century, conquered the existing kingdoms and divided the Kissi from the Bullom. They set out their rice fields in clearings in the forest.

The Mende are outstanding for their wood carvings which — a rarity in Africa — they produce mainly for their women's societies, and particularly for the *Bundu* society (the *Sande* society amongst the Vai of Liberia) which undertakes the education of the girls. Their training in the camp in the bush is a hard one. There the girls learn everything they need for their future life as wives and mothers. This includes singing and dancing. The climax of the period of instruction is the concluding festival, which always brings with it the appearance of the so-called *bundu* devil. This protective spirit of the society appears in a black mask which covers the whole head, clothed in a garment of fibre and with a whip. The Temne, Vai and Sherbro have similar masks.

Characteristics: the hair is arranged in heavy crests; there is a high forehead over a small delicate face with lowered eyelids, and broad spiral bulges of fat on the neck as an expression of prosperity and the idea of beauty. The hair style, adorned with heraldic emblems, is highly imaginative. The less well-known masks of the male societies of the Mende display a coarser style.

In addition to the masks the Mende also make statuettes which they call *minsereh.* The heads of these *minsereh* display the same features as the *Bundu* masks, a high forehead, a small face and a ringed neck. The body is slim, naturalistic and with smooth lines. The *minsereh* are used by the *Yassi* society of prophetesses. When the prophetess falls into a trance, the figure begins to move. It bows if the answer is to be 'No'. If it is soaked with a magic potion, it is able to heal the sick.

The Temne style of carving is related to that of the Mende, is equally sensitive to natural form, but in spite of the relationship possesses its own distinctive character.

The Toma

The Toma, a Mande-speaking tribe in the region of Guinea around Macenta, north-western Liberia and north-eastern Sierra Leone, a transitional region between the savannah and the forest, carve their *landa* masks following a strict Sudanic style. They achieve the utmost cubist simplicity and concentration of form. A board-like face with a featureless crocodile-shaped jaw and a straight nose under an arched forehead is the

F 2
Mahan Yafe, spirit of a chieftain.
North Sierra Leone.
Stone, 23 cm.
Coll. Max and Berthe Kofler-Erni, Basel.

96

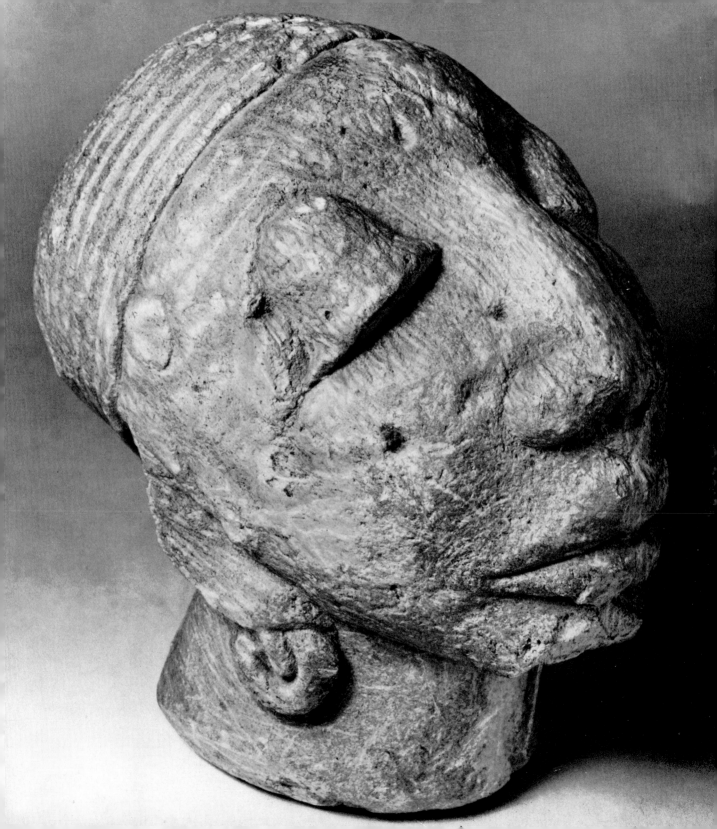

way the Toma represent the mighty *Poro* bush spirit. When the abstract face of wood stares out of the tangled costume of leaves and skins, the effect is weird and unreal.

Dan-Ngere

Dan and Ngere are each general terms for numerous sub-styles often differing in essentials, which are to be found in the region between the upper Cavally and the Sassandra in eastern Liberia, in the west of the Ivory Coast and in the adjacent parts of Guinea. This is the region of masks *par excellence.* The Dan and the related groups are savannah tribes, speaking the Mande tongue, who came from the north about three hundred years ago. The Ngere and the Wobe are Kru-speaking forest farmers. Despite all the differences between them, they share the institution of powerful secret societies running through the whole of their cultural and religious life and giving it a unified character. In all the secret societies the function of the masks is of outstanding importance. They help men to control the environment and life, they support the chief in his task of ruling the land. Each mask represents a bush divinity. Each mask has its own spirit and its own name. The greater the age of the mask, and the power it has accumulated through repeated sacrifices, the greater its value, regardless of its form. Depending upon their inherent power, each mask is used by a higher or lower rank of the *Poro* society. They are venerated in accordance with their rank and power by obeisances right down to the ground. Everyone wearing a mask is accompanied by musicians and assistants who even include a translator for the twittering of the secret language.

We possess extensive accounts of the function of the Dan-Ngere masks (G. W. Harley, E. Donner, H. Himmelheber, E. Fischer). The most important masks, of highest rank, represent a powerful bush spirit and act as judges, law-givers and peace-makers. They make the choice between war and peace, no-one dares to lie in their presence, and they are a neutral court of appeal recognized by everyone. In the past, prisoners were sacrificed to the war masks. Today these masks are regularly fed with the blood of cocks, palm oil and chewed kola nut. The mighty mother spirit of the secret society is called *Dea,* the ideal of womanhood, who resolves disputes and in particular protects the new-born and the boys in the bush camp. In accordance with her peaceful character she speaks in a deep, warm voice and the accompanying musicians play gentle music. Other masks, on the other hand, control lightning and thunder, and are the protecting patrons of fishermen and smiths, twins and travellers; they resist evildoers, those who eat children, and adulterers; they watch over household affairs, protect pregnant women, help childless women, and cure sicknesses like stuttering and facial paralysis. A number are said to be portraits of beautiful women or effigies of important persons who have died. The monkey mask plays the part of the jester. But if anyone laughs, he must do penance.

A particularly important mask is that of the night watcher, who supervises cleanliness and makes sure that no-one leaves his excrement near the houses.

Other masks discover thieves, collect debts, are divinators, or supervise burials. A further important function is carried out by the masks in the circumcision camp, where the novices are symbolically swallowed by the spirits and are reborn as full members of the society.

Another mask is the fire-runner. It is carried by the young man who turns out

F 3
Statue of a woman. Mende. Wood, 95 cm. Coll. E. Storrer, Zurich.

F 4
Female figure. Temne, Sierra Leone. Wood, 57 cm. The University Museum, Philadelphia, Pennsylvania.

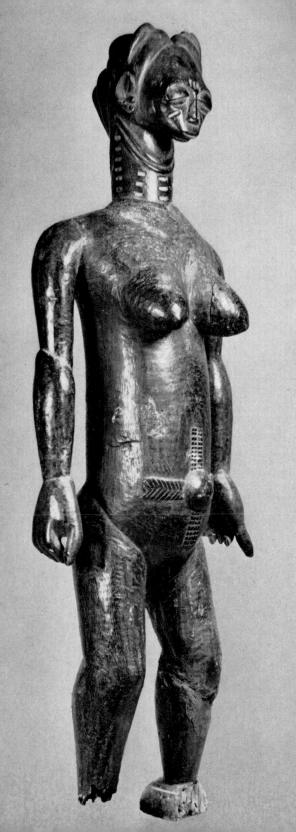 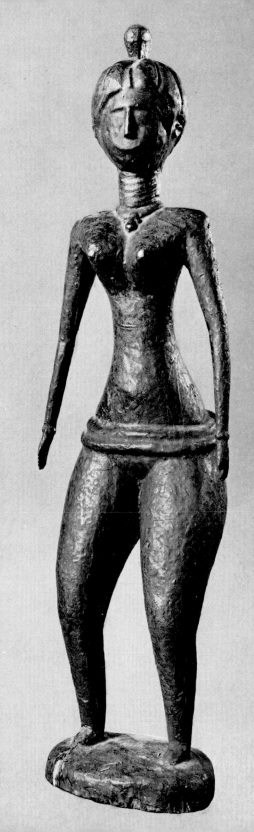

to be the fastest runner. In the dry season he has to run masked through the village and check that all hearth fires are extinguished. When there is a fire he must give the alarm to the people in the fields. To find the best fire-runner, the Dan organize eliminating competitions between the villages.

It is not easy to classify the many different kinds of masks. Although the Dan and the Ngere, the two main representatives, are basically different, there are numerous sub-styles and intermediary styles which draw features from both. In a recently published essay, Hans Himmelheber demonstrates that the greatest differences lie within a tribe between the female and male masks, and indeed that the female masks of the Dan and Ngere look more like each other than do the female and male Dan masks. We owe to Vandenhoute a clear classification of the different styles, and shall follow his categories.

The Dan group includes the sub-tribes of the Yakuba, Geh, Gio, Uame (Flanpleu village) and Kulime. The Mano, Shien Bassa and Kran in Liberia, the Kpelle (Gerse) in Liberia and Guinea, the Kono in Guinea, and the Diomande and Tura in the western Ivory Coast all come under their sphere of influence.
1. The classical northern Dan style
2. Masks with a beak-like mouth and movable jaw, Geh
3. Southern Dan style
4. Ngere-Wobe, sometimes exaggeratedly realistic
5. Dan-Ngere sub-style, cubist
6. Flanpleu, a sub-style of the Uame sub-tribe
7. Kulime sub-style

The classical northern Dan style is simple, noble and harmonious in its idealized naturalism; the masks are oval in shape with expressive lips, usually round eyes (sometimes also narrow eyes in female types), and a shiny black patina obtained by steeping in mud.

The southern Dan prefer narrow eyes. The masks always have a vertical line up the brow and a pointed chin. The black surface is less shiny.

The male Dan masks have a beard and a moustache and are less expressive, closer to the Ngere style.

The Dan sub-styles are more dynamic, more expressive or more cubist, with protruding elements in the forehead or the mouth, beak-shaped noses, movable jaws and tube-shaped eyes, often with small iron plates inserted for the teeth. Amongst the Diomande, Kpelle and Kono the fire-runner mask has horns or a bird's beak.

The Ngere-Wobe group adjoins the Dan group on the south-east, and its centre is on the Nzo, a tributary of the Sassandra. The Ngere are the eastern Kran. The Ubi, Grebo and other tribes of the Kru coast fall into the sphere of influence of the Ngere, as do the Bete and Niabwa on the river Sassandra in the Ivory Coast. To give concrete form to their powerful bush demon, conceived of as a hateful personality, the Ngere-Wobe style uses bold, aggressive and dynamic forms, exaggeratedly realist human and animal elements, protruding forehead and cheekbones, swollen lips, flattened fleshy noses, eyes in the shape of tubes or castanets, boars' tusks and horns in some masks, while in others it uses abstract spheres, cylinders, arches and half-circles. It also uses real feathers, skins and monkey's hair, panther's teeth and huge moving jaws, in order to increase the effect. The resultant appearance in the dance produces a fantastic and grotesque effect of exaggerated reality.

F 5
Landa mask. *Poro* guardian spirit. Toma, Guinea. Wood, 58 cm. Rietberg Museum, Zurich.

F 6
Mask with six pairs of eyes. Ubi, Guiglo district, Ivory Coast. *Grebo* style. Wood and raffia. Musée I. F. A. N., Dakar.

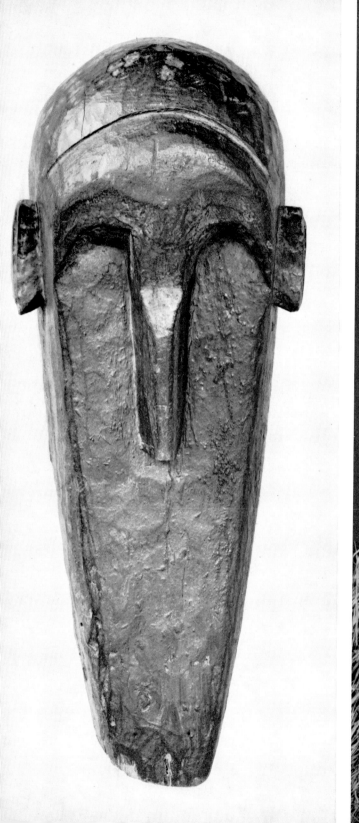
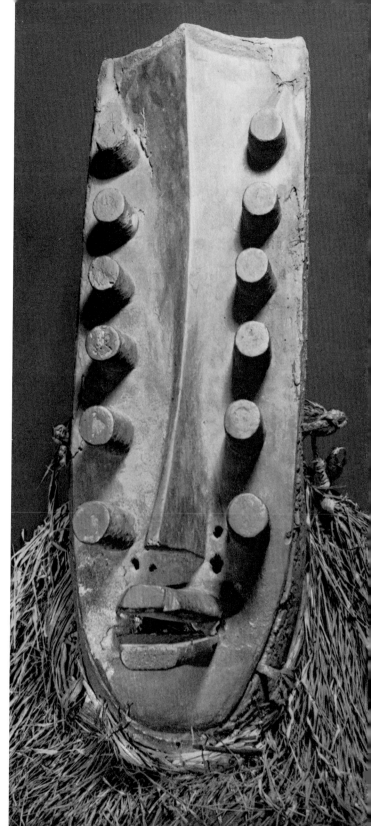

The masks of the Grebo style — on the lower Cavally in Liberia and the Ivory Coast — are influenced by the cubist style of the Ngere. Their form is less violent. On a board-like base the features of the face are built up from geometrical elements, and the eyes are sometimes set on as multiple pairs of tubes.

Not all the Dan masks are worn. There are also masks with no holes in them, which are never fixed in front of the face and yet which cannot be regarded as counterfeits. And by virtue of the medicine with which they are endued, they have such a powerful magical radiance that the Dan have only to set them up before themselves to partake of their power.

Finally, there are the *ma* miniature masks, three or four inches high. The *ma* are miniature versions of the great sacred masks and serve as symbols of the mighty bush spirit which protects the member of the society in his daily life. They are carefully preserved or carried on the body. They receive chewed kola nuts as nourishment. During sickness the *ma* have oil and rice rubbed into them and a diagnosis is sought from them. Their answer is interpreted by the way in which they fall, and it is hoped to obtain a rapid cure with their aid.

Compared with the rich variety of their masks, the figures produced by Dan-Ngere art are of little importance. There is a particular story behind the famous large *po* spoons, which can be almost a yard long and are of great beauty. We read in ancient sources that the spoon is an emblem of the chief's principal wife, and that at great banquets, at which the invisible ancestors also take part, she serves the rice with it. In 1965 Hans Himmelheber wrote an article about the *po* spoons. He tells how every Dan village chose from amongst the married women the so-called *wun-kirle,* who had to prove herself to be particularly skilful, hospitable, magnanimous and generous and was always ready to treat her guests sumptuously. In public ceremonies the *wunkirle* appeared in pomp and splendour in festivals put on by the village — at the cow festival, for example, or at the return of the successful warriors — and danced with the spoon to a particular song. These two *wunkirle* legends derive from the same source, because it is obvious that it is the chief's wife who in the first instance possesses the means to obtain the reputation of hospitality.

The *po* spoons are regarded as living beings. Hans Himmelheber tells that a *po* spoon once hid itself in a straw roof to prevent itself from being sold, and only much later revealed its hiding place to its owner in a dream. The human head is probably the portrait of the *wunkirle* for whom the spoon was carved.

The spoons take many forms, sometimes that of human bodies on stocky legs, sometimes with the delicate face of the Dan carvings, and sometimes also with the head of a goat or sheep. There are also spoons with strongly abstract lines, the effect of which is particularly successful.

Ornamental rings

Ornamental rings of bronze, brass or gold, produced by the lost wax method, provide an impressive variety of elegant forms. Sometimes several rings are put together to form collars. Most of them are decorated with spiral or arched designs or spheres. The rings, which can weigh over ten pounds, can only be worn by rich people who do not need to work. In the purchase of wives they can be used as money. The ability to give power to the wearer and protection to the warrior is also attributed to them.

F 7
Buffalo mask with horns and cylindrical eyes. Ngere.
Wood, 30 cm.
Coll. Charles Hug, Zurich.

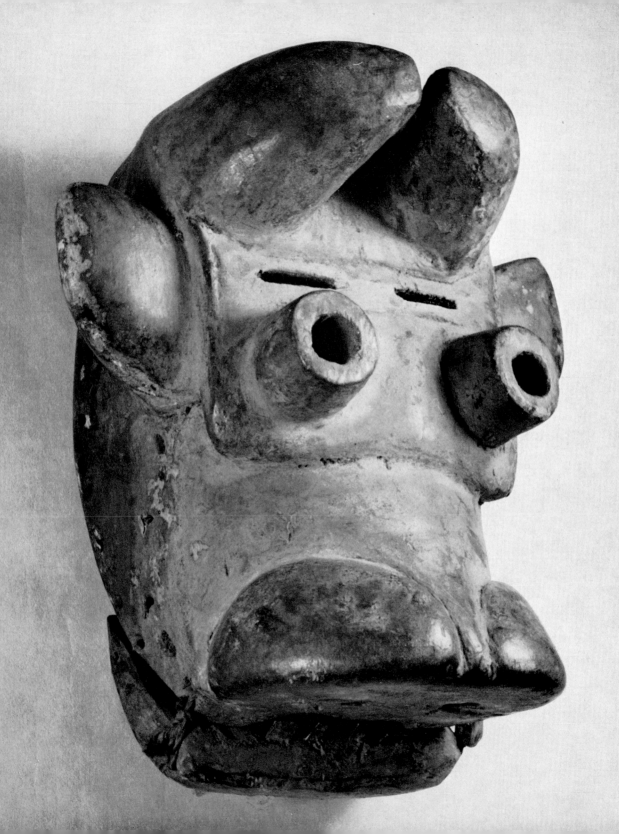

F 8
Group of figures. Kissi, Guinea. Stone, 38 cm.
Coll. Nicaud, Paris.

F 9
Nomoli. Sherbro, Sierra Leone. Stone, 14 cm
Museum für Völkerkunde, Basel.

F 10
Mother and child. Dan. Brass, 20 cm.
Coll. Winizki, Zurich.

F 11
Ring. Neyo, Ivory Coast.
Bronze, 33 cm. wide, 16 cm. tall.
Musée I. F. A. N., Dakar.

F 12
Female figure. Mende. Wood, 53 cm.
Coll. J. Kerchache, Paris.

F 13
Bundu mask. Mende. Blackened wood, 42 cm.
Coll. W. and D. A.

F 14
Mother mask. Dan. Wood, 25 cm.
Ethnological collection, Zurich.

F 15
Mask with painted red decoration and hung with
bells. Dan-Ngere. Wood, metal and raffia, 27 cm.
Coll. Alfred Muller, St Gratien, France.

F 16
Mask. Ngere. Wood, 26 cm.
Coll. Max and Berthe Kofler-Erni, Basel.

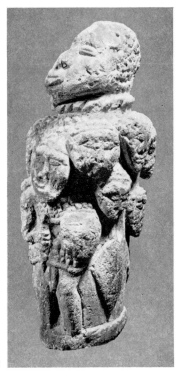

F 8

F 9
F 10

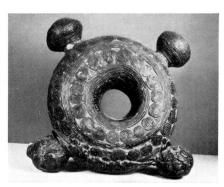

F 11

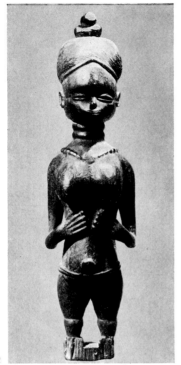

F 12

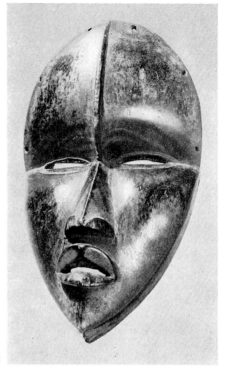

F 14

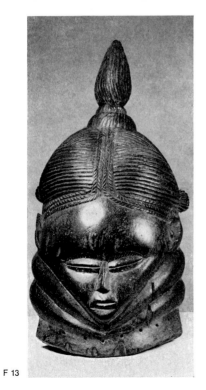

F 13

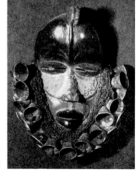

F 15

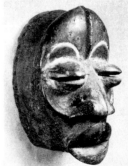

F 16

F 17
Beaked mask. Dan. Encrusted wood, 60 cm.
Coll. André Held, Ecublens.

F 18
Horned mask. Toma. Wood, 76 cm.
Coll. Edith Hafter, Zurich

F 19
Po spoon with cow's head. Wood, length 65.5 cm.
Coll. J. Müller, Solothurn, Switzerland.

F 20
Mask with hinged mouth. Ngere. Wood, 28 cm.
Coll. Charles Hug, Zurich.

F 21
Judge's mask with moveable lower jaw by the
sculptor Sra. Ngere. Wood, 34 cm.
Coll. Dr. Hans Himmelheber, Heidelberg, Germany

F 22
Mask without a nose. Kran,Liberia. Wood, 26 cm.
Coll. Dr. Hans Himmelheber, Heidelberg, Germany

F 23
Mask with a crown of medicine horns. Dan. Wood.
Coll. Koenig, Ganslberg/Lower Bavaria.

F 24
Female mask. Bete. Ivory Coast. Wood, 26 cm.
Coll. W. Kaiser, Stuttgart, Germany.

F 25
Po spoon with human head. Dan.
Wood, raffia and kaolin, 63.5 cm.
Coll. Maurice Bonnefoy / D'Arcy Galleries.

F 26
Mother figure with a child on her back. Dan.
Wood, 64 cm.
Coll. J. Kerchache, Paris.

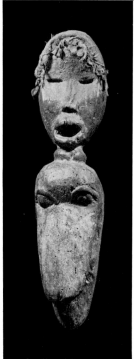

F 17

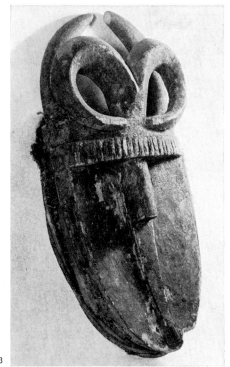

F 18

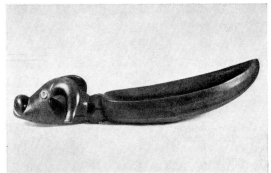

F 19

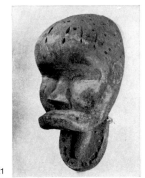

F 20

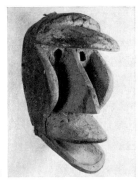

F 21

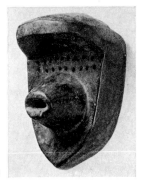

F 22

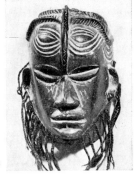

F 23

F 24

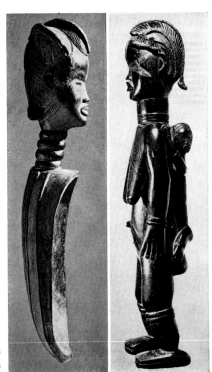

F 25
F 26

From the Ivory Coast to Dahomey

The River Bandama in the Ivory Coast forms a clear cultural watershed: to the west we find the people of the primeval forest, dominated by secret societies and often leading a very hard life, while to its east the people live in a savannah region which here describes the shape of an arrowhead and at places reaches to the coast. Here the conditions of life are easier, numerous elements from the advanced cultures of other peoples have penetrated the area, and the situation favours the formation of large states: the kingdoms of Ashanti, Dahomey, Ife and Benin flourished and came to their fulfilment.

Along this stretch of coast the acceptance by West African culture of elements from other advanced civilizations had already led, centuries ago, to the institution of sacral kingship. This is a form of advanced civilization which is widespread in Africa and is accompanied by certain specific practices. Thus the king is always an absolute ruler, the incarnation of God upon earth, highly regarded and venerated. He is at the head of a large and complicated court with ministers, princes, officials and a precisely regulated ceremonial. The king and the nobility have a liking for sophisticated manners. The distinctive features of their art are defined by the life of the court. It has both a sacral and a secular function and is carried out by professional artists who have to fulfil the need of the king for splendour and representative works of art.

G 1
Guli, god of the dead. Baule.
Painted wood, 85 cm.
Private collection, Paris.

G 2
Mask with bird. Baule.
Wood, 40 cm.
Coll. Edith Hafter, Zurich.

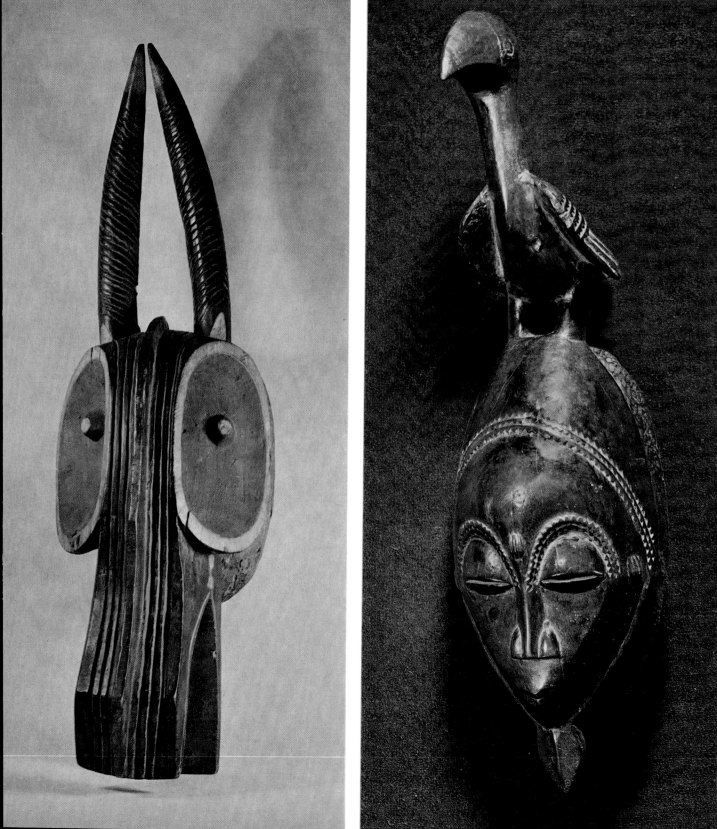

G The Baule and Guro

The Baule are a characteristic people of the central zone of the Ivory Coast. They are a Nigritic tribe, speaking the Akan language, and are ruled by an upper class related to the Ashanti. The Baule relate that their feudal kingdom was founded about 1730 by Queen Aura Poku. Because of disputes over the throne, the Ashanti princess was driven at that time out of her homeland of Ghana and reached the Bandama with a large retinue, and there set up her capital. At the crossing of the river Comoe the floods were so threatening that she sacrificed her little son to appease the river spirits.

The ruling class of the Baule from the Ashanti tribe mingled with the ancient indigenous tribe between the Nzi and the Bandama. Some ancient tribes, however, preferred to retreat into the region of thick forest west of the Bandama, and these included the Guro, who speak the Mande language. Even today the life of the Guro is still dominated by their secret societies and their belief in spirits, while the Baule believe in many gods, in the creator god *Alurua,* the god of heaven *Nyamye* (whose symbol is the ram), the earth and mother goddess *Assye* and the wind god *Gu* as the organizer of the world, into which he blew his breath. *Guli* or *Kakagye,* the powerful bull-headed spirit, and *Gbekre,* with the baboon's head, are sons of *Nyamye.*

This rich mythology, in combination with the most varied cultural influences, has done a great deal to encourage and inspire art. The inspiration for the art of the carver amongst the Baule probably came from the Senufo and the Guro. They brought no tradition of carving with them from Ghana, but a courtly culture which taught them a certain degree of sophistication and delicacy. The care with which they executed their works was derived from the art of the goldsmiths in their ancient homeland.

Amongst the Baule the art of carving is carried out by professional carvers, and not by smiths as in the West Sudan. A successful carver has sufficient means to keep several wives to cultivate his fields. The art of the Baule spans a wide range of qualities. Depending upon the artist's talent and capacity for experience, the works may be superficial and hollow or, on the other hand, masterpieces of the first rank. In the latter case they are marvellously poetic in their expression and so attractive that they are amongst the favourite prizes of collectors.

Their characteristics are: a restful attitude, the arms on the stomach; the body a slim pillar, adorned with scars; the limbs rounded and bent; a large head with a high, carefully structured coiffure; a face with delicate features, the eyebrows arched high, the eyelashes touched in, heavy eyelids, half-closed, and the visible part of the eye more or less three-dimensional, almond-shaped or in the form of a half-circle; the nose straight and delicate; a small mouth; and a smooth forehead adorned with scars. The faces are usually oval and delicately stylized. In the case of the masks a flat profile is preferred, so for the most part they produce their effect only when seen from the front. There is no doubt that amongst the Baule a closer study would also reveal the characteristics of particular sub-styles and masters. Thus for example a group of sculptures which is outstanding for its extreme closeness to nature and pronounced portrait-like features could well be the creation of a particular single master carver. They are attributed to the Attie, the neighbours of the Baule, who speak the Akan

G 3
Mask. Spirit of *Gu,* ruler of the world. Baule.
Wood, 32 cm.
Coll. Charles Ratton, Paris.

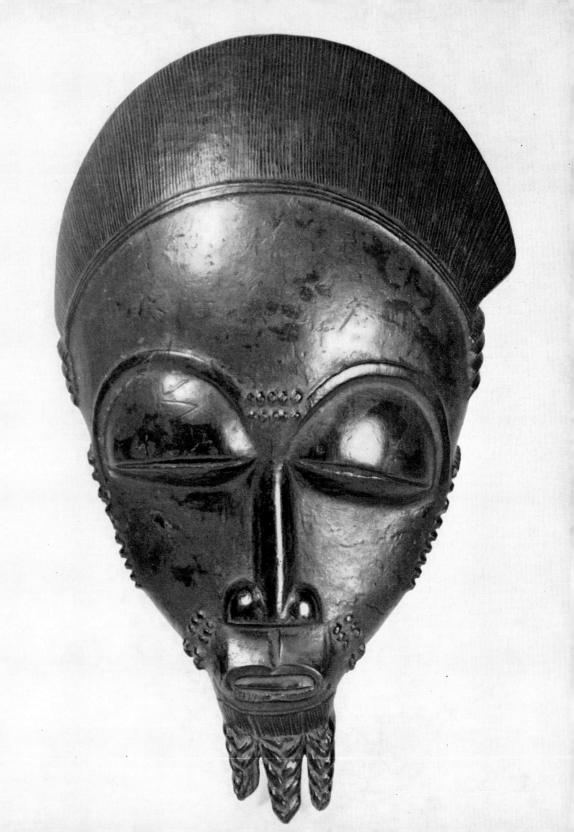

language. There are also heads with a powerful effect of profundity, and exceptionally, round heads instead of the usual oval ones. The frontier between this and the Guro style is a fluid one. The Yaure sub-style of the Baule, which surrounds the face with a zig-zag band, is very close to the Guro style. The lidded bowl, with a delicately carved head on top, is from the hand of a long dead master from the neighbourhood of Buake, and other similar works by the same artist have been identified. Here the Baule face, with its typical scars, makes a very profound effect. The proportions between the lid and the bowl are very harmonious. The bowl was used to contain the shea butter with which the Baule anointed themselves for ceremonies, and which possesses magical power and protects against all invisible dangers.

The Baule usually make use of hardwoods, so that it is easier to cut out the details of the carvings with the knife. Steeping in mud and black juices gives them their beautiful bronze colouring. The splendour of some figures is enhanced by gilding with fine gold leaf. Masks are as numerous amongst the Baule as figures. The large statues of ancestors are the common possession of the village. In addition, every Baule has his own small personal ancestor figure which he cherishes and cares for, and which he brings to the great ceremonies to be charged up with life force. When I was trying to obtain a small ancestor figure from a Baule village, I had first to seek the consent of its owner, a small boy, who was specially brought out from the fields.

The whole carving of the Baule is characterized by a delight in beauty. This is true both of the great ancestor figures or the masks of the god *Gu,* throne stools, drums, doors or small objects for functional use, such as loom heddle-pulleys, fly whisk handles, oracle containers or ointment pots and rattle staffs. The Baule even produce art for art's sake, objects with no real function, simply made to give pleasure.

When the mythical *Guli* and *Kplekple* with all his attendants have to be represented by masks, Baule choose grandiose and fantastic forms. Yet they are always moderate and disciplined. The *Guli* mask is lengthy, and painted in many colours. It is worn horizontally and diagonally across the head. The *Kplekple* is a round, disc-like face with horns and eyes shaped like an inverted tear drop, set in a bizarre surround. The *Kplekple* represents an aspect of the sun. It appears accompanied by castanets, in order to avert evil. The *Guli* race through the village at night, when all the women are out of sight, in order to devour witches.

Gbekre (or *Mbotumbo),* the monkey god, punishes wicked souls in the next world. He is at the same time the god of agriculture. Encrusted with sacrificial blood, he stands in an upright position with an offering bowl in his hand.

The cotton cloth of the Baule is decorated with patterns by the tie-dyeing process. Before the dyeing takes place, the parts of the cloth which have to remain pale are tied up with bast fibre. After the indigo bath the threads are removed, and a flame-like blue and white pattern remains.

The Guro

The style of the Guro masks is totally different from the Baule style. Its great elegance is most attractive.

Its characteristics are: a specifically three-dimensional form; gently rounded unbroken surfaces, flowing lines; almond-shaped eyes, often sloping diagonally backwards; a long narrow face, and a deli-

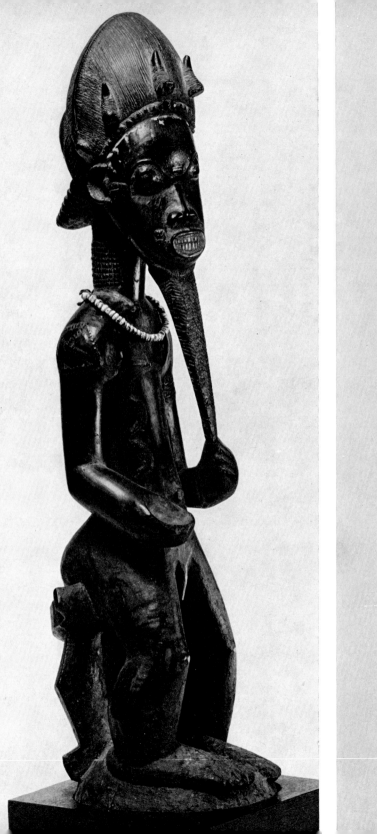
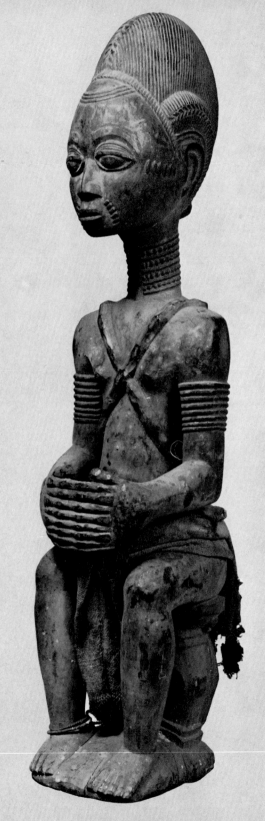

cately undulating profile running from the vaulted forehead without interruption to the end of the slightly up-turned nose. The particular charm of the Guro masks is best realized when they are seen in profile. The coiffure is always carefully constructed, and is topped by horns, birds or other figures, and separated from the face of the mask by a zig-zag band. In the case of the *Zuenula* masks, which represent certain bush spirits, we find a mixture of human and animal features. Even the *Zamle* animal masks display the characteristic flowing lines, sloping eyes and three-dimensionality. In the small loom heddle-pulleys with human and animal heads, the Guro have created works of great refinement and pure poetry. The device hangs over the loom and is used to guide the warp thread. In the stirrup-shaped section there is a small pulley, and through it runs the thread which lifts the cord holding up the two heddles (through which each set of warp threads passes) and raises and lowers them alternately.

The Ebrie

In the coast region of the Ivory Coast, particularly on the Grand Bassam lagoon, a few small local styles can be found. To the Ebrie, Alangoa and Attie are attributed various styles which can be indentified by their round bulbous limbs, the buns and knobs of their coiffure and their arms, which are often raised. Their faces are strongly reminiscent of Baule art. The Ebrie are a breakaway tribe from the north. They probably brought the art of carving with them.

Krinjabo

In the south-eastern corner of the Ivory Coast, on the abandoned graves of the Attie, an Akan-speaking tribe, we find

a remarkable kind of clay sculpture: clay figures of an expressive but naïve style. In part, they may go back as far as the seventeenth century, to a period when the Sanwi kingdom, with its capital Krinjabo, had a considerable role.

Tradition tells that the figures are royal portraits and were made by the kings' widows of that period. The queens adorned the memorial figures with clothes and pearls, placed them in a covered depression on the grave and gave them palm wine, meat and rice in special jars.

Characteristics: a large head with puffed-out cheeks, a lively expression, protruding slit eyes, a large nose, tribal scars, hair in tufts, a ringed neck, short stumps as arms, and the body usually in a rudimentary form with a cylindrical pedestal instead of legs. The fine, light-coloured clay was modelled over a core of wood, which was burned away when the piece was fired (figs H 22/23).

To sum up, we must once again emphasize that the Ivory Coast has produced outstanding achievements in the art of carving: the Senufo, Guro, Baule, Dan, Ngere and Bete are names which refer to specific styles of great importance. In metal working, in brass and in gold, the inhabitants of the southern Ivory Coast have also produced magnificent works. But since they were inspired entirely from Ghana in this particular branch of art, we shall treat the art of metal casting as practised by the above peoples at the same time as that of the Ashanti.

G 6
Lidded bowl with human head, container for shea butter. Baule. Wood, 25 cm. Coll. E. Leuzinger, Zurich.

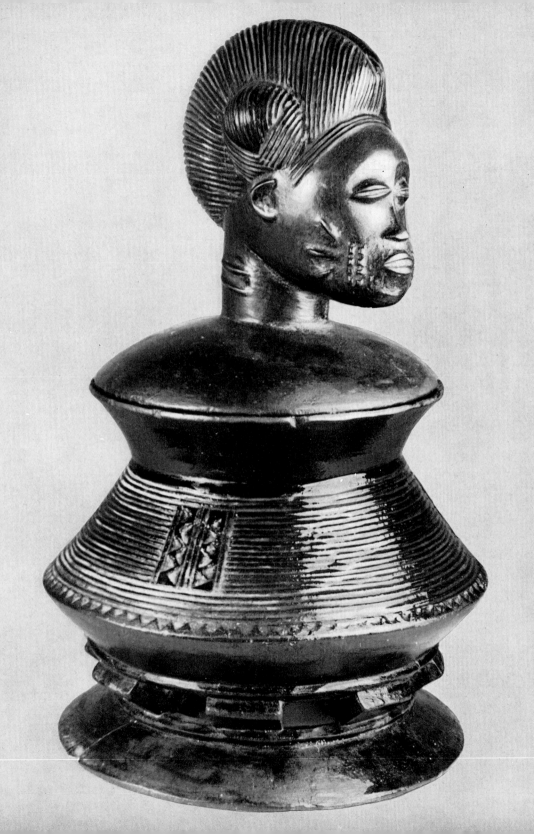

G 7
Door with two fish in relief.
Baule. Wood, 146 cm.
Coll. J. Müller, Solothurn,
Switzerland.

G 8
Double mask. Baule.
Wood, 28 cm.
Coll. Pierre Verité, Paris.

G 9
Animal mask. Guro.
Wood, 62 cm.
Coll. E. Storrer, Zurich.

G 10
Mask with elephant.
Yaure-Baule. Wood.
Coll. Nicaud, Paris.

G 11
Doors of a tribal shrine.
Baule. Wood, traces of paint,
130 cm.
Rietberg Museum, Zurich.

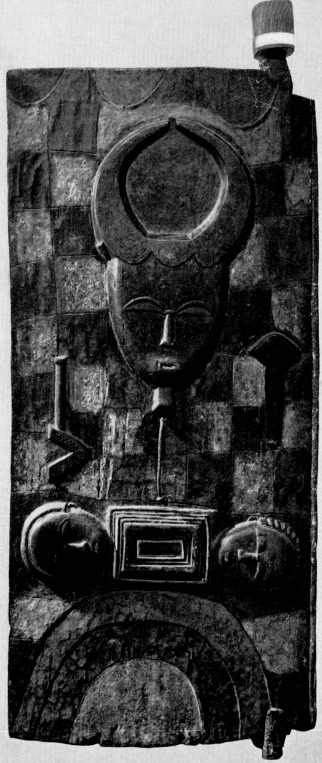

G 12
Mask. Guro. Wood, 28 cm.
Coll. Max and Berthe Kofler-Erni, Basel.

G 13
Mask with zig-zag surround and tiny round mouth.
Baule-Yaure. Wood, 31,5 cm.
Rietberg Museum, Zurich.

G 14
Female figure with hands crossed behind her back.
Baule, Buake region. Wood, 46 cm.
Coll. J. Kerchache, Paris.

G 15
Loom heddle-pulley with human head, beard and
hair ribbons. Baule. Wood, 23 cm.
Coll. Nicaud, Paris.

G 16
Animal mask. Guro. Wood, 36 cm.
Coll. J. Müller, Solothurn, Switzerland.

G 17
Mask. Baule. Wood, 27 cm.
Coll. Simone de Monbrison, Paris.

G 18
Loom heddle-pulley with head. Guro. Wood, 12 cm.
Ethnological collection, Zurich.

G 19
Statue of a woman. Ebrie. Wood, 25 cm.
Coll. J. Müller, Solothurn, Switzerland.

G 20
Loom heddle-pulley with head. Guro. Wood, 12 cm.
Rietberg Museum, Zurich.

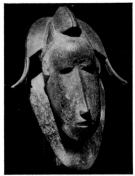

G 12

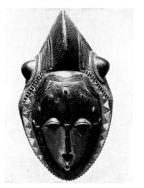

G 13

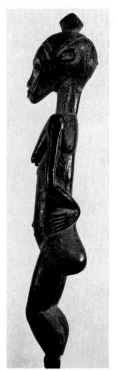

G 14

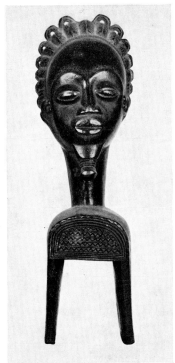

G 15

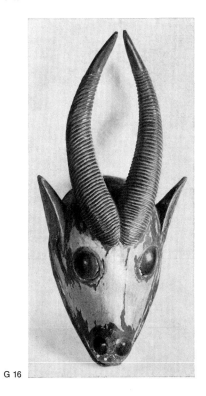

G 16

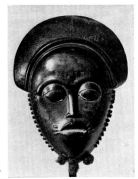

G 17

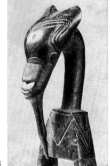

G 18

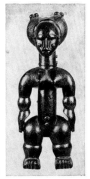

G 19

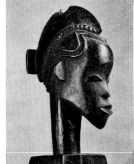

G 20

G 21
Figure with round head. Baule. Wood, 38.5 cm.
Coll. R. Duperrier, Paris.

G 22
Monkey, *Gbekre*. Baule. Wood, 83 cm.
Coll. Charles Ratton, Paris.

G 23
Statuette with beard. Baule. Wood, 42.5 cm.
Coll. E. Leuzinger, Zurich.

G 24
Enthroned ancestor figure with beard. Baule.
Wood, 50 cm.
Coll. J. Müller, Solothurn, Switzerland.

G 25
Large *boar's head Guli* mask. Baule. Wood, 119 cm.
Musée des Arts Africains et Océaniens, Paris.

G 26
Door with rider in relief. Baule. Wood, 135 cm.
Musée des Arts Africains et Océaniens, Paris.

G 27
Round buffalo mask *Kplekple*. Baule. Wood, 92 cm.
Coll. Edith Hafter, Zurich.

G 28
Small rider. Baule. Brass, 16.5 cm.
Coll. E. Storrer, Zurich.

G 29
Ancestor mask. Baule. Wood, 39 cm.
Coll. Henri A. Kamer, New York.

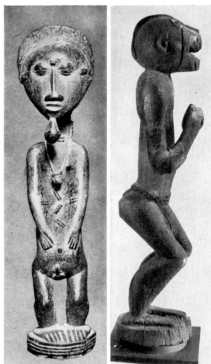

G 21
G 22

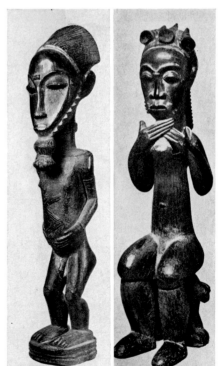

G 23
G 24

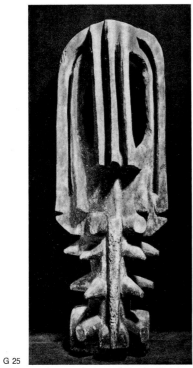

G 25

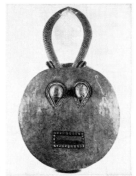

G 27

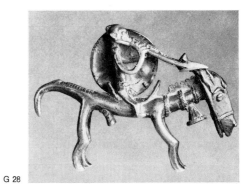

G 28

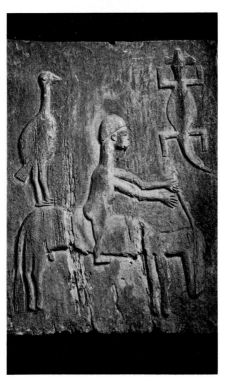

G 26

G 29

H Ghana and Dahomey

The Ashanti

Present day Ghana, which takes its name from the famous ancient kingdom of Ghana in the West Sudan (p. 22) can look back to a past when gold was abundant, to a mighty state with a sacral kingship.

At that time several peoples fought for political hegemony in Ghana. In the end it was the Ashanti of the central region who in the first half of the eighteenth century were able to build up a powerful state by virtue of their efficiency and the superiority brought by firearms. It was a kingdom sometimes extended over almost the whole of Ghana, as far as the Ivory Coast, and which earned great prosperity by means of a flourishing trade in gold and slaves. Gold played an important role in trade with Europeans in the seventeenth and eighteenth centuries, and gold was also used by the king and his court to a lavish extent.

The Europeans of that period speak of Ghana with great enthusiasm. They praised the discipline and order of the Ashanti kingdom and the splendour of Kumasi, the magnificent capital of the sacrosanct ruler. The houses and streets were swept clean, the sanitary arrangements functioned, and the burning of refuse went without a hitch.

The kingship was inherited matrilineally. Great respect was enjoyed by the queen mother, who had the right to speak in the council and represented the son when he was away on military campaigns.

The religion of the Ashanti possessed a pantheon of gods with *Nyame*, the god of heaven, at its head. The order of the universe was explained by definite philosophical systems. But the Ashanti do not represent their gods in images. Their contact with the supernatural is made by means of the sacred golden stool: the most sacred symbol known to the Ashanti.

Legend tells that this stool fell from heaven during a storm around the year 1700, right on to the knee of the great king Osei Tutu, who founded the kingdom. The throne became not merely the symbol of the state, but also the altar on which sacrifice was offered to the invisible gods. The Ashanti regarded it as the seat of the soul of their people and as a guarantee of health and of prosperity. Neither the king nor his golden stool were allowed to touch the ground. For this reason the throne always stood on a skin or a stand and was never used to sit upon. At certain state solemnities it was washed, smeared with fresh sacrificial blood and placed on open show.

The specific political, social and religious structure of this state and the influences from the ancient Mediterranean region and from the East to which it was exposed gave its art its distinctive features and led it into paths which differ from the development amongst other Negro peoples.

Instead of religious sculpture in wood we find here an explicitly courtly and emphatically secular art, concentrating upon representation of the king and his court. The king possessed a monopoly of brass casting, gold and silk. The people were allowed only wood, clay and gourds. Art in metal was regarded as secular, which allowed more freedom of form and greater trueness to life, and led to the production of groups, and indeed a genuine portrait art. Artists and craftsmen formed guilds at the court. The metal founders were so highly regarded that they were counted amongst the upper aristocracy. Their main task

H 1
Head with diadem.
Ashanti, Fomena style, Ghana.
Terracotta, 37 cm.
Coll. Comte Baudouin
de Grunne,
Wezembeek-Oppem, Belgium.

was to produce the regalia of the king, the symbols which were carried in all processions in which the king took part.

T. E. Bowdich, the English envoy to the court of Ghana, wrote in 1817 about the magnificent procession of the Ashanti king Osei Bonsu: 'The caboceers, as did their superior captains and attendants, wore Ashantee cloths, of extravagant price from the costly foreign silks which had been unravelled to weave them in all the varieties of colour as well as pattern; they were of an incredible size and weight, and thrown over the shoulder exactly like the Roman toga ... and massy gold necklaces, intricately wrought, suspended Moorish charms ... A band of gold and beads encircled the knee, from which several strings of the same depended; small circles of gold like guineas, rings and casts of animals, were strung round their ancles; their sandles were of green, red, and delicate white leather; manillas, and rude lumps of rock gold, hung from their left wrists, which were so heavily laden as to be supported on the head of one of their handsomest boys. Gold and silver pipes, and canes dazzled the eye in every direction. Wolves and rams heads as large as life, cast in gold, were suspended from their gold handled swords, which were held around them in great numbers; the blades were shaped like round bills, and rusted in blood; the sheaths were of leopard skin, or the shell of a fish like shagreen. The large drums supported on the head of one man, and beaten by two others, were braced around with the thigh bones of their enemies, and ornamented with their skulls ... The war caps of eagles feathers nodded in the rear, and large fans, of the wing feathers of the ostrich, played around the dignitaries; immediately behind their chairs (which were of black wood, almost covered by inlays of ivory and gold embossment) stood their handsomest youths with corslets of leopard's skin covered with gold cockle shells, and stuck full of small knives, sheathed in gold and silver, and the handles of blue agate; ... a large gold handled sword was fixed behind the left shoulder, and silk scarves and horses tails (generally white) streamed from the arms and waist cloth: their long Danish muskets had broad rims of gold at small distances, and the stocks were ornamented with shells. Finely grown girls stood behind the chairs of some, with silver basins. Their [ancestor] stools were conspicuously placed on the heads of favourites ... Native dignity in princes we are pleased to call barborous was a curious spectacle: his [the king's] manners were majestic, yet courteous ... He wore ... a necklace of gold cockspur shells strung by their largest ends, and over his right shoulder a red silk cord, suspending three saphies [amulets] cased in gold; his bracelets were the richest mixture of beads and gold, and his fingers covered with rings; his cloth was of a dark green silk ...'

Extracts from this account have been reproduced here because they give us some inkling of the magnificence, the lavish use of gold and the rich art of the Ashanti. Unfortunately little has been preserved, and our museums contain for the most part only small, albeit excellent ornamental pieces. Decorated gold discs with pierced or chased ornamentation, rosettes and sometimes European motifs are particularly characteristic of the Ashanti. Most of these ornaments were cast by the lost wax technique, while others were chased or hammered. Gold symbolizes the sun; but gold is also the bearer of the soul power of the Ashanti. At the great purification and yam feast, which used to be associated with bloody sacrifices, the whole aristo-

H 2
Fertility doll.
Fante, Ghana. Wood, 34 cm.
Coll. W. Kaiser, Stuttgart.

H 3
Kuduo, spirit container with fighting animals. Ashanti, Ghana. Brass, 31.5 cm.
Ethnological collection, Zurich.

cracy shone and glittered with gold. The sumptuous use of gold ornaments was also adopted by the Baule and other tribes in the Ivory Coast. By contrast to the ornaments of the Ashanti, those of the Baule are fitted with little rings by which they can be hung. They are worn to adorn the breast or head, or fastened to the sword as war trophies. Small human and animal masks with carefully plaited hair, beards, eyebrows and tribal marks are a speciality of the Baule. The animal motifs include fish and birds, crocodiles, tortoises and snakes. The mask of a ram symbolizes the god of heaven. The half moon is the sign of water and rain. At the great yam and fertility feast, which takes place every two years, the princes and nobles of the Baule wear and display all their gold; young men have sometimes carried as many as twenty-five golden masks hanging around them.

The gold was obtained by the washing of deposits in rivers or of gold-bearing earth from mines. The Ashanti used finely decorated bellows and ladles and fine sieves in the refining process. The gold dust was kept in small metal boxes and fine fabric. The gold was weighed with the aid of a small balance and several sets of very pretty weights, *mrammuo,* which were cast from metal. A set of weights contains 60—70 pieces of every size from 2 g. to 1 kg.; rich people possessed several sets. In their *mrammuo* the Ashanti developed an extremely attractive branch of art, which bears witness to an abundance of ideas and their creative inspiration. The themes are inexhaustible; everything that moves man in the earthly and religious sphere is represented in a vivid and lively way. Even maxims, aphorisms and humour in the form of proverbs and stories told in pictures find their way into the *mrammuo.*

The lost wax technique is always used. The model is formed from beeswax, either by modelling a lump of wax or by building up the model from wax threads and cutting the wax. Occasionally small animals were covered directly with a layer of clay. The human figures have a tube-like curved form.

The small weights of brass are a speciality of the Anyi and Akan peoples, especially the Ashanti and Baule. The production of these small works of art must therefore have been in full swing in the eighteenth century, that is, before the emigration of the Baule. At first the weights were cast from gold and silver and their use restricted to the king and his mother. Later ordinary citizens were allowed to use them. The weights of the king were a third larger, and those of the nobles a tenth larger than the weights used by ordinary citizens; a very simple way of raising a tax in kind! Certain types of weight were used for the payment of fines. Small figures were also worn as amulets.

An important cult object of the Ashanti is the *kuduo,* the soul container of brass. This too was cast by the lost wax process and covered with ornamentation. Twisted bands and rosettes occur frequently, motifs drawn from themes associated with the divine king.

The lid of the *kuduo* is also decorated with figures. Its form is reminiscent of the cists of ancient Italy. In the *kuduo* box the Ashanti believe that the power of the souls of the dead is stored up, and they offer sacrifice to them. *Kuduo* are also used to keep the sacrificial gifts for the great ceremony of the purification of the souls, and many other sacred things which are believed to be filled with soul material. At death the *kuduo,* filled with gold, ornaments and cowrie money is placed with its owner in his grave.

H 4
Buffalo head. Togo.
Terracotta, 21.8 cm.
The Museum of Primitive Art,
New York.

The highly developed art of the Ashanti also includes their magnificent *kente* materials, gay silk and cotton fabrics, which are worn at ceremonies. The patterns, woven in or printed on the cloth, are specially designed for the persons who wear them. Many patterns portray a particular wish or tell of an event in the past. The most famous are the *adinkra* mourning gowns, for which the patterns are printed with gourd stamps and the black juice from bark.

Apart from works cast in gold or brass, we find amongst the Ashanti almost no representational sculpture of importance. There are only the earthenware figures from the graves of the nineteenth century, which are made with a delicate sensitivity. They represent kings and queen mothers, and yams, meat and pearls are offered to them.

Wood carving plays little part amongst the Ashanti. The small *akua'ba* statues, which women carry in order to bear perfect children, are typical. The heads of these *akua'ba* are disc-like amongst the Ashanti, and narrow and rectangular amongst the Fante in the south of Ghana.

Togo

There is so little to say about Togo that it is mentioned only in passing. There are Togo tribes which use a distinct primary style, like, for example, the ancestor figures of the Moba. On the other hand, a few other works of art display a certain relationship to the ancient kingdoms, such as:
— the magnificent terracotta buffalo head, which betrays a connection with the Abron, the representatives of an ancient kingdom in northern Ghana. It is a bold abstraction, fascinating in the contrast between the smooth head and the firmly structured horns which curve elegantly outwards.

— a delightful work in silver, a pierced crocodile head with a fish in its mouth, used as the insignia of a sultan.
— the brass castings of Ali Amonikoyi, a Yoruba artist who emigrated from Ilorin to Togo and attained a certain fame. He cast life-size masks, sceptres, groups of figures composed of numerous parts in a smooth, unpleasantly naturalistic style, a pale reflection of the ancient Yoruba tradition.

Dahomey

In southern Dahomey the Fon built up a powerful kingdom with a sacral kingship, which occasionally practised the ritual killing of the king. It lasted from the seventeenth century to the end of the nineteenth century, and its riches were obtained through the slave trade — hence the term Slave Coast. The kingdom owes the period of its prime to King Agaja (1708—1717), who set it free from the domination of the Yoruba kingdom of Oyo and incorporated the other smaller states of Dahomey into his kingdom. In the fortified city of Abomey resided the omnipotent divine king, protected by a bodyguard of armed amazons and served by hundreds of women and slaves. In Abomey the professional artists developed a lively business in their workshops, because the requirements of the king and nobles for secular magnificence was considerable. The king made silver, brass founding and textiles his own monopoly.

The Fon produced little of any intrinsic value out of the numerous foreign influences to which they were subject, from Benin or Ghana, from the Yoruba or from their European trading partners. Unfortunately we have only a handful of individual pieces, as impressive examples of the court style:
— large, garishly painted royal statues in

H 5
Ritual club for summoning the god *Legba*. Dahomey.
Wood, 62 cm.
Coll. J. Kerchache, Paris.

H 6
Bochio, post figure.
Fon, Dahomey. Wood, 176 cm.
Coll. J. Kerchache, Paris.

H 7
Bochio, village fetish.
Fon, Dahomey. Wood, 168 cm.
Private collection, Paris.

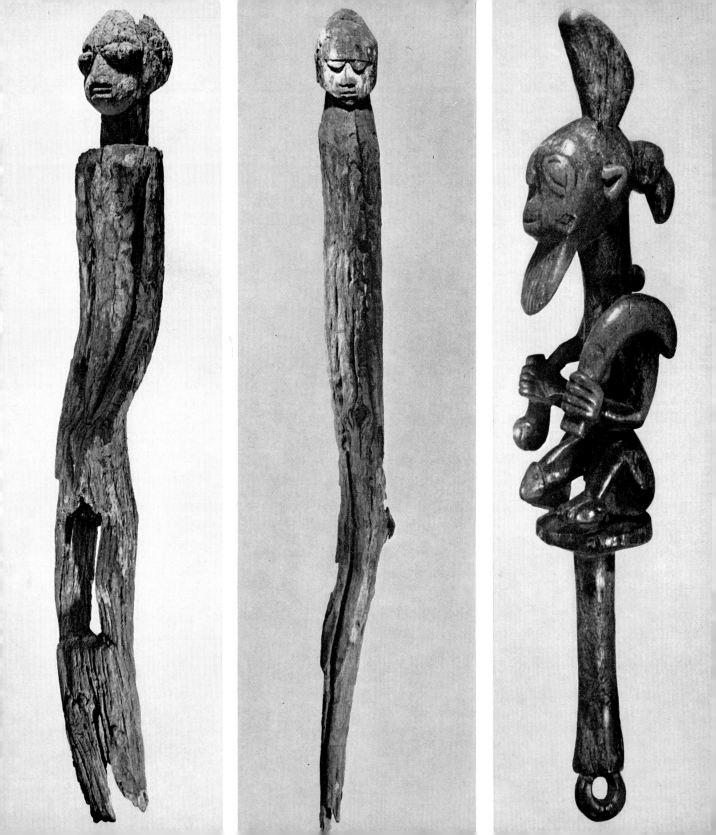

wood, farcical combinations of man and beast.

— cast iron and bronze statues of *Gu,* the god of war and of iron, who corresponds to the god *Ogun* of the Yoruba (e. g. the standing figure which comes from the treasury of the king Gbehanzin; it carries two swords, and is built up from plates of brass hammered smooth).

— siver-plated animal figures, e. g. the large guinea fowl and the lion, made from the most delicately structured silver sheets over a core of wood.

The doors, pillars and thrones of the palaces were adorned with sculptures: on the walls hung brightly coloured appliqué fabrics with pictures of scenery. Fabrics on which pictures were sewn in an appliqué style were also used by the nobility for state robes and caps, for cushions and ceremonial umbrellas.

The same somewhat carefree narrative style is also found on the relief tablets which, arranged in rows, covered the outer walls of the royal palaces. These pictures show glorious battles, particularly against the Yoruba of the kingdom of Oyo, and all kinds of allegories of the king. Striking examples of craftsmen's work are the *rekade,* the batons of the rulers, developed from the war axe. On the decoratively pierced blade of iron or brass, coats of arms are displayed. The *rekade* represents the authority of the owner. The king's messenger carries it, covered by a veil, upon his shoulder and then reveals it to the recipient of the message, in order to authenticate it.

When the court monopoly for brass founding was removed, the art of working in brass in Abomey enjoyed great prosperity. Suddenly there were produced many very lively small brass figures and groups. They have thin cylindrical limbs and are decorated with punched-in ornamentation (clothing, feathers,

skins). These figures are not without charm, and are therefore a favourite purchase amongst tourists. They can still be found, encrusted with blood, upon the *asen,* the portable iron altar for the cult of the royal ancestors, and of the god of destiny and oracles, *Fa.* The art of carving the gourd, often in the technique of the negative image, was practiced and developed with great care both by the Fon in the south and also the Bariga in the north. Stylized figures, representing a word in a riddle, were placed against a background of lines and linked by geometric patterns.

The wood sculpture of the Fon is simple and realistic, and often shows a delicate sensitivity. In this respect it is reminiscent of the figures of the Lobi. It represents the *bochio,* the protecting spirits of the cult of the god *Legba.* *Legba* corresponds to the god *Eshu* of the Yoruba. The tall, thin figures, encrusted with blood, feathers and palm oil, stand in small mounds of mud in the village square — or else one finds thick packets of magical substances, from which a round, lively head protrudes.

Large parts of the population of eastern Dahomey — the Nago and others — belong both by their tribal origin and also their style of carving to the Yoruba group. Like the Yoruba they have figures of gods and masks, cult objects and door posts, often with complicated groups of figures. We shall look at these works more closely when discussing the Yoruba.

H 8
Figure of a man wearing the leather cap of an executioner. Ashanti. Wood, 32.5 cm. Coll. W. Kaiser, Stuttgart.

H 9
Janus-faced *Bochio.* Village fetish. Fon, Dahomey. Wood, 52 cm. Coll. J. Kerchache, Paris.

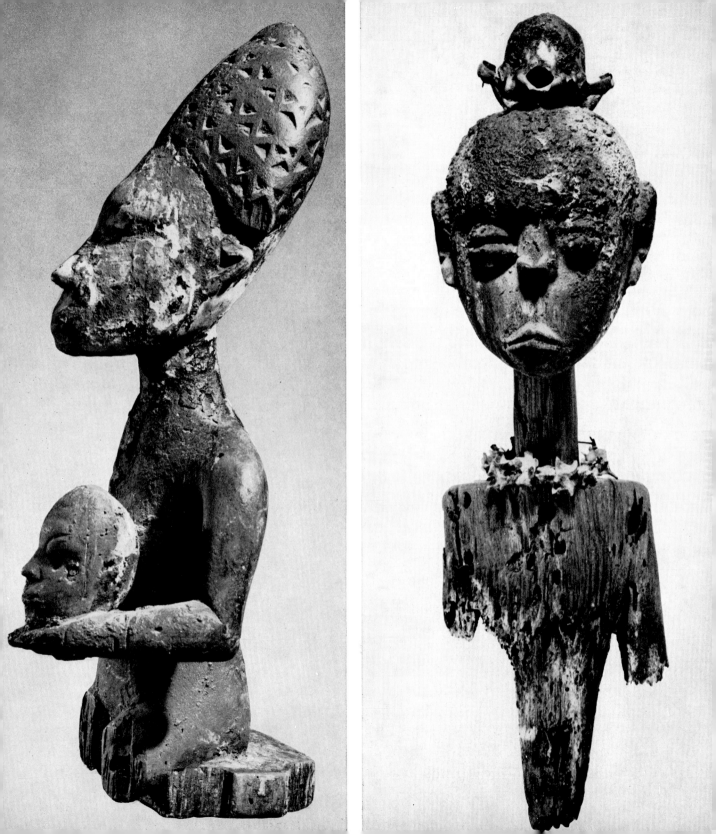

H 10
Decorated disc, badge of the king's soul-washer.
Ashanti. Gold, diam. 10 cm.
Coll. W. and D. A.

H 11
Frog pendant. Baule. Gold, 9.5 cm.
Coll. Edith Hafter, Zurich.

H 12
Gold mask. Baule. 8 cm.
Coll. Edith Hafter, Zurich.

H 13
Ram mask. Baule. Gold, 7 cm.
Coll. Edith Hafter, Zurich.

H 14
Lidded bowl for gold dust. Ashanti.
Brass, 6.3 cm.
Coll. George Ortiz, Geneva.

H 15
Guinea-hen, probably originating from the treasure
of King Gbehanzin. Dahomey, 19th century.
Silver sheeting over wood, 34 cm.
Coll. Pierre Verité, Paris.

H 16
Altar figure from the cult of the god *Gu.* Probably
from the palace of King Gbehanzin. Dahomey.
Assembled from iron sheets, 102 cm.
Coll. Charles Ratton, Paris.

H 17
Weight in the form of a mud-fish. Ashanti. Brass.
Galerie Künzi, Oberdorf-Solothurn, Switzerland.

H 18
Weight: man beating a talking drum.
Ashanti. Brass, 7 cm.
Coll. Alfred Muller, St Gratien, France.

H 19
Royal *Kuduo* with three crocodiles in relief and
geometric ornament. Ashanti 17th/18th centuries.
Gilded bronze, 26.8 cm.
Coll. George Ortiz, Geneva.

H 20
Lid of a *kuduo:* couple playing *mancala.* Ashanti.
Brass, diam. 16.7 cm.
Coll. George Ortiz, Geneva.

H 10

H 11

H 12

H 13

134

H 14

H 17

H 15

H 18

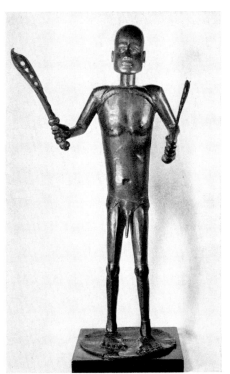

H 16

H 19

H 20

H 21
Head with knotted hair. Ashanti, Ghana.
Terracotta, 20 cm.
Coll. Dr. Ernst Anspach, New York.

H 22
Bearded head, fragment of a funerary statue.
Krinjabo, Ivory Coast. Terracotta, 18 cm.
Coll. André Held, Ecublens.

H 23
Funerary statue. Krinjabo. Terracotta, 33 cm.
Coll. Winizki, Zurich.

H 24
Double *Akua'ba,* fertility doll.
Ashanti, Ghana. Wood, 21 cm.
Coll. Edith Hafter, Zurich.

H 25
Nail fetish. Fon, Dahomey.
Wood and iron nails, 45 cm.
Coll. Comte Baudouin de Grunne,
Wezembeek-Oppem, Belgium.

H 26
Double headed village fetish, *Bochio.* Fon, Dahomey.
Wood, 43 cm.
Coll. J. Kerchache, Paris.

H 27
Sitting monkey: the water in the pot reflects the thief.
Fon, Dahomey coast. Encrusted wood, 51 cm.
Coll. J. Kerchache, Paris.

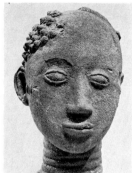

H 21

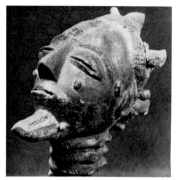

H 22

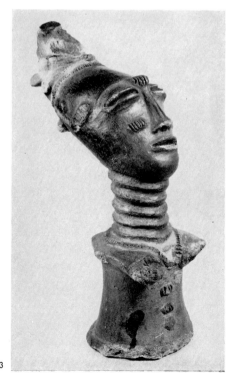

H 23

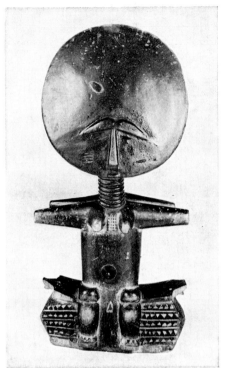

H 24

H 26

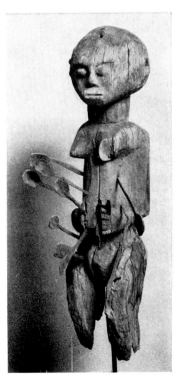

H 25

H 27

Nigeria

A vast area between Lake Chad and the Niger Delta; far-ranging steppe in the north, thick tropical forest in the south; dynamic peoples with a troubled history, during which great kingdoms were formed; the utmost diversity of races and culture: these are the elements of which the complex 'Nigeria' is composed. Influences from advanced cultures which from the earliest times have found their way from the Sudan by way of the rivers Benue and Niger were readily accepted and integrated, especially those which brought early iron age culture and the sacral kingship to which numerous archaeological discoveries bear witness. Thus in Nigeria we have what may well be a unique opportunity to follow the traces of two thousand years back into the past, until we reach the Nok terracottas. From the Middle Ages we can observe outstanding monuments of various advanced civilizations (Ife, Benin). In the recent past, we find a tribal art of the utmost vitality and complexity.

Nigerian tribal art is displayed at its purest and strongest where men's guiding and driving force is still the traditional religion: where ancestors, spirits and a pantheon of gods are still in full force, and the secret societies guarantee their undiminished strength. This is the case in the backwoods areas. Even amongst the highly civilized Yoruba and Ibo, many of whom have become Christians or Mohammedans, a belief in the indigenous gods and heroes is still present, and has never ceased to shape and inspire their art. Thus it is no accident that the art of Nigeria presents so complex and fascinating a picture. The range of art forms extends from the strictest cubism to a high degree of realism. Naturalistic tendencies can of course be attributed to the influence of the advanced culture at the ancient royal courts.

J 1
Portrait of a priest-king. Ife. 10th—13th centuries. Found in excavations near the palace of the Oni of Ife. Bronze, 31 cm. Ife Museum, Nigeria.

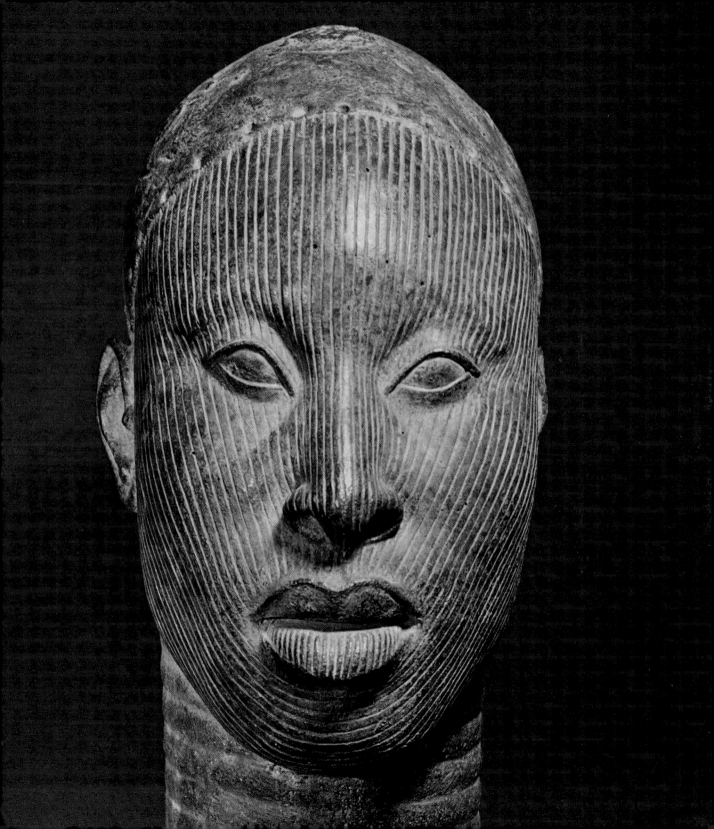

J Early Nigeria: Nok, Ife, etc.

Nok

It was Bernard Fagg who in 1943 recognized the importance of some chance discoveries in the tin mines of Northern Nigeria. He called them Nok, after the place where the first clay head was found in the Jaba village of Nok. Since then there have constantly been new discoveries. At a depth of from fifteen to seventy feet hundreds of terracotta fragments have been brought to light, all apparently belonging to the same culture, in an area which extends from the river Kaduna in the north-west, across the river Benue in the south as far as Yorubaland in the west.

Geological estimates and carbon-14 datings suggest that the Nok works are of great antiquity. They must have been manufactured between 500 B.C. and 200 A.D. Thus the Nok culture represents the oldest sculpture demonstrably produced by a Negro people. Besides the figures there were also stone and iron tools: polished stone axes, ornaments of iron, tin and stone. This shows that the Nok culture already belonged to the iron age. The clay of the Nok figures is reddish in colour and very fine. It was fired in a wood fire, which gave it a brownish colour with black marks.

The artistic quality of the Nok fragments is of an astonishingly high level. It shows great diversity and imagination. In addition to small objects, there were also found fragments which must have come from more than life-sized statues. The animal fragments of monkeys, snakes, lizards and various quadrupeds are lively and realistic. The natural form underlies the human figures, but it is strongly stylized and already set in the proportions which are so typical of Africa: that is, with a large head which usually forms a quarter to a third of the whole figure.

Its characteristics are three-dimensionality, triangular eyes with the point at the bottom or as a half-circle, open and with a wide-awake expression. The pupils, nostrils, opening of the mouth and ears are provided with holes. The sides of the nose spread out to the side and are surrounded by a hollowed-out area. The lips protrude. The hair of the head, the eyebrows and the beard are shown by grooves. In one group of human heads the ears are long like those of animals. One can observe a great deal of decoration and clothing, and sometimes a turning of the body. The works are full of life and expression, varied and stylized: and all were produced more than two thousand years ago! It is a long time, however, before we come to the next reliably dated discovery: in the ninth century the bronzes of Igbo-Ukwu were produced in Iboland. It is not too bold to see a link between Nok and Ife, because in both cases there are details so similar that they might be confused. Even the recent carvings of the Yoruba show how persistently a formal element can assert itself. For example, in the *Gelede* masks the formation of the eyes and lips is similar to that of the Nok heads.

Igbo-Ukwu

Unusual discoveries have been announced from excavated graves in Igbo-Ukwu, thirty miles south-east of Onitsha in Iboland: bronzes and other objects of high quality, displaying in their formal elements an attractive and original style. Carbon-14 datings place their time of origin in the years between 660 and 1045 A.D. This is astonishingly early for Black Africa, when one recalls their com-

J 2
Head, part of a figure.
Nok, 400—200 B. C.
Found during excavations by
Bernard Fagg in 1943.
Terracotta, 23 cm.
Federal Department of
Antiquities, Lagos, Nigeria

pletely courtly character. The present day inhabitants of Onitsha have no connection with this culture.

In one grave the figure of a high religious dignitary could be recognized, probably a priest-king, who had been buried seated and in full regalia. He belonged to the complex of the divine kingship in the Eze Nri clan. The find included ritual objects of bronze, cast by the lost wax technique, and also bells, pedestals, large grooved earthenware vessels, many ornaments of metal or beads of cornelian and glass, clothes and mats, skulls and bones, bronze containers in the form of a snail shell with exquisite decorative detail. One small bronze head has decorative scars on the face like the Ife faces. This is a sophisticated art of considerable technical perfection.

Ife

Ife, the sacred city of south-west Nigeria, is still at the present day the capital of the priestly overlord of Yorubaland, the Oni of Ife. According to the myth Ife was the centre of the world, because in Ife the gods had climbed down from the clouds on a staircase, in order to create men at the bequest of the creator god and a mythical ancestor Oduduwa. Perhaps this myth still keeps alive the memory of the immigrants who in the ancient past came bringing civilization from the Nile valley, and carried with them the technique of bronze casting. In about the tenth century they established in Ife the sacral kingship, which practised a courtly intellectual life, required courtly art and produced marvellous masterpieces: figures and heads of men and animals, of terracotta, copper and bronze, all of high technical and artistic perfection. They are impressive for their subtle forms, very true

to life, and for a sophisticated realism which brings them astonishingly close to our Greek ideal of a classically beautiful and harmoniously balanced sculpture. Ife is the Black Athens! And yet in the sculpture of Ife one looks in vain for elements which are not of exclusively Negro origin: all this is the work and achievement of the Negro. The sculpture of Ife shows how fine the observation and sensitivity of the Negro can be when it is his task to find a form for the countenance of the man venerated as God, or of the God incarnate in man. In the artistic representation of human dignitaries he had more freedom than in the magical images of the Nok sculpture or the much more recent tribal art of the Yoruba.

The portraits of the Oni, more than life size, with an expression of proud nobility, are most imposing in their effect, as are the full length figures of the priest-kings with all their regalia, clad in a lavish adornment of beads, diadems on their heads and pendants on their breasts. The proportions of the figures, with an exaggerated head and short legs, show the characteristic African vision which we have already noted amongst the Nok. The clothing shows the high degree of civilization.

A whole series of Ife sculptures are covered with regular grooves, which are probably meant to represent scars: in the little holes round the mouth chains of beads were hung and on the head a real life diadem was fixed. One may suppose that the metal heads were placed on clothed wooden bodies, as is still done today by the Ekiti, so that their dead kings can take part in the ceremonies.

The Ife bronzes were cast by the lost wax method. The metal consisted either of copper or brass, that is, an alloy of copper, zinc, lead and very little tin (so

J 3
Head. Ife. 10th—13th centuries. Found in 1953 by Bernard Fagg beneath the shrine of the goddess of riches, Olokun Walode.
Terracotta, 12.5 cm.
Federal Department of Antiquities, Lagos, Nigeria.

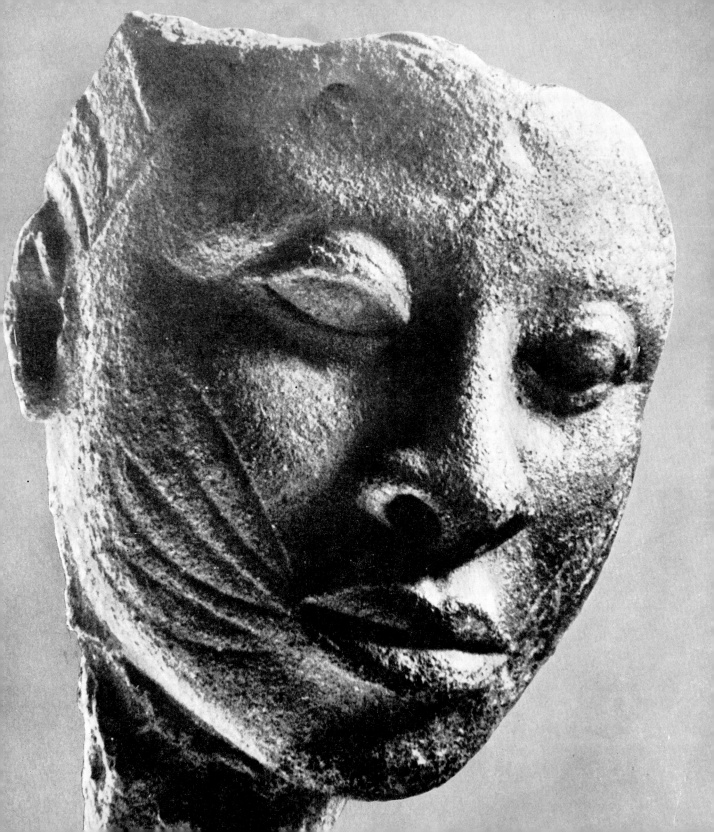

that one cannot strictly speak of bronze, which must contain more than five per cent of tin). The clay sculptures are much more numerous than those in bronze, because the metal was probably repeatedly melted down and re-used. In the way the faces are formed, the terracottas show the typical delicacy of feeling which distinguishes the style of Ife. One example is the small clay head found in 1953 by Bernard Fagg under the shrine of the goddess of the kingdom, *Olokun Walode;* the head with its negroid features may be connected with the slave Lajuwa, who usurped the throne. The queens can be recognized by their stepped diadem. The most recent find is the marvellous hippopotamus head, adorned with a diadem, which comes from a grave complex excavated by Professor Ekpo Eyo. Here various animal heads served as lids for the grave vessels. Animal heads, some of which were found upon the altars, may also symbolize animal sacrifices.

Sculpture in earthenware makes considerable technical demands. Although it is usually the woman who works clay in Africa, here it must have been the man who formed the damp clay by hand in the same sophisticated fashion as the bronzes. The figures were fired without a kiln, simply in a wood fire at 300° C., not really qualifying as terracotta.

In addition to earthenware and bronze there are also some sculptures in stone. The finest of these are the monolithic seats in quartz.

The most recent carbon-14 datings by Ita Yemoo enable us to place the zenith of the classical court art of Ife earlier than hitherto; it must have flourished between the tenth and fourteenth centuries. In particular, the terracottas are of such a varied nature that the period in which they were manufactured must have been much longer in extent.

Tsoede bronzes

A group of unusual bronzes, standing far to the north in the sanctuaries of the villages Tada, Jebba and Giragi in the Nupe country, present further riddles. Their origin is unknown, but we are told that they were brought by Tsoede, the bastard brother of the Atta of Idah, from his homeland when he set off up the Niger in the fifteenth or sixteenth century and founded the Nupe kingdom. For this reason they are known as the Tsoede bronzes. They are large figures of men and animals which are still venerated today in the cult. Some of them are regularly ritually bathed and scrubbed at the river, for the Africans believe in their power to bestow fertility. The great seated figure of Tada and the great archer of Jebba are masterpieces of the first rank.

Esie

In 1933 Father Aimée Simon discovered in the bush, near the small Yoruba town of Esie in the Ilorin province of Northern Nigeria, a hoard of almost a thousand stone figures. They are still used today for a local cult, although their place of origin is unknown. The figures are full of dignity, with a simplified realism and in a very personal style. They stand on short legs or are seated on mushroom shaped stools, and hold an object in their hands; there are also female figures, kneeling in front of water pots. The figures have hats or elaborate coiffures in the form of feathers or bunches of hair, and are liberally adorned with beads. The negroid faces have scars like those of the earlier advanced cultures or some more recent Nigerian tribes. Thus some details repeatedly suggest a relationship both with Nok, Ife and Benin, and also with Idah and Igbo-Ukwu.

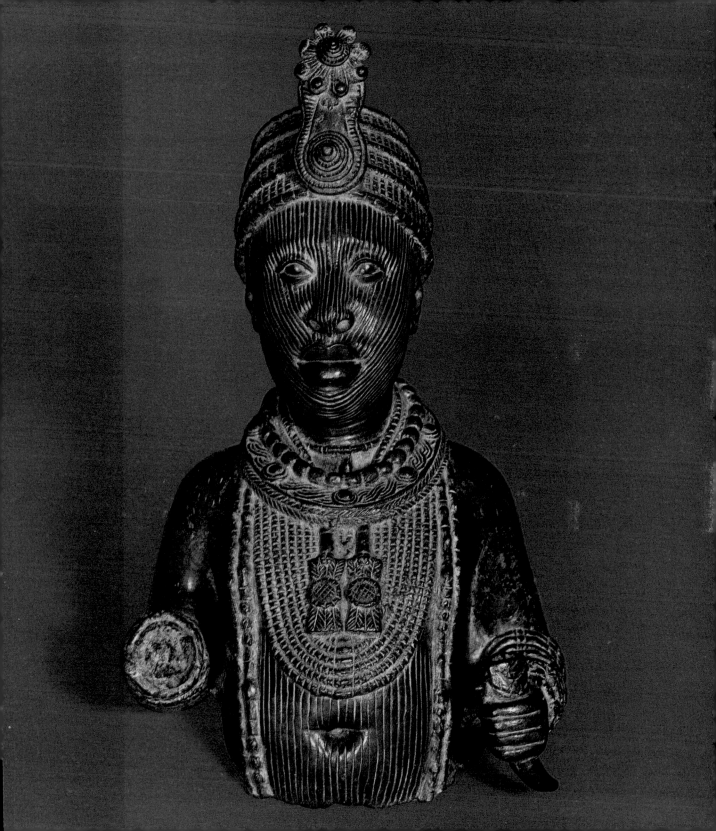

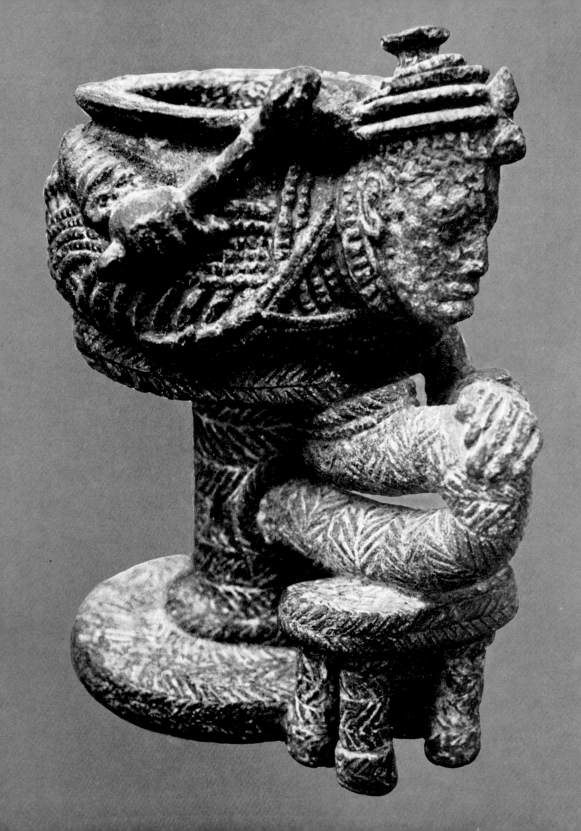

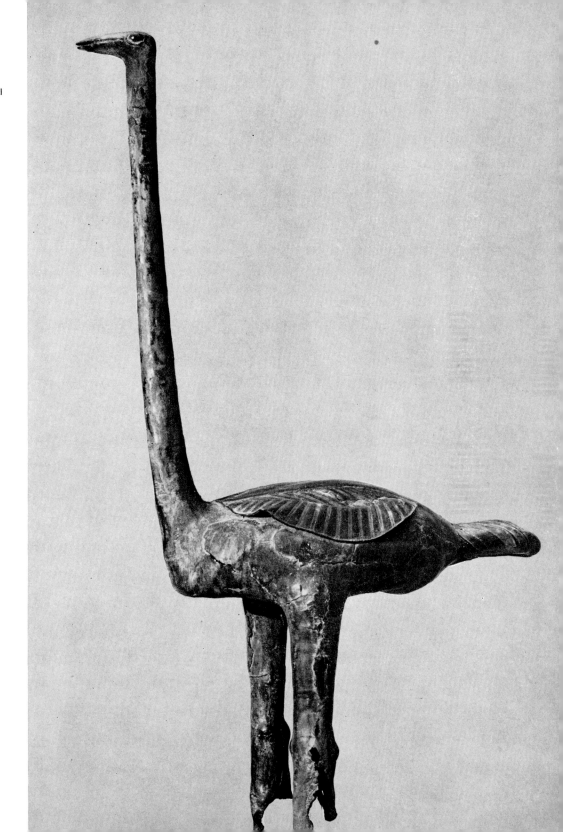

J 5
Ritual vessel: a queen with
diadem, the sceptre in her
hand, is entwined round a pot
that rests on a throne; the
handle is supported on a small
stool.
Ife, Ita Jemoo, 10th/12th
centuries. Brass, 11.5 cm.
Federal Department of
Antiquities, Lagos, Nigeria.

J 6
Tsoede bird. Tada.
Brass, 140 cm.
Federal Department of
Antiquities, Lagos, Nigeria.

J 7
Head, part of a figure. Nok culture, 400 B. C.
— A. D. 200. Found in the tin mines in the Jaba
village of Nok. Terracotta, 35 cm.
Federal Department of Antiquities, Lagos, Nigeria.

J 8
Head. Esie. Steatite, 29 cm.
House of Images, Esie, Nigeria.

J 9
Figure of an archer in ceremonial dress and slatted
armour, filled with gripping vitality. The face has
decorative grooving; the disc on the forehead is
particularly interesting, bearing the unusual motif of
a bird, the wings of which end in snakes — the same
decoration appears on the ivory gongs of Benin.
Jebba Gungu on the middle Niger. Bronze, 92.5 cm.
Federal Department of Antiquities, Lagos, Nigeria.

J 10
Statue with bulbous hairstyle. Esie. Steatite, 70 cm.
House of Images, Esie, Nigeria.

J 11
Decorated shell with leopard.
Igbo-Ukwu near Akwa,
9th century. Excavator:
Thurstan Shaw.
Bronze, 19 cm.
Federal Department of
Antiquities, Lagos, Nigeria.

J 12
Head of a hippopotamus.
10th—13th centuries. From the
new excavations led by Prof.
Ekpo Eyo in Lafogido in Ife.
Terracotta, 12.5 cm.
Federal Department of
Antiquities, Lagos, Nigeria.

J 13
Memorial head of an Oni of
Ife, with diadem.
Ife, 10th—13th centuries.
Bronze, 25 cm.
Federal Department of
Antiquities, Lagos, Nigeria.

J 14
Mask of Obalufon II,
Oni of Ife.
Ife, 10th—13th centuries.
Bronze, 32.5 cm.
Federal Department of
Antiquities, Lagos, Nigeria.

J 15
Negroid head. Ife.
Terracotta, 21 cm.
Federal Department of
Antiquities, Lagos, Nigeria.

J 16
Head of a queen with the
characteristic layered diadem.
Ife, Iwinrin grove.
Terracotta, 20 cm.
Federal Department of
Antiquities, Lagos, Nigeria.

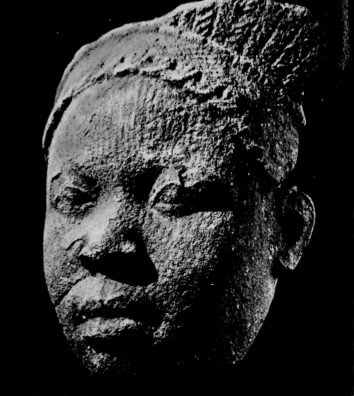

K Benin

Benin, the ancient kingdom in the forests of Southern Nigeria, just over a hundred miles south-east of Ife, has also become a by-word for African courtly splendour and for the magnificence and power of the sacral kingship.

We hear of it in the accounts of early European travellers who came to Benin in the course of trade. The first were J. A. d'Alveiro in 1485, Nyendael in 1702, and between 1769 and 1792 Landolphe and others. In 1668 a Dutchman by the name of Dapper published a detailed description of Benin. The accounts are full of astonishment at the splendid city and the magnificent procession of the god-king. Amongst the visible and tangible monuments which make Benin so famous are almost two thousand bronzes, together with works in ivory and wood, which were brought to Europe following a British punitive expedition in 1897, and created a great sensation. No wonder! Who at that time would have supposed that Black Africa was capable of such outstanding castings in bronze? Ife was still unknown. Who could the artists, the authors of the bronzes have been? There was no question of their being Europeans, because the Portuguese explorers had already found works in bronze in the fifteenth century, that is, long before the European presence in Africa.

Fortunately one of the Bini himself, chief Egharevba, wrote down part of the history of his people and its customs. We learn from him that the history of Benin begins with the mythical Ogiso dynasty, the origin of which is lost in the forgotten past. The present dynasty, which down to the present day counts thirty-seven kings or Obas, comes from Ife, for from the year 1300 Benin was a dependency of the sacred city. If an Oba died, his head was sent to Ife for burial, and in its place a bronze memorial head was brought back from Ife. About 1400 the sixth king, Oguola, sought in the sacred city of Ife a master who could teach the art of bronze casting to the Bini. The Oni sent his own son, Igue-igha; and to this day Igue-igha is venerated as a divine hero and celebrated at his own altar, a shrine with terracotta heads, on which the guild of metal founders offer their sacrifices.

There are two kings from the early period of Benin who are described as outstanding personalities: Ewuare the Great, who ruled from 1440 to 1473, and had the reputation of being a skilled magician and healer, a brave warrior and a wise man; and the Oba Esigie, who lived in the first half of the sixteenth century and commissioned the beautiful heads of queens.

At that time almost two hundred settlements were ruled by Benin. Its power extended to Dahomey in the west and Port Harcourt in the east, and made itself felt as far as Cameroon. Then the Portuguese arrived in the country and the first trade connections were set up. The Oba was a man who was to be taken seriously; thus it was natural that envoys should be exchanged between Portugal and Benin. The Oba was an absolute monarch; he ruled over a splendidly organized state with ministers, officials and a faultlessly functioning police. Indeed he had the reputation of being able to put into the field in twenty-four hours an army of 100,000 men. Dapper records that Benin was a gigantic city with a wall ten feet high. The royal palace was crossed by thirty broad streets with well-built houses. In the low, spacious dwellings with long covered courts there were smoothly polished walls of mud, like marble, and columns of wooden pillars. The pillars were covered with

K 1
Head. Bronze workshops on the lower Niger, but found in Benin City.
16th/17th centuries.
Fine cast bronze, 1—2.5 mm thick. 26.2 cm.
Coll. George Ortiz, Geneva.

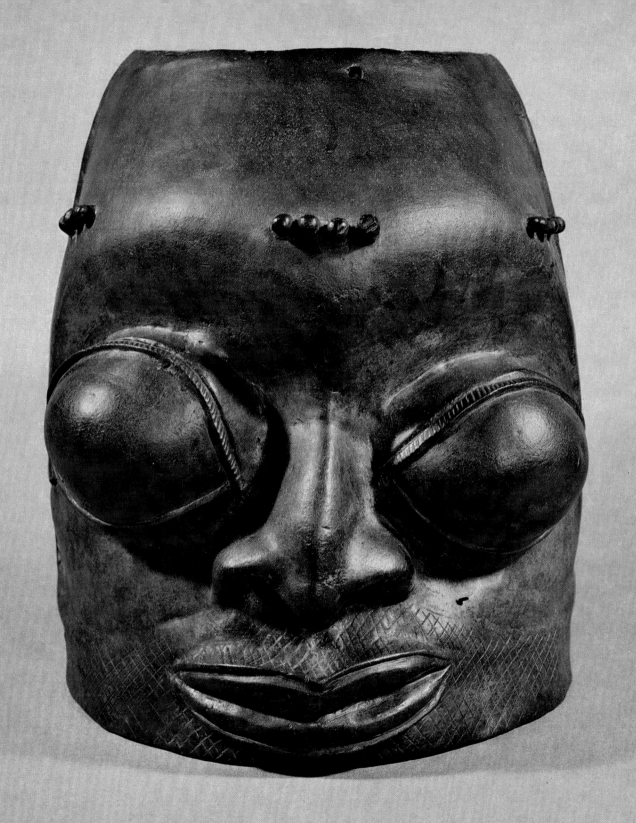

shining plates of brass which glorified the king's victories. The portals were decorated with copper snakes with hanging heads.

Landolphe writes of the cults and festivals which he was allowed to attend, and with horror of the human sacrifices which were offered at the burial of the king. Every year there took place a religious ceremony, celebrated with sacrifices, in honour of the royal ancestors and the king's own head, which was identified with the prosperity of the whole country. At another ceremony the king's coral beads were consecrated, so that they could bestow new magical power. Life at the court was regulated by numerous conventions and laws determined by a complicated system of titles and ranks.

A strange practice required that the king should never look on the face of his mother Jyoba, who had a high position at the court, or speak to her directly. He had to converse with her by a messenger. The queen mother and her retinue lived in another part of the city.

Under the oba Eresonye Benin flourished once again in the eighteenth century. Eresonye is said to have introduced many improvements and innovations into the art of bronze casting; we are also told that brass came down from heaven and brought great prosperity. At the end of the nineteenth century the splendour of Benin began to decline: in 1897 the British fell upon a kingdom which was in decay.

The king of Benin reserved to himself the monopoly of bronze, ivory and coral beads. The monopoly of trade also lay in his hands and brought him great riches.

The artists and craftsmen — the bronze founders, the carvers of ivory and wood, and those who had charge of the decorated walls and the head ornaments — were united in guilds and lived in special parts of the city or the palace. Ten chiefs of the bronze founders were responsible for seeing that the objects for the altar were properly produced. This must be why there are virtually no defective castings from the period when Benin was flourishing. Not until the nineteenth century did the quality begin to decline. The castings of the pre-Portuguese period consist of 78 % copper, 5 % lead and 14 % zinc, so that like those of Ife they are not bronzes in the strict sense. Bronze made of copper and tin became known through the Portuguese.

As far as the technique is concerned, it was adopted from Ife. But the form of the bronzes arose solely from the artist's own feeling for style, and is strongly stylized and sometimes rather stereotyped. William Fagg, the great connoisseur of Nigerian art, has attempted to place the works of Benin in date order on the basis of a few certain dates, tradition and comparisons. He distinguishes three main periods:
— the early period: from 1400 (or possibly earlier) to the end of the sixteenth century.
— the classical or great period: the end of the sixteenth century to the middle of the eighteenth century.
— the late period: the second half of the eighteenth century and nineteenth century.

In the early period the bronzes were very thin-walled, only 1—3 mm. thick; they are the most beautiful bronze figures and heads, executed with marvellous delicate feeling and modelled very closely on nature. The kings' heads have a narrow collar of beads. At the end of this period — when the first Portuguese arrived — the beautiful ivory masks were produced.

The classical period, when Benin was at its greatest, clearly concentrates on

K 2
Mask as ceremonial dress of the king. Benin, early 16th century. Ivory, 20 cm. Katherine White Reswick Collection, Los Angeles.

K 3
Double gong that was struck with an ivory staff. One side shows the *Oba Oseñ* with catfish legs, beneath him a bird with outspread wings that end in snakes. On the other side is a king wearing a snake belt with two companions, and below them a mask with spiral decoration. Two little figures sit on the upper edge. Benin, 16th century. Ivory, 36 cm. Coll. A. Schwarz, Amsterdam.

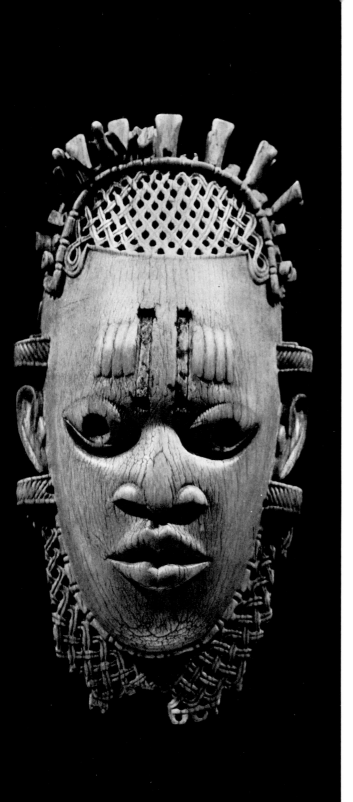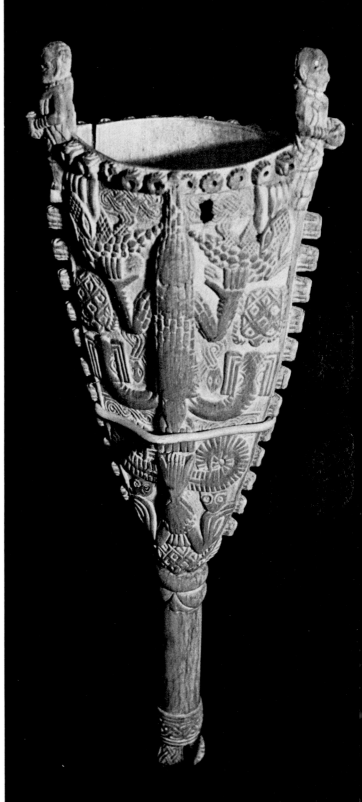

monumentality and the effective representation of the monarchy.

Its characteristics are as follows. The figures are solemn and unemotional. The memorial heads have high collars of beads, extending up over the chin. At first they had no plinth, that is, no kind of pedestal. Towards the end of the classical period plinths adorned with symbols were introduced, and these later became the rule. The faces are formalized with large, wide open 'key-hole' eyes which are not dissimilar to Coptic painting. The lips and nose are broad, and there are scars on the forehead in the form of small three-dimensional knots or small inlaid pieces of iron sheet. The head of the full length figures is exaggerated in size, while the legs, decorated with ornamental bands, are short. The seventeenth century is the period of the bronze plaques. They are always cast without defect. The background is mostly filled with a pattern of rosettes and symbolic animals, from which the figure stands out in more or less high relief.

Since the Portuguese period the bronzes became thicker, almost 6mm. thick: through the growth of trade, the metal was much easier to come by.

In the late period a gradual decline of artistic and technical quality can be discerned. Exuberance of ornamentation, formalization, inflexibility and careless casting increased. Nevertheless, even in the nineteenth century there were still impressive achievements, such as the majestic memorial heads with decorative bead wings at the side, which are typical of the reign of Osemwenede (1816–1848), as well as many impressive pieces in ivory or bronze.

In their abundance the bronzes are records of the utmost interest. They bear witness to the great power of the divine king and give an insight into the life of a court with an advanced culture, where every Oba strove to create a memorial to himself and to practise the cult of the royal ancestors still more intensely. Thus on the plaques and in the groups of figures the most impressive figure is always the monarch himself, in an hieratic attitude, in full regalia with a robe and cap of beads, or armed for battle. A large jewel and two crossed ropes of beads adorn his breast. At his belt the king wears small masks. In his hand he holds emblems such as the stone axe, the staff with a rattle or a sword. On the plaques he is also portrayed with companions, e. g. with chiefs, the sacrificial priest or the throne follower who supports his arms. An Oba with catfish-legs, as he appears on the ivory gong reproduced here, is meant to represent the god of the sea and river, *Olokun,* who guarantees riches. According to tradition this portrays the crippled Oba Oheñ (first half of the fourteenth century) who made the people and nobles believe that he was possessed by the god *Olokun.* The features of the Obas are not reproduced as individual portraits, but as stereotyped ruler symbols. From the sixteenth century on they were scarcely altered. The queen mother is also shown adorned in beads: in her case, a lattice-like pointed bonnet of beads covers the high, peaked and curved coiffure.

The almost life-sized bronze heads were made as a memorial to dead kings and queen mothers. They stand on the altars. For each ancestor of the king there was a special altar, on which stood several heads, but also full length sculptures and bells, bronze axes, rattle staffs and other ritual objects.

Since the 'classical period' the bronze heads have been dominated by huge elephant tusks carved in relief, which were set in holes in the vertex. Beside the king the dignitaries of the court and their retinue were represented: warrior

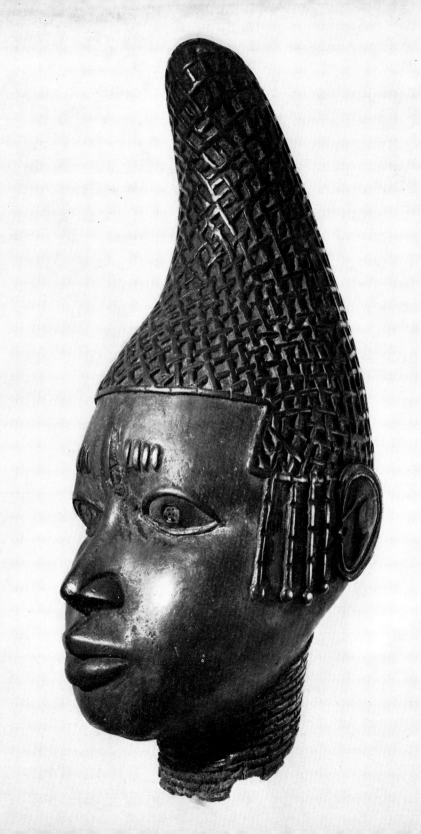

princes in armour and helmet, with spear and shield, or in a garment of feathers with all kinds of emblems of rank, such as a necklace of leopard's teeth, bestowed upon him by the Oba. Small masks of animals or human faces, with little bells, dangled from the belt.

On the bronze plaques are representations of the hunter, who is admired and honoured for his courage. He hunts the leopard, the royal animal. Musicians appear with drums, horns, rattles or the sacred sistrum, in order to drive away spirits. Members of the retinue carry boxes for kola nuts.

The Portuguese of the seventeenth century are shown in solemn courtly style; they wear heavy clothes and helmets and have long hair, beards and moustaches. The weapons they carry are halberds, long swords and the crossbow. In the portraits of the Portuguese the size of the head is also exaggerated.

There were visits by chiefs on horseback from the northern districts. The royal messenger presents an imposing appearance, a hat upon his head and a cross upon his breast; he went to Ife to ratify the monarchy.

Apart from static ceremonial reliefs, there are also reliefs in narrative form, sometimes with turbulent scenes containing many figures.

Garments and other materials are carefully structured, and are clearly distinguished from the smoothed curves of the body. The different size of various figures does not correspond to reality, but to the hierarchy of rank at the court. There are numerous animals, both in three-dimensional sculpture and as reliefs on plaques. They occur, for example, as beautiful ewers, ceremonial water pots in the form of a leopard or a ram. The vessel is filled with water through a hole in the head, and the lid is attached with a hinge. The water, which is poured over the king's hands at ceremonial washings, comes out through the nostrils.

On the roof of the palace birds were set up on top of snakes. On the queen mother's altar stood the figure of a mighty cock, and cocks were sacrificed on it. A bird like an ibis tops the rattle staff, while leopards are royal animals; and horses, crocodiles, fish, chameleons etc. also have a symbolic character.

In addition to the memorial heads which symbolize the god-king's authority to give judgement, the Oba also set up the 'altar of the hand', the king's hand as a symbol of the exercise of power. It is made of wood or bronze, and adorned with various symbols. The worship and sacrifices at this altar of the hand were primarily offered by warriors and nobles.

Thrones, chests and cultic pedestals, bells, gongs, ceremonial staffs and axes were also made of bronze. Small masks in human or animal form, hanging as signs of rank from the belt, and many other ornaments, have been preserved in large numbers. Elephant trunks, ending in a hand holding a trefoil, cowrie shells, *Ofoe* the god of death in the form of a head on feet etc. all have symbolic significance. The twisted band is also found.

Besides the bronzes mentioned, which are meant to give prestige to the god-king, there are some heads and masks which are meant for the cult of gods, and possibly also for Osun, the impersonal god of medicine and the life force. These cult heads are particularly imaginative and associated with all kinds of symbols, with birds and frogs which crawl over the head and snakes which creep out of the nostrils.

Works of art of great perfection were also produced by the *Igbe-Samwan* ivory carvers: sensitive ivory masks from the early Portuguese period, large elephant

K 5
Memorial head of a queen.
Benin, 1475–1525.
Bronze, thin walled, patinated (1 mm thick), copper inlay on the forehead. 21 cm.
Coll. Peter Schnell, Zurich.

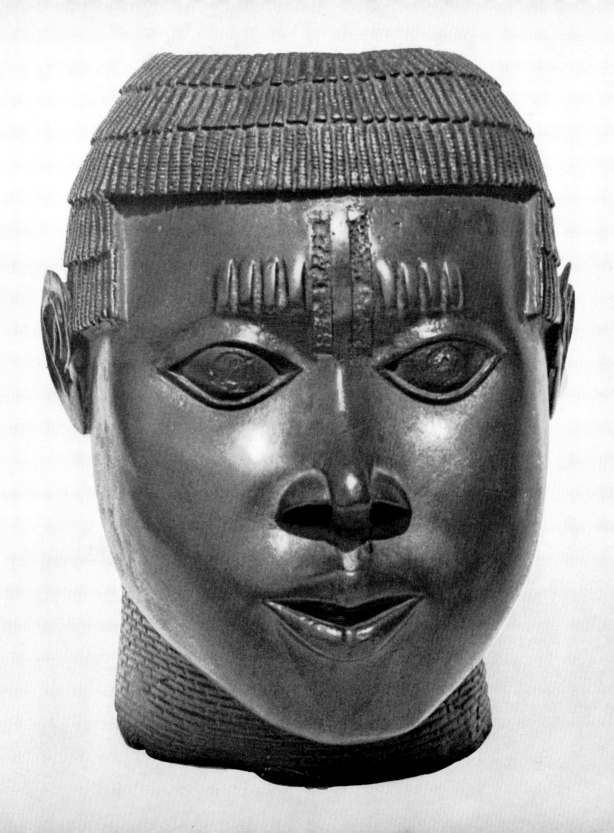

tusks covered with mythological scenes and signs, delicately carved double gongs and broad arm-bands. The arm-bands are worked out of a piece of ivory in such a way that two cylinders, one inside the other, can be moved. On the gong we recognize the image of the Oba Oheñ with catfish-legs, and also a bird whose wings turn into snakes, while on the arm-band there are rams' heads and snails.

Fine goblets and spoons were made of ivory, and also lidded boxes for the royal regalia. There were also signal horns and three-dimensional figures of leopards with inlaid plates of copper, which reproduce the pattern of the skin.

Wood carving of great charm was also produced at the court of Benin. This included lidded boxes in the form of a cow's head, in which kola nuts were kept, or wooden rattle staffs to call up gods and spirits.

Apart from this court art the Bini continue to practise their own tribal art, which was quite different in nature.

Afro-Portuguese ivory

As far as ivory carving is concerned, the Yoruba city of Owo, eighty miles further north, can compete on equal terms with Benin. Owo not only supplied the Oba of Benin with works in the courtly classical style, but also worked for European travellers at the time. For centuries white men have sought and coveted this noble material, and this made possible a tourist art of high quality. The Igbe-Samwan spared no pains in carving complicated goblets, vessels, trumpets, spoons etc. from it. Sometimes they have overdone the decoration and produced objects which are both overloaded and slightly sweetish. It is not always easy to distinguish the ivory carving of Sierra Leone from works produced in Nigeria.

Bronze workshops on the lower Niger

Benin and Ife, the powerful centres of art in bronze in the African past, were not alone. In other areas of Nigeria new discoveries of works in bronze are constantly being made; they show a clear connection with Ife and Benin.

Igbo-Ukwu and the Tsoede bronzes are only two examples. From the region of the lower Niger there are also works in bronze which can be distinguished from the courtly style of Benin, although they could not have been possible without them. Since we do not yet know the centres in which they were produced, William Fagg categorizes them under the heading 'Bronze industry of the lower Niger'. From these workshops there come impressive groups and figures, heads, masks and bells in the shape of heads which, however, are more flexible, more dynamic and less stylized in form than those of Benin. Their characteristics are a bloated face and protruding eyes, sometimes naive or ludicrous, and sometimes again of expressive force, and bold attempts to execute complicated groups of figures as bronze sculptures. A local style which differs from that of Benin is found in Udoh, at one time a neighbouring kingdom of Benin: the delightful head of a girl with ringlets hanging down at the side is an example of this style.

K 6
Relief: warrior prince with two musicians.
Benin, 17th century.
Bronze, 45 cm.
Ethnological collection, Zurich.

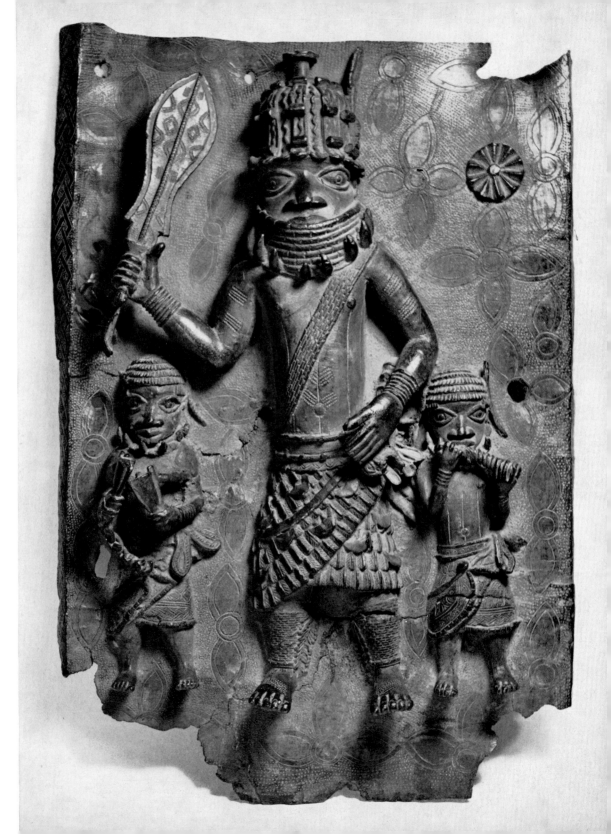

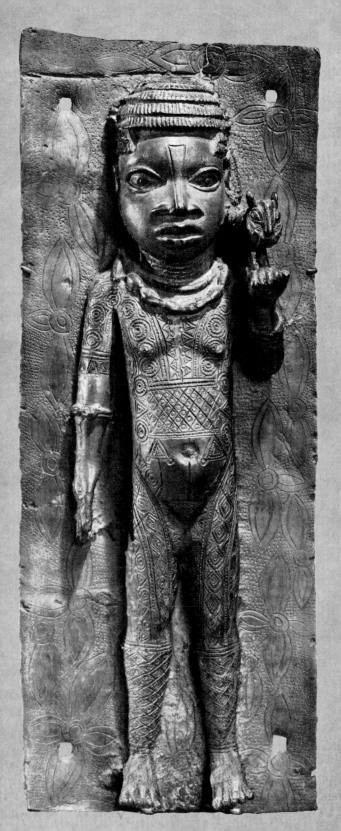

K 7
Plaque with a Bini warrior.
Benin, 16th/17th century.
Bronze, 31 cm.
Coll. A. Schwarz, Amsterdam.

K 8
Plaque of a girl in relief.
Benin, 16th or 17th centuries.
Bronze, 31 cm.
Coll. A. Schwarz, Amsterdam.

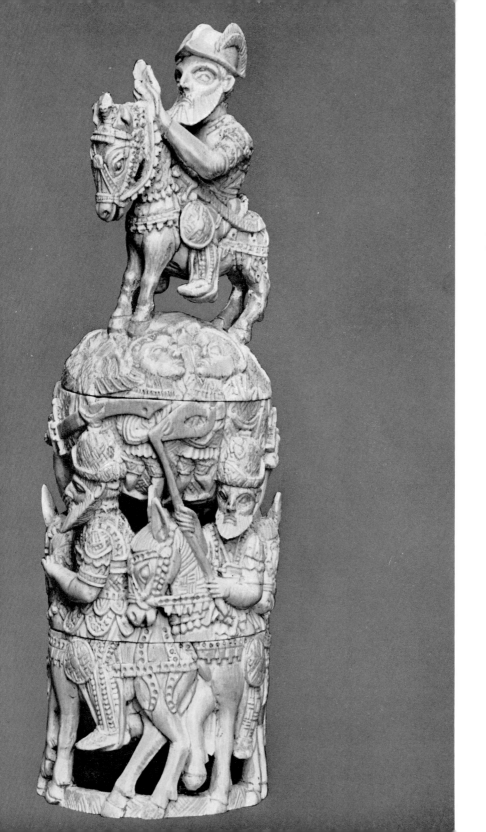

K 9
Richly decorated salt
container with carvings
of horsemen.
Benin, 16th century.
Afro-Portuguese ivory, 27.5 cm.
Danish National Museum,
Ethnographical Department,
Copenhagen.

K 10
Rectangular box with lid
bearing the snake motif.
Benin. Ivory, l. 24.5 cm.
Coll. George Ortiz, Geneva.

K 11
Group: man and woman
between a board game and a
fat four-legged beast with
a fish-bone collar. From the
bronze workshops on the lower
Niger, but found in Benin City.
Bronze, thin walled: 1.6 mm.,
16.3 cm.
Coll. George Ortiz, Geneva.

K 12
Man with hat, rich attire and cross on his chest,
probably a messenger of the king. Benin.
Bronze, 59 cm.
City of Liverpool Museum, Liverpool.

K 13
Staff with an ibis, harbinger of ill-fortune.
Benin, 17th/18th centuries. Bronze, 31 cm.
Coll. A. Schwarz, Amsterdam.

K 14
Snake's head with open, toothed jaws (part of the
lower jaw broken away). Benin.
Bronze, length 43 cm.
Museum für Völkerkunde, Basel.

K 15
Leopard relief. Benin, 17th century.
Bronze, length 39.2 cm.
Linden-Museum für Völkerkunde, Stuttgart, Germany.

K 16
Relief by the so-called Master of the Leopard Hunt:
the hunter is aiming at the ibis in the tree.
17th century. Bronze, 45.5 cm.
Museum für Völkerkunde, Berlin.

K 17
King's head with wide bead collar.
Benin, late 16th century.
Bronze 4—5 mm thick, copper inlay on the forehead,
23 cm.
Coll. Peter Schnell, Zurich.

K 18
Portuguese soldier relief. Benin, 17th century.
Bronze, 43 cm.
Rijksmuseum voor Volkenkunde, Leiden, Holland.

K 19
Memorial head with bead wings at the sides and a
beautiful plinth. Benin, early 19th century.
Bronze, 41 cm.
Coll. Peter Schnell, Zurich.

K 20
Relief of crocodile with fish in its jaws.
Benin, 17th century. Bronze, 41 cm.
Coll. Peter Schnell, Zurich.

K 21
Mask for wear on a belt. Benin. Bronze, 17.5 cm.
Rietberg Museum, Zurich.

K 12

K 13

K 14

K 15

K 19

K 16

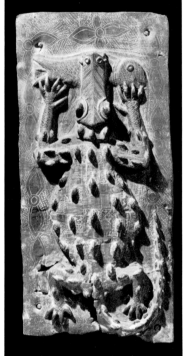

K 20

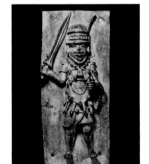

K 17

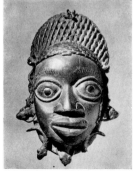

K 18

K 21

K 22
Large elephant's tusk carved in relief with kings,
Portuguese, animals and other symbols.
Benin, 19th century. Ivory, 169 cm.
Coll. Edith Hafter, Zurich.

K 23
Bracelet in the form of two interlocking cylinders
with openwork. Benin, in the style of Owo: rams'
heads, fabulous beasts, snails, etc.
Carved from one piece of ivory, 17 cm.
City of Liverpool Museum, Liverpool.

K 24
Horseman on a visit from the North, with large
decorative feathers, armour and bridle.
Benin, middle period. Bronze, 56 cm.
The head is in the possession of the British Museum,
London, and the torso in the Ethnological Collection,
Zurich.

K 25
Ewer in the shape of a leopard.
Benin, middle period. Bronze, length 42 cm.
Coll. Charles Ratton, Paris.

K 26
Kneeling woman with a vessel, probably for the
Oronmila (Ifa) cult. Made in Owo for use in Benin.
Ivory, 18.5 cm.
British Museum, London.

K 27
Bell in the shape of a head. Bronze workshops on the
lower Niger, 16th/17th centuries. Bronze, 16.2 cm.
Coll. George Ortiz, Geneva.

K 28
Semi-spherical head, open at the top of the skull,
with Bini tribal cicatrices. Bronze workshops on the
lower Niger, 15th/16th centuries.
Thinly cast bronze: 0.5—2 mm, 14.5 cm.
Coll. George Ortiz, Geneva.

K 29
Head with plaits at the side. Udo. Bronze, 25 cm.
Coll. A. Schwarz, Amsterdam.

K 30
Box in the shape of a mud-fish with wide, open
mouth. 15th century.
Ivory, eyes encrusted with lead, abt. 17 cm. long.
Coll. George.Ortiz, Zurich.

K 22

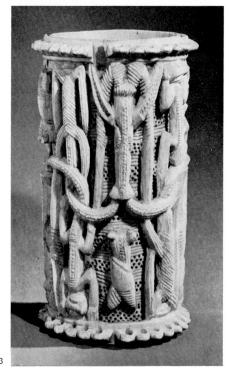

K 23

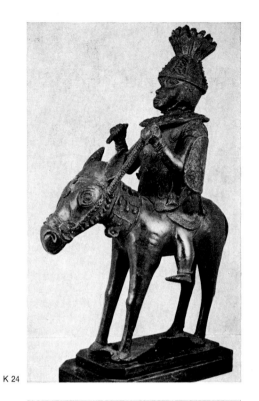

K 24

K 27

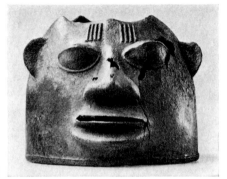

K 28

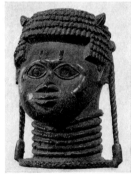

K 25

K 29

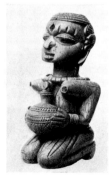

K 26

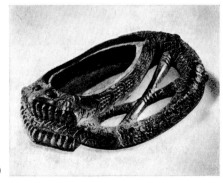

K 30

L The Yoruba in the recent period

The Yoruba of south-western Nigeria and parts of Dahomey and Togo are twelve million in number, and are the largest tribe in West Africa. They were originally peasant farmers, but for the most part have settled in city states, of which Oyo and Ife are the most powerful: Ife in the southern forest country, where the sacred priest-king resides and guards the precious treasure of the glorious past; and Oyo in the northern savannah country. At the turn of the seventeenth century Oyo was a kingdom feared over a wide area, and at times Ife, Benin and Dahomey paid tribute to it. Every province has its Oba and every village its chief; and everywhere the powerful *Ogboni* society, to which the older notables of the tribe belong, dominates as a source of political and social authority and as a counterbalance to the power of the king and priest. The *Ogboni* society appoints certain officials and conducts secret courts, and its power is still effective at the present day. Its members keep certain ritual objects hidden and call upon the power of the earth spirits. The *Ogboni* society was formerly supervized by the smiths, and is therefore of very ancient origin.

Although most of them have received Christian baptism, the Yoruba still feel today that they have a tie with their high god *Olorun (Olodumara)* and the long venerated *Orishas*. The *Orishas* are spirits, messengers of the mighty *Olorun,* and the mediators of certain powers which man needs or fears. They are originally natural phenomena or divinized mythical kings.

The most important *Orishas* are: first *Shango,* the immensely dynamic spirit of thunder and lightning, the mythical founder of the tribe, a tyrant and brave warrior; *Obatala,* a heavenly rider, the god of growth and creation, of purity and compassion; *Oduduwa,* the wife of *Obatala,* and the earth goddess, sometimes symbolized by the nursing mother; *Oduduwa* can also be the legendary hero and founder of the state of Ife; *Oshun* and *Oyo,* river goddesses; *Olokun,* the god of the sea; *Eshu, Elegbara* or *Erinle,* the uncertainty principle, the divine trickster; *Ifa,* the personification of divine wisdom and omnipotence and of eternal, cosmic order; *Ogun* or *Osanyin,* life force in the form of 'powerful medicine', the god of iron and war, the patron of hunters, craftsmen and carvers; *Ibeji,* the god of twins.

There is an *Orisha* for every occasion: against war; against illness — for every family, every individual, every society. And a shrine with its priest is dedicated to every *Orisha,* and to everyone a feast is devoted at regular intervals, with invocations, sacrifices and oracles. Besides this the gods of the secret societies, *Gelede, Epa, Egungun,* and many others, are also active forces.

The carvers and metal founders have adapted themselves to these religious and secular requirements. The art for the royal court is predominantly secular and decorative. Doors and the pillars of verandahs are adorned with figures and reliefs. The secret societies require masks and costumes; the temples and shrines need various kinds of ceremonial objects. The gods and *Orishas* are usually not represented in personal form, but through their attributes. An exception to this is *Eshu,* who appears with a pointed cap and a flute. The worshipper approaches *Shango,* the god of thunder, through the mediation of a female figure which is combined with a double-headed stone axe; this is the axe of lightning, which *Shango* hurls at the earth during

L 1
Mask of the *Gelede* society
Yoruba of Dahomey.
Wood, multicoloured, 27 cm
Private collection, Geneva.

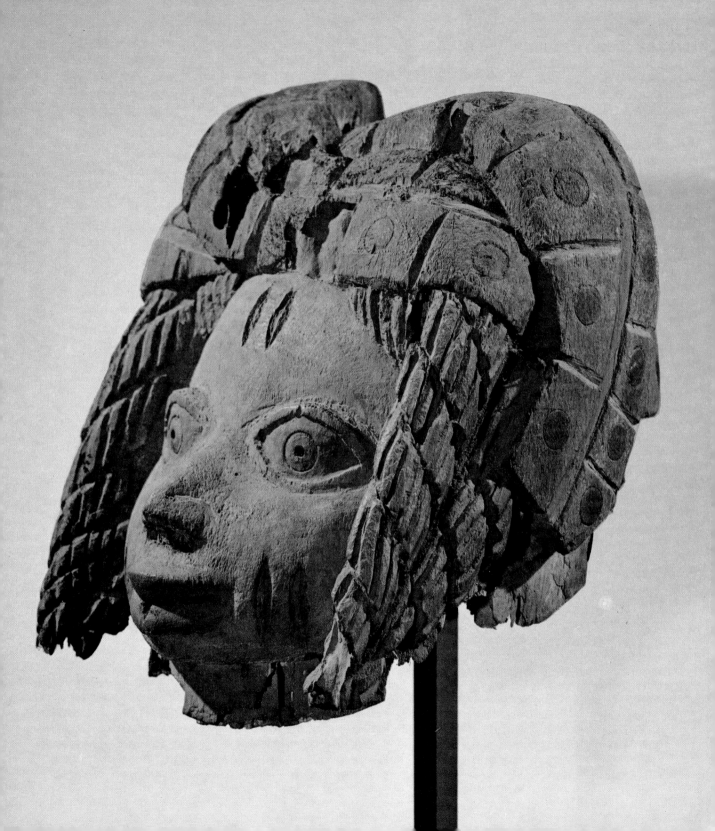

a thunderstorm. When the carved staff has poured over it the blood of the sacrificed ram, the symbolic animal of *Shango,* it can work miracles. The sacrificial staff of the river god *Oshun* bears the mounted figure of the warrior Jagun-Jagun. The small *Ibeji* figures are found throughout the country. *Ibeji* is the god of twins, who is invoked when a twin dies in childhood. For twins have only one soul between them; and the part of the soul of the dead twin wanders around without rest until he is found a dwelling place in the form of the tiny figures. In former times twins had to die because they were regarded as bringing misfortune; nowadays the mother buys a pair of *Ibeji* figures, and lies one in a calabash and cherishes and cares for the other like the living child. It is always fed, clothed, bathed and adorned at the same time as the other. Sometimes a family can continue this practice for a hundred years, in order to avert any visitation.

Certain carvings are reserved for the priest of the *Ifa* oracle, such as the oracle board bearing the face of *Eshu* (who is the cheerful opponent of *Ifa,* who loves order); the *iroke* ivory bell, carved with representational figures, for invoking the *Orisha;* the decorated bowl for keeping palm nuts and tiny bone figures as 'guards'. The *Ifa* priest strews the oracle board with flour, throws the palm nuts on to them, draws curves and interprets the gods' decision from them. He carries the *orere,* an iron rattle staff with two birds set one upon another, which serves as a sistrum, a rattle to drive away evil spirits.

The iron stands, rather like altars, and known as *asen,* are used for the cult of different *Orishas.* Their points are stuck into the earth, and they contain eggs and kola nuts as sacrifices. On the *asen* of *Osanyin,* the principle of life force, sit sixteen birds in a circle. These refer to a legend in which the creator god *Oduduwa* sent *Obatala* and *Orunmile* to the earth when it was still water and chaos, and commanded them to plough up the bottom of the sea with sixteen chickens and create the world.

The secret societies of the different regions each have their characteristic kind of mask:

The *Gelede* men's secret society in south-western Yorubaland and neighbouring Dahomey sends its masks once a year into every village, at the festival of growth, at which fertility is sought and evil driven away. Dressed as women, the men of the *Gelede* society ask for the fruitfulness of their women. In Dahomey the face mask is completed by a body mask of delicate form. Garish fabrics complete the costume. The masks are worn on the head, so that the size of the *Gelede* spirit as it appears is exaggerated.

Its characteristics are an extreme protrusion of the jaw, large open eyes with holes marking the pupils, typical Yoruba lips with the corners of the mouth cut off vertically at the sides and a friendly expression; a superstructure in which the carver exercises his imagination by combining the symbols with scenes representing anecdotes from daily life. In Dahomey snakes are added as decorative bands which refers to a particular snake cult.

The *Gelede* spirits always dance in identical pairs and carry out vigorous flapping and rocking movements in a complicated sequence of figures. In the dance the dancer believes he is possessed by the *Orisha Gelede.*

The *Egungun* society in south-eastern Abeokuta obtains contact with the dead: during the ceremony the spirit of a dead person takes possession of the masked dancer. Through the medium of the mask he comforts those left behind and reveals

L 2
Painted body mask.
Yoruba of Dahomey.
Wood, 83 cm.
Coll. Comte Baudouin de Grunne, Président des Amis du Musée de Tervuren, Wezembeek-Oppem, Belgium.

L 3
Torso with tattoos and wide collar, the eyes open.
Yoruba, Nigeria. Wood, 48 cm.
Coll. J. Kerchache, Paris.

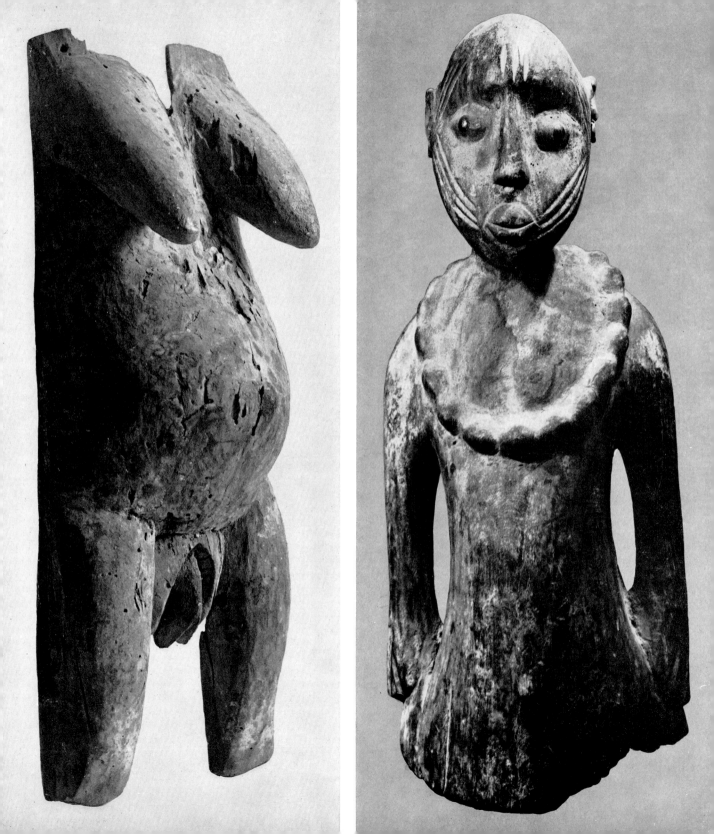

his will to them. The *Egungun* masks can be recognized by their large hare's ears and a motif resembling an hourglass. The circlet of medicine horns points to the power of the magic medicine of the great spirit.

The masks of the *Epa* society of north-eastern Yorubaland (from the Ekiti and Igbomina sub-tribes) are also meant to represent the spirits of the dead. They are strikingly large masks. Above an abstract, stereotyped and often Janus-headed face with large protruding eyes are set figures in a realistic rounded style, painted in bright colours. Every great carver has displayed his talent and imagination in these masks. The *Epa* masks are sometimes six feet high, and can weigh as much as 140lb. The dancer has to balance these heavy images on his head in the course of vigorous leaps and turns. If he drops it, he is severely punished.

In spite of the multitude of themes and forms of the carver's art, it must be affirmed that the style of carving has maintained an astonishingly unified character down the centuries, so that a Yoruba work can usually be easily recognized as such.

Its characteristics are a naturalistic human round style, a heavy head with a massive coiffure, horizontal full lips cut off vertically at the sides, large bulbous eyes with pupils, the eyelashes and eyebrows marked in, a fleshy nose, scar marks, sometimes visible rows of teeth, a prognathous jaw, heavy hanging breasts, and garish colouring.

Not content with previous inquiries, British and Nigerian scholars have further investigated the origin, sources and names of the Yoruba artists and their schools. Thus William Fagg has already been able to identify more than a hundred Yoruba artists with their specific style of carving, and states that there are

thousands more. The great masters are distinguished by their power and imagination, but it is rather more difficult to identify with certainty the work of lesser artists. In localizing a sub-style one should pay special attention, for example, to the way the ears are drawn. Important centres of carving are to be found in the Ekiti province in the north-east (Efon-Alaye style), round Abeokuta in the south-west, round Ondo and in the Oshogbo region in central Yorubaland, and round Ketu across the border in Dahomey.

Odo-Owa in northern Ekiti is proud of the famous Bamgboye, who created the boldest *Epa* masks. The masters Fakaye of Illa and his sons, and also Agbonbiofe and Ologunde of Efon have produced work of unmistakable characteristics. Amongst their work are many of the impressive posts carved with figures at the palace in Efon-Alaye. The imaginative Olowe worked for the king of Ise in southern Ekiti. In Abeokuta, where the main product was *Gelede* masks, one of the great names is that of Adugbologe, who died about 1940.

The cult objects of the *Ogboni* society occupy a special position. They are not masks or ancestor figures, but the large wooden *agba* drums and smaller statuettes, objects and ornaments of brass. So far as one can work out from the secrets of the society, they are related to the cult of the earth spirit *Onile*. It is possible that the relief figure with the catfish-legs on the *agba* drums represents this *Onile*. When the *agba* drum sounds to call the members of the society together everyone is seized with terror, because the call always means that a sentence of death is to be passed, usually as a punishment for the betrayal of the secrets of the society. The blood of the sacrifice used to be poured over the drum. At the initiation of a member of

L 4
Ritual club *Oshe shango* serving the god of thunder, *Shango*. Yoruba, Oyo region. Early 19th century. Wood, 48 cm. Rietberg Museum, Zurich.

L 5
Mother with child, a double axe on her head. Religious figure from a *Shango* temple in Ogbomosho. North Yoruba. Painted wood, 72.5 cm. The Museum of Primitive Art, New York.

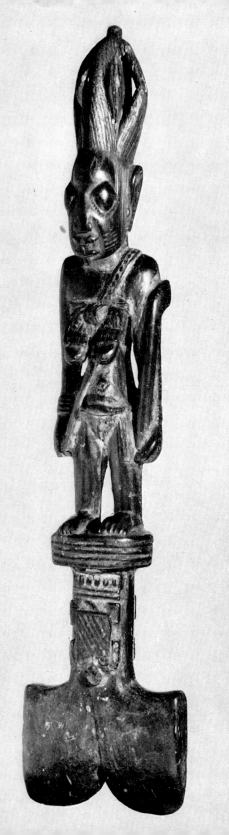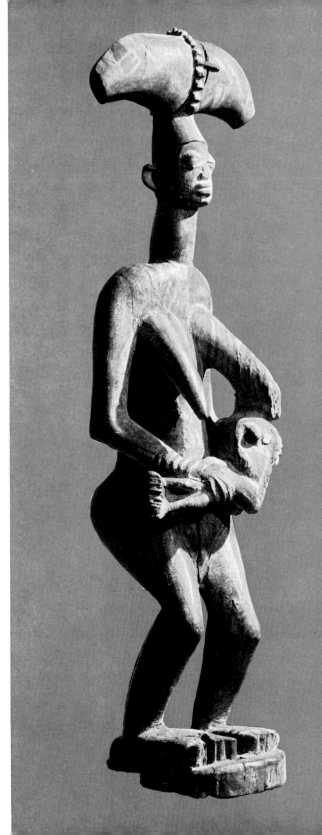

the Ogboni society the high priest laid an *edan* in his hand with an injunction to keep silence. The *edan* is a pair of figures in brass on an iron staff, which are joined together by chains: they are perhaps *Ogboni* and his wife *Erolu.* The large *edan* always remain hidden in the shrine, stuck into the earth or laid on the ground; smaller ones — e. g. pairs of heads with chains — are used as messenger staffs and give protection against the activities of witches.

In the *Ogboni* sanctuary there is also a larger figure of brass with protruding eyes and a horn-like hair-style. Its hands form the *Ogboni* greeting. Morton Williams investigated its secrets and learned that it was *Ajagbo,* a terrible Alafin of Oyo who became a revenging spirit and is invoked by the *Ogboni* society when a divine sentence of death has to be passed. *Ajagbo* is also identified with *Onile,* the earth spirit.

The style of works in metal and ivory is very different from the style of carving in the Yoruba country. This phenomenon is no doubt to be explained by its completely different function.

In many places decorative headdresses covered with brightly coloured glass beads are worn in dances. They are reminiscent of the crowns of beads which the god-king wore as a sign of the authority bestowed by the god Oduduwa.

L 6
Mother and child with companions, possibly the earth and mother goddess Odudua. Yoruba. Wood, 67.5 cm. Afrika-Museum, Berg en Dal, Holland.

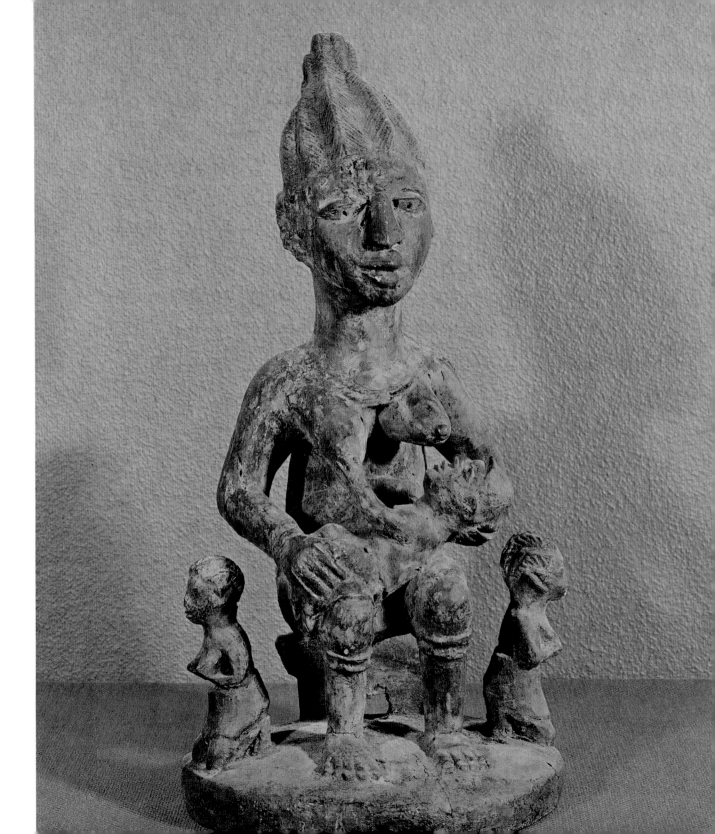

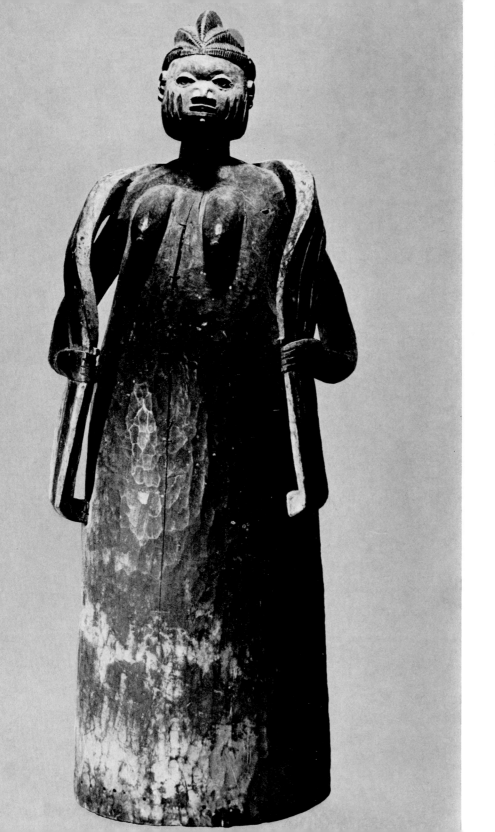

L 7
Gelede figure as fertility
statue. Yoruba of Dahomey.
Painted wood, 124 cm.
Coll. Mr and Mrs Arthur
Grunewald, Tucson, Arizona.

L 8
Piece of furniture from the
grave of a *Shango* priest;
excavated 1910—12 by Leo
Frobenius in Modeke.
Yoruba. Wood, 38 cm.
Museum Folkwang, Essen,
Germany.

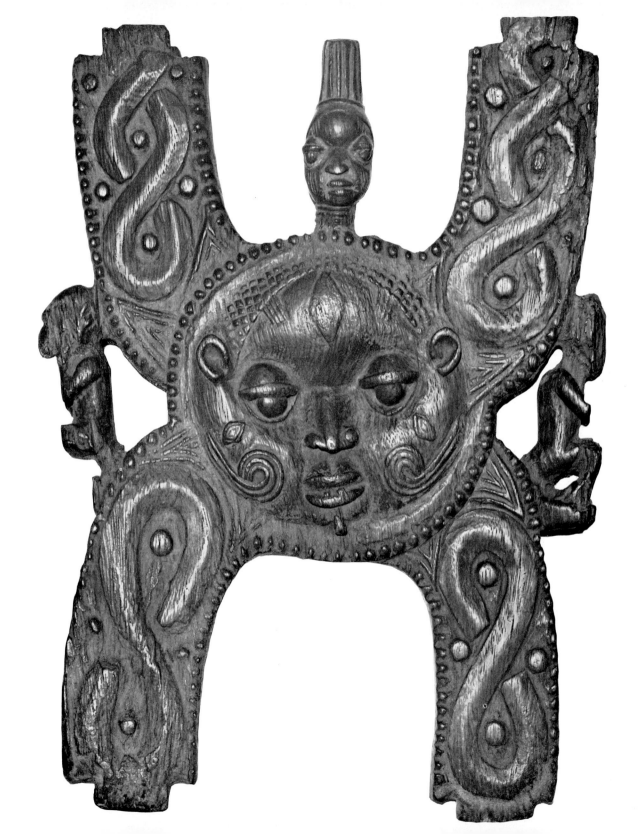

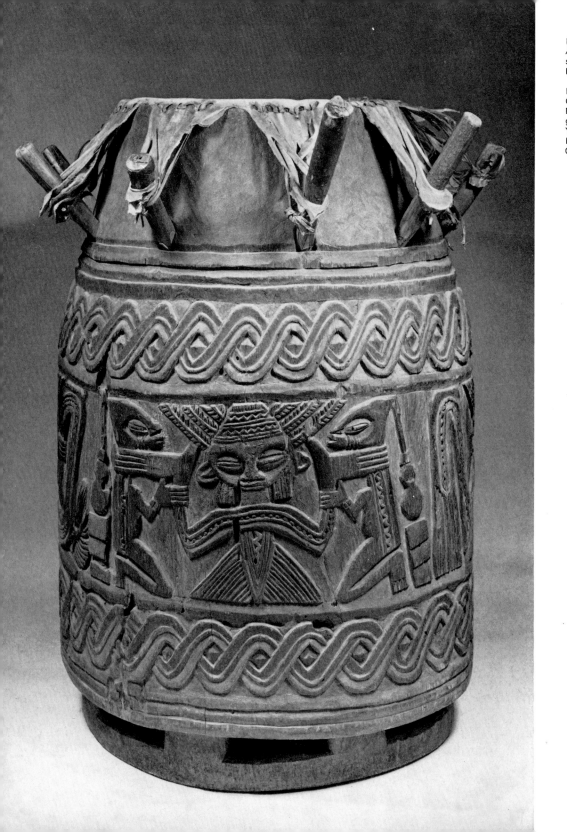

L 9
Agba drum for the *Ogboni,*
society. Yoruba. Wood, 87 cm.
Ethnological collection, Zurich.

L 10
Group of riders. Made in
Nigeria and brought as a
gift to the king of Ketu.
Yoruba, 17th century.
Painted wood, 37 cm.
Coll. M et Mme Bellier, Paris.

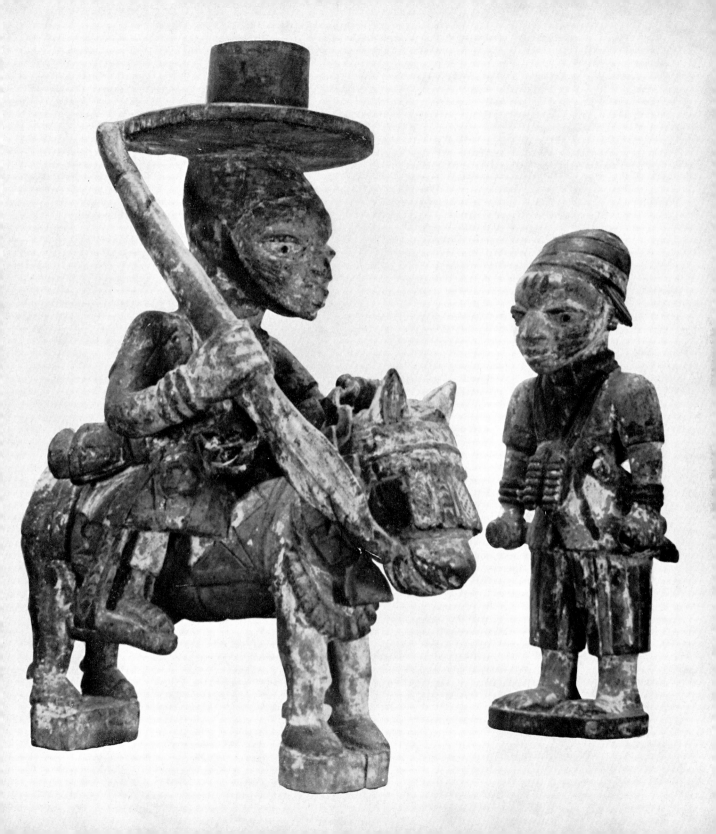

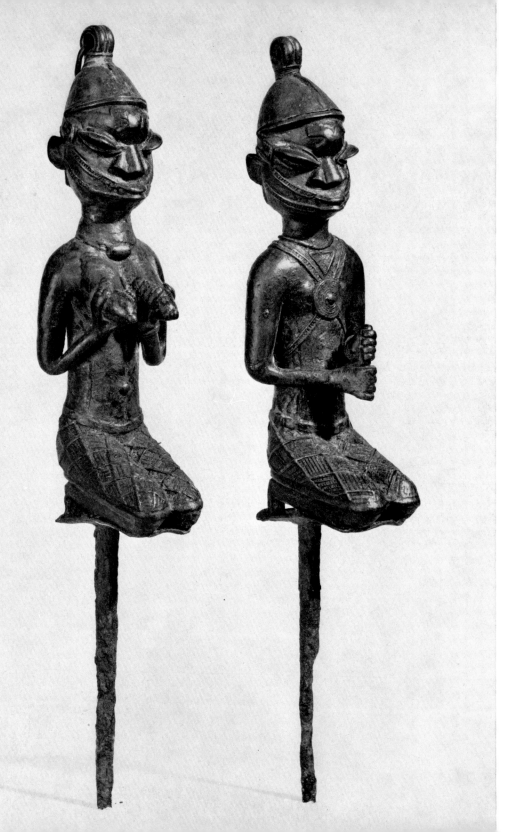

L 11
Edan: kneeling couple; the
man with the *Ogboni* hand
position. Yoruba. Brass, 19.5 cm.
Coll. Dr. Theo Dobbelmann,
Amsterdam.

L 12
Epa mask with rider.
Yoruba. Wood, 110 cm.
Federal Department of
Antiquities, Lagos, Nigeria.

L 13
Statue of *Onile,* earth spirit
of the *Ogboni* society. Yoruba.
Brass, 65 cm.
Coll. Ch. W., France.

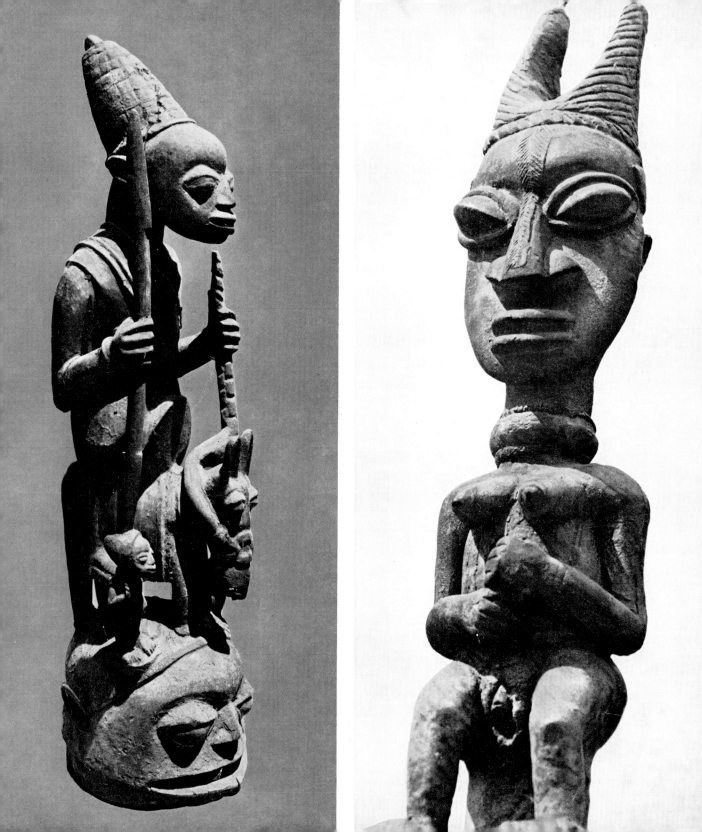

L 14
King's throne with group of figures. Yoruba, Dahomey.
Painted wood.
Private collection, Geneva.

L 15
Oduduwa group with bowl. Yoruba, Nigeria.
Wood, 105 cm.
Coll. Maurice Bonnefoy / D'Arcy Galleries, Geneva.

L 16
Double figure by the carver Fakaye of Illa. Yoruba.
Painted wood, 145 cm.
Federal Department of Antiquities, Lagos, Nigeria.

L 17
Part of a chieftain's portal with a carving of
Oduduwa, goddess of the earth, suckling her child.
Yoruba, Nigeria. Blackened wood, 117.5 cm.
Coll. Maurice Bonnefoy / D'Arcy Galleries, Geneva.

L 18
Door carved in relief in three sections: men,
reptiles and quadrupeds. Yoruba. Wood, 187 cm.
Galerie Hilt, Basel.

L 19
Egungun mask. Yoruba, Abeokuta. Wood, 41 cm.
Private collection.

L 20
Ritual staff, *Oshe shango.* Yoruba, Nigeria.
Wood, 60 cm.
Private collection, Paris.

L 14

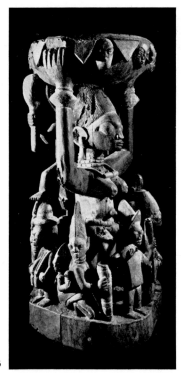

L 15

184

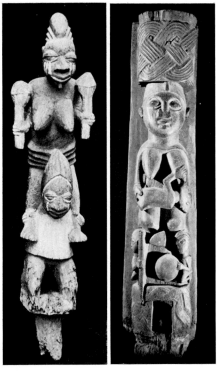

L 16
L 17

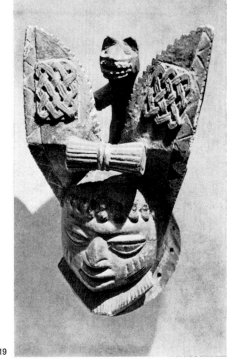
L 19

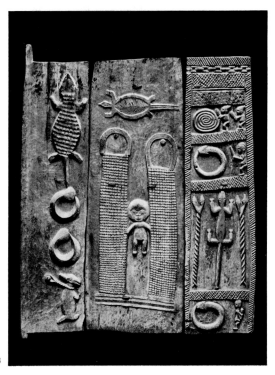
L 18

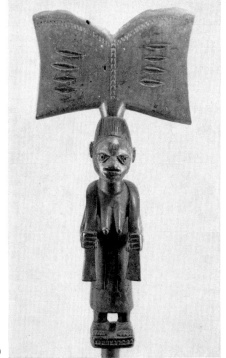
L 20

L 21
Statue of a woman. Yoruba. Wood, 84 cm.
Coll. Hélène Kamer, Paris.

L 22
Dish with kneeling woman for the nuts of the *Ifa*
Oracle. Yoruba. Wood, 23 cm.
Rietberg Museum, Zurich.

L 23
Ifa board with the face of Eshu and other symbols.
Yoruba. Wood, diam. 44.2 cm.
Coll. Peter Schnell, Zurich.

L 24
Ibeji, figure for the twins cult. Yoruba. Oyo style.
Wood, 32 cm.
Rietberg Museum, Zurich.

L 25
Ibeji figure Yoruba, style of Abeokuta.
Wood, 20.5 cm.
Rietberg Museum, Zurich.

L 26
Mask of the *Gelede* society. Yoruba.
Wood and real hair, 30 cm.
Private collection.

L 27
Orere, rattle staff of the *Ifa* priest, with two birds.
Yoruba. Iron, 140 cm.
Federal Department of Antiquities, Lagos, Nigeria.

L 28
Asen, altar for the god *Osanyin*. Yoruba.
Iron, 60 cm.
Coll. Max and Berthe Kofler-Erni, Basel.

L 29
Bracelet of the Ogboni tribe. Yoruba.
Brass, diam. 12 cm.
Coll. George Ortiz, Geneva.

L 30
Group of figures from the *Edan* secret society.
Yoruba. Brass and iron, 29.5 cm.
Coll. Dr. Theo Dobbelmann, Amsterdam.

L 31
Edan pair: double male and female figures joined
with chain. Yoruba. From an excavation. 32 cm.
Coll. Alfred Muller, St Gratien, France.

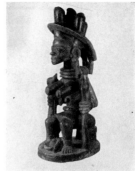

L 21

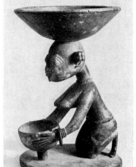

L 22

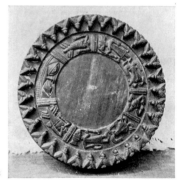

L 23

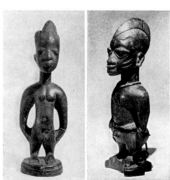

L 24
L 25

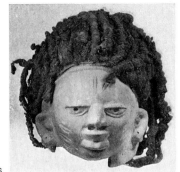

L 26

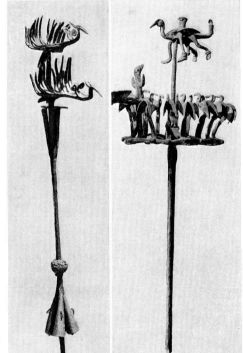

L 27
L 28

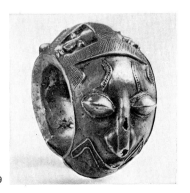

L 29

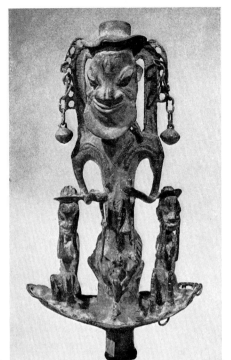

L 30

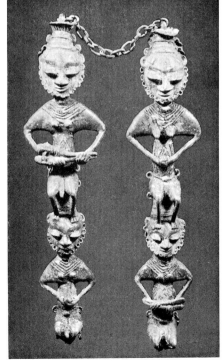

L 31

M The tribal art of the lower Niger

The region of the lower Niger with its forests and swamps and the practice of ancient cults which is still in full force (mask dances, and the invocation of gods and spirits), is a carving region of the first importance. Here a series of distinct styles of carving has been developed, principally amongst the Ijaw and the Ibo, but also amongst the Urhobo and Bini.

The Ijo

Hidden in the jungle of the Niger delta live the Ijo a west African people of ancient Nigritic culture, who were forced into the jungle and mangrove swamps of the Niger delta by tribes advancing from the north. The Ijo were much feared head hunters, who once played a lively part in the slave trade.

Today the Ijo live in huts of palm rib in the marshes, and live by fishing and hunting. Secret societies watch over the social and religious order and keep the ancient practices in force. Every living thing has its protecting spirit. The souls of the dead and the heroes who brought civilization to the tribe, and also the water spirits, demand the utmost respect from all these other spirits. They guide all supernatural activity. In order to make the spirits subject to them, masked processions and libations in the shrines of the ancestors are carried out. Every twenty-five years the *Sekiapu* society of the eastern Ijo (New Calabar) invite the water spirits to the great banquet in order to beseech them for fertility. And they respond to the invitation: stiff, ludicrous faces which, coming out of the sea, glide over the water, crocodiles, hippotami, fish, an uncanny

procession. The masked dancers who represent these spirits wade along up to their mouths in the water of the marshes and carry the wooden masks horizontally upon their heads. Thus the faces of the masks look towards the sky and give the impression that they are swimming on the water.

On the basis of this conception the Ijo have developed a fascinating abstract form, a thoroughly simplified face mask, cubist in concept, with angular and cylindrical shape. Tube-like eyes, nose and mouth protrude from a concave face. The Ijo are well aware that the bleak sternness of the face of the mask produces the most uncanny effect. Animal-like motifs, such as the jaws of the crocodile, horns, or the tortoise which guarantees a long life, allude to magical forces. The children of the water spirit *Sapele* appear as little heads.

The Ijo of the western delta region display just as much fantasy. But it is difficult to say where they received the inspiration for their curious groups of figures: from Benin, perhaps, or from the figureheads of European ships? Who inspired *Ejiri,* the monster on which the head of the family rides with his 'staff' in order to offer a libation to the mighty protecting spirit? Horton emphasizes that the Ijo are not at all concerned about earning approbation from the outside world by producing pretty carvings and imaginative personal creations, as often happens among other tribes. Their concern is a religious one: they are interested only in influencing the spirits through the sculptures. This is the task to which the artist must subject himself.

Other tribes in the Niger delta also display cubist tendencies, and this shows their connection with the Ijo, e. g. the sculptures of the Urhobo (Sobo) and the Bini.

M 1
Large ancestor statue: mother with child. Ibo. Painted wood, 175 cm.
Private collection, Geneva.

M 2
Large ancestor figure. Ibo. Painted wood, 165.5 cm.
Coll. Delenne, Brussels.

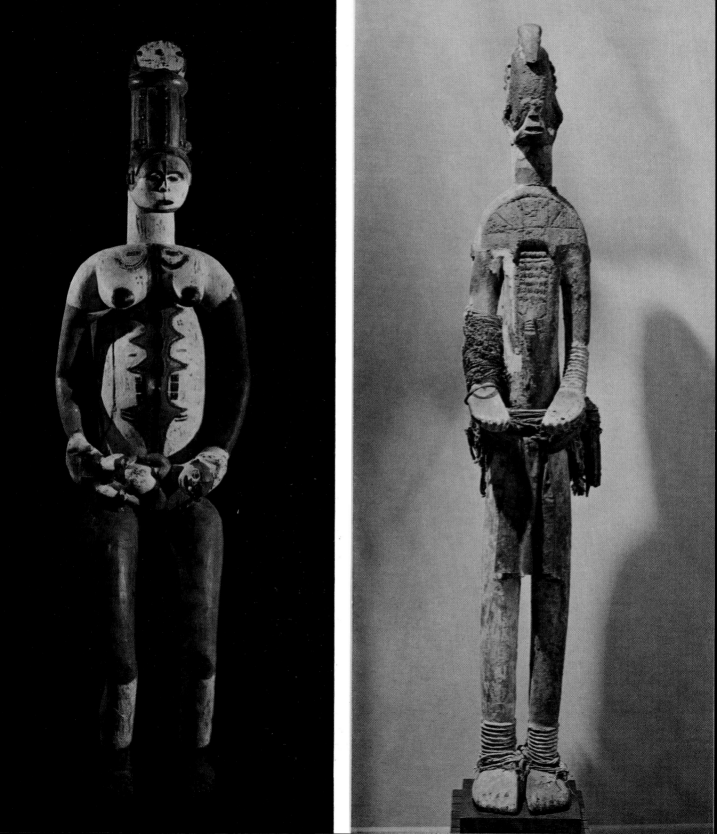

The Bini

In the Bini country, where the kingdom of Benin was once to be found, tribal art contrasts strongly with the courtly style. It has its own laws. Until the nineteenth century the Bini chiefs were not permitted to place memorial heads upon their altars; they had to be content with wooden animal heads. But these animal heads have their own artistic quality and a dynamic which is absent from many of the classical works of Benin. From 1830 on the Oba of Benin gave the chiefs permission to set up wooden memorial heads in human form.

The masks which the Bini use in the villages for the dances of various cults are of a more sensitive kind.

In the south-west of the Bini country, in Okitipupa and Ughoton, the port of Benin, the influence of the Ijo style inspired the Bini carvers to the truly magnificent achievement of the cubist heads with superstructure for the water spirit *Ikbile.* Such a head, set up in the shrine of *Ikbile* at Ughoton, was intended to protect the inhabitants from the British punitive expedition of 1897.

Ibo

The Ibo are a powerful, highly civilized tribe, almost eight million strong, inhabiting a wide area east of the lower Niger. They live in small settlements and seem to have had very little to do with the sacral kingdoms.

Every Ibo endeavours to achieve a high rank in the men's society by his personal ability. The Ibo are very vital and lively and carry out active trade with the neighbouring people. Their highly distinctive characteristics have given them the inherent ability to distinguish themselves in the art of carving. Although many Ibo profess Christianity at the present day, their art remains wholly under the influence of the invocation of spirits and the cult of the divine pantheon. Masks of various kinds are made for the masked plays and funeral celebrations of the secret societies. Their art is uncommonly diverse and powerful and gives rise to individual creation of immense power and intensity. Amongst the various Ibo sub-tribes, however, one can observe many forms which could have been borrowed from other tribes, so that it is not easy to identify clearly the many sub-styles. And for this reason one can never speak of a single Ibo style. None the less, one cannot regard the Ibo as imitators; the monuments of their art are too forceful for this. Rather, it is rooted in the same cults which the Ibo share with their neighbours, such as the cult of the water spirit of the Ijo, the *Ikenga* cult of the Igala, Idoma, etc. The Ibo love curves, dynamic forms and bright colours. Abstract figures alternate with others of startling realism. The proportions and combinations are unreal, as unreal as the beings which they have to represent.

The white masks of the spirits of the dead worn by the *Mmwo* men's society, which represent a dead wife, are most impressive. They appear every three years at the initiation of the boys. In the mask of the woman the ideal of female beauty is combined with the conception of the spirit of a dead person to produce a vision of extraordinary boldness. The *Mmwo* masks are worn in front of the face. With them is worn a massive ornament of feathers and a narrow garment made of brightly coloured pieces of cloth.

In the Ibo *Ekkpe* play, in the region round Aba and Bende, the beautiful spirit of a virgin and deliberately ugly and powerful elephant spirit are opposed. In the *Ogbom* play the mother goddess

M 3
Ancestor figure. Ibo.
Wood, painted red, 139 cm.
Coll. J. Kerchache, Paris.

M 4
Female ancestor statue. Ibo.
Wood, painted red, 105 cm.
Coll. Comte Baudouin de Grunne, Président des Amis du Musée de Tervuren, Wezembeek-Oppem, Belgium.

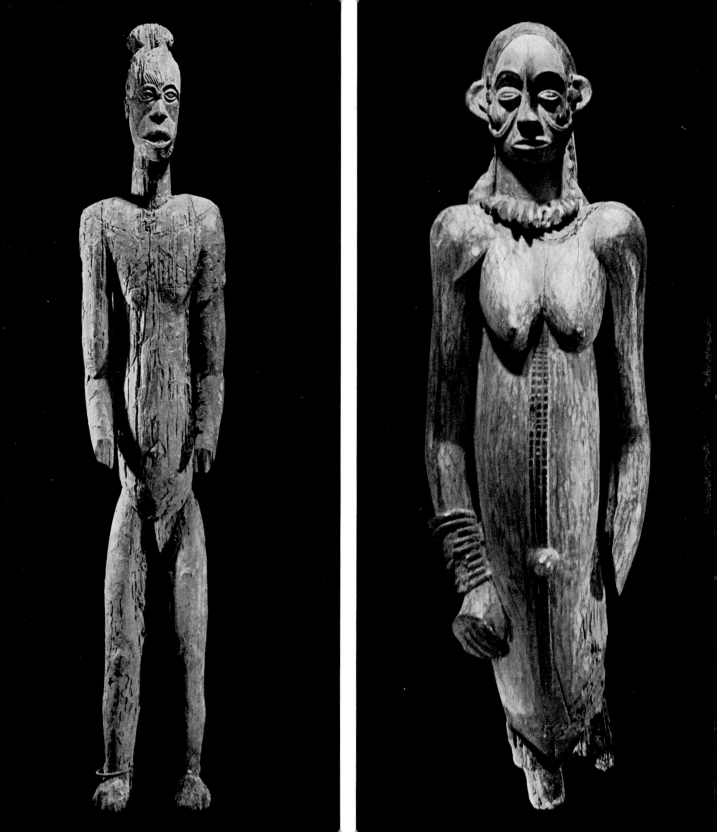

Ala is honoured by realistic headdresses worn in a dance, the effect of which is often somewhat aggressive. Even *Mbari,* the sanctuary of *Ala,* is decorated with paintings and with powerful, fantastic mud sculptures. In the *Mbari* house lively performances of dancing and music take place.

In the family shrines of the Onitsha region are found ancestor figures, larger than life size, painted in shining colours. They have a small head with a wide-awake look, a tall pillar for a neck and lengthened bodies, heavily marked with scars, arms hanging down with open hands, sturdy legs with gaiters and feet that look like slippers. They are most impressive individual creations of monumental power. At every ceremony the figures are dressed in new coloured clothing. These statues were cult objects, firmly restricted to the shrine. For many centuries they remained hidden from unconsecrated eyes, until the Moslems dragged them into the daylight, sold or destroyed them.

A particular form of Ibo sculpture is connected with the *Ikenga* cult. *Ikenga* means 'altar for the power of the right hand', as a term for the effective force of manhood. Whenever the foundation of a house is laid, such a figure is set up, and destroyed again at the death of the owner. It also acts as the god of destiny. It is asked for advice on every occasion and honoured with sacrifices of palm wine and kola nut. A typical detail are the ram's horns of the *Ikenga* figures, which refer to the thunder god, who once appeared in the form of a ram and whose voice could be heard in the thunder. Ram's blood is poured over the altar to renew the life force, to ensure prosperity and to beg protection. Head hunts used to be undertaken and with the heads of the enemy brought back as booty request was made for the growth of the fields. For that reason the *Ikenga* carry knives and trophy heads in their hands.

The *Ikenga* are usually ungainly and stiff in form and garishly painted. Many give an uncanny effect of being alive and even aggressive. From the trunk of the iroko tree complicated forms can be carved out.

In order to ensure the luxuriant growth of the yam tubers, the basic nourishment of the savannah tribes, there were various cults and specific art forms, such as the *mba* masks for the *Oko Okochi* harvest thanksgiving festival, or, amongst the Kwale-Ibo (west of the Niger) groups of figures in clay for the family altar of the yam spirit *Ifefioku*. The small, wholly abstract *maji* masks come into action at the initiation of the boys. The upturned sickle above the forehead signifies the ceremonial knife of the yam harvest, and the forward pointing pegs indicate the teeth. The masks are completed by a costume in coloured fabric and a string of small bells crossed over the breast.

M 5
Ikenga altar with figures and
symbols. Ibo. Wood, 40 cm.
Coll. René Salanon, Paris.

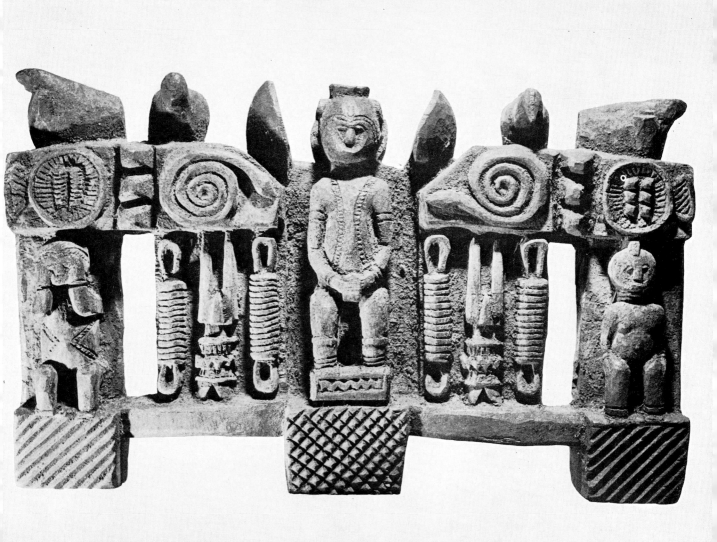

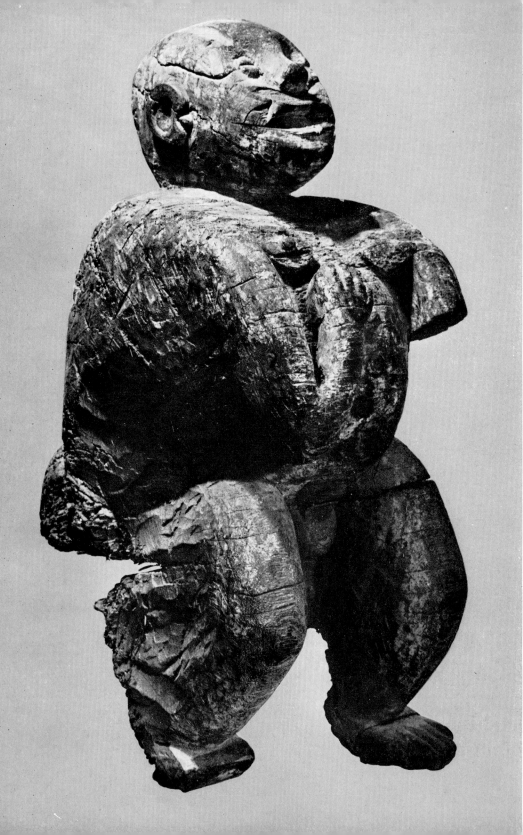

M 6
Female figure. Ibo.
Wood, 74 cm.
Coll. J. Kerchache, Paris.

M 7
Double mask with man and
animal. Ibo.
Wood, 30 cm.
Coll. René Salanon, Paris.

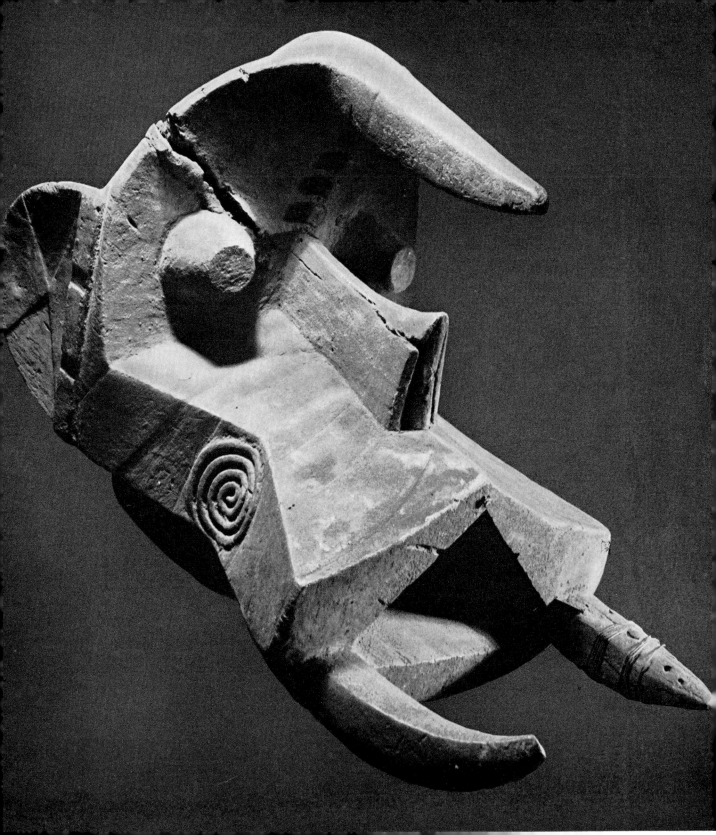

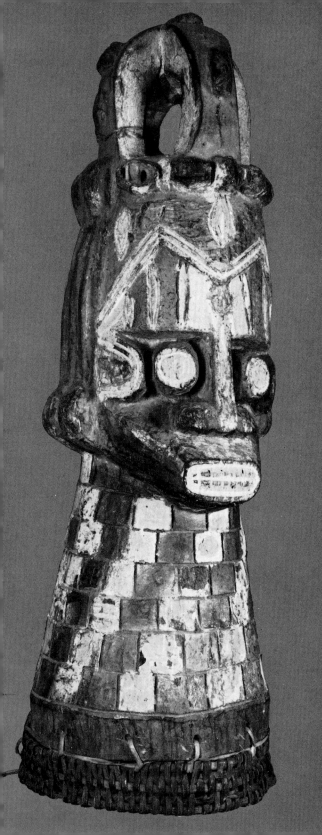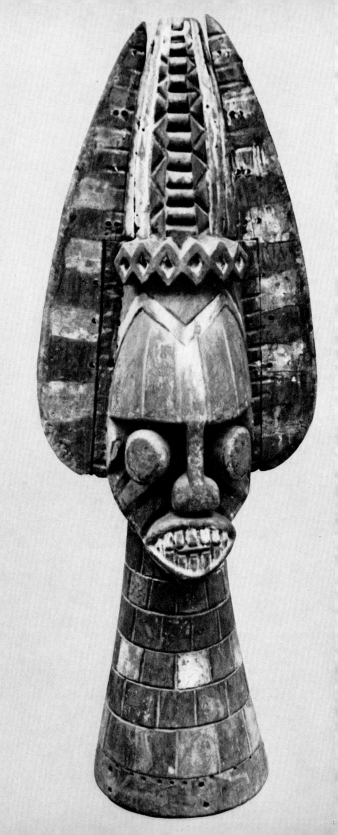

M 8
Head: Eki of Mahin.
Bini of Okitipupa.
Painted wood, 75 cm.
Federal Department of
Antiquities, Lagos, Nigeria.

M 9
Cubist head for headdress from
an Igbile shrine, set up in
1897 as protection against the
British punitive expedition.
Bini, Ughoton, West Ijo style.
Painted wood, 54 cm.
Coll. Egerton, Ringwood.

M 10
Mask. Bini. Wood, 31 cm.
Coll. Comte Baudouin de
Grunne, Wezembeek-Oppem,
Belgium.

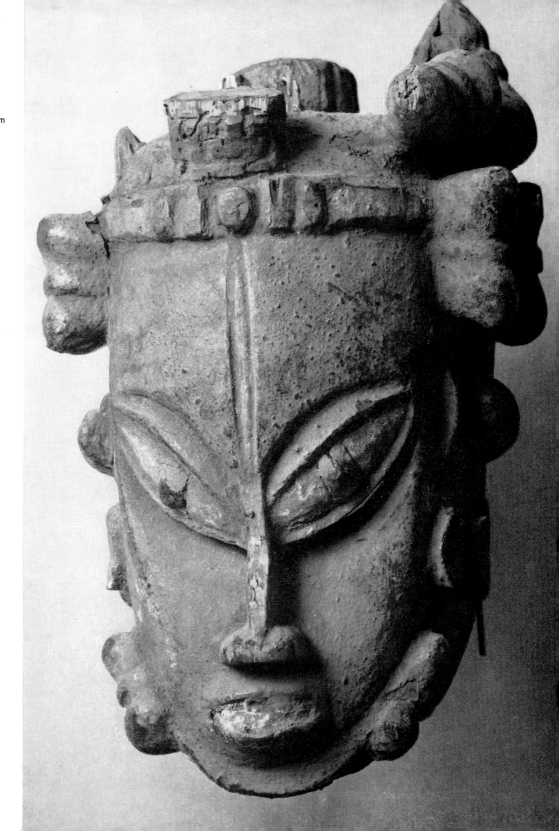

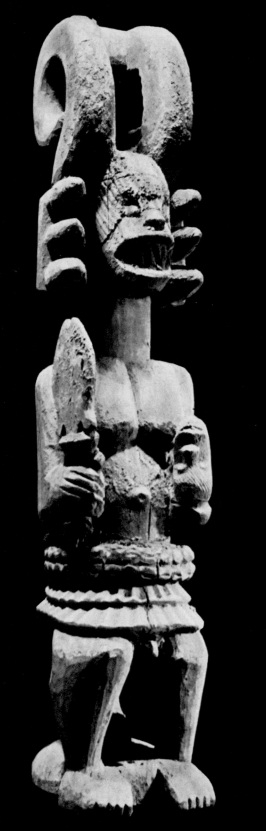
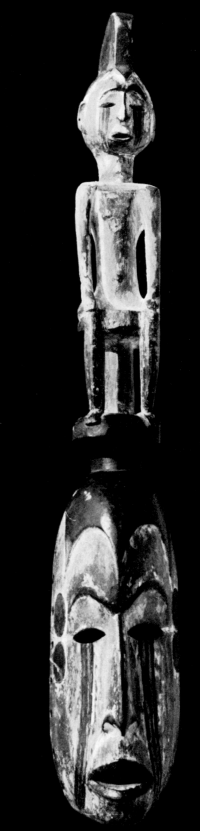

M 11
Horned *Ikenga* figure with knife and trophy head.
Ibo. Wood, 73 cm.
Coll. J. Kerchache, Paris.

M 12
Mba mask for the *Iko Okochi* harvest festival.
North-eastern Ibo, Afikpo. Wood, 51 cm.
Coll. Alfred Muller, St Gratien, France.

M 13
Ejiri figure on a hippopotamus. Wood, 58 cm.
Afrika-Museum, Berg en Dal, Holland.

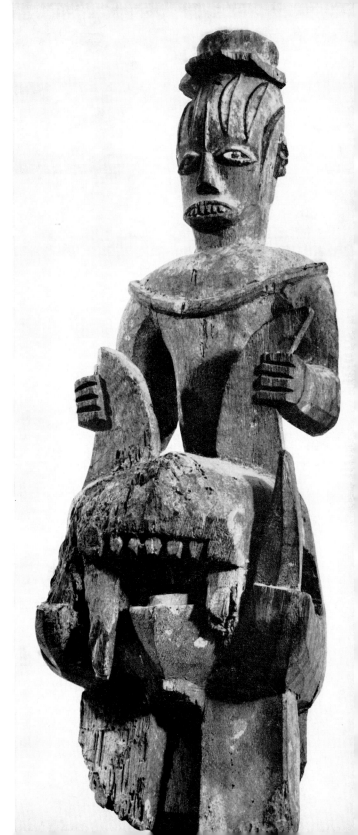

M 14
Kneeling figure with sacrificial vessel. Urhobo.
Wood, painted with redwood powder, 66.5 cm.
The Museum of Primitive Art, New York.

M 15
Water spirit mask, hippopotamus head. Kalabari Ijo.
Wood.
British Museum, London.

M 16
Door with relief pattern of circles and concentric
diamonds. Ibo, Okigwe. Wood, 94 cm.
Coll. Christian Duponcheel, Brussels.

M 17
Water spirit mask *Ikbile*. Ughoton.
Painted wood, 93 cm.
Federal Department of Antiquities, Lagos, Nigeria.

M 18
Female ancestor figure. Ibo. Wood, 108 cm.
Coll. J. Müller, Solothurn, Switzerland.

M 19
Ancestor statue. Ibo. Painted wood, 174 cm.
Coll. Comte Baudouin de Grunne,
Wezembeek-Oppem, Belgium.

M 20
Statue with headdress. Ibo. Wood, 122 cm.
Coll. Comte Baudouin de Grunne,
Wezembeek-Oppem, Belgium.

M 21
Post with two figures. Ibo. Painted wood, 187 cm.
Coll. Ettore Cacciaguerra, Milan.

M 22
Mother figure for the altar of the Yam Spirit,
Itjioku. Kwale-Ibo. Terracotta, 28 cm.
Ethnological Collection, Zurich.

M 23
Maji mask, knife mask for the Yam cult. Ibo. 43 cm.
Private collection, Paris.

M 24
Pair of large statues with scar decoration. Ibo.
Painted wood, 160 and 151 cm.
Private collection, Geneva.

M 14
M 15

M 16

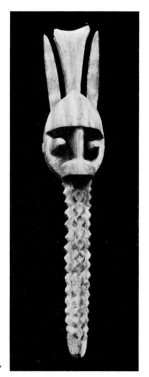

M 17

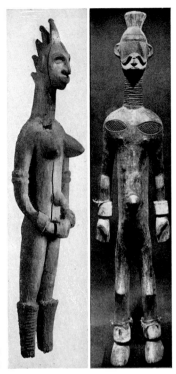

M 18
M 19

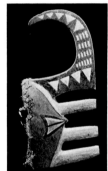

M 22

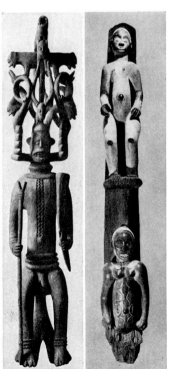

M 20
M 21

M 23

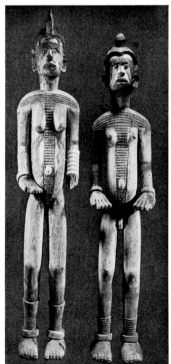

M 24

M 25
Ancestor statue. Ibo. Wood, 98 cm.
Private collection, Paris.

M 26
Ikenga statue holding a pot. Ibo. Wood, 79 cm.
Coll. J. Kerchache, Paris.

M 27
Dance mask. Bini. Wood, 35 cm.
Coll. Hans Hess, Basel.

M 28
Ofo ritual object with face and four feet.
West Ibo. Brass. l. 20.6 cm
Coll. George Ortiz, Geneva.

M 29
Mask of the *Mmwo* secret society, used in the Yam
cult and at burials to invoke the spirit of a dead
woman. Ibo. Wood, 49 cm.
Coll. M et Mme Bellier, Paris.

M 30
Mask with scar pattern and feather decoration.
Ibo. Painted wood, 51 cm.
Private collection, Geneva.

M 31
Ram's head, *Uhumwelao* from the royal ancestor altar.
Bini. Wood, 37 cm.
Coll. Christian Duponcheel, Brussels.

M 32
Janus mask. Ibo. Wood, 42 cm.
Private collection, Paris.

M 33
Girl's head from the *Ekkpe* play. Ibo. Wood, 54 cm.
Coll. Comte Baudouin de Grunne,
Wezembeek-Oppem, Belgium.

M 34
Mask with tattooing on the temples. Ibo.
Painted wood, 24 cm.
Private collection, Paris.

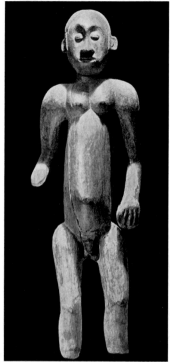

M 25

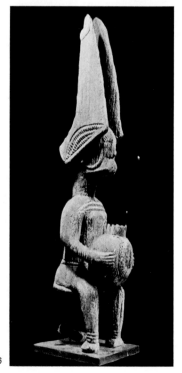

M 26

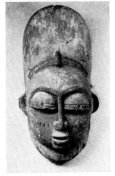

M 27

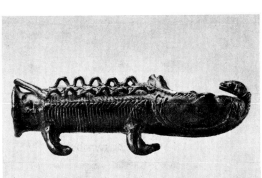

M 28

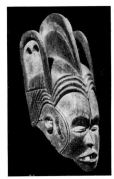

M 29

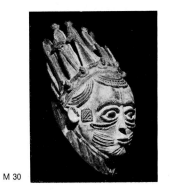

M 30

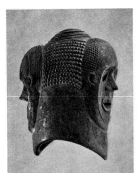

M 31

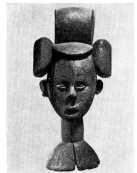

M 32

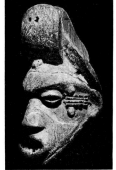

M 33

M 34

N South-eastern, eastern and northern Nigeria

The Ibibio

On the south-east of the Ibo adjoin the Ibibio, who speak a Bantoid tongue. They have never formed large states, but were ruled by the powerful *Ekpo* secret society. As early as 1710, the traveller and scholar Snellgrove recorded that the *Ekpo* secret society dominated every village and that the great *Juju* spirit even demanded the sacrifice of children. The dance plays are organized by the medicine men. The masks and figures which the society uses to conjure up fear and terror are also of a macabre realism. They have distorted features in the case of the demon of 'palsies', and grimacing faces when they are there to conjure up the demon of the sickness *Gangosa pharyngitis,* a disease which is regarded as a religious impurity. Elements from a skull of a corpse add to the already aggressive form to build up an uncanny vision.

The masks are boldly conceived. The original natural shape is expressively exaggerated with the aim of producing the maximum visual effect. Many wooden masks have a hinged lower jaw. Their surface is dark with a gleaming matt finish. The high rank of *idiong* in the *Ekpo* society is distinguished by circular signs on the temples. Not all the masks of the Ibibio, however, display this cruelty. There are also faces with a delicate naturalism and smoothly flowing curves. Certain Ibibio styles present a relatively unified picture over extensive regions. Nevertheless, specific styles can be distinguished, especially amongst the Efik and Oron.

The Oron-Ibibio, near Old Calabar, represented their ancestors in the last century in a pillar-like abstract style. The form is developed from the pole and built up from rounded elements. The surface is heavily worn away or eaten by termites. There are bearded men with hats upon their round heads and objects signifying attributes in their hands. They are serious, dignified tribal heroes of great artistic power. The *Ekpo* society which tended them venerated them as wise advisers and as bestowers of life force.

The Ogoni

The Ogoni (or Kana), a small tribe related to the Ibibio, near Port Harcourt, display an exceptional achievement in their original, strongly abstract masks. On the occasion of their harvest play, *karikpo,* the Ogoni execute acrobatic dances in honour of their local deity, and even turn somersaults in front of the great sacred drum.

The tribes south of the Benue

The mountain tribes south of the Benue, on the western slopes of the Adamawa massif, are interesting in so far as the faces they carve suggest the existence of an early kingdom of the sacral kingship type. The Jukun (Kororofawa), with their capital at Wukari, ruled over extensive regions of eastern and northern Nigeria in the seventeenth century. At the enthronement it was obligatory for the new king to eat the brain, kidneys and heart of his predecessor. After a reign of seven years he was strangled: the ritual murder of the king. The king was so intensively filled with life force that he was not allowed to touch the earth, because otherwise he would endanger the harvest. Many negro tribes must have worked for the Jukun, because in the works of the various pa-

N 1
Mask headdress with stylised human figure, for the agrarian cult. Koro-Ache. Wood decorated with red jequirity beans, 60.4 cm.
Musée royal de l'Afrique centrale, Tervuren, Belgium.

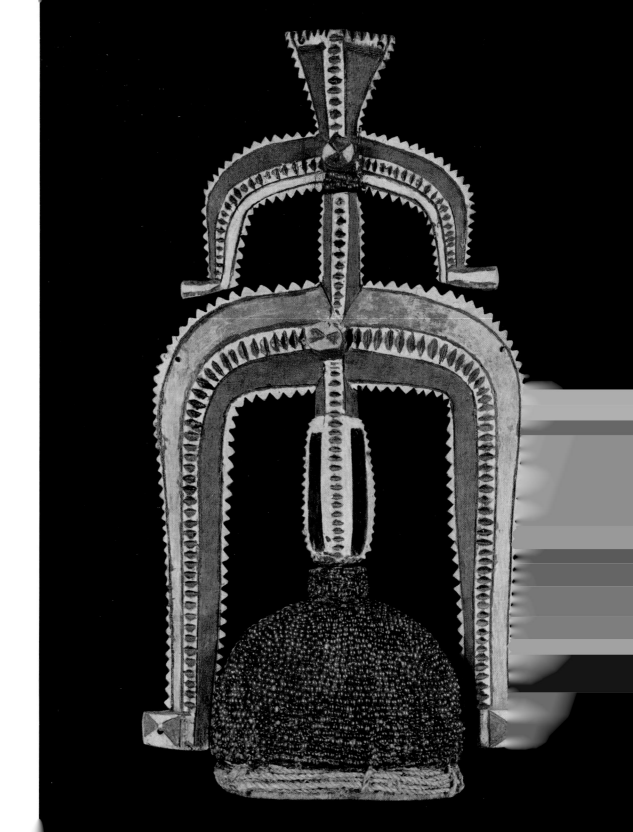

gan (i. e. non-Mohammedan) tribes on both sides of the Benue numerous similarities are found to sculptures which can be shown to derive from the court of Wukari. One of these is the mother figure found in the Horniman Museum in London, which could almost be a variant of the Afo style. A wholly abstract style of mask is ascribed to the Jukun themselves. On the other hand, cults with white and black masks of the dead, with female fertility statues, and above all with masks of the sacred bush cow, are a widespread phenomenon in eastern and northern Nigeria. Numerous tribes take part in such cults; and the styles are expressed in all kinds of variants between the round and the pole style, between forms naturalistic in feeling and intellectual abstractions.

The Chamba give their protecting spirit, the bush cow, a particularly powerful and strongly abstract form. The broad-mouthed mask is worn on the head at an angle of 45°. The wearer hides under a garment of bast. The male mask is painted red and the female black.

The Mumuye present their ancestor figures in impressive abstract variations: a kind of pole style of lapidary forcefulness, with a tiny head and jagged or undulating limbs. These figures are kept strictly concealed, are tended by the 'rain-maker', and sacrifices are regularly offered to them. In order to fill them with life force, they are set against the skulls of the greatest amongst the ancestors; then they protect the house. The rain-maker brings them out to public view, for example to welcome an important guest. He converses with them as with living beings and at a trial learns the name of the guilty person through them. The figures punish thieves and give help in the case of serious illness.

The Mambila in the Adamawa region also have their own personal style:

vital human or animal figures with large heads and masks with wide open jaws and eyes of tear-drop shape. They are painted with redwood powder (pterocarpus), bone ashes and soot, and they dance, dressed in a garment of feathers, at funerals and agricultural festivals. The Kaka have similar figures with concave faces.

When we find in these regions figures cast in brass of various provenance, we recall that this means that the pagan Abakwariga, who live south of Wukari, made many brass castings commissioned by the Jukun. On the other hand the Tiv also have the reputation of being excellent brass founders. They used to form the models from latex, the juice of a cactus. These Tiv also made remarkable wooden figures, with an artistic execution which displayed a very delicate feeling.

The Idoma, Igala, Igbira, Bassange tribes etc., who live in the area between the lower Benue and the Niger, have carvings which must be seen in relation to their close links with certain neighbouring peoples, particularly with the Ibo and Afo, but also with the Yoruba. They too have white masks of the dead, Ikenga and fertility statues, and they too like to decorate them with jequirity beans and horns. Sometimes the Idoma make geometric abstractions, and at other times figures of a delicate organic character, such as the ancient figure of Ekwotame. At the burial of a high dignitary the figure is set against the body, so that it is re-filled with the body's life force.

The Igala, whose aristocracy seems to be depended from the Jukun, show no links in their tribal art with the former kingdom of the Atta of Idah, though their works in bronze seem to derive from his court.

N 2
Death's head mask. Ibibio.
Wood, 26 cm.
Coll. Alfred Muller,
St Gratien, France.

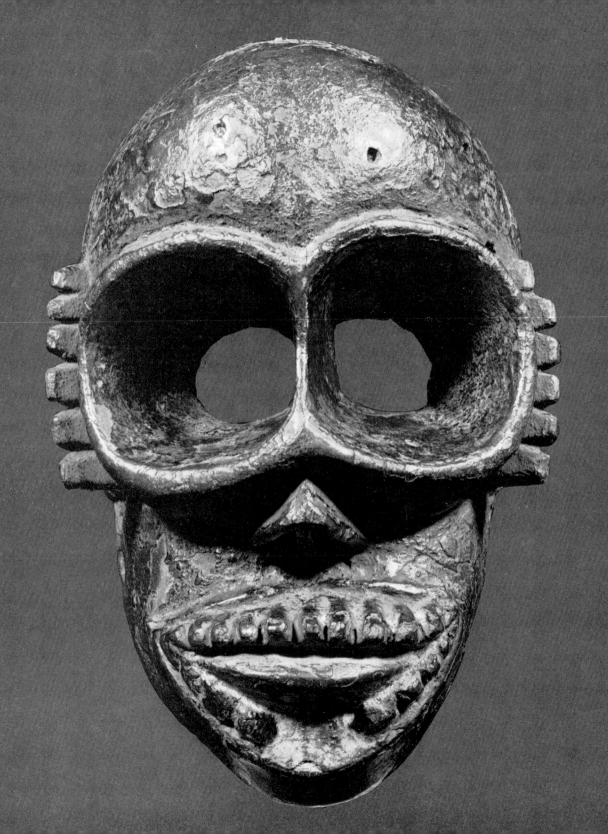

Northern Nigeria

Northern Nigeria — the area north of the Benue as far as Lake Chad — has had a turbulent history. In this area important kingdoms were set up (Bornu, Hausa, Jukun, Fulani, etc.), and this was the scene of the population movements, feuds, battles and wars of conquest of the Moslems. Many Negro tribes were converted to Islam; as many again escaped into the mountains or fled before the Mohammedan cavalry into the isolated regions of the Bauchi plateau. Consequently, there are still enclaves to be found of a powerful art which is wholly worthy of our attention. This I personally found amongst the Afo tribe in the Nasarawa mountains while on field research with Jolantha Neukom-Tschudi, where we discovered an unadulterated and simple hunting and agricultural culture conducted by people who, in spite of every influence from the higher civilizations which surrounded them, have succeeded magnificently in preserving intact their traditional way of life. Full of pride, the Afo in the Nasarawa mountains showed us their masks, dance headdresses and statues — though not until night had fallen, because the Afo women were not permitted to see these sculptures. The men quite readily allow the women to continue in the belief that they would die if they saw the holy images. It also proved impossible to watch an Afo artist at work. For the Afo, carving is such a sacred act that no uninitiated person can be present while it takes place. The sculptures are far above average. The bush cow mask, for example, radiates great power and achieves an extremely aggressive effect by formal means: it is stylized, and many of the surfaces are reduced to angled planes, so that the play of light and shadow is increased; and animal and human features are imaginatively combined.

The Afo represent their ancestor spirits in white and black masks and on stilts. They appear at the harvest festival or at funerals, to speak with the living again. In the dance headdresses, which represent neither deities nor ancestors, we recognize symbols of power: cock's combs, rhinoceros ears, animal horns, or the weird features of the chameleon. Red colouring is provided by jequirity beans. The cock is regarded as the messenger of the highest god, whom he reminds of his sacred promise always to provide abundant food. Because of his slow movements, and his change of colours, the Afo also regarded the chameleon as enchanted and bewitched. Depending upon his colour, he brings long life, riches, the blessing of children, or death. The headdresses are abstract compositions, and have a fortuitous similarity with the Suguni type amongst the Bambara. Less fortuitous is the fact that the pair of horns ascending sideways out of the round rhinoceros ear is a formal element found amongst the Afo, which can also be observed on the *Ikenga* of the Igala, the Idoma, the Ibo and other tribes of southern Nigeria. An important function in the Afo cult is exercised by the great statue of the mother and child, which is always the common property of the village. In it dwells a deity which brings about fertility. Once a year it is brought out of its shrine and decorated, palm oil and sacrificial blood are poured over it, and it is placed in the stone circle in the village square. The men sing, beat drums and call on the power dwelling in the figure to give their wives many children. This is the reason for the representation of a pregnant woman. The Afo say that fertility lies in the breasts as long as they are giving milk, that the spiritual

N 3
Ekwotame figure, set at the head of a dead king. Throned mother with child on her back. Idoma. Wood, 68 cm.
Ex coll. Epstein.
Coll. Philip Goldman, Gallery 43, London.

N 4
Ancestor statue. Oron-Ibibio. Weathered wood, 104 cm.
Federal Department of Antiquities, Lagos, Nigeria.

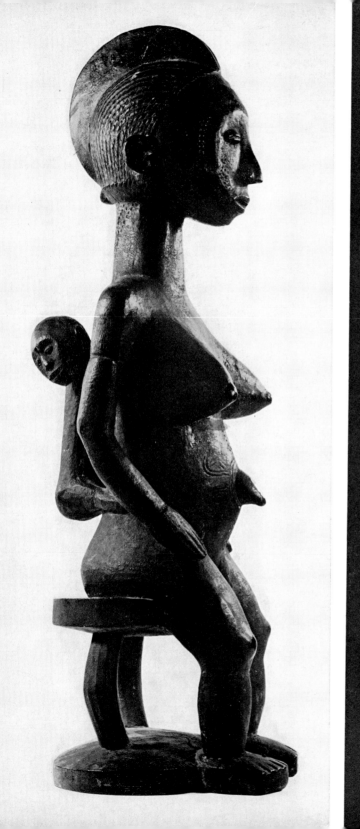
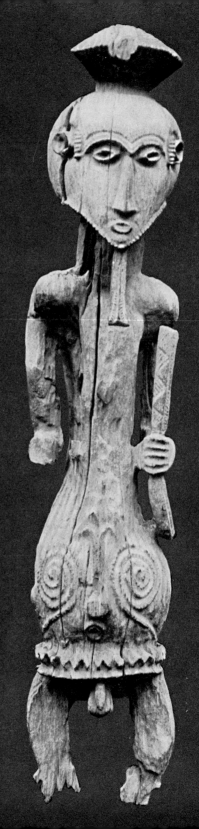

powers and the intelligence dwell in the large head, while strong children have left the womb through the strongly emphasized navel. The most beautiful statue, which was the common property of the village and had been venerated from the earliest times, could not be bought at any price.

Carving is practised by many of the smaller, so-called pagan tribes of northern Nigeria, living between the Bauchi plateau and the river Benue. These include the Mama near Wamba, the Koro and Jaba (Ham) of the Nok region and the Goemai (Ankwe), the Montol, the Waja and the Karim east of them. Every tribe possesses its clearly recognizable personal style. We observed every variation from a lapidary primary style to highly complex works of art. Of these, we show the marvellously abstract buffalo and antelope masks of the Mama (who are known as bold warriors and head hunters), which are used in the *kambon* mask play of the *Udawaru* society, and worn in funeral and sacrificial cults; the abstract images, decorated with jequirity beans, of the Koro; the powerful, cubist headdresses, with a head on top, made by the Waja; the rare, sensitively conceived figures, with their large ear plugs, of the Karim, a Jukun-speaking tribe south of Gombe. Many artists in these tribes are still working in wood and clay at the present day.

Towards the north, where the sphere of influence of the Moslems makes itself increasingly felt, the force of the carving declines. The Hausa use their artistic powers to produce a rich range of art, none of which, however, is representational: fine leather work, embroidery, textiles in wool and cotton, basketwork and decorative facades to houses.

N 6
Buffalo head mask. Mama.
Reddish-painted wood, 48 cm.
Federal Department of
Antiquities, Lagos, Nigeria.

N 7
Mask with large round eyes.
Ibibio. Wood, multicoloured,
27.5 cm.
Federal Department of
Antiquities, Lagos, Nigeria.

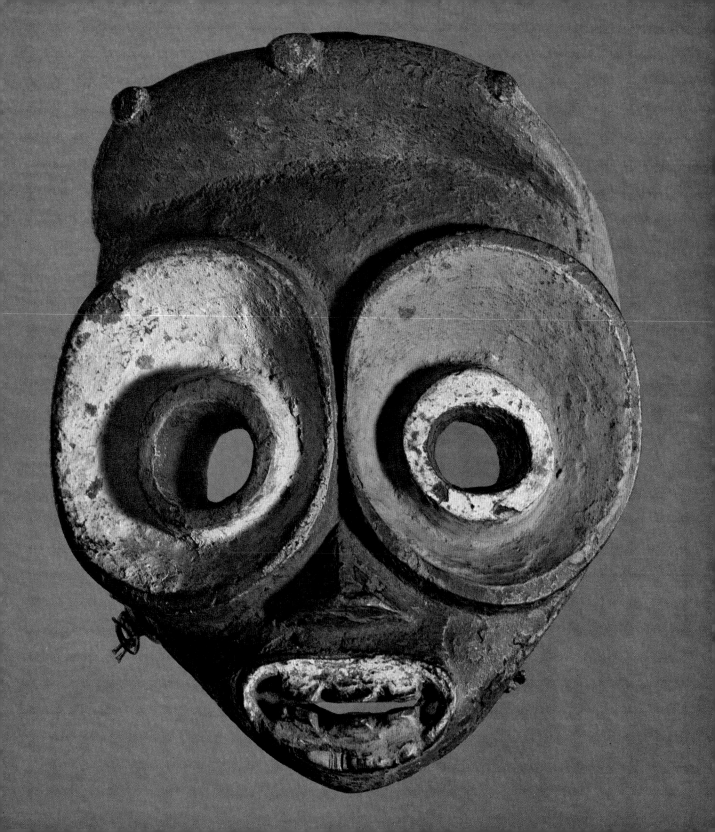

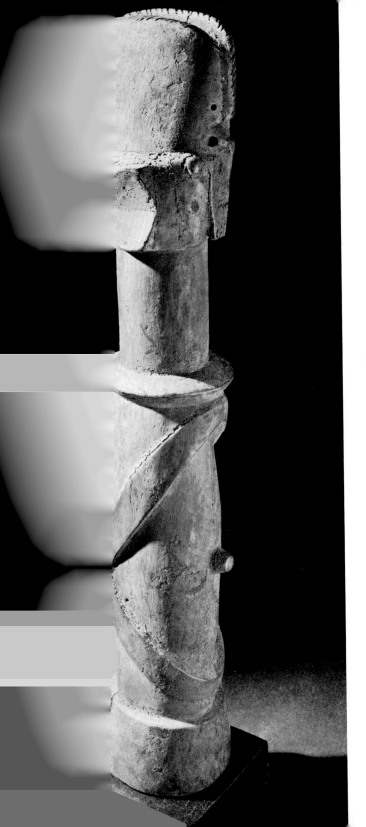

N 8
Abstract ancestor figure,
pillar-like. Banyo region.
Reddish-coloured wood,
46.5 cm.
Coll. Maurice Bonnefoy /
D'Arcy Galleries, Geneva.

N 9
Ancestor statue. Tiv. Wood,
132 cm.
Coll. Comte Baudouin de
Grunne,
Wezembeek-Oppem, Belgium.

N 10
Ancestor statue with ringed
hairstyle. Mumuye.
Wood, 127 cm.
Coll. René Salanon, Paris.

N 11
Ancestor statue. Mumuye.
Wood, 100 cm.
Coll. J. Kerchache, Paris.

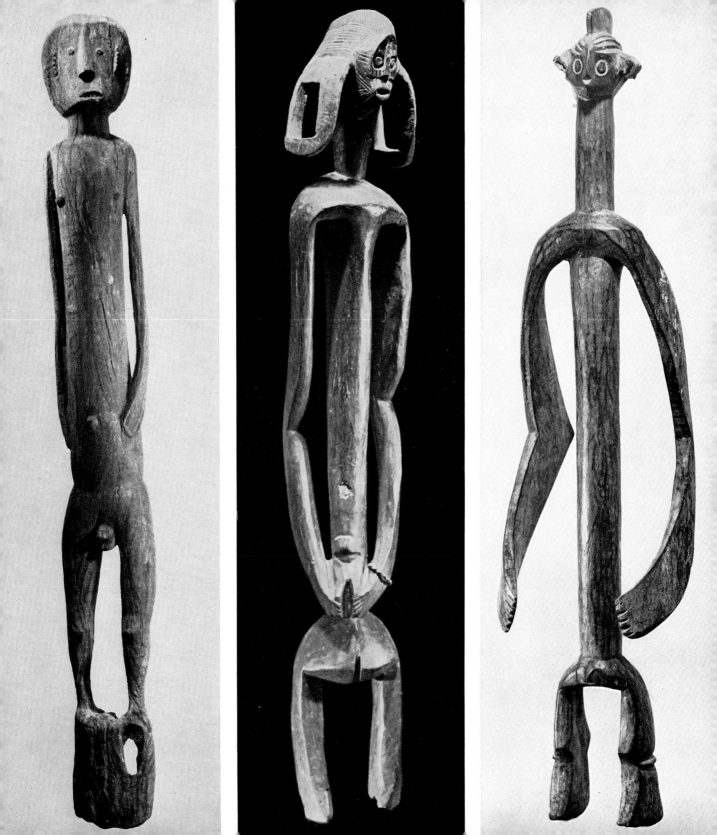

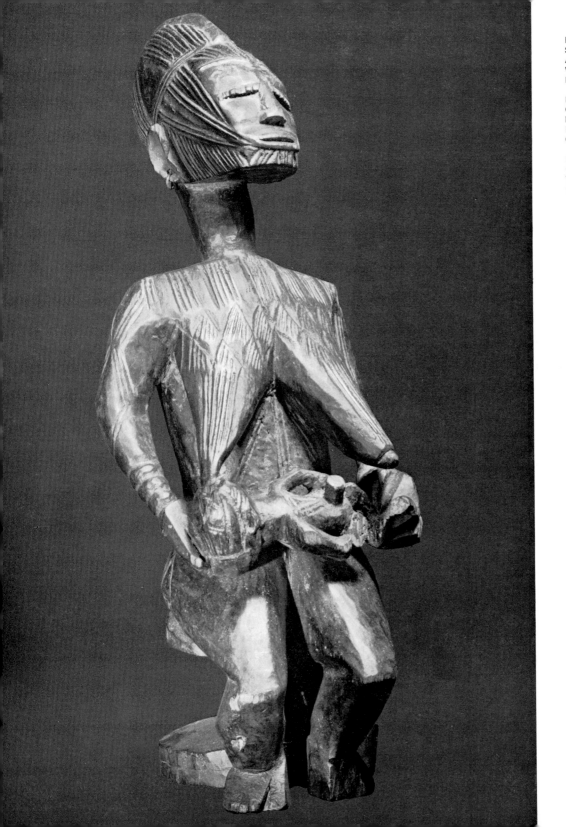

N 12
Seated mother with child.
Afo-Jukun. Collected 1875.
Wood, 51 cm.
Horniman Museum, London.

N 13
Cult figure with abstract
head. Waja on the Gongole
River. Wood, 130 cm.
Coll. J. Kerchache, Paris.

N 14
Old expressive carved head.
Waja. Weathered wood, 112 cm.
Coll. René Salanon, Paris.

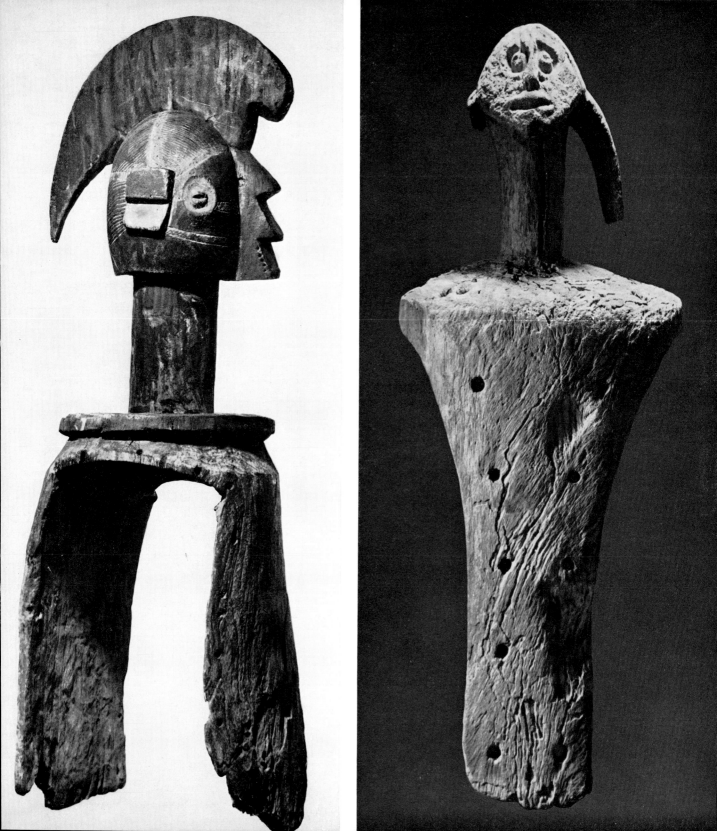

N 15
Mask representing a beautiful young girl.
Ibibio. Wood, 22 cm.
Afrika-Museum. Berg en Dal, Holland.

N 16
Mask with moveable jaw. Ibibio. Wood and raffia,
35.5 cm.
Linden-Museum für Völkerkunde, Stuttgart, Germany.

N 17
Mask with beak-like moveable jaw. Ibibio.
Wood, 27 cm.
Coll. Comte Baudouin de Grunne,
Wezembeek-Oppem, Belgium.

N 18
Karikpo mask with horns. Ogoni.
Blackened wood, 35 cm.
Federal Department of Antiquities, Lagos, Nigeria.

N 19
Standing figure with jewelry and scar decoration.
Tiv, Katsina-Ala. Brass, 30.5 cm.
Coll. Maurice Bonnefoy / D'Arcy Galleries, Geneva.

N 20
Mask of a bush cow with a wide mouth.
Chamba. Wood, 60 cm.
Linden-Museum für Völkerkunde, Stuttgart, Germany.

N 21
Ancestor statue. Mumuye. Wood, 120 cm.
Coll. J. Kerchache, Paris.

N 22
Ancestor statue with loop decoration. Mumuye.
Wood, 162 cm.
Coll. J. Kerchache, Paris.

N 23
Figure. Bauchi Plateau. Wood, 47 cm.
Coll. Comte Baudouin de Grunne,
Wezembeek-Oppem, Belgium.

N 24
Ancestor statue. Mumuye. Wood, 133 cm.
Private collection, Geneva.

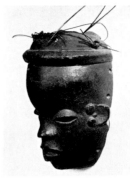

N 15

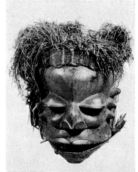

N 16

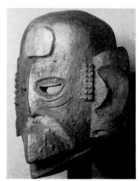

N 17

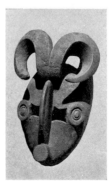

N 18

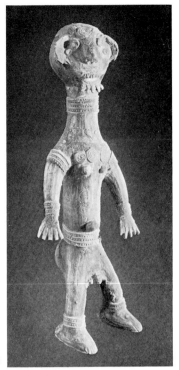

N 19

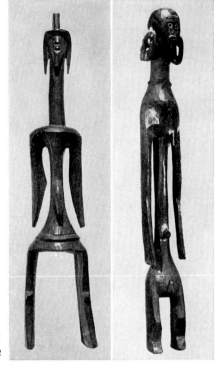

N 21
N 22

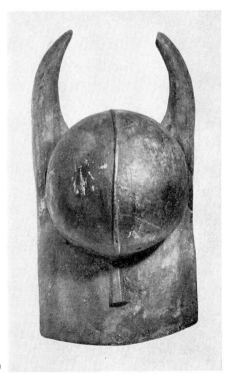

N 20

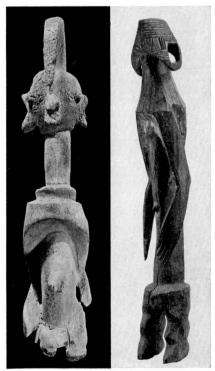

N 23
N 24

N 25
Mask of a bush cow. Afo. Wood, 38 cm.
Collected by E. Leuzinger and J. Neukom-Tschudi.
Federal Department of Antiquities, Lagos, Nigeria.

N 26
Dance headdress with horns and chameleon. Afo.
Wood and jequirity beans.
British Museum, London.

N 27
Antelope mask with long horns. Mama.
Wood, 68 cm.
Coll. Charles Ratton, Paris.

N 28
Statuette. Mambila. Weathered wood, 42 cm.
Coll. Deletaille, Brussels.

N 29
White dance mask representing a death spirit. Afo.
Wood, painted white and black, 30 cm.
Coll. E. Leuzinger and J. Neukom-Tschudi, Zurich.

N 30
Ancestor figure with large ear-plugs.
Karim, Eastern Nigeria. Wood, 71 cm.
Coll. J. Kerchache, Paris.

N 31
Carved head. Waja. Wood, 117 cm.
Private collection, Paris.

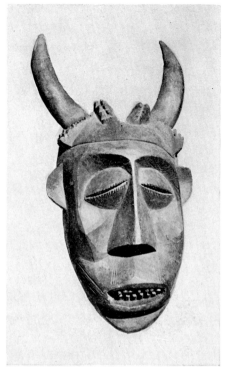

N 25

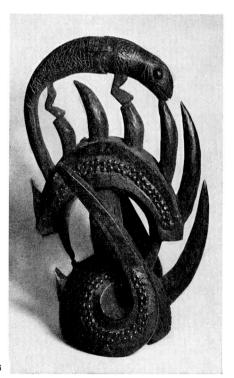

N 26

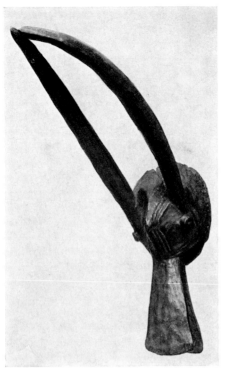

N 27

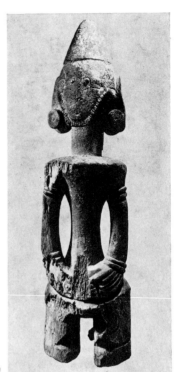

N 30

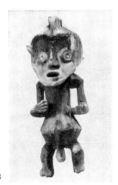

N 28

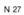

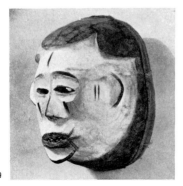

N 29

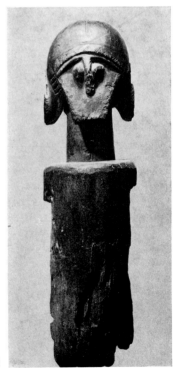

N 31

Cameroon

All the climatic zones of West Africa are found in Cameroon.

— In the north, towards Lake Chad, the dry savannah with the rivers Logone and Chari, which flow into Lake Chad (the Sao culture).
— In the west, Adamawa, the mountain country, with ancient negro cultures; this is the watershed separating the country from Nigeria.
— In the centre, the grassland, a fertile high plateau including Bamenda, Fumban and Dschang, where kingdoms were set up.
— In the south and south-west, forest regions, with styles isolated from each other (Ekoi, Bafo, Duala).

The most important area is the Cameroon grassland, which offers the best conditions for human life. It has received many influences from advanced cultures from the north and has made fruitful use of them. Influential kingdoms came into being in this region, while the earlier populations were forced back into the forest and were of little importance. Duala, the port, attained a certain importance through trade with the Europeans.

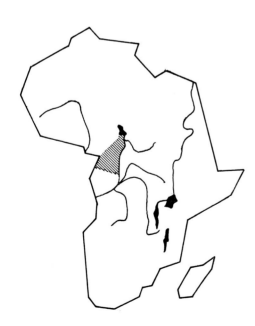

O 1
Animal-headed dance head-
dress with large spiral horns.
Ekoi. Wood covered with skin,
86 cm. wide.
Coll. Nicaud, Paris.

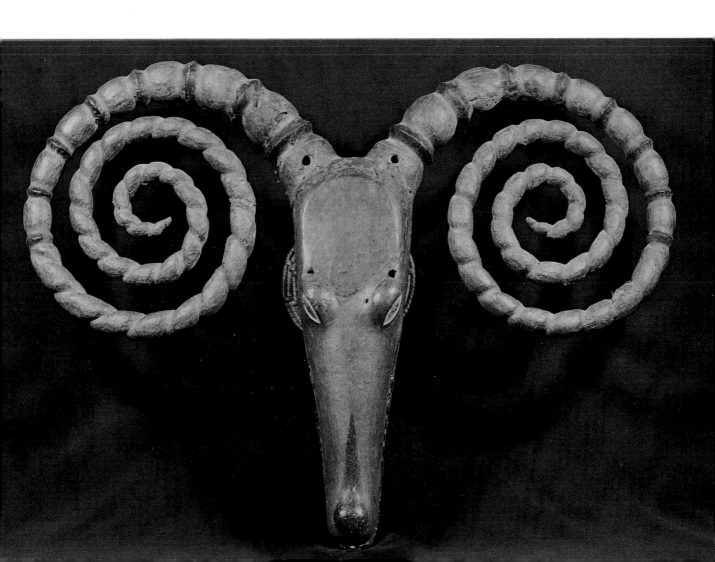

O North and south Cameroon

The Sao

The northern region is nowadays so dominated by Islam that no representative art is found there. In the past this was not the case. This is shown by the remains of settlements, city walls, sanctuaries, and thousands of graves at the mouth of the river Chari, partly in northern Cameroon and partly in the territory of Chad. These finds are the remains of an important culture. The expedition of A. and J. P. Lebeuf has largely explained them. The people who produced this culture can not be identified as yet. They are called Sao, i. e. pagans (non-Moslems). They seem to have immigrated in about the fifth century from Kanem. They succeeded in setting up an independent kingdom with cities and villages, practising an iron age culture, but with no writing. They seem to have received all kinds of outside stimuli by way of the Sudan, because a number of ancient trade routes met at Lake Chad. In its greatest period, from the tenth to the sixteenth century, the mighty walled cities were built. For a long time the Sao lived on good terms with the neighbouring kingdoms of Cameroon, until they were entangled in wars with the Moslems and were conquered or scattered by the Bornu (Kanuri) towards the end of the sixteenth century. The ancient Sao peoples may well have been the ancestors of the Kotoko who live in this region today.

When the Sao kingdom was at its greatest, the dead were buried in huge clay jars. The finds from the graves are particularly rich and artistic: figures in well-fired clay represent human beings, animals and mythical figures, with human bodies and animal heads. Many of the figures are modelled with startling simplicity, some with a lofty power of expression and others in a grotesque primary style, or greatly abstract. They strike majestic poses, often with unusual gestures, and most of them are heavily decorated. The features of the face are exaggerated or sensitively drawn, while the chin is flattened. The bodies are often without limbs or in the form of a massive pedestal, or again, provided with rudimentary arms. In the graves were also found all kinds of functional objects and ornaments in iron, copper, bronze, ivory and glass.

The Ekoi group

In the south-western corner of Cameroon and the neighbouring parts of Nigeria we find the Ekoi group, which includes various tribes on the middle Cross River in thick forest, particularly the Keaka, Anyang, Banyang, Obang, Boka, etc. The Ekoi call themselves Ejagham. The dictatorial power exercised by their primitive forest environment and by the secret societies has meant that all these tribes share a relatively unified pattern of culture.

The rise of their emphatically realistic style has been attributed to the former practice of head hunting. The victors tied the heads of their victims on to their own heads and danced with them in an ecstasy of victory. The blood of the enemy was thought to bring fertility to the fields, which is a widespread belief in lands with a matriarchial social organization. The wooden heads, mostly covered with skin, probably served as a substitute for the real heads and were therefore carved as realistically as possible, not only with naturalistic living features, but also with inset iron teeth, inlaid eyes, real hair, etc. As late as the end of the last century the skin of slaves

O 2
Akwanshi, memorial to a chieftain priest. Ekoi. Stone, 112 cm. Federal Department of Antiquities, Lagos, Nigeria.

O 3
Large elephant mask. The mask embodies the *Losango*, protective spirit of the *Ngwe* secret society. Made by the Bafo for the Bakossi in Nyasoso. Woodlands of Cameroon. Wood, traces of paint, 97 cm. Basler Mission, Basel.

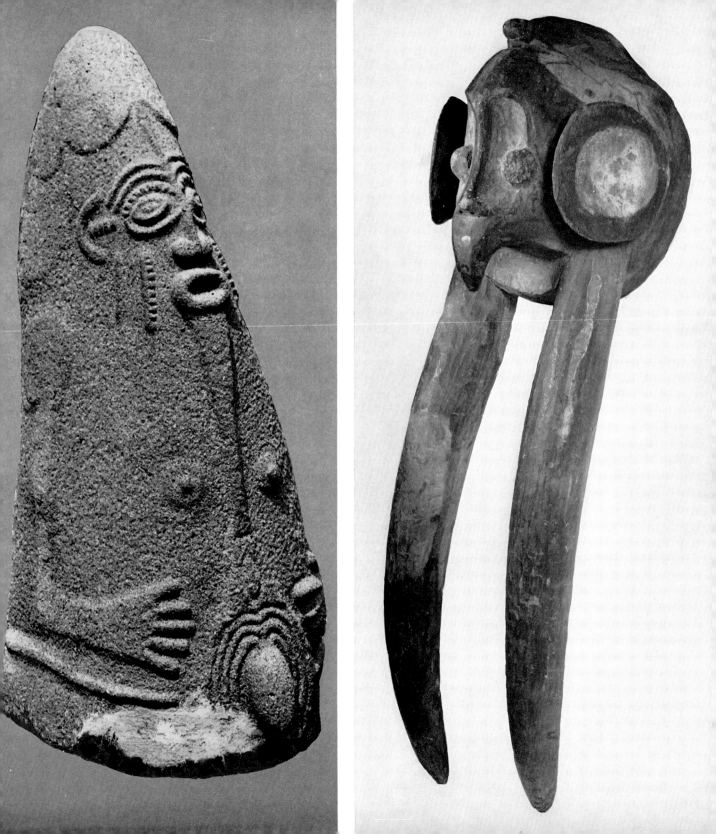

and prisoners of war is said to be used to cover them, while later the skin of antelopes and goats had to suffice. Eyebrows and lips were emphasized with black colouring, and the rank of the possessor was shown by markings, because the prestige of a person in the secret society played a very great role. The heads were mounted on basketwork caps, so that the dancers could wear them on their heads.

The dance headdresses include all kinds of combinations of heads and horns. In the Janus masks the dualism of 'dark-man-death' with closed eyes and 'light-woman-life' with open eyes is expressed. Hidden from the gaze of the women, the medicine men wear the masks and headdresses at burials or to heal sick members of the society. Animal headdresses or full length figures covered with leather and with movable limbs display the same expressive forms. Marionettes of the latter kind are hung on ropes and moved with threads by someone standing beneath them.

Deep in the forest of the Ekoi region, in the abandoned villages of the Ekoi sub-tribes of the Nta, Nselle, Jyala, Nde, Nnam, etc., were found the three hundred huge figures in dolerite and sandstone, the so-called *akwanshi*. These are pillars over six feet high, sometimes phallic in shape, and with human features, a beard, scar patterns and in most cases a large navel. *Akwanshi* means 'dead man in the earth'; the figures to whom this name refers are said to be memorials of the great priest-chiefs, the *ntoon,* from the dim and distant past. The reason for their precise significance, however, is largely forgotten. 'Our fathers offered their human sacrifices there,' say the Ekoi. Now they ask them for prosperity with gifts.

The forest region of southern Cameroon

The cultural pattern in the forest region of southern Cameroon is also determined by the conditions of life. The ancient and very isolated small peoples of this remote region have mostly produced a rough pole style sculpture and have created very little art worth mentioning.

An exception is found in the charming miniature works of the Bafo and Bakundu of the forest country, who produce figures in highly imaginative contrapuntal variations, which they use in taking oaths. The figures, Janus heads and heads with huge horns made by the Ngutu etc., are reminiscent of similar works made by the Ibo and Ekoi.

Duala

The coastal region with its mangrove swamps, the port Duala and the hinterland where the Bodiman and Wuri live have clearly been affected by their many years of contact with European merchants. This encounter has produced a strange mixed style. The Duala have taken over the garish aniline dyes and motifs of the white men and combined them with their indigenous mythological figures. The great war boats, the dance sceptres, the throne stools and masks of the *Ekongolo* secret society are combined with compositions of figures or faces to produce curious forms with many curved lines. Often the rich decoration overshadows the somewhat weak form. The art of the south-eastern part of Cameroon forms part of the great Pangwe (Fang) complex of Gabon, and is discussed in that chapter.

O 4
Dance headdress. Anyang-Ekoi.
North bank of the Cross River.
Wood with leather cap, 40 cm.
Ethnological collection, Zurich.

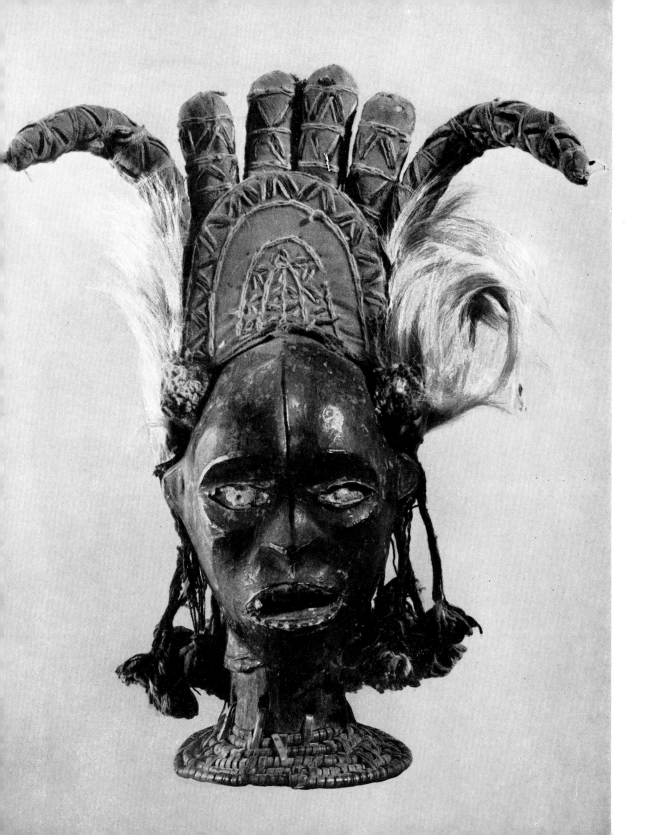

O 5
Headdress, head with
multicoloured cap. Ekoi.
Wood, leather cap. 40 cm.
Coll. Ph. Guimiot, Paris.

O 6
Painted bark.
Chad region.
Inner bark, 145 cm.
Musée des Arts Africains et
Océaniens, Paris.

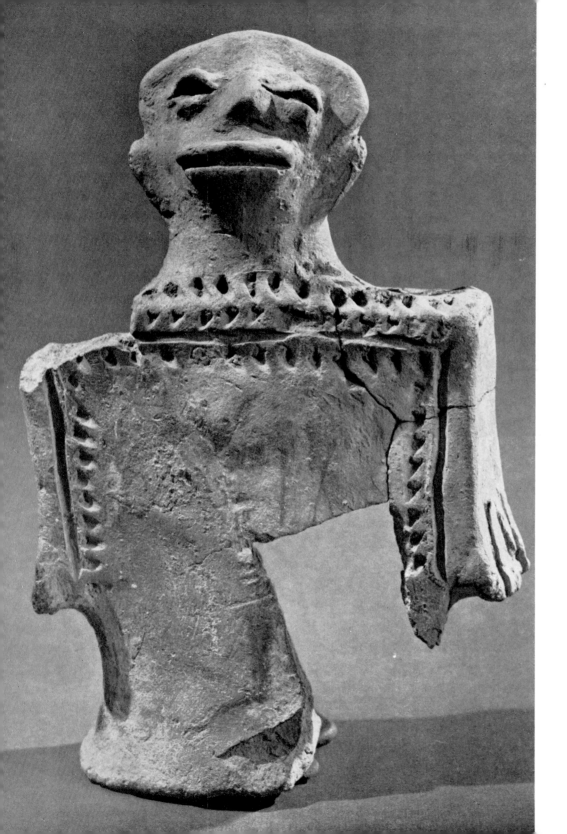

O 7
Ancestor figure.
Sao culture, 5th century B. C.
— 18th century A. D.
Terracotta, 17.6 cm.
Musée de l'Homme, Paris.

O 8
Ship's bow with figure and
strongly contrasting animals.
Duala. Wood, l. 120 cm.
Coll. Pierre Harter.

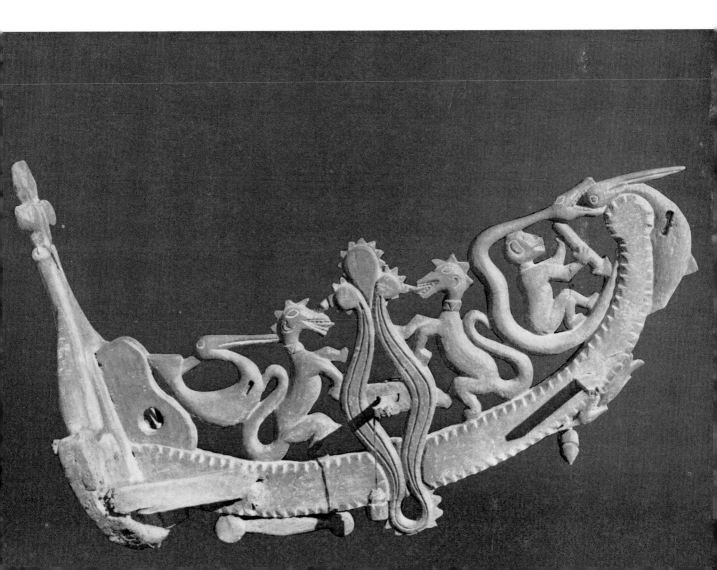

O 9
Janus helmet mask with light and dark face.
Ekoi. Wood covered with skin, 49.5 cm.
Ethnological collection, Zurich.

O 10
Helmet mask. Anyang-Ekoi. Wood and hair, 43 cm.
Coll. Helmut Gernsheim, Castagnola, Switzerland.

O 11
Monkey. Bulu, South Cameroon.
Weathered wood, 24 cm.
Private collection, Paris.

O 12
Animal mask. Duala. Painted wood, 83 cm.
Linden-Museum für Völkerkunde, Stuttgart.

O 13
Animal mask. Duala. Painted wood, 78 cm.
Coll. J. Müller, Solothurn, Switzerland.

O 14
Head. Sao, Chad region. Terracotta, 15 cm.
Institut National tchadien pour les Sciences
Humaines, Fort-Lamy, Chad Republic.

O 15
Statuette. Bafo. Wood, 20.5 cm.
Coll. W. Kaiser, Stuttgart, Germany.

O 16
Janus headdress mask with ringed horns.
Ngutu, woodlands of Cameroon. Wood, 51 cm.
Ethnological collection, Zurich.

O 17
Figures. Bafo. Wood, 14 cm.
Liverpool City Museum, Liverpool, England.

O 18
Double figure. Bafo. Wood, 10.5 cm.
Ethnological collection, Zurich.

O 9

O 10

O 11

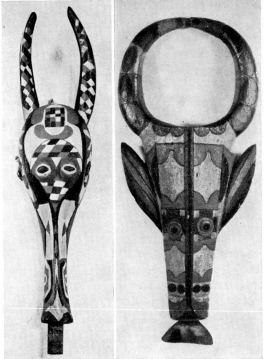

O 12
O 13

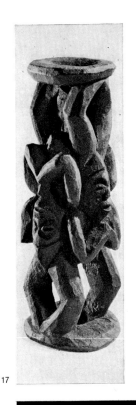

O 17

O 14

O 15
O 16

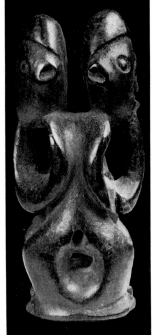

O 18

P The Cameroon grasslands

The landscape here is one of unexpected beauty. Palms and mango trees in profusion stand on gentle hills. The fields of red earth are industriously cultivated. Great domes tower over the magnificent royal palaces. In the markets trade is lively, with the coming and going of gaily clad people, and the unconstrained encounter of Negro and Fulani. Everything speaks of prosperity; and everywhere the stranger encounters an overpowering richness of artistic forms.

The culture of this country has been formed and determined by numerous greater and smaller kingdoms: a variety of village states with despotic kings, courtly palaces and a hierarchically ordered society.

The men build the palaces and decorate the gates and verandahs with reliefs. They are warriors and do some cattle raising, while the women tend the fields almost on their own. At the court, carvers in wood and ivory, brass founders, dyers and weavers work for the ruler and on the furnishing of his palace. They aim not so much at sophistication as at bold decorative visual effects, and achieve the outstanding vigour and vitality which characterizes the art of the grasslands. A degree of realism is something which must not be overlooked: it derives from the desire on the part of the kings for easily recognizable representation, and is somewhat secular in its effect.

In addition to statues and masks, there is an exuberant variety of architectural ornamentation, reliefs, throne stools, drums, food bowls, tobacco pipes and other regalia. Objects for everyday use show the same force, viguor and luxurious ornamentation. The seats of the round stools are often supported by caryatids or decorated with animal or human motifs.

The artists are skilled craftsmen. They work either as commissioned or to build up a stock. Each artist restricts himself to the production of a particular article, at which he becomes a master, although not all succeed in avoiding a tendency towards routine. Many of the masks representing faces, with their open goggle eyes and the teeth showing in their mouths, have been formalized till they are no more than a grimace. Usually the artists give their works to the king, from whom they expect a princely gift in return.

It is difficult to define the styles of individual kingdoms, because there has been a constant mutual influence by means of the exchange of works of art.

A whole series of important styles of carving derives from the Bamileke group. This extends from Bamenda across the Dschang district as far as the River Nun, and includes amongst others the following tribes: the Bangwa, Bacham, Bagam, Bangante, Batie, etc. It is characterized by original forms, imaginative in their movement. A certain influence from the Tikar can be discerned amongst the western Bamileke. The Bangwa achieve interesting and very bold turning movements. Every king of the Bamileke has an image made of himself and the mother of his firstborn son, which is set up on the verandah of his palace as a source of power for his descendants. Here kings can be found smoking pipes, warriors with enemy trophies, mothers with children, etc. The style is harsh and stern, rarely naturalistic, and sometimes expressive to the point of being grotesque.

A few of the gigantic masks which Pierre Harter ascribes to the western Bamileke (the Bangwa and Dschang region) are the most magnificent and

P 1
Queen, mother of the twins, symbol of greatest fertility. Bamileke. Wood, 73 cm. Private collection.

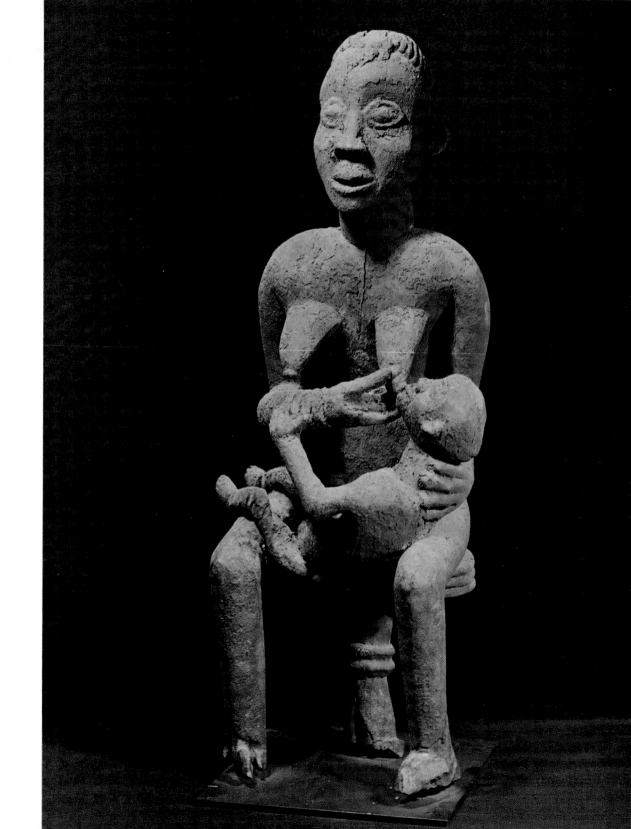

powerful of all. They bear witness to a clear conception, and a knowledge of the effective combination of three-dimensional forms and smooth and interrupted surfaces. These masks are carried in front of kings and members of the secret society at important state events. Grandiose masks of this kind appear above all at the funeral of the king.

The Bangante, on the other hand, make more delicate masks with a sensitive expression.

Several styles from western Cameroon, from Bamenda and the adjacent districts, display the decisive influence of the Tikar, who immigrated from Adamawa. Amongst these are the styles of the Bekom, Babanki and Bali. The Tikar were famous artists in cast brass, connected with Benin.

The thrones, adorned by a statue, and the masks of the Bekom are particularly noble, well-proportioned and majestic. They show a certain degree of realism, combined with a vigorous simplification. It has been conjectured that these thrones served as stands for the gourds which contained the teeth and bones of the royal ancestors, and therefore the life force of the tribe. The faces are expressive, and are often covered with copper foil. Protruding ears and prominent eyeballs are typical features. Since the great masks are carried on the top of the head, their eyes do not need to be pierced. The art of the Babanki is particularly rich in figures. Their carvers were so highly regarded that they could reach the rank of king. Whole compositions of figures formed the frame of the palace gates and supported the verandah roofs. They record certain events which serve to glorify the king or act as an exhortation to loyalty and morality. Most of the stools decorated with a heavy carved surround and figures are made by the Babanki, and the same is true of

ivory horns and drinking horns carved in relief. The size and shape of the thrones which are used at the meetings of the council and law court depends upon the rank of the kings and nobles in the hierarchy.

The third important group of styles in the Cameroon grasslands is that of the Bamum, who live east and north-east of the Bamileke, and whose capital is Fumban. At the turn of the century there ruled here King Njoya, an outstanding personality of whom German colonists speak with admiration. Njoya was a wise ruler and a magnificent patron of the art and culture of his country. He even invented his own form of writing in which to record the history of his people, and founded in Fumban a museum where historical records could be protected and preserved. The stimulus Njoya gave to the artists at his court was immense. In the workshop of his founders and carvers, weavers and dyers, there was never a moment's rest.

The Bamum were also influenced by the Tikar, and adopted from them the art of brass casting for masks, tobacco pipes and ornaments.

The characteristics of their work are puffed-out cheeks, open eyes in deep hollows, double arches representing the eyebrows, spreading nostrils and protruding ears, open mouths with white teeth and gaps between the teeth, and various kinds of headdress.

The fullness of the cheeks expresses the idea that the rulers were well nourished. The decorations on the carvings, textiles, brass and clay pipes and ornaments are a delight to behold. Regardless of anatomical correctness, motifs of different symbolic animals are combined to give a decorative effect, with the aid of complicated pierced work. We see bats, chameleons, toads and spiders as symbolic and oracle animals, while

P 2
Giant mask with lizard on top, worn in burial and enthronement processions of the kings. Bamileke. Wood, 86 cm. Private collection.

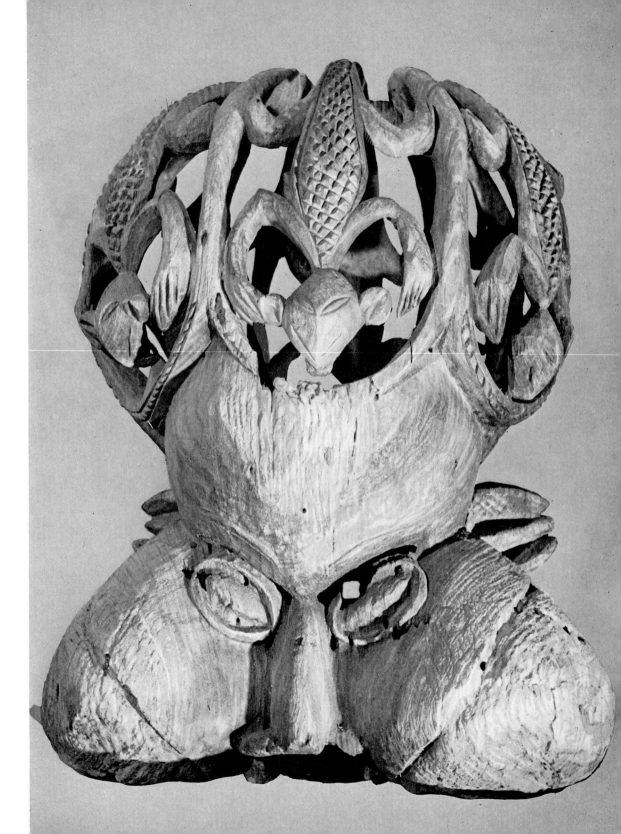

buffaloes, elephants and leopards are symbols of power.

The great tobacco pipes, carved as figures, were carried behind the kings by servants, and King Njoya gave away such pipes as gifts of honour. The intricate snake motifs are a reference to the royal power, while the bird spider, which is said to have lowered the first ancestor from heaven on its thread, is the spirit of wisdom and an oracle animal. In the cult, tobacco smoke is blown on to the fields in order to bring fertility. The men carve the tobacco pipes from soft clay and combine them with human and animal motifs.

At the time of the new moon and before hunts, masked dances are performed with the animal masks.

As far as textiles are concerned, large cotton cloths with a blue and white pattern are a dominating theme in the cult and dance area. The patterns are produced by the tie-dyeing process; all the parts of the cloth which are meant to remain white are tied round with bast before the cloth is dipped in the bath of indigo, and are untied afterwards. Even today, artists and craftsmen are at work on the 'artists' street' of Fumban. Their main customers are tourists. The quality of the castings has largely declined and many of them have become coarse and schematic.

Brass casting was particularly practised and spread by the Tikar, Bamum and Bagam.

P 3
Ancestor statue, demon head above the head covering, sword handle in the hand. Bamileke. Weathered wood, 145 cm.
Private collection, Geneva.

P 4
Throne with statue. Bekom. Wood, necklace of glass beads, hair, iron and brass, 172 cm.
Coll. Katherine White Reswick, Los Angeles.

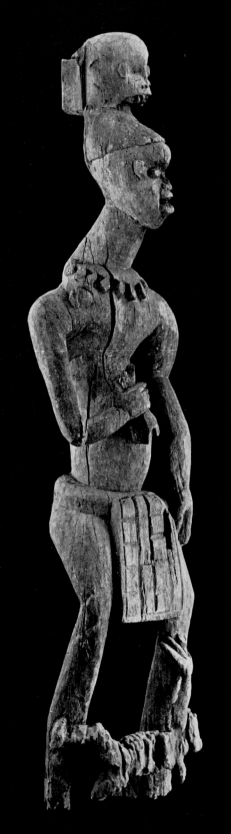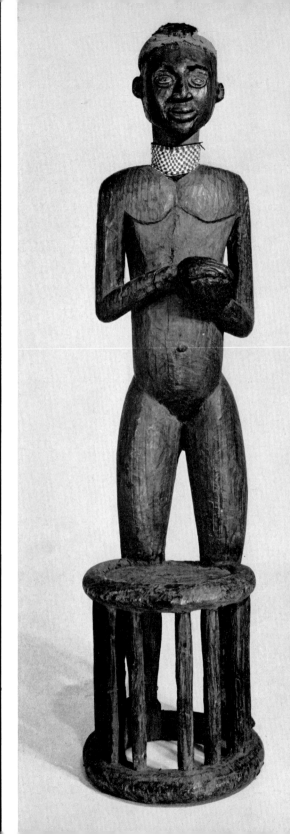

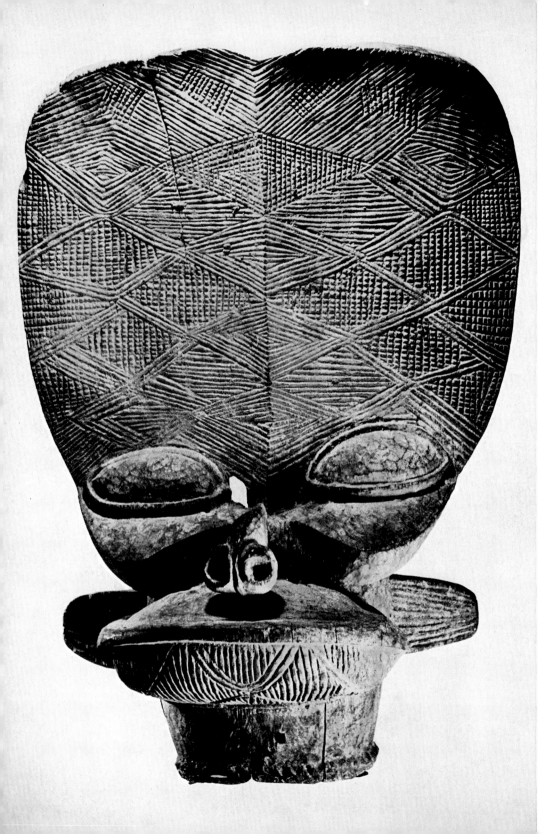

P 5
Dance mask. Bamileke-Bacham.
Wood, 82 cm.
Coll. J. Kerchache, Paris.

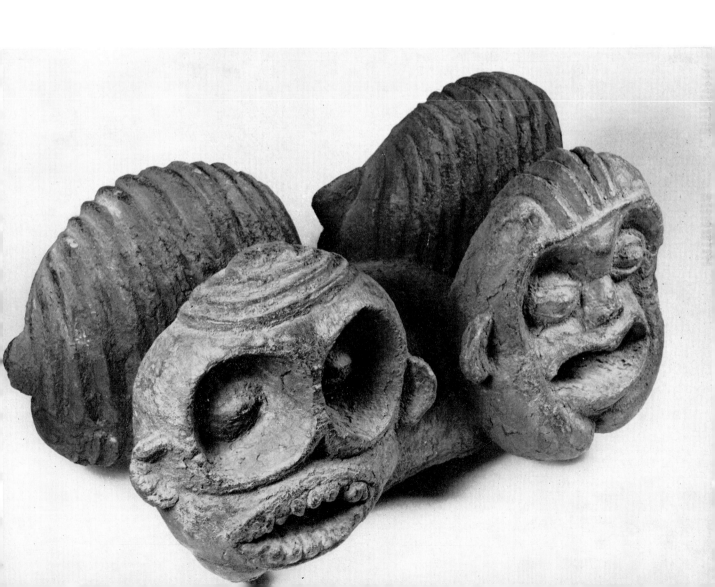

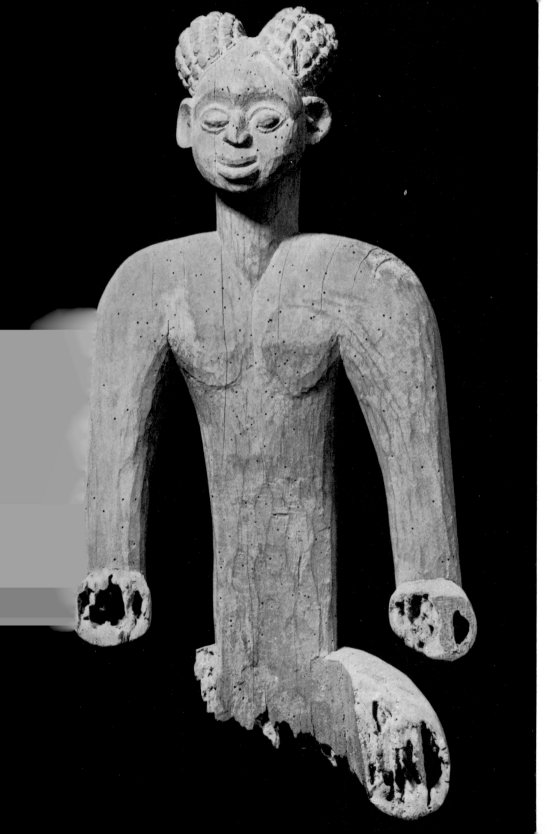

P 7
Ancestor statue. Bekom.
Wood, 55 cm.
Coll. Pierre Harter.

P 8
Veto staff with two heads.
Bangwa. Wood, 15 cm.
Coll. Hélène Kamer, Paris.

P 9
Dynamic figure. Bamileke.
Wood, weathered and eaten by
termites in places, 83 cm.
Coll. J. Kerchache, Paris.

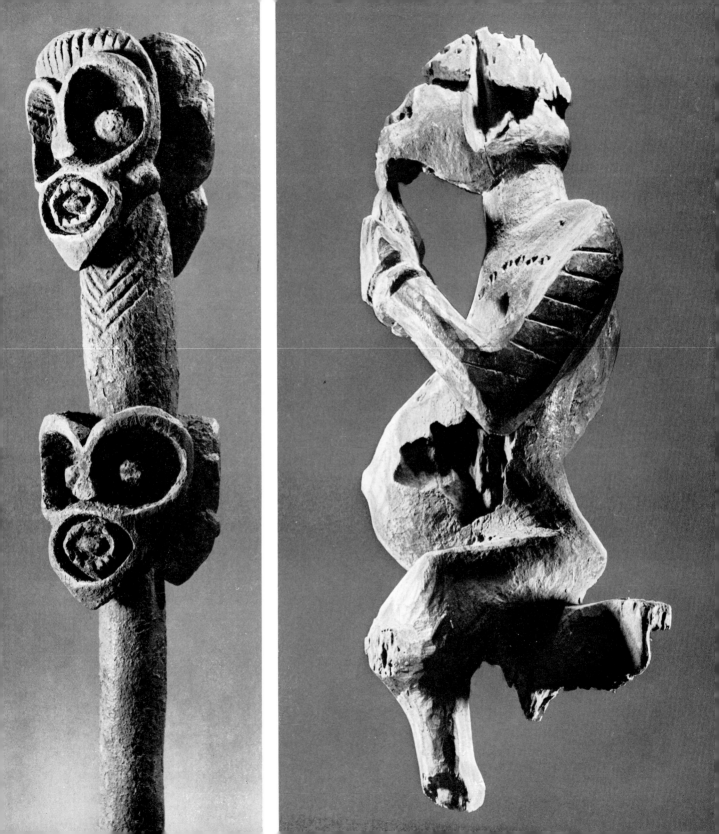

P 10
Headdress mask. Bekom. Wood, 36 cm.
Linden-Museum für Völkerkunde, Stuttgart, Germany.

P 11
Kungan mask of the *Mandyong* society.
Bamileke-Bangante. Wood with human hair, 34 cm.
Coll. Pierre Harter.

P 12
Running figure. Bamileke- Bangante. Wood, 31 cm.
Private collection, Paris.

P 13
Seated statue with dish. Bamileke.
Wood with white, blue and red glass beads, 67 cm.
Coll. J. Kerchache, Paris.

P 14
Mask. West Bamileke, Bangwa-Dschang region, with
Tikar influence. Wood, 67 cm.
Rietberg Museum, Zurich.

P 15
Buffalo mask. West Bamileke, Bangwa-Dschang region.
Wood, l. 75 cm.
Private collection, Geneva.

P 16
Animal mask with beasts on top. Bekom.
Wood, 42 cm.
Coll. W. Schweizer, Kastanienbaum.

P 17
Elephant mask. Cameroon Grasslands. Wood, 67 cm.
Coll. J Müller, Solothurn, Switzerland.

P 18
Dish with supporting figure. Bamileke. Wood, 23.5 cm.
Coll. E. Leuzinger, Zurich.

P 19
Twins. Bamileke, Little Bangwa. Wood, 45 cm.
Coll. Pierre Harter.

P 10

P 11

P 12

P 13

P 14

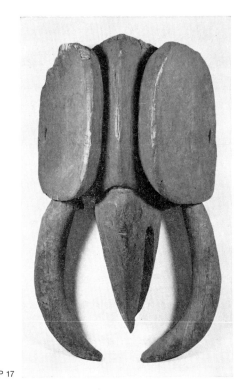

P 17

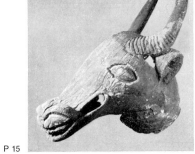

P 15

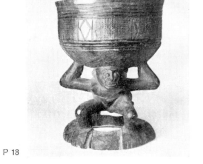

P 18

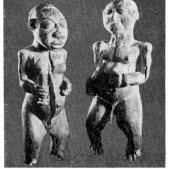

P 16

P 19

P 20
Standing statue. Bamileke. Wood, 110 cm.
Private collection, Geneva.

P 21
Statue of a man with open mouth showing teeth.
Bamileke. Wood, 130 cm.
Coll. Comte Baudouin de Grunne,
Wezembeek-Oppem, Belgium.

P 22
Post with two female figures. Bamum. Wood, 170 cm.
Coll. J. Kerchache, Paris.

P 23
Executioner's post from the royal audience chamber;
warning to guests as to the fate of those who
misbehave towards the queen.
Babanki-Tungo. Wood, 192 cm.
Museum für Völkerkunde, Basel.

P 24
Bowed figure. Bamileke. Wood, 43.5 cm.
Rietberg Museum, Zurich.

P 25
Lidded bowl with animal. Bamileke. Wood, 56 cm.
Coll. Pierre Harter.

P 26
Stool with six hares. Cameroon Grasslands.
Wood, 39.5 cm.
Linden-Museum für Völkerkunde, Stuttgart.

P 27
Stool with twelve supporting figures. Bamum.
Wood, diam. 40 cm.
Coll. Maurice Bonnefoy / D'Arcy Galleries, Geneva.

P 28
Bead throne with snake motifs. Bamum.
Wood, coloured beads and cowrie shells, 130 cm.
Rautenstrauch-Joest-Museum, Cologne, Germany.

P 29
Drum with crouching figure. Bamileke. Wood, 60 cm.
Private collection, Geneva.

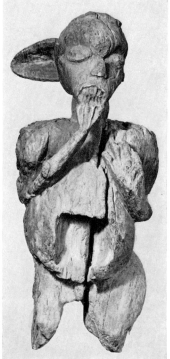

P 20

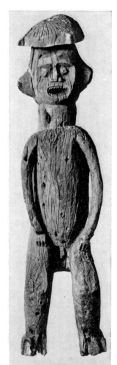

P 21

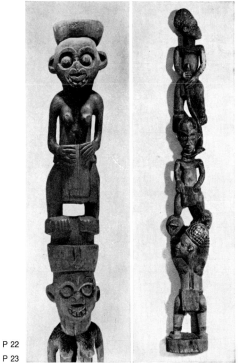

P 22
P 23

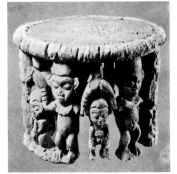

P 26

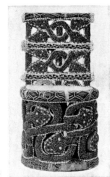

P 27

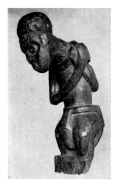

P 24

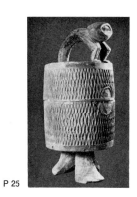

P 23

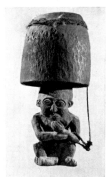

P 25

P 29

Gabon and neighbouring countries

Thick rain forest with an oppressively damp climate, the slash and burn cultivation of clearings in the forest and the supreme authority of the secret societies provide the conditions under which life is lived by the various peoples between the Sanaga and the lower Congo in Gabon, Spanish Guinea, southern Cameroon and part of the Democratic Republic of the Congo (Brazzaville). Large and small migrations and population movements have always taken place in this region. In the first place, the practice of slash and burn agriculture obliged the Africans to move their settlements frequently, while in the second place the immigration of new tribes led to population movements on a larger scale. The indigenous inhabitants are the Pygmies and the Bakwele. Centuries ago, the Bakota and Mpongwe and many others entered the Ogowe region from the north-east. The River Ivindo has been the route of many migrations, linking equatorial Africa with Adamawa and the central Sudan. But in the last century the Bakota had to give way in their turn to new arrivals and move further south, under pressure from the warlike Pangwe, who came from Adamawa and about 1870 reached the Atlantic coast. Once again the encounter with people and ideas from outside influenced art. In the protection of the rain forest, cut off from the influences of Islam, art could develop freely in the service of the cult of the ancestors and spirits. Thus in spite of difficult living conditions, we find here sculptures of the highest rank and a great variety of carvings.

We can distinguish three main centres of art, the Pangwe (Fang), Bakota and Bapunu groups. There are in addition a number of interesting sub-styles, particularly those of the Bakwele, Mitsogho and Kuyu.

Q 1
Mask in a circle of horns, Bakwele. Wood, 55 cm.
Coll. Charles Ratton, Paris.

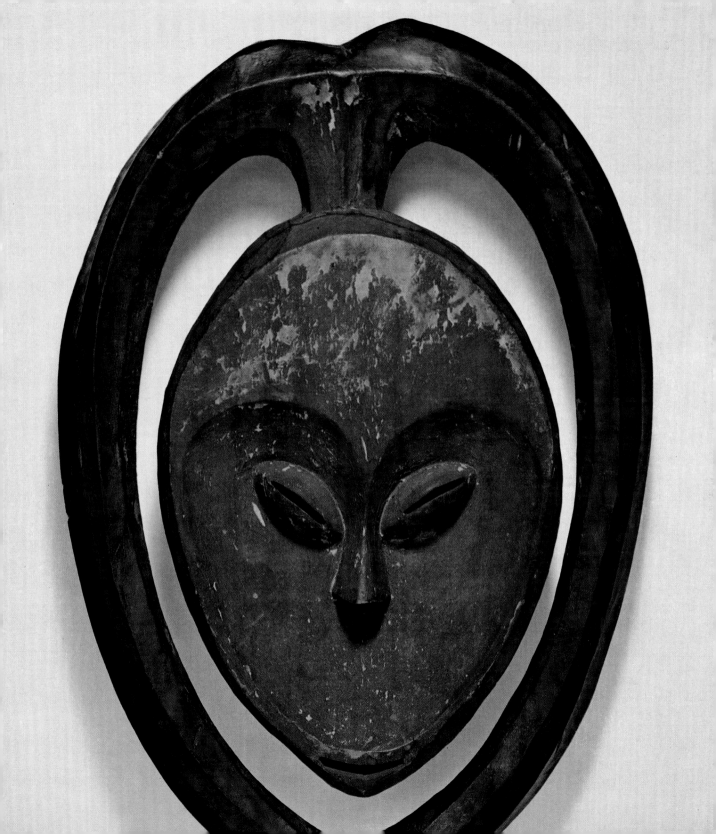

Q The Pangwe (Fang) and Bakwele

The Pangwe

Today the Pangwe live north of the Rivers Ogowe and Ivindo: the northern Pangwe, i. e. the Bulu, Yaunde, Eton and Ngumba in southern Cameroon; the central Pangwe, i. e. the Mvae and Ntumu in Spanish Guinea and northern Gabon; and the southern Pangwe, i. e. the Fang in Gabon.

Fang is the usual term applied to the art of the various Pangwe tribes. It applies both to those who were driven out by the Pangwe and to those who mixed with them, for in both cases the style seems to have been due largely to the Pangwe.

Their wooden *bieri* figures and *bieri* heads are the most highly valued by western artists. *Bierie* are boxes with lids consisting of a piece of bark sewn into a cylinder. Their main content is the skull of the founder of the village, but they also contain other skulls and bones of prominent figures of the past or of enemies killed in battle. They are all washed clean, painted, encrusted with copper and decorated with beads, and all kinds of substances which contain life force are added to them. On top of these boxes are set wooden sculptures which are not merely symbols of the mythical first ancestors, but the very essence of the soul of the tribe. Thus the *bieri* are reliquaries, bearers of power and a protective force for the whole family.

The *bieri* are placed on an altar and cared for by the head of the family. They are rubbed with oil every morning and sacrifices are regularly offered to them. They are so full of power that they can heal the sick. Women and the uninitiated are never allowed to see them. At the great initiation feast the boxes with the figures on them are brought out, for the ancestors are meant to take part in the feast and grant petitions. Indeed they will even speak to the newly initiated members of the society, an illusion which the priest effects with the aid of sleight of hand and narcotics.

If one of the Pangwe leaves his village to set up his own farmstead, he takes with him the skull of the founder of his own clan's village and with it makes his own *bieri,* which he enriches in the course of time with other bones, skulls and objects which bear power.

These conceptions provide the source of a spiritualized art, an excellent and utterly serious sculpture, sensitive in feeling yet powerful. The sunken cheeks, the protruding, angular chin and the spellbound attitude give a presentiment of death. But the bodies are rounded, well-proportioned and balanced. The trunk takes the shape of a tall column with a protruding navel, the limbs bulge and sometimes give the impression of having been tied in at the joints. The face is oval and formed of peaceful, finely arched shapes; the curve of the eyebrows forms a continuous line with the nose. Sometimes the eyes are carved as a semi-circle, while sometimes they are disc-like in shape, or marked by inlaid discs of metal or bone or even nails, standing out brightly in the dark, bronze coloured wood. The finely vaulted forehead is topped with a woven cap or ringlets. The ringlets often fall behind to the neck or hang down at the side, forming a counterpoint to the peaceful face. The hands often hold a vessel or a medicine horn, or rest on the thighs. Decorations are added very sparingly. The *bieri* heads, with their lengthened necks, or the whole figures seated on a post, are placed on top of the boxes

Q 2
Bieri, reliquary figure.
Pangwe. Wood, 49 cm.
Coll. J. Kerchache, Paris.

Q 3
Bieri, reliquary figure.
Pangwe, 19th century,
wood, 58 cm.
The Brooklyn Museum,
New York.

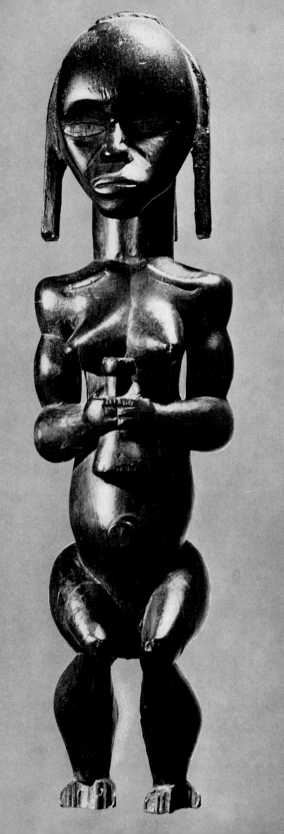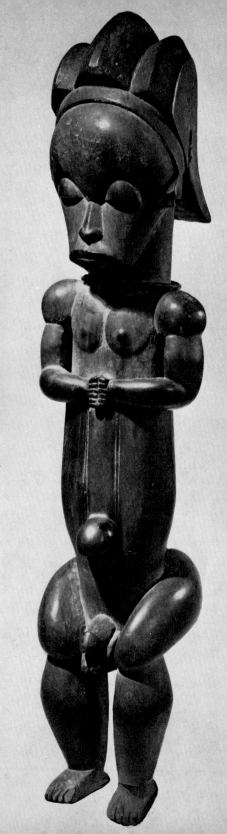

of bark. Small *bieri* figures on boxes filled with herbs protect the children. The artistic significance of Pangwe sculpture lies in the force and intensity of its brilliantly simplified forms. Even though its basic character is relatively the same everywhere, there are all kinds of astonishing changes and variations, from realism to the starkest abstraction; every figure and every head is a distinct personality. Even an outsider is aware that a valid statement is being made here. But it seems scarcely possible to classify the various styles by region. Too many migrations and influences have crossed in Gabon for this to be possible. Moreover, their origin lies so far back that it is no longer possible to trace these schools of carvers. In general the figures of the northern Pangwe are slimmer and have shorter legs. Those of the Ngumba have inlaid discs as eyes, an oval mouth with teeth and a cylindrical navel. They come in pairs, the man wearing a beard. Those of the Mvae, Ntumu, etc. have the upper thighs horizontal, and hollowed-out semi-circular eyes. The dark patina, like a lacquered surface, is produced by steeping in a decoction of kopal resin, pulverized wood charcoal and palm oil, and also by the regular pouring on of libations.

The Fang secret society masks are very different from the figures. They appear as terrifying forest spirits, as highly respected judges and policemen, who drive out all evil wizards and witches. Their white colour greatly increases their spirit-like appearance.

Most of the three-dimensional figures made by the Pangwe are intended for reliquaries. There are, however, also objects for everyday use, such as harps, drums, bells, fans, spoons and staffs which are decorated with figures, and which all reveal a sure feeling for style.

The Bakwele

The Bakwele, who live along the upper courses of the Rivers Ivindo, Sangha and Likwale in eastern Gabon, south-east Cameroon and parts of the Democratic Republic of the Congo, produce masks of a high degree of abstraction and an effect of unreality. Many of the human faces have three-dimensional narrow almond-shaped eyes set diagonally in a heart-shaped face, while others are worked with animal motifs into a cubist pattern. The phenomenon of 'heart-shaped' faces in Gabon, as well as amongst the Balega and Wabembe far to the east, and amongst many other peoples throughout the world, calls for comparative studies. To represent the human face with its eyebrows in the abstract form of a heart seems to me to be an elementary idea, one of many which is common to all people. Within the limits of Africa, however, there must have existed either links between the tribes mentioned or at least a common source. Such parallels can also be extended, for example, to the extraordinary shape of the shoulder blades in the figures of the Mitsogho and Bambole.

The two Bakwele masks shown from the Charles Ratton collection, together with the Bakwele masks of the Webster collection in the British Museum, those in the Museum of Modern Arts in New York, those with six eyes in the collection of the artist Lapicque, the double mask of the Rautenstrauch-Joest Museum in Cologne, and other important pieces were brought from French Equatorial Africa by the administrator Aristide Courtois. Aristide Courtois found all the pieces in the same cult house. Some of the masks were worn as face masks, while others were hung on the wall at ritual gatherings.

Q 4
Bieri, reliquary figure.
Pangwe. Wood, 49 cm.
Coll. A. Fourquet, Paris.

Q 5
Female *bieri* on a reliquary box. Pangwe.
Wood and bark, 25.5 cm.
Ex coll. Ullmann.
Coll. A. Fourquet, Paris.

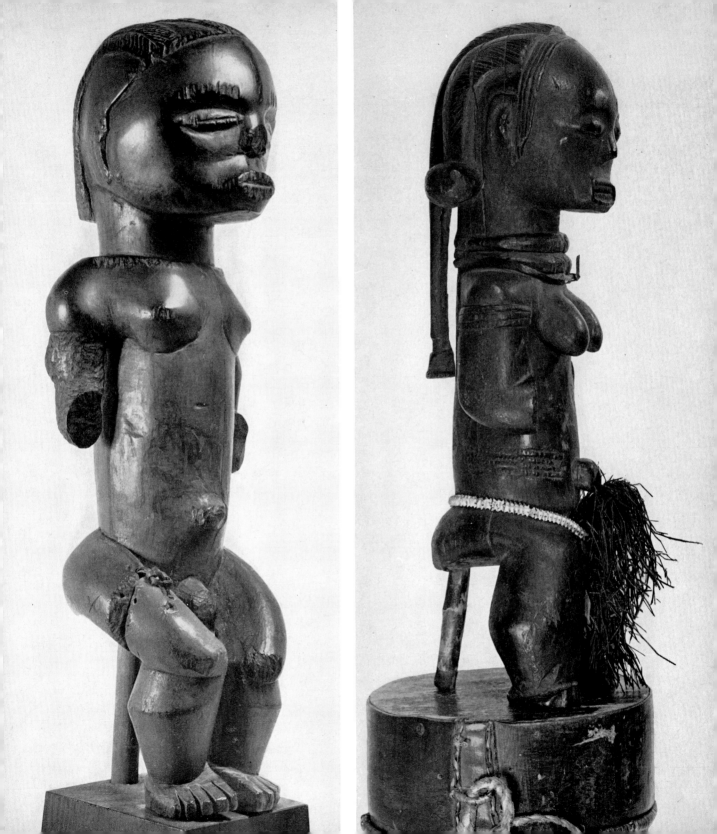

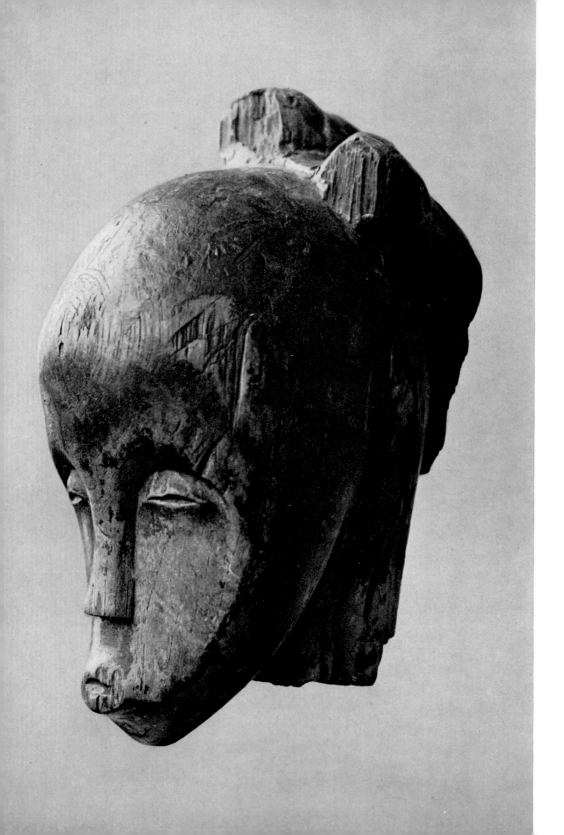

Q 6
Bieri head. Pangwe.
Wood, 29 cm.
Coll. Alfred Muller,
St Gratien, France.

Q 7
Bieri head. Pangwe.
Wood, traces of red and white
paint, 39 cm.
Rietberg Museum, Zurich.

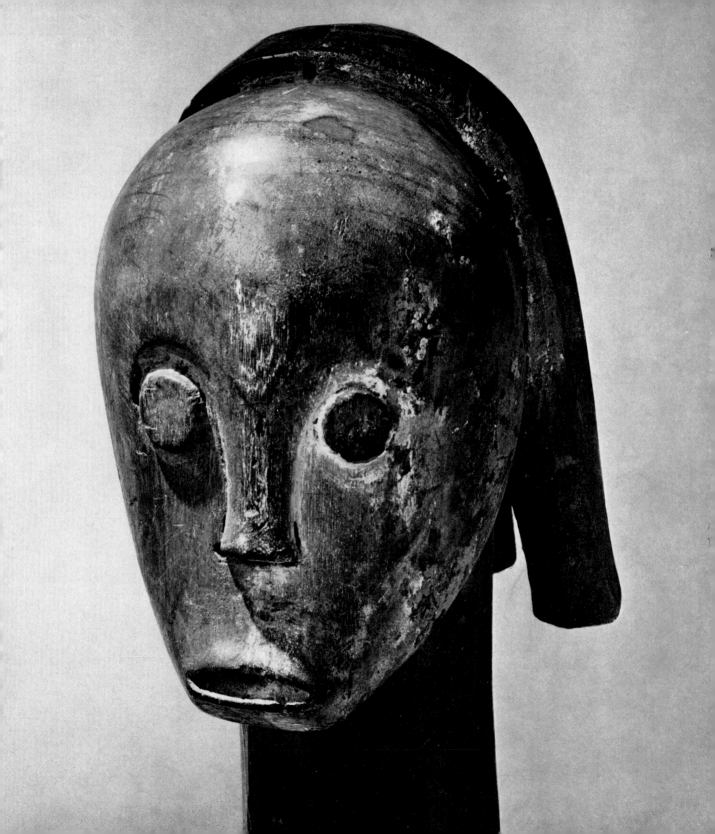

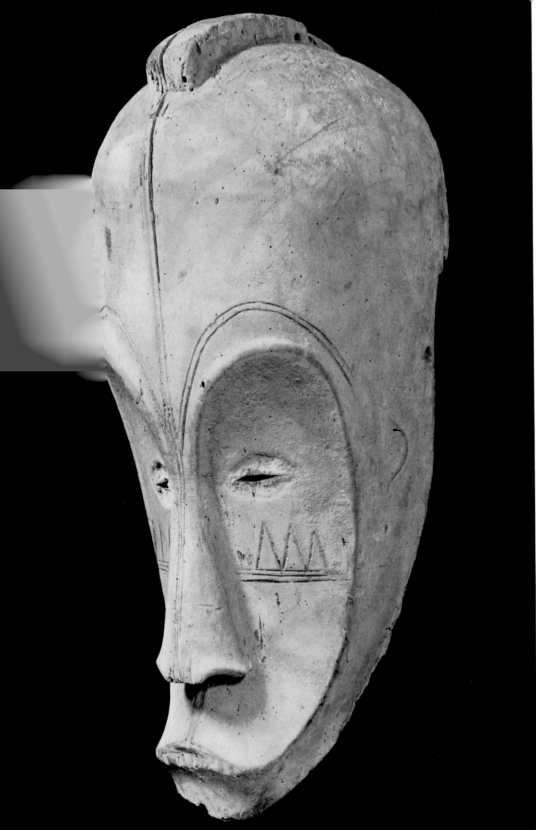

Q 8
Dance mask of the *Ngi* society.
Fang. Wood, 50 cm.
Coll. Pierre Verité, Paris.

Q 9
Antelope mask. Bakwele.
Sembe village, Upper Central
Congo, Central African
Republic.
Wood painted white, 68 cm.
Göteborgs Etnografiska
Museum, Göteborg, Sweden.

Q 10
Boar mask. Bakwele.
Wood, 36 cm.
Coll. Charles Ratton, Paris.

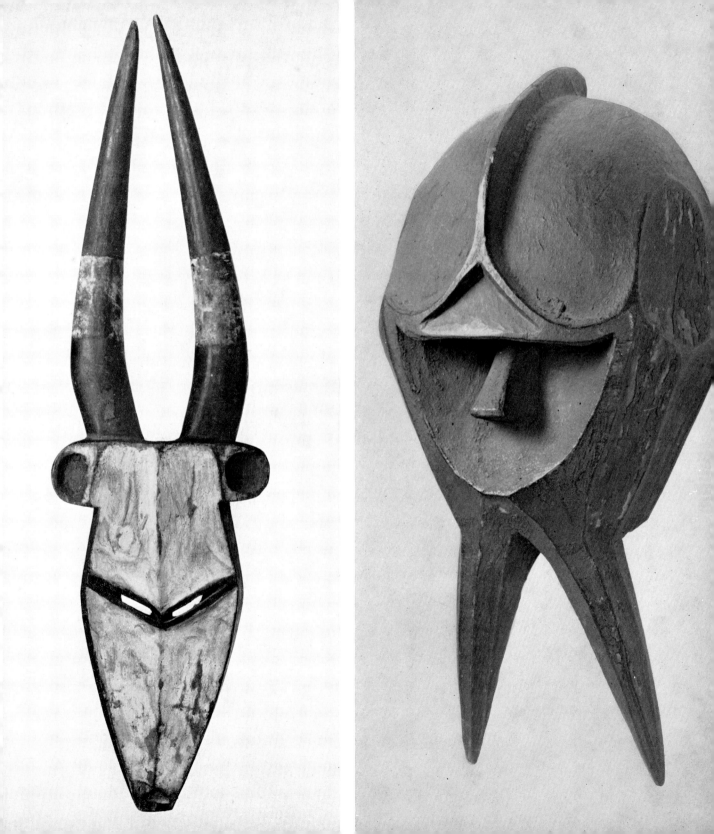

Q 11
Bieri figure. Pangwe. Wood, 21 cm.
Coll. Couillard, Vincennes.

Q 12
Bieri figure. Pangwe. Wood, 25.5 cm.
Coll. A. Fourquet, Paris.

Q 13
Bieri head on a bark box. Pangwe.
Wood and bark, round shell eyes, 48.5 cm.
Musée d'Ethnographie, Neuchâtel, Switzerland.

Q 14
Bieri, reliquary figure. Pangwe. Wood, 53.5 cm.
Rietberg Museum, Zurich.

Q 15
Bieri, reliquary figure, Pangwe-Ngumba. Wood, 48.5 cm.
Ethnological collection, Zurich.

Q 16
White mask of the *Ngi* society. Fang. Wood, 58 cm.
Private collection, Geneva.

Q 17
Bieri figure with medicine horn in the hands.
Pangwe-Ngumba. Wood with tin eyes, 53 cm
Ethnological collection, Zurich.

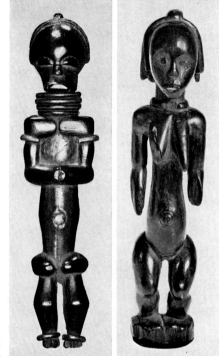

Q 11
Q 12

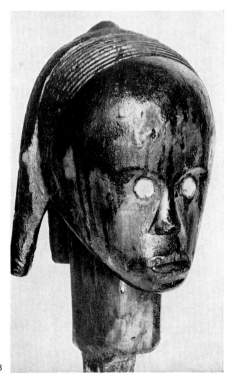

Q 13

258

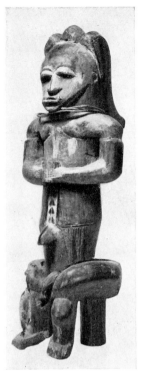

Q 14

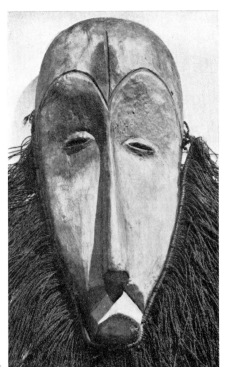

Q 16

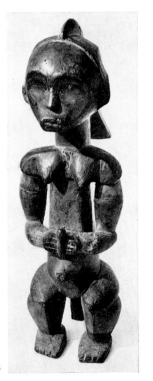

Q 15

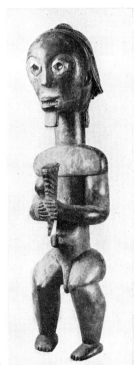

Q 17

Q 18
Bieri, reliquary figure. Pangwe.
Wood, eyes garnished with brass, 42 cm.
Rietberg Museum, Zurich.

Q 19
Bieri, reliquary figure. Pangwe. Wood, 46.5 cm.
Coll. E. Leuzinger, Zurich.

Q 20
Chimpanzee. Fang-Ntumu. Wood, 40 cm.
Coll. Christian Duponcheel. Brussels.

Q 21
Mask. Fang. Wood, 40 cm.
Coll. Christian Duponcheel, Brussels.

Q 22
Head on a stool. Bakwele. Painted wood, 41 cm.
Coll. M. Couillard, Vincennes, France.

Q 23
Janus helmet mask. Fang.
Wood, white painted decoration, 32 cm.
Coll. Winizki, Zurich.

Q 24
Helmet mask with five faces. Fang.
Wood, painted white, with kaolin, 39 cm.
Coll. A. Fourquet, Paris.

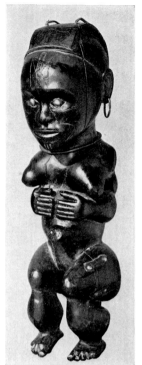

Q 18

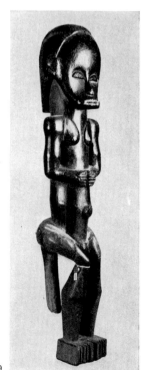

Q 19

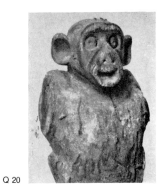

Q 20

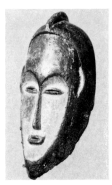

Q 21

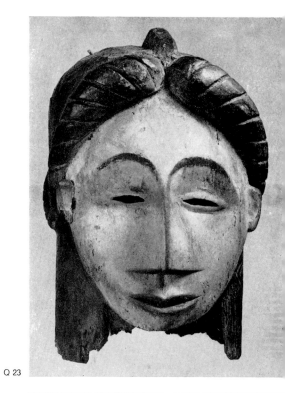

Q 23

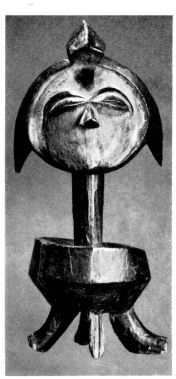

Q 22

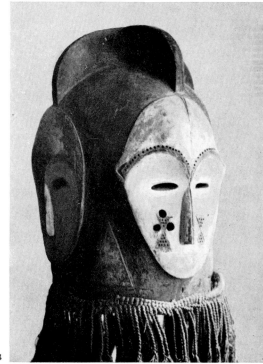

Q 24

R The Bakota, Mitsogho, Bapunu, Kuyu, etc.

The Bakota group

The Bakota, who settled under pressure from the Pangwe in the forest between the upper Ogowe and the Ivindo share with many other tribes in eastern Gabon and part of the Democratic Republic of the Congo the practice of making boxes to hold skulls, topped by carved figures. The spirit of the dead watches over the well-being of the clan. In this case, however, they are made in a completely different way. The container consists of a woven basket and on it is set an imaginary figure, in the form of a flat wooden board plated with metal foil. The face is raised, and takes the form of a narrow oval. Above it is set an arch in the shape of a half-moon, derived from horns. The curves at the side represent the cheeks or the coiffure. To the geometrically-shaped head with its narrow neck are added lozenge-shaped arms or shoulders, not feet — so that the often-used expression 'head on feet' is wrong. The basket for the skulls on which the head is set forms the body of the guardian figure, which is known as *mbulu-ngulu*. If it is a double, Janus figure, with one forehead concave and the other convex, it is called *mbulu-viti,* and represents the antagonistic forces of the cosmos. The small spherical eyes and the small ridge representing the nose lie exactly at the intersection of the two axes of the brass foil, which alternates decoratively with copper foil.

The sweeping forms are discreetly ornamented with inscribed patterns.

Metal-plated flat faces of this kind occur in many sub-styles. Thus we find similar forms amongst the Aduma, the Obamba and the Ondumbo. The *bweti* of the Mahongwe and related tribes (the Ossyeba in earlier studies) show special artistic charm. Strips of brass surround the surface of the face, in which the knobs representing the eyes provide an effective centre point.

The tribes of the Bakota region also use masks to drive out evil spirits (Ambete, Banzabi, etc.). The mask forms have not the slightest resemblance to the guardian figures. The powerful *mboto mboli* helmet masks of the Bakota, which represent a terrifying spirit, are worn especially at the boys' circumcision festival. They are three-dimensional, often Janus-headed, and have heavy eyebrows, protruding eyes and often a cut-away chin. A board-like narrow arch, running from back to front, towers above the top of the head, and forms a constantly changing focal point in the dance.

A speciality of the Bakota consists of throwing-knives in the shape of a hornbill's head. Amongst the other styles of figure found in Southern Gabon we have already mentioned the vigorous sculptures of the Ambete and the sensitive three-dimensional sculptures of the Mitsogho. The Mitsogho, in the hilly forest country of central Gabon, erect large planks, carved as figures, in their cult houses. They combine their *bweti,* cult bells, fans and bells with tiny carved human heads, which can be recognized by their heavy arched eyebrows, narrow slit eyes and delicately carved mouths. Many of their carvings have powdered red *tukula* wood rubbed into them. An unusual feature is the way in which the shoulders of many statues are thrust forward; this is reminiscent of the carvings of the Bambole who live in the northern Congo.

The Bapunu group

French scholars tend to attribute the origin of the famous 'white masks of the

R 1
Mbulu-ngulu. Guardian figure with dished forehead. Bakota. Wood, covered with brass sheeting, 68 cm. Coll. Charles Ratton, Paris.

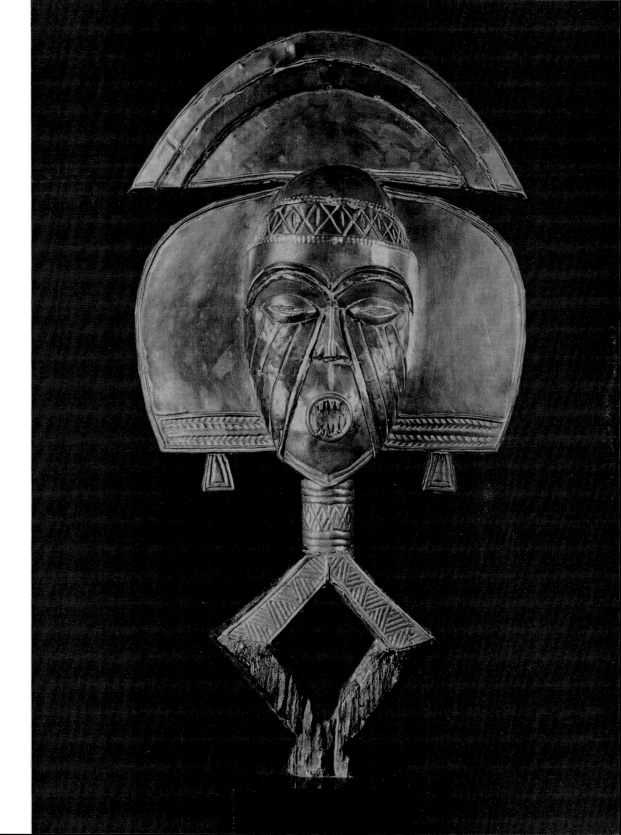

Ogowe to the Bapunu. But almost all the tribes of southern Gabon, between the upper Ogowe and the Atlantic Ocean, make use of these white masks: the Balumbo, the Eshire, the Mashango, the Bakota, the Mpongwe, the Galoa, the Bapunu, the Myene, the Mitsogho, the Banzabi, the Bavui, etc. Since collectors usually obtained these masks in Lambarene and on the Mpongwe coast, they called them 'Mpongwe' masks. But the coast was only the end of their journey. Their centre of distribution is certainly to be sought in the heart of Gabon. Hans Himmelheber saw the white masks appear on stilts as the spirits of the dead. They spoke with spirit voices by means of a concealed instrument consisting of a small gourd closed with spider's web. There is a startling similarity between this and the costume of the spirits of the dead which I saw myself amongst the Afo in the highlands of Nigeria: the same white masks on stilts, the same concealed instrument. One recalls that many of the tribes of Gabon migrated from Adamawa.

The white masks of the Ogowe differ in detail and expression, but all share a characteristic and unmistakable style. They are three-dimensional. The realistic, smooth and gently rounded face, with its full red lips, delicately curved eyebrows and elongated, almost closed eyelids, radiates an atmosphere of enchantment. It is painted white with kaolin, and crowned with heavy twists of hair, painted black. The forehead and temples are sometimes decorated with patterns of scars. It can only be by chance that the total impression is sometimes reminiscent of Japanese masks, for no single formal element is present which is not wholly African. We have often already encountered the white colour of the spirits, the slit eyes (Bakwele) and the delicate lyrical expression.

The Kuyu

Here we have an outpost of the art of carving, situated right down in the Democratic Republic of the Congo between the Sangha and the upper Ogowe, on the river Kuyu, which flows into the Congo. In order to give due honour to the mythical snake *Ebongo,* who created the first man, the Kuyu, the Baboshi, etc., perform the *Kebe-kebe* snake dance. The dancers carry wooden heads tied to poles over six feet above their heads. They themselves are hidden under a flowing white garment — formerly made of raffia — and give a convincing effect of a spirit. The wooden face, with its open eyes, and teeth showing in its mouth, is broad and swollen, and is sometimes of an agressive realism. The carvings are covered with scar patterns and painted in garish colours. The female figures symbolize *Ebolita,* the mother of mankind.

R 2
Head for the *Kebekebe* snake dance; mother with two children, towered over by an elephant. Kuyu. Painted wood, 71 cm. Coll. Charles Ratton, Paris.

R 3
Double-sided guardian figure. *Mbulu-viti.* Bakota. Wood covered with copper and brass sheeting, 64 cm. Coll. J. Kerchache, Paris.

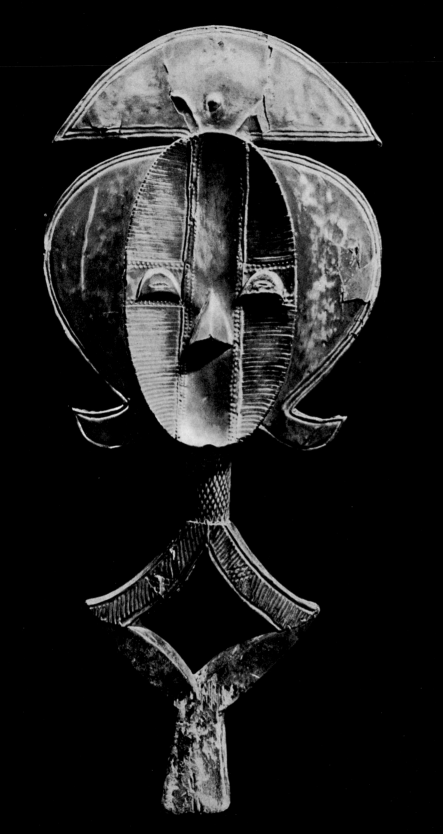
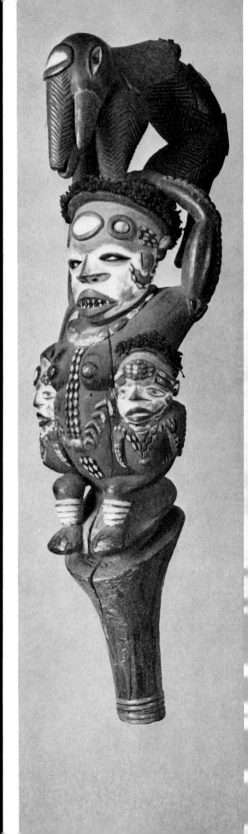

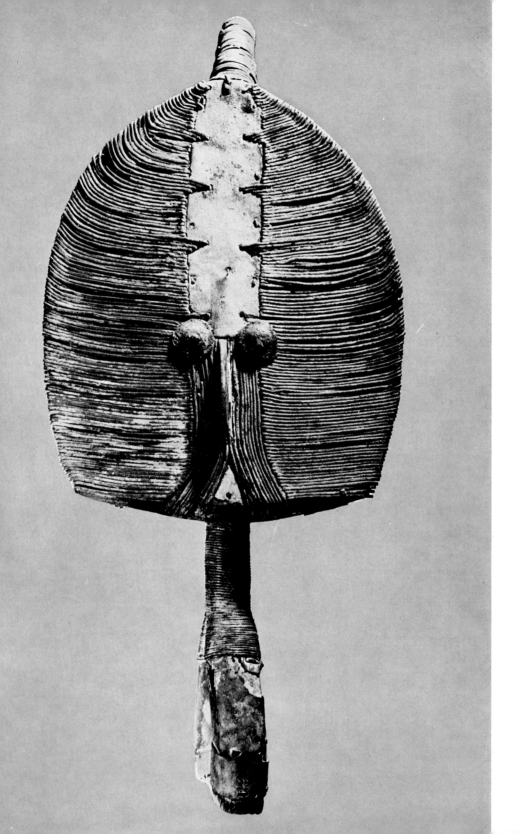

R 4
Bweti, guardian figure.
Mpongwe, Gabon.
Wood and metal strips, 56 cm.
Coll. J. Kerchache, Paris.

R 5
Mask. Bakota.
Wood with brass sheeting,
32 cm.
Coll. Pierre Verité, Paris.

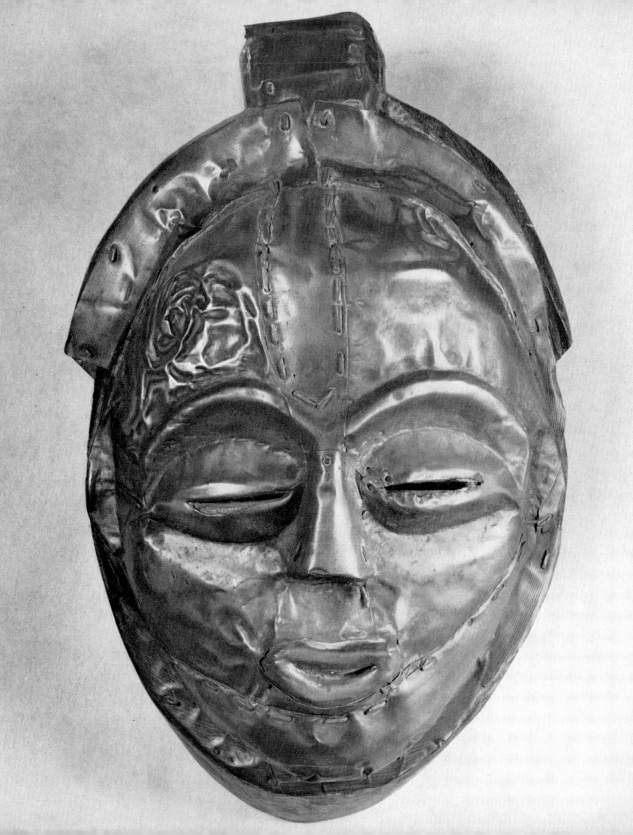

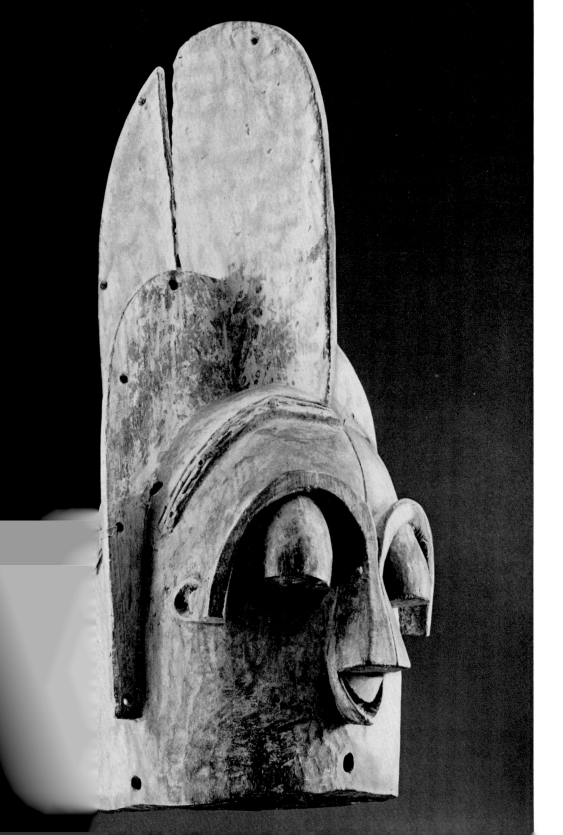

R 6
Helmet mask, *Mboto-Mboli*.
Bakota, Gabon. Wood, 70 cm.
Coll. J. Kerchache, Paris.

R 7
Janus head, hair arranged in
three peaks. Mitsogho.
Wood, copper nails and white
kaolin, 26 cm.
Coll. A. Fourquet, Paris.

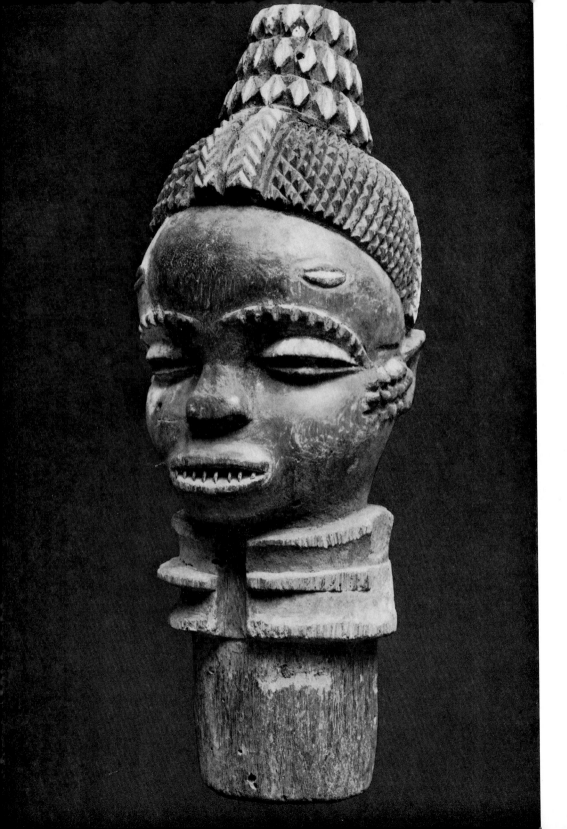

R 8
Head for the *Kebekebe*
snake dance. Kuyu.
Painted wood, 37 cm.
Coll. Charles Ratton, Paris.

R 9
White mask, hair in two
ridges, tribal cicatrices.
Bapuno tribe.
Painted wood, 30 cm.
Coll. Pierre Verité, Paris.

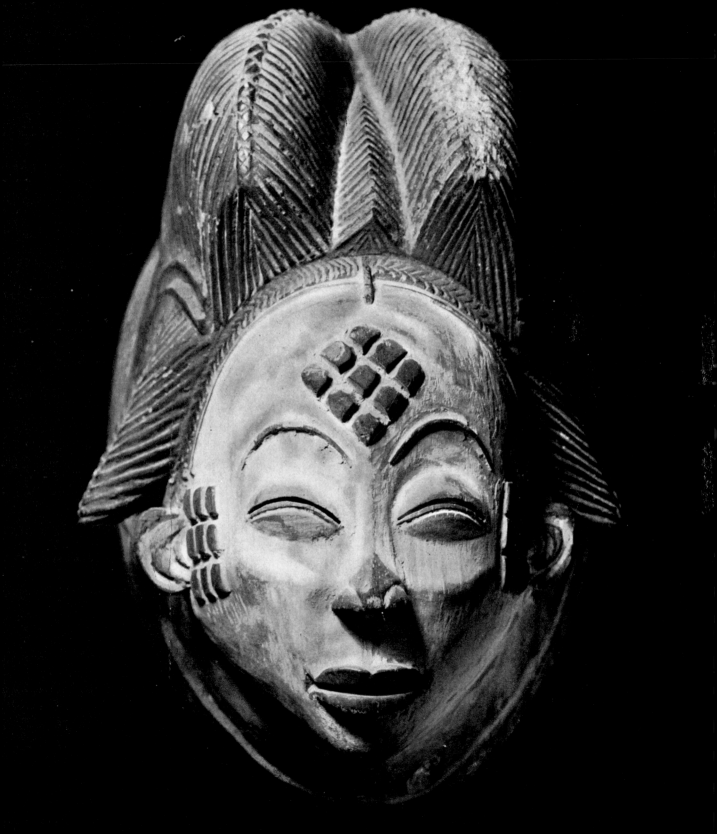

R 10
Bweti, guardian figure. Mpongwe.
Wood and metal strips, 51 cm.
Coll. J. Kerchache, Paris.

R 11
Mbulu-Ngulu, guardian figure. Bakota.
Wood and metal sheeting, 53 cm.
Coll. Pierre Verité, Paris.

R 12
Guardian figure. Bakota.
Wood with copper and brass sheeting, 29 cm.
Coll. A. Fourquet, Paris.

R 13
Bweti, guardian figure. Mahongwe.
Wood and copper strips, 35 cm.
Coll. A. Fourquet, Paris.

R 14
Elimba mask. Bakota-Mpongwe. Wood, 40 cm.
Coll. Christian Duponcheel, Brussels.

R 15
Reliquary head. Ambete, Central Congo.
Wood, painted black and white, 36 cm.
Rietberg Museum, Zurich.

R 16
Small guard, *Mbulu-ngulu.* Ondumbo.
Wood covered with metal, 40 cm.
Galerie Künzi, Oberdorf-Solothurn, Switzerland.

R 17
Helmet mask, *Mboto-Mboli.* Bakota, Ivindo region.
Gabon. Painted wood, 70 cm.
Coll. Christian Duponcheel, Brussels.

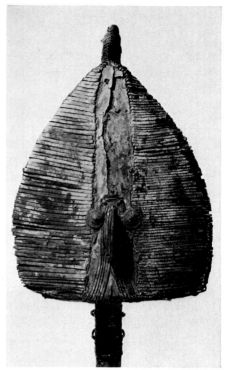

R 10

R 11

R 12

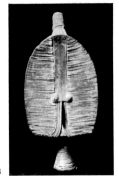

R 13

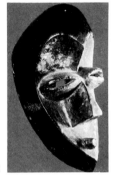

R 14

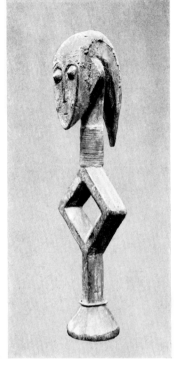

R 16

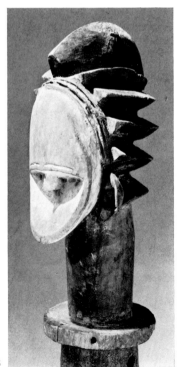

R 15

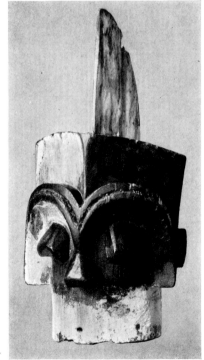

R 17

R 18
Altar board with human face. Mitsogho.
Painted wood, 168 cm.
Coll. Edith Hafter, Zurich.

R 19
Ceremonial bell with an ancestor head. Mitsogho.
Iron and wood, painted red and white, 44 cm.
Coll. A. Fourquet, Paris.

R 20
Reliquary head with strands of hair at each side.
Mitsogho. Painted wood, 30 cm.
Galerie Künzi, Oberdorf/Solothurn, Switzerland.

R 21
Statuette. Mitsogho. Wood painted white, 35.5 cm.
Galerie Künzi, Oberdorf/Solothurn, Switzerland.

R 22
Door with relief. Mitsogho. Wood, traces of reddish
colour, beige, grey and white, 151 cm.
Coll. J. Kahane, Uitikon/Waldegg near Zurich.

R 23
White mask, female spirit of the dead. Bapunu.
Wood painted red and white, 29 cm.
Coll. A. Fourquet, Paris.

R 24
White mask. Bapunu. Wood, painted white, 31,5 cm.
Coll. Jean Roudillon, Paris.

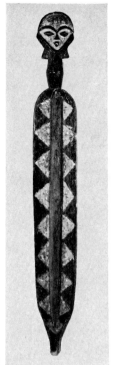

R 18

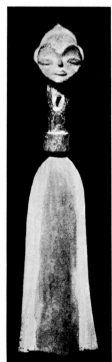

R 19

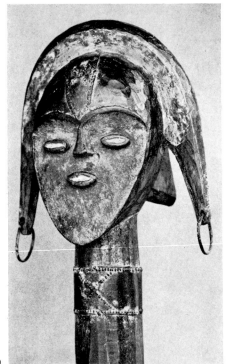

R 20

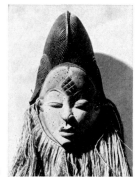

R 22

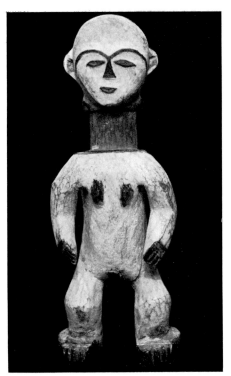

R 21

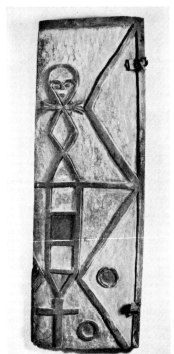

R 23

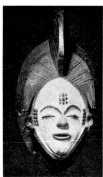

R 24

The Congo

By the 'Congo' we mean the whole basin of the River Congo with all its tributaries: the vast area which extends from the Atlantic Ocean as far as the East African lakes in the heart of the continent, beyond the frontiers of the Republic of the Congo (re-named Zaïre). In such an extensive region, there are extreme variations in climate, topography and living conditions; and the same is true of the art which flourishes in this 'greater Congo'.

In the northern part of the Congo area — the inland curve of the Congo as far as the Lualaba and northwards of it within the curve of the Ubangi — the thick, constantly wet rain forest prevails. This is the retreat of Palaenegrids who live in symbiosis with the wandering pygmies and cultivate clearings in the forest. The development of advanced cultures has been hindered by the difficult living conditions, and art has been able to develop only spasmodically (Ngbaka, Ngbandi, Togbo, the Bantu-speaking Ababua and Bambole, etc.).

On the other hand, in the south and east of the Congo, from latitude 2^0 to 4^0S, approximately, the forests open out into a parklike hill country, through which innumerable rivers run and which offers excellent living conditions. This at once brings about a change in the pattern of culture. The Bantu who live there cultivate the fertile arable land; the women undertake the greater part of the work in the fields and as a result enjoy many privileges. The men hunt and fish, build houses and devote themselves to arts and crafts.

In the past the Bantu have been receptive to all kinds of outside influences, which came in particular along the courses of the Ubangi, the Congo and the Kasai — and especially to the concept of the sacral kingship from the Nile valley. There is clear evidence that

S 1
Flat, disc-like mask, abstract face. West Bateke, north of the Niari River. Painted wood decorated with feathers, down and raffia, 38 cm. Private collection, Paris.

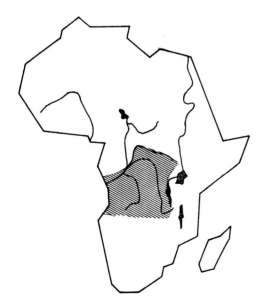

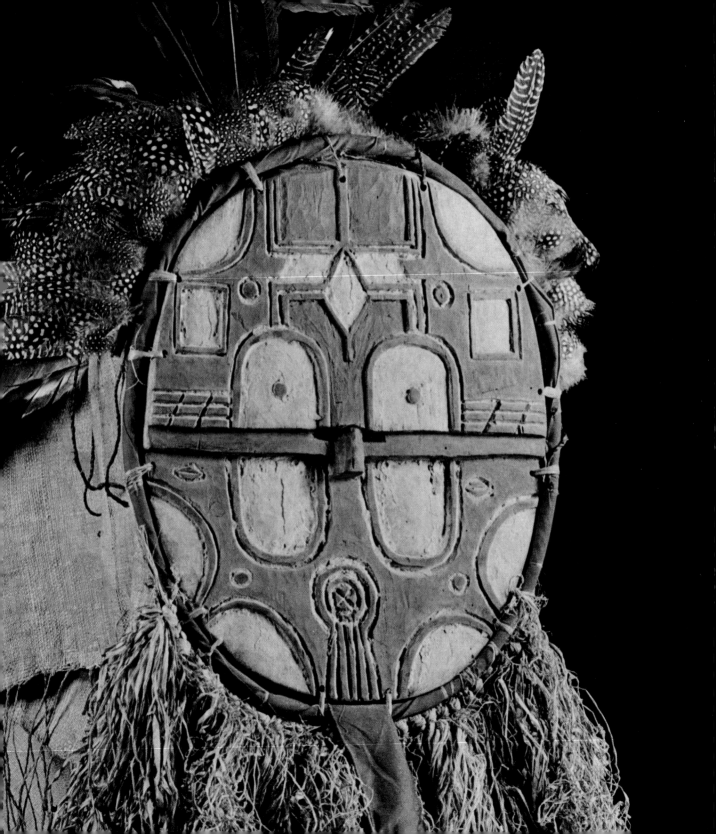

the main entry of iron age civilization and the sacred kingship took place during the second half of the first millenium A.D. (e. g. the carbon-14 dating of the excavations in Lake Kisale in northern Katanga).

Of the newly founded kingdoms, Kongo and Loango on either side of the mouth of the Congo, Bakuba, Baluba and Balunda in the south and southwest, Azande and Mangbetu in the north-east are amongst the most important.

The twisted band and loop ornamentation of the dimple based pottery culture in the Congo States therefore goes back to the same sources as that of Nigeria, Cameroon, Sierra Leone and south-eastern Africa.

In the Congo too the high culture and luxurious requirements of the royal courts gave a great impetus to art. This can be traced back as far as the sixteenth century, continues to display an exuberant variety of forms right down to the modern period, and repeatedly displays, in the very smallest objects of everyday use, the sophisticated taste of the royal courts.

The place of honour is occupied by figures, masks and ceremonial objects. The figures are those of ancestors, cult heroes or supernatural forces, and are mostly to be found in special huts on altars. The masks are intended in the first instance for the initiation solemnities of the secret societies and for police functions and have a style of their own. Sceptres and messenger staffs represent the royal power, or refer to mythological events. They have a judicial and religious significance, being used for oracles, healing, exorcisms and for giving judgement.

The artists of the royal court are usually highly respected craftsmen with a first class training.

The matriarchal Central Bantu cultures, with their powerful inheritance from the divine monarchy, have allowed women to take part in the life of the cult. Since women are connected with the fertility of the fields it is necessary to carry out from time to time a possession ritual for the girls. And the image of the deified first mother, as the giver of life, is a favourite theme in both sacred and secular sculpture. In the case of most styles in the Congo the concept of the mother is represented by the naturalistic round style; but isolated enclaves of the pole style are also known. It is an interesting coincidence, for example, that the patriarchal Basonge in the central Congo prefer the pole style; on the other hand, the round style of sculpture, in association with matriarchy, occurs in the Rovuma region, jutting through a patriarchal region as far as the Indian Ocean.

In the southern Congo, from the Atlantic to Lake Tanganyika, one style follows another in a creative variety. A sure feeling for form is found everywhere, although each style has its own distinctive formula, so that it is once again impossible to speak of unity, any more than in the rest of Africa.

S 2
Medicine man mask.
Bakongo-Bavili.
Wood, raffia, feathers, animal skin, pieces of mirror, iron nails, painted red and white, 33 cm.
Linden-Museum für Völkerkunde, Stuttgart, Germany.

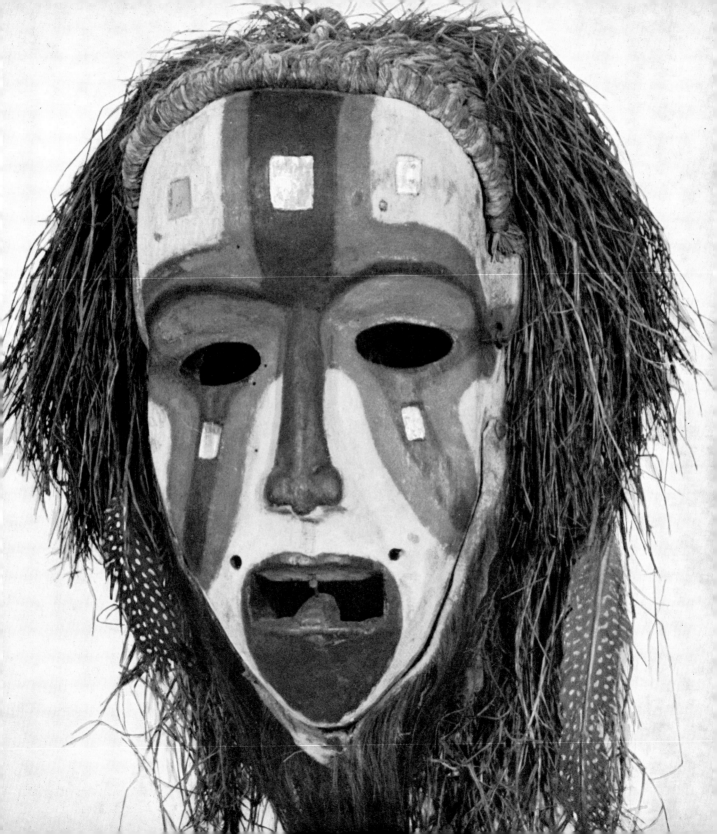

S The lower Congo

In the Congo there already existed flourishing sacral monarchies when the first European, the Portuguese Diego Cão discovered the mouth of the Congo. For example to the north there was the Kakongo kingdom in the Portuguese enclave of Cabinda, as well as the Loango kingdom. To the south was the powerful kingdom of Congo, which reached as far as the River Kasai; it had three million subjects and its capital was São Salvador. The king of that period, Manikongo, accepted Christianity and traded with Portugal. Christian missionaries worked for two hundred years in the kingdom of Congo and set up monasteries and chapels, before they had to give way about 1717 before the rapid upsurge of indigenous belief. They were driven out and killed, and little remained of their work. Not until the nineteenth century was there once again contact with white men. Tribal art had borrowed little from Christianity, and indeed was opposed to it. A slight trace may perhaps be seen in a higher degree of realism and perhaps in the preference for the figure of mother and child, although this itself is a typically African theme. In the mother figures the founders of matriarchal clans or the mothers of great men are honoured.

The Congo forms, with their arbitrary proportions and large heads, are a genuinely African development. The style of the lower Congo tribes is summed up under the heading 'Bakongo', and includes: the Bavili of Loango in the Democratic Republic of the Congo (Congo-Brazzaville), the Bawongo and Kakongo of Cabinda enclave, the Basundi of the Mayombe region in the forest area to the north of Boma in Zaïre, and the Basolongo in northern Angola. These tribes all belong to the western Bakongo group, and possess a relatively unified style of figure sculpture, while the eastern Bakongo, especially the Bankanu, already form part of the stylistic region of the Bayaka.

The first Negro figures which reached Europe from the Congo were the *mintadi,* stone figures, memorials and funeral statues of the kings. The statue shown in fig. S 10 was brought in the year 1695 to Rome with four others. Since then numerous other *mintadi* have been found near Matadi in the Noqui massif of northern Angola, as well as in the Mayombe region north of the mouth of the Congo. Typical ancient *mintadi* are made of steatite or slate and show men seated cross-legged, the head slightly inclined to one side or supported on one hand. The caps, decorated with leopard claws, are signs of the consecrated ruler. More recent stone figures, in which European influence can be detected, show the mother and child, or men in all kinds of anecdotal attitudes. The last Bakongo mason died in 1910. The figures were regarded as the seat of the spirits of the dead, which provided a protective force *(mintadi* means protecting spirit) but only as long as the sacrifices flowed freely. They protected the state when the king went on a journey. The female figures were set up in houses and used in praying for fertility. At the death of the king, his retinue had to follow him into the grave.

Memorial figures of prominent personalities were also carved by the Bakongo in wood, set up in funeral chapels and honoured from time to time with sacrifices, as a means of receiving the life force and the advice of the mighty ones who are dead. Mother figures possess a quiet dignity and an expressive face; amongst the Basundi a pointed cap is the sign of a woman of noble family.

S 3
Mintadi, burial statue of a king.
Bakongo, Noqui region.
Stone, 25 cm.
Rijksmuseum voor Volken-
kunde, Leiden, Holland.

Characteristic features are a naturalistic round style, an expressive realism, an oval face, inlaid eyes, full eloquent lips and rows of teeth, decorative scar patterns and ornamentation, and figures and groups in asymmetric compositions.

The expression and movement of the figures becomes more violent and aggressive in the case of the *nkisi* or *n'konde* fetishes, which are supposed to intervene actively against all evil. These are fetishes in the true sense of the word, because their importance lies in their being charged with magic. The head or body is hollowed out and filled with magical substances; a mirror closes the outlet, looks at everything and reflects the sinner; it can possibly be compared to a reliquary. Another form of these Bakongo fetishes is studded with nails, which give power to wishes and curses or call upon the spirits to carry out an act of vengeance. *Nkisi* are spirits of the dead which enter the mirror and nail fetishes, ward off diseases, bring healing, protect warriors and hunters, spy out thieves, arouse love and, in short, contribute to the good of the owner in a supernatural way. Above the body, thick with nails, or the packet of medicine, there is frequently set an expressive face in the style of the great memorial figures, with eyes which gaze wide awake into the world and with a weapon in its raised hand.

Nail figures in the form of animals are also set up as a defence against those who devour souls.

The masks of the Bakongo are formed with a delicate naturalistic feeling. The Basundi paint them in black, white and red and leave the point of their tongue sticking out of the slightly opened mouth, which produces an expression of suffering. The priest wears such a mask, together with an immense garment of feathers, on important occasions: in praying for rain, at the coronation of the prince, when giving a divine oracle. Other masks and rattle staffs are used by members of the *Bakhimba* sect for their initiation ceremonies.

A speciality of the Bawongo of Cabinda are the proverb lids, each bearing a symbol or a scene which expresses a certain situation or a wish.

Two examples: the representation of a boa constrictor entwined round a man (fig. S 4), which signifies: 'We have said "Yes" without ever having seen for ourselves' or 'One should no listen to yesmen'.

A man sits on his wife's bed, while she lays her hand on her stomach (fig. S 19). This signifies, 'My wife is dying, what will become of me?'

If a Bawongo woman carries the food bowl with one of these lids on it, her husband knows without her saying what she is complaining about The wife finds the lid in her family store or obtains it for herself from the wise man of the village. The situation becomes somewhat embarrassing when guests are present and the matter turns into an open accusation. The example shows that the Bakongo, with their delight in carving, know how to enrich their daily life with their art. Musical instruments, boxes, sceptres, many of them made of ivory, are treasures of the first rank. Weaving and plaiting are also important.

A few other lesser styles from the lower Congo region are also worthy of note:

The *Babembe,* a Basundi group, who live between Sibiti and Minduli in the Democratic Republic of the Congo (Congo-Brazzaville) and have developed an unmistakable style of their own. With a few exceptions, their art consists of small, highly polished ancestor figures with sensitive features, eyes in the form of inlaid mussel shells or glass beads and extended barrel-shaped bodies co-

S 4
Proverb lid with a snake
entwined round a man.
Bakongo-Bawoyo, Cabinda.
Wood, diam. 24 cm.
Museu d'Etnologia do
Ultramar, Lisbon.

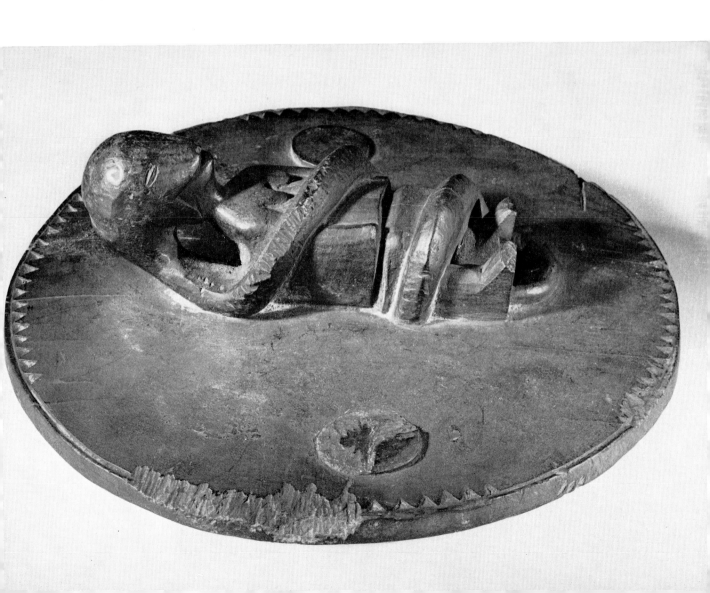

vered with scar patterns. These are the typical patterns of dimple based pottery. We find women with extended arms or a child, men with a beard holding in their hands weapons or other attributes, standing, striding or seated. The figures are used for oracles and other magical practices, and especially for driving out evil spirits.

The *Bateke* also live for the most part in the savannah behind Brazzaville. Like the Bakongo, they use fetishes filled with magical substances, known as *biteke*. The style, however, is strictly cubist, with angular forms, a helmet-like headdress, a trapezium-shaped beard, parallel grooves down the face, and the eyes and mouth as straight lines. A little box against the stomach contains the magic medicine, e. g. the placenta of a son. But the carvers belong to the tribe of the Wambundu, who sell their figures over a wide area and supply both the Bateke and the Bayanzi and other tribes in the region of the Congo Falls with individually made *biteke.* The western *biteke,* north of the River Niari, produce unreal, disc-like masks with painted, abstract features. Apart from the stylized form of a human face, a lizard is often represented upon them. These highly revered masks always belong to the clan of the 'lord of the soil' as the descendant of the first immigrants. They are worn in the *kaduna* dance. The two-dimensional picture is symmetrically balanced, with alternating red, white and black.

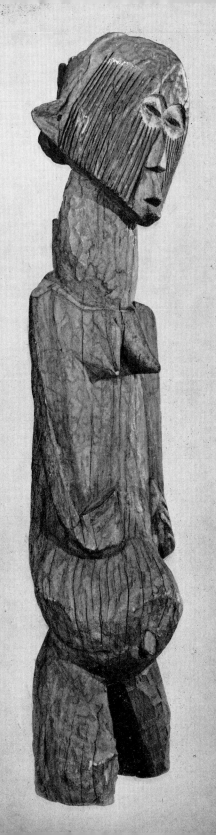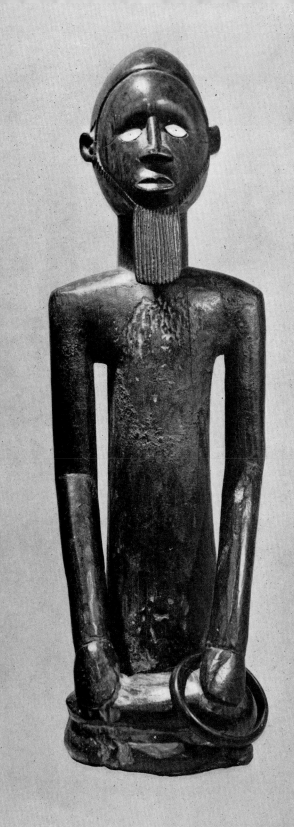

S 7
Nsundi crucifix, meaning 'the highest', used as
magical protective power. Bakongo, 15th/17th
centuries. Brass cast on wood, 54.5 cm.
Coll. Delenne, Brussels.

S 8
Medicine horn with mother figure (detail).
Bakongo. Wood, 16 cm.
Coll. Jean Roudillon, Paris.

S 9
Pendant to be worn by a king: three seated figures,
probably the king with his sons.
Bakongo, Mayumbe region. Wood and chain, 19 cm.
Coll. A. Fourquet, Paris.

S 10
Mintadi, memorial figure of a dignitary.
Bakongo. Steatite, 48.5 cm. (Arrived in Rome before
1695).
Direttore del Museo L. Pigorini,
Dr. Pellegrino Claudio Sestieri, Rome.

S 11
Memorial figure, Bakongo-Basundi.
Wood painted white and brown with red markings,
51.2 cm.
Rietberg Museum, Zurich.

S 12
Figure on a tortoise. Bakongo. Wood, 35 cm.
Private collection, Geneva.

S 13
Kneeling mother with child. Bakongo. Wood, 20 cm.
Coll. Hans Röthlingshöfer, Basel.

S 14
Mirror fetish. Bakongo-Basundi.
Wood and other materials, 23 cm.
Rietberg Museum, Zurich.

S 15
Painted mask. Bakongo.
Wood, blue, red, black and white.
Coll. Hélène Kamer, Paris.

S 7

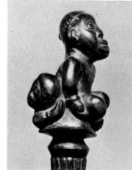

S 8

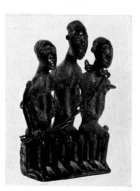

S 9

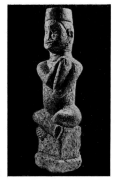

S 10

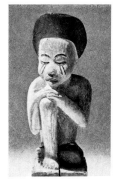

S 11

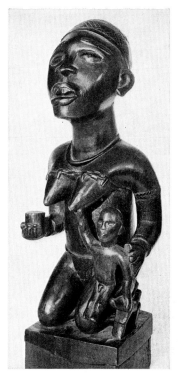

S 13

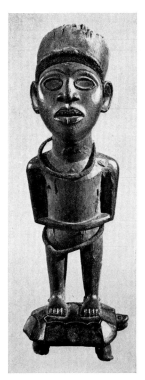

S 12

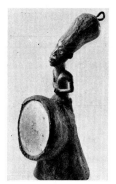

S 14

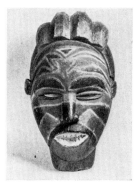

S 15

S 16
Sceptre; royal lady riding a leopard holding a
gazelle between its forepaws.
Bakongo, Cabinda. Ivory, 19 cm.
Coll. Maurice Bonnefoy /D'Arcy Galleries, Geneva.

S 17
Sceptre: king standing above a prisoner. Bakongo.
Ivory, 23 cm.
Coll. J. Kerchache, Paris.

S 18
Proverb lid with bird's head. Bakongo-Bawoyo.
Wood, diam. 22 cm.
Musée de l'Homme, Paris.

S 19
Proverb lid: man at his wife's deathbed.
Bakongo-Bawoyo. Wood, diam. 18.4 cm.
Musée royal de l'Afrique centrale, Tervuren, Belgium.

S 20
Flat mask with abstract face. West Bateke.
Painted wood, 34 cm.
Ex coll. Derain,
Coll. J. Müller, Solothurn, Switzerland.

S 21
Biteke, fetish figure. Bateke. Wood, 29 cm.
Coll. Nicaud, Paris.

S 22
Seated female ancestor figure with cicatrices.
Babembe. Wood, shell rings for eyes, 15.4 cm.
Rietberg Museum, Zurich.

S 23
Seated figure with beard and sceptre. Babembe.
Wood and copper, 20 cm.
Coll. Pierre Harter.

S 24
Large ancestor figure with king's beard and
cicatrices. Babembe. Wood, 56 cm.
Ethnological collection, Zurich.

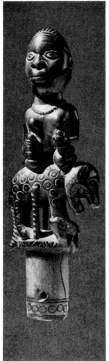

S 16

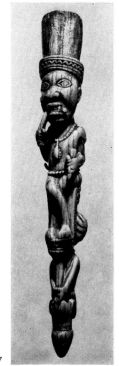

S 17

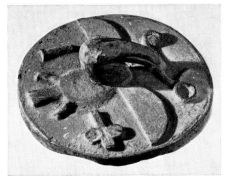

S 18

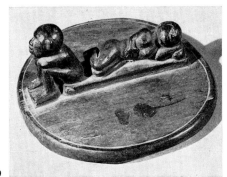

S 19

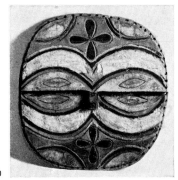

S 20

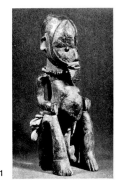

S 21

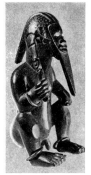

S 22

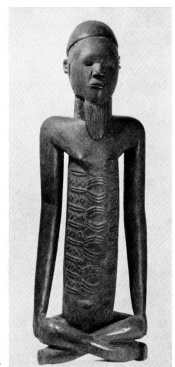

S 23

S 24

T The south-western Congo

The Bayaka, Basuku, Bapende etc.

In the region between the great southern tributaries of the Congo, the Kwango and Kasai we find a whole series of talented tribes: the Bayaka, the Basuku, the Baholo (and west of the Kwango the Bahungana a Bakongo tribe which comes under the influence of the Bayaka), the Bapende, the Bakuana and Bambala. They practise agriculture, and live in villages in the fertile moist savannah, broken by stretches of forest. Many of them grew rich in the past by taking part actively in the slave trade.

The *Bayaka,* east of the Kwango, were once greatly feared warriors, and took part in 1568 in the conquest of São Salvador. They were also known as passionate hunters. In the *Mukanda* bush school the boys are trained to an iron discipline and a lofty morality. The bush school is an institution which still exists at the present day. Amongst the Bayaka too, initiation into the men's society is sealed by the circumcision of the boys and celebrated with masked plays. The *tudansi,* the newly circumcised boys, appear in pairs, after a year of training and the completion of a test, as adult members of society. When they are dressed in the masks no wish will be denied them and no gift refused. This is the ancient right of the spirits to demand what they will. Even when, today, the dances have more of the function of a popular entertainment, they still have something of the uncanny atmosphere of the spirit world.

The masks represent supernatural forces. They take the form of helmets. The massive head-covering consists of basketwork covered with raffia bast, coated and painted with juices. Only the face is carved from wood and is elaborated with all kinds of additional features and carved figures set above it.

Its characteristics are a round face, usually with a large, snout-like upturned nose and deep set three-dimensional eyes set in a framework, like spectacles. One variation of these masks, a face with a thick nose, is kept for the leader of the dance society. The storeyed decoration on top is a sign of high rank.

The decoration on top of the mask displays a high degree of imagination. In this respect every artist seeks to surpass the others. For at the end of the ceremony the masks are displayed to the village. They are criticized, judged and awarded prizes amidst general rejoicing. The prize-winner receives the honoured title of a *kimvumbu.*

Apart from these dance masks, the leader of the secret society possesses another particularly sacred mask: a gigantic sculpture with inflated features painted red, which expresses the immense force of the *Kakungu* spirit. It has so much power that it heals the sick and halts whirlwinds, and its magic power is so feared that it has to be kept in an enclosure well away from the village.

The neighbouring Basuku and Bankanu tribes also have *kakungu* masks.

The magic figures of the Bayaka, together with functional objects decorated with figures and faces (neck rests, signal pipes, musical instruments, combs, fans etc.) display expressive and three-dimensional forms: podgy bodies with exaggerated buttocks, thickened or upturned noses and eyes set in a spectacle-like framework.

The influence of the Bayaka upon their neighbours is considerable. Thus the Bankanu, west of the Kwango, paint their initiation huts with garish, esoteric images: three-dimensional appliqué representations against a background of

T 1
Decorated panel with carved birds from a circumcision hut. Bankanu, eastern Bakongo. Wood, 102.2 cm. Musée royal de l'Afrique centrale, Tervuren, Belgium.

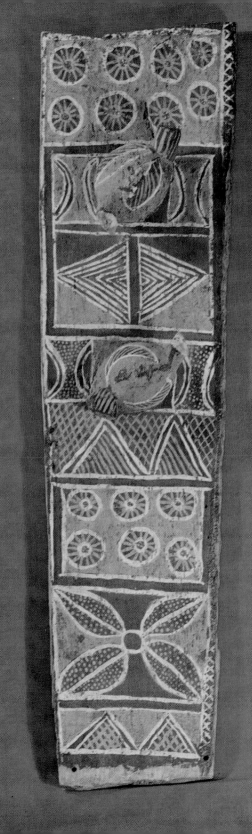

geometrical patterns, principally zig-zags and peripheral curves.

The *Basuku* are related to the Bayaka, but have their own style. They adjoin the Bayaka on the east, between Bakali and Kwenge. But their helmet masks are made entirely in wood and have finer features than the masks of the Bayaka. They are painted red or white and picked out with black markings. They are embellished with three-dimensional headdresses in the form of animals, etc.; a frill of fibre falls over the wearer's shoulders. The mask represents the peaceful features of a spirit. White is the colour of the mysterious realm out of which the novices are symbolically reborn as men ready for marriage.

The *Bambala,* between the lower Kwango and the Kwilu, produce figures in a powerful, dynamic style, heads with a vaulted forehead and a high comb running from back to front in the centre.

The *Bahungana,* a small tribe of smiths on the Kwilu near Djuma, specialize in charming, stylized small figures of ivory, with the face as a round, smooth disc. They also produce squatting figures, with the hands on the chin or breasts. Their original use is long forgotten, but it can be assumed that they were worn as a pendant, and served as an amulet or as the sign of an initiation undergone.

The *Baholo,* on the left bank of the Kwango in Angola, and also in part on the right bank in Zaïre, near the Basuku, have been subject to decisive influences from the Bapende, as well as from the Batchokwe. They produce original and highly stylized works.

The *Papende,* an important tribe with a famous style, live between the Kwilu and the Kasai. They came from the upper Kwango region in northern Angola and had intensive contact with the Balunda kingdom. The River Loange divides the Bapende into an eastern and western group with different styles. That of the eastern group is strictly geometrical, and is related to the Bakete style. In the west, particularly in the Kilembe region, we find the smooth and lyrical Katundu style. Although the figures, such as those placed on gable ends, and the objects of everyday use with carved figures on them (seats, signal pipes, and head-shaped drinking vessels) are of considerable artistic value, they are less well known than the fine, poetical masks of the western Bapende, which have achieved the greatest fame.

The characteristics of the Katundu style are a broad vaulted forehead, powerful joined arches for the eyebrows, coming down as far as the bridge of the nose, heavy lowered eyelids, a nose upturned a little, a mouth either slightly open and showing the teeth or closed with the corners of the mouth turned down, a chin running to a point, and scar patterns on the brow and cheeks.

The coiffure is made of twisted bast. It comes to three points when it is meant to be that of a chief; and when a beard is carved under the mask, this is also the sign of a ruler. About forty different types of mask, varying in their colour, costume and tattooing, appear at every *mbuya* play. *Mbuya* are short comedies, in which ancestors and other spirits, chiefs and their wives, hunters and prophets, the sick and old men, as well as young girls, or even a jester appears, with the enthusiastic participation of the whole population. In spite of their comic inspiration and performance the *mbuya* masks have a deeper significance. In miniature, and carved in ivory, they are worn on the body as the insignia of members of the secret society. The Bapende believe in the magical protective power of the tiny *minyaki*. But we admire the delicate carving, their elegance, and the patina which they receive in wear.

T 2
Figure of a man beating a drum, used at the initiation of a chieftain.
Bambala, from Mukulu, Kwilu region. Wood, 41.5 cm.
Kongo-Kwango-Museum, Heverlee, Belgium.

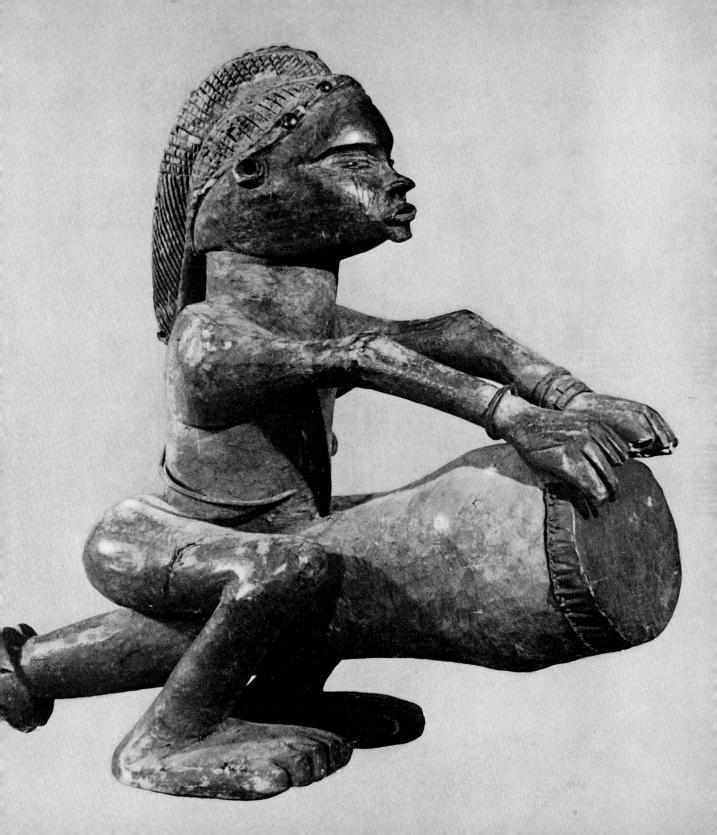

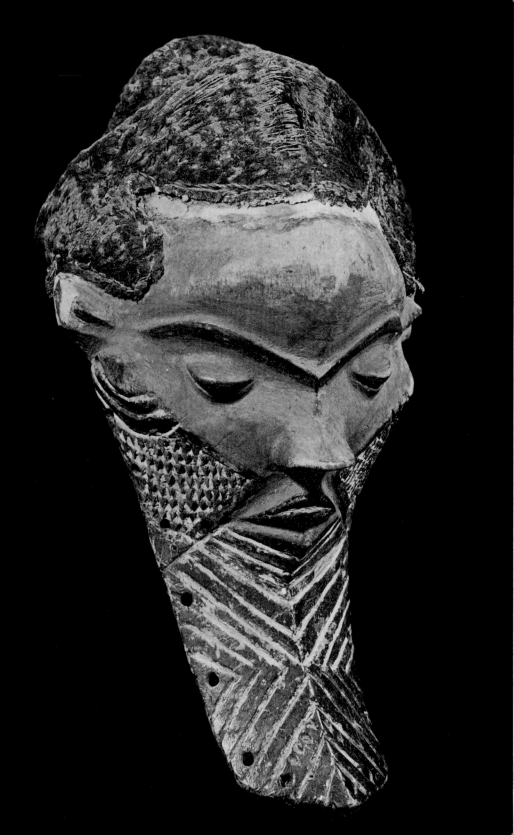

T 3
Initiation mask of the Mbuya
player, representing a ruler.
West Bapende, Katundu style.
Wood and raffia, 38 cm.
Coll. Alfred Muller,
St Gratien, France.

T 4
Protective figure with
outstretched arms, framed and
in the form of a cross. The idea
of Christ crucified may lie
behind the composition, for its
name, *Nzambi* means 'the
sublime god of creation'.
Baholoholo. Wood, 34.1 cm.
Musée royal de l'Afrique
centrale, Tervuren, Belgium.

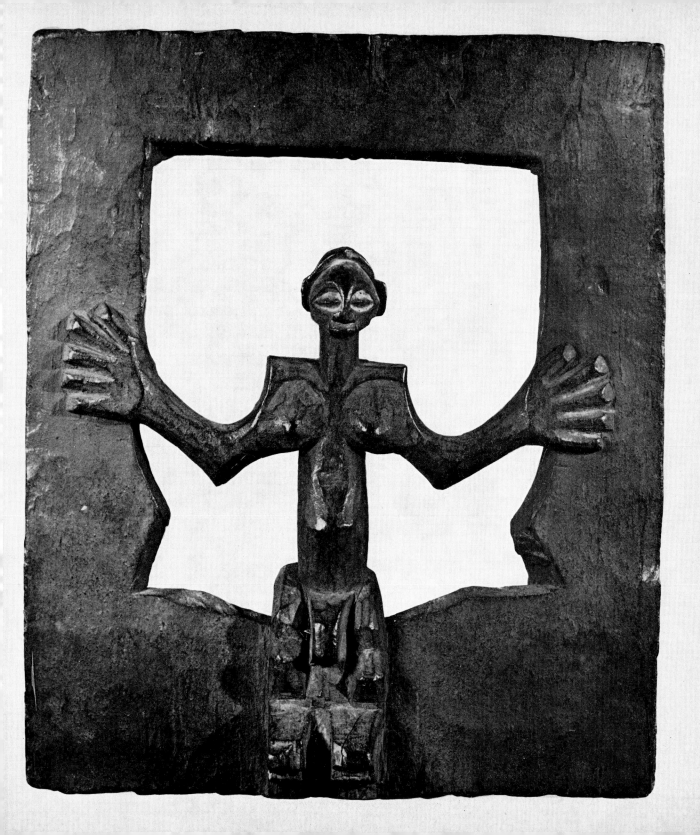

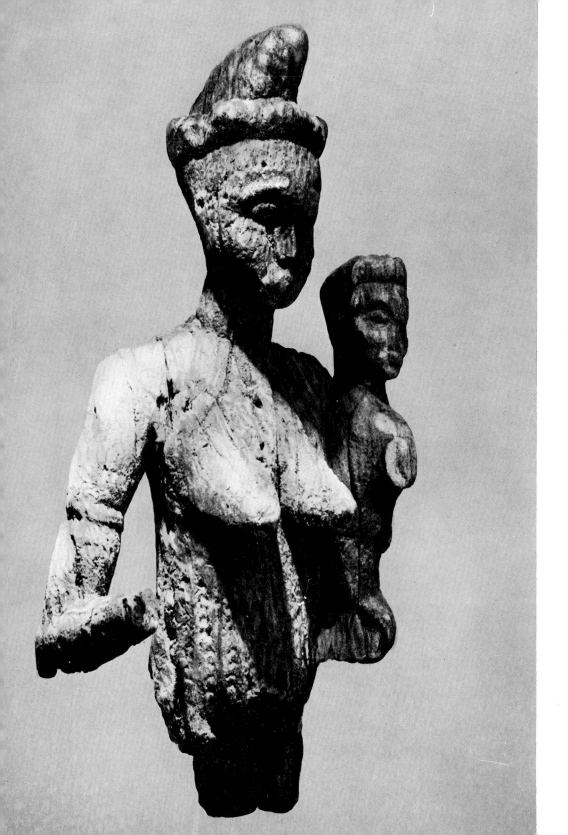

T 5
Roof crest: mother with child.
Bapende. Wood, traces of
red colour, 82 cm.
Coll. Delenne, Brussels.

T 6
Fertility statue.
Bapende, Katundu style.
Wood, 58.8 cm.
Rietberg Museum, Zurich.

T 7
Figure of a man, his hands to
his forked beard.
Basuku, Lukula region.
Wood, 32.7 cm.
Kongo-Kwango-Museum,
Heverlee, Belgium.

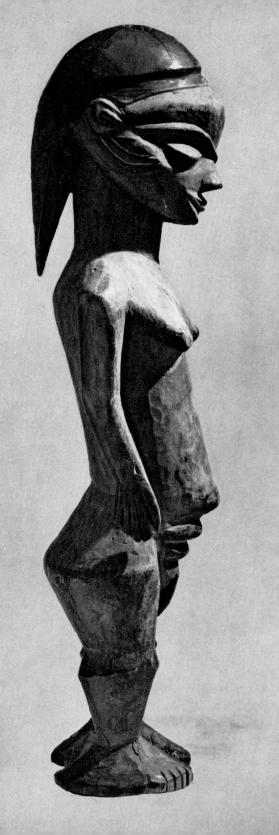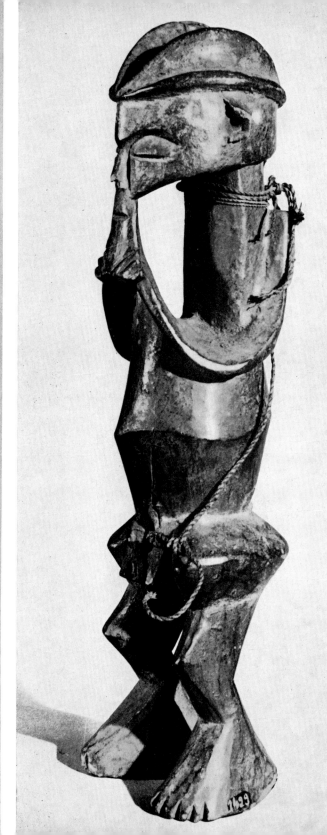

T 8
Headdress mask; human face with nose curved
upwards, a leopard above it. Bayaka.
Wood and woven raffia, painted, 45 cm.
Coll. Erdrich.

T 9
Mask of a secret society. Basuku.
Painted wood, raffia, 60 cm.
Rietberg Museum, Zurich.

T 10
Head-rest with female figure. Bayaka. Wood, 19 cm.
Rietberg Museum, Zurich.

T 11
Large leopard mask. Bankanu. Painted wood, 45 cm.
Kongo-Kwango-Museum, Heverlee, Belgium.

T 12
Amulet. Bahungana. Bone, 8.4 cm.
Rietberg Museum, Zurich.

T 13
Amulet; kneeling figure with large head.
Bambala. Bone, 8.5 cm.
Coll. Erdrich.

T 14
Crouching woman, made for the investiture of a
chieftain. Bambala, Kwilu region. Wood, 33.5 cm.
Kongo-Kwango-Museum, Heverlee, Belgium.

T 15
Mask, on the crown a squalting man. Basuku.
Painted wood, 50 cm.
Ethnological collection, Zurich.

T 16
Mbuya mask in Katundu style. West Bapende.
Wood and raffia, 30 cm.
Coll. Max and Berthe Kofler-Erni, Basel.

T 17
Minyaki, miniature mask of a ruler with beard.
Bapende. Katundu style. Ivory, 5 cm.
Ethnological collection, Zurich.

T 8

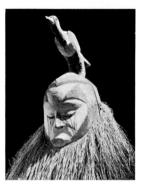
T 9

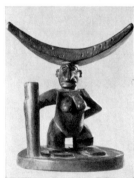
T 10

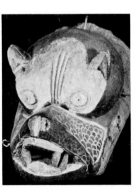
T 11

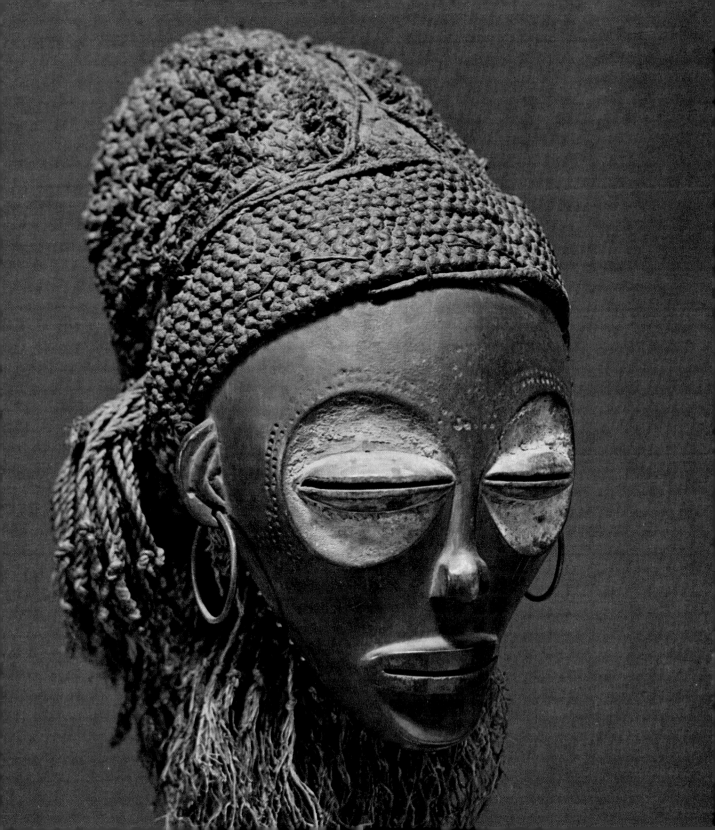

'lord of the soil' wear them at the enthronement of a king. The *chikungu* masks are made of the same materials as the *chikunza.*

3. Dance masks made of wood, with a decorated bast wig dipped in *tukula* (the red powder of the *pterocarpus)* sometimes with sticks piercing the nose, and sometimes with a disc carved on to represent the beard.

Today professional dancers appear in masks to beg for money and as an entertainment. They have largely lost their former demonic power. They particularly like to display the young woman *Mwana Pwo,* as she emerges with her nose and ear ornaments from initiation in the bush camp, ready for marriage. This is the *Pwo* dance, which brings fertility. The son of the chief wears a male mask with the features of the *chihongo* and a beard as a sign of dignity and riches.

The different sub-styles of the Batchokwe group are very similar to each other and differ only in details, such as the hair style, the scar patterns, the deformations of the teeth, etc. (*see* M. L. Bastin).

The *Kaluena,* south-east of the Batchokwe, show gently nuanced lines and forms, in a sophisticated realism. Typical features are the sun-rosette pattern and the hair falling to each side from a parting in the middle. The men of the Kaluena make effigy vessels with a black shiny surface.

The *Kasongo,* the western neighbours of the Batchokwe, live on the Angola plateau west of the Kwango as far as Luando. Here archaic forms prevail, 'tear drop' and sun-ray motifs, while the teeth are filed diagonally.

The *Ovimbundu* live in the Benguela table-land in western Angola. The characteristics of their work are lengthened bodies and delicate, rounded naturalistic facial features. Ringlets fall down at each side and are tied together in a horseshoe-shaped curve at the back. The *Makula* mother statue symbolizes the prosperity of the kingdom, in which the first wife of the ruler occupies a prominent place.

A whole series of small but extremely interesting sub-styles can be found in the *Kasai-Lulua* region. Here the influence of powerful neighbours can be observed: the Bakuba, Baluba, Basonge or Batchokwe. In view of this, the value of their own creative achievements is even greater.

The *Bena Lulua* (Bashilange) are a tribe which long ago settled round Luluaburg. The style of their figures has a particularly pleasant lyrical note and often has a moving expression. Here we find the mother with her child in her arms, *Chibola,* a figure which women wear in their belts as a protection for their still unborn or newborn children. The statue of a chief with a beard and other insignia is stuck in the earth when the owner is away in order to protect his farm and to preserve him personally against dangers during the hunt. The striking scar patterns on the figures show that this style of carving is of great antiquity, for as early as the 1880s Wissmann was no longer able to find any of the inhabitants who wore scar patterns. Amongst minor artistic productions we find tobacco pipes carved with figures, spare tobacco mortars with figures seated with their elbows on their knees, protruding ribs and vertebrae which are always most skilfully carved and balanced.

They have the following characteristics. The three-dimensional, naturalistic form is covered with decorative scar patterns, in such a way that form and decoration form a harmonious unity and result in a picture of calm. There is a heavy head with a round forehead, lowered eyelids, a delicate mouth, the neck

II 2
Statue of a king with staff and tiny figure. Batchokwe.
Wood, 49 cm.
Coll. Pierre Verité, Paris.

II 3
Statue of a king. Batchokwe, Zambia, 19th century.
Wood, 41 cm.
Museum of the Philadelphia Civic Center, Philadelphia.

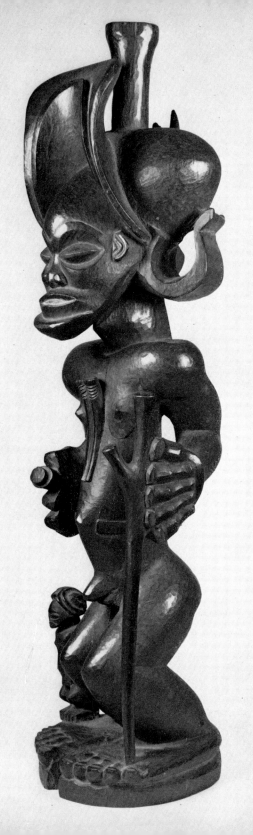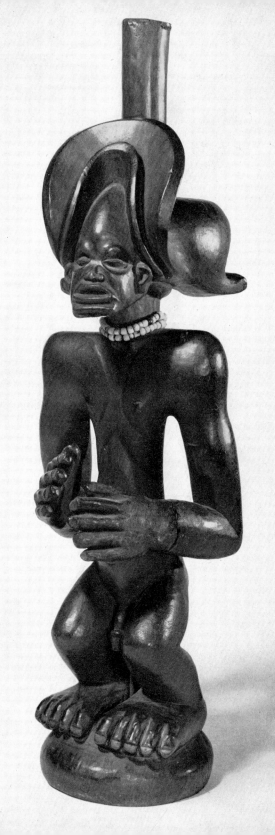

lengthened into a column, and a slender body. The total effect is one of great charm, and indeed they are amongst the most beautiful works of African sculpture.

The circumcision masks also reveal the subtle, imaginative mind of the *Bena Lulua* artists.

The *southern Bakete*, related to the Baluba, reveal in their figures a strong influence from the Batchokwe, but in their circumcision masks they display a style of their own with a cubist tendency. Notable features are the large slits of the eyes against a white background, and the angular mouth and chin, which, as in the Basonge style, protrude forwards.

Mbagani (the southern Babinji), an ancient people living between the Kasai and the Bushimaie, make abstract masks with large eyes in the shape of a coffee bean in deep hollows.

The *Bena Kanioka,* east of the Bushimaie, in the region of Kanda Kanda, formed part of the Baluba kingdom as early as the sixteenth century, and under their chiefs preserved an independent political unity. Their sculpture is rounded like that of the Baluba, but it has fine limbs, considerable variety and a remarkable vitality, sometimes giving the impression of a degree of aggression.

Its characteristics are unusual attitudes, an open oval mouth with visible teeth and tongue, a lattice-patterned hair style, with knots falling to the neck, a vaulted forehead and heavy eyelids.

The masks are also aggressive and bold, with a dished forehead and snarling teeth.

The *Balwalwa* are a small tribe in the middle of the Batchokwe, between the Kasai and the Lueta rivers in the southern Congo and northern Angola. Their lozenge-shaped masks have a particularly heavy nose, which begins high above on the forehead. They are intended to neutralize the spirit who avenges the sacrifices of the head hunters. In order to achieve a high rank in the secret society, the candidate had to execute human sacrifice.

The *Basalampasu* on the left bank of the Lulua river are southern neighbours of the Balwalwa and Bakete. They are known as cruel warriors, who were able to preserve their independence from the Balunda kingdom. They make figures, reliefs and masks, the latter for the circumcision ceremony and for exorcisms. Their style is boldly cubist, with a dished forehead, eyes cut out in angular form, a bulbous nose and an angular mouth with the teeth showing.

Many masks are simply plaited nets. Others are made of wood, carved, painted white or plated with copper foil and decorated with brass nails. The hair and beard are reproduced as finely plaited spheres.

U 4
Sceptre with two heads, back to back, wearing *Chihongo* chief's headdress. Batchokwe, Angola. Wood, 46 cm. Coll. A. Fourquet, Paris.

U 5
Sceptre with head wearing *Chihongo* chief's headdress. Batchokwe, Angola. Wood, 40 cm. Coll. J. Kerchache, Paris.

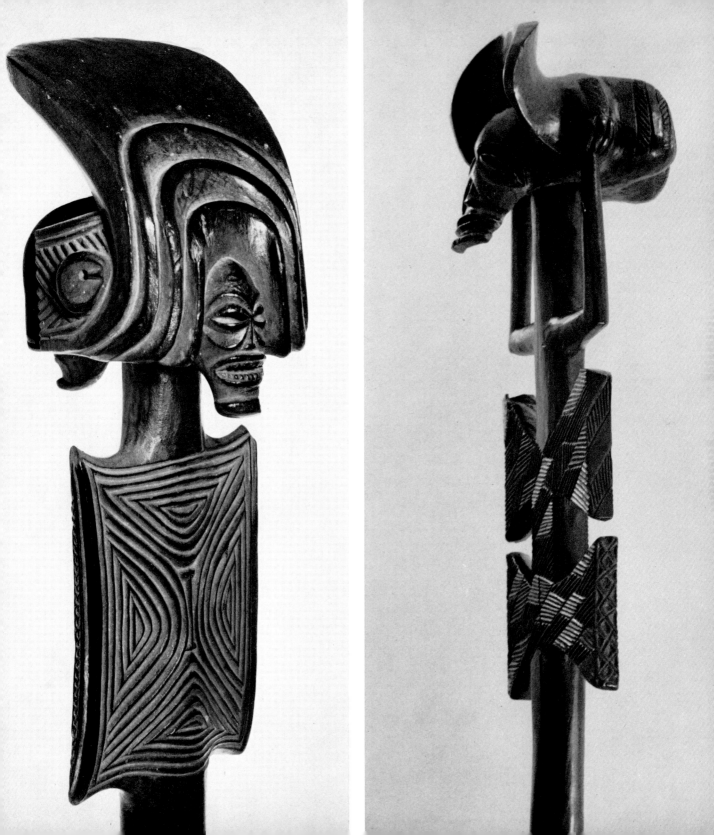

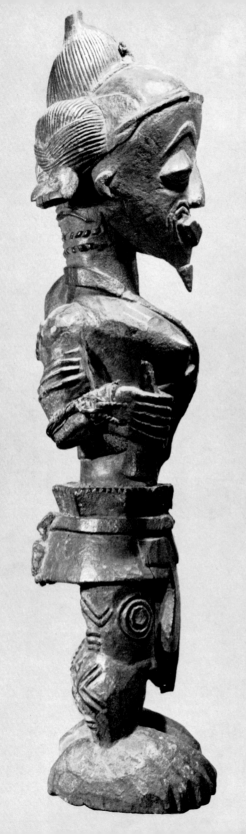
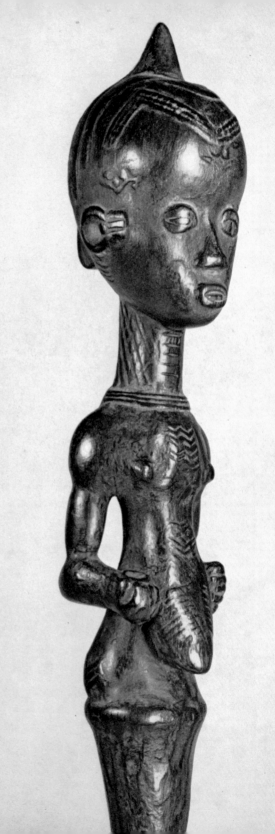

U 6
Ancestor figure. Bena Lulua.
Wood, 59 cm.
Coll. J. Kerchache, Paris.

U 7
Protective figure on a pointed
staff. Bena Lulua.
Wood, 52 cm.
Coll. Pierre Verité, Paris.

U 8
Protectivefigure: mother and
child. Bena Lulua,
19th century. Wood, 35.6 cm.
The Brooklyn Museum,
Frank S. Benson Fund,
New York.

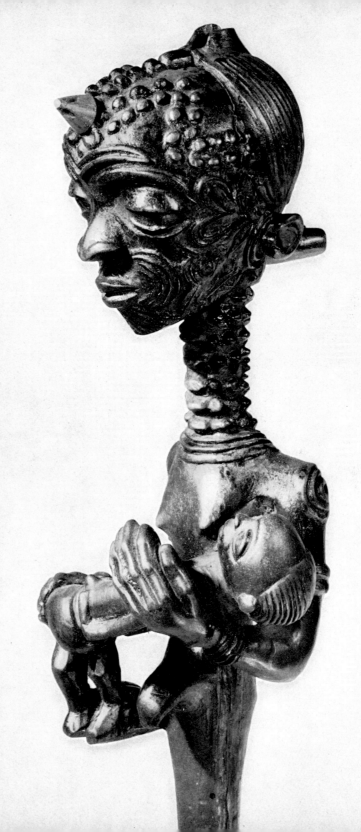

U 9
Statue of a king. Batchokwe, Angola. Wood, 35 cm.
Museu d'Etnologia do Ultramar, Lisbon.

U 10
Figure with helmet and lidded container, sitting on
a chair. Batchokwe. Wood, 44.5 cm.
Linden-Museum für Völkerkunde, Stuttgart, Germany.

U 11
Tobacco mortar in the shape of a squatting human
figure. Face has cicatrix decoration.
Bena Lulua. Wood, 15 cm.
Previously coll. Kjersmeier;
Danish National Museum, Ethnographical Department,

U 12
Tobacco mortar with figure sitting cross-legged
wearing the *Chihongo* chief's headdress.
Batchokwe, Angola. Wood, 46 cm.
Coll. A. Fourquet, Paris.

U 13
Mother figure. Balunda, Angola. Wood, 28 cm.
Private collection, Paris.

U 14
Chikunza mask, patron of the *Mukunda* school.
Batchokwe, Angola. Painted basketwork, 180 cm.
Musée d'Etnographie, Neuchâtel, Switzerland.

U 15
Chieftain's chair with tableaux of ancestor figures
and masked dancers. Batchokwe, Angola.
Wood and leather, 64 cm.
Coll. A. Fourquet, Paris.

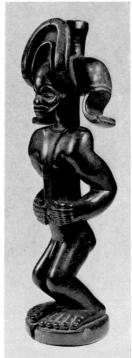

U 9

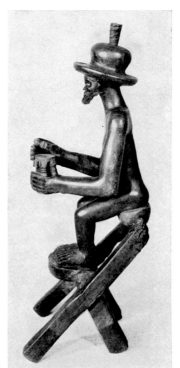

U 10

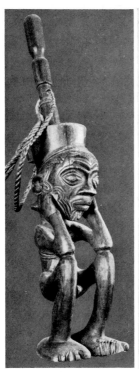
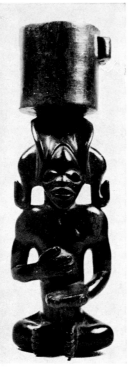

U 11
U 12

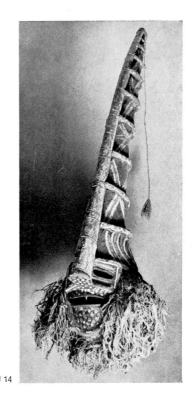

U 14

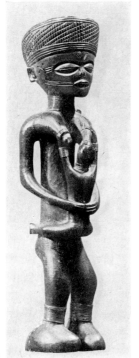

U 13

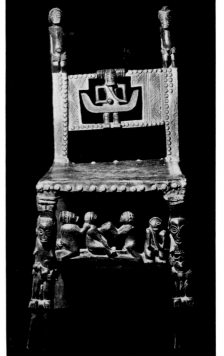

U 15

U 16
Initiation mask *Mbuecho* with the *Chihongo* chief's headdress. Painted basketwork, 62 cm.
Musée d'Etnographie, Neuchâtel, Switzerland.

U 17
Mother with child. Ovimbundu, Benguela province, Angola. Wood, 22.5 cm.
Musées Royaux d'Art et d'Histoire, Brussels.

U 18
Effigy vessel. Kaluena, Angola.
Terracotta, 20 cm.
Ethnological collection, Zurich.

U 19
Mask. Bena Kanioka. Painted wood, 29 cm.
Hamburgisches Museum für Völkerkunde
und Vorgeschichte.

U 20
Figure of a woman for the *Chibola* fertility cult.
Bena Lulua. Wood, 49.5 cm.
Musée royal de l'Afrique centrale, Tervuren, Belgium.

U 21
Male initiation mask. Balwalwa.
Wood painted red and white, 32 cm.
Musée royal de l'Afrique centrale, Tervuren, Belgium.

U 22
Mask with tattooing. Kaluena.
Wood, woven string, hair and glass beads, 19 cm.
Coll. Jean-Pierre Jernander, Brussels.

U 23
Captive fettered to a block. Bena Kanioka.
Wood, 38.5 cm.
Rietberg Museum, Zurich.

U 16

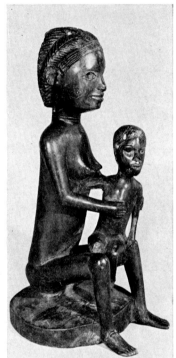

U 17

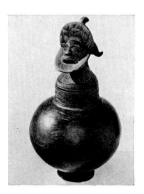

U 18

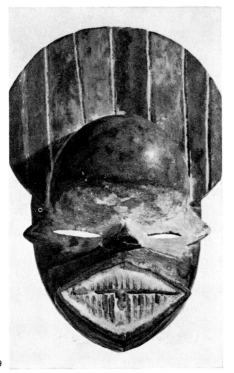

U 19

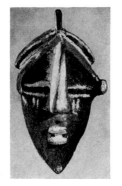

U 21

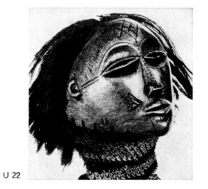

U 22

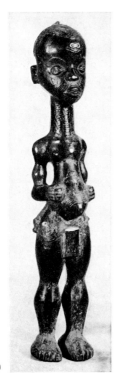

U 20

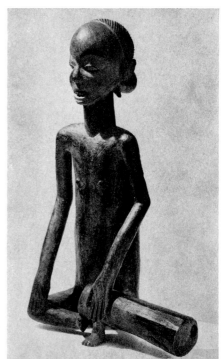

U 23

V The central Congo

Bakuba is the sonorous name of a once powerful kingdom in the hill country between the Kasai and the Sankuru, but it is also a stylistic term for a highly developed courtly art of carving. The name Bakuba, applied to a federation of eighteen tribes, was formed by the Baluba: it means 'people of the lightning'. The ruling class call themselves Bushi-Bushongo, that is 'people of the javelin'. They recruited their members from the Bambala sub-tribe (which is not to be confused with the Bambala between the Kwango and the Kwilu). The former kingdom included, besides the Bambala, also the Babinji, the Bakele, Bangende, Bashobwa, Pianga, Bangongo, etc. A number of neighbouring peoples also came under the influence of the Bakuba federation, e. g. the Ndengese, Yaelima and Bankutshu to the north, the Bakete to the south-east, and the Bawongo and Bashilele to the west. With each of these names there is associated a particular branch and a particular achievement of art.

The Bakuba kingdom was the home of a sacral kingship as in Nubia, Ife and Benin. Certain tribal customs and the twisted band and loop ornamentation show definite connections. In addition the indigenous chroniclers, the so-called 'rememberers', tell of the immigration of those who brought their civilization some fifteen hundred years ago: they came from the north, crossed four great rivers (the Ubangi, the Congo, the Busira and the Lukenie) and set up their capital on the Sankuru. They were light-skinned. The royal family tree includes, up to the present day, the names of a hundred and twenty-four kings. In the sixth century the sixth king is said to have introduced iron: a date which corresponds with

astonishing accuracy to that postulated by Hermann Baumann for the spread of iron age culture in the southern half of Africa.

The feudal organization of the state, the hierarchy of ministers and offices, the social stratification into court aristocracy, free men and slaves, and the extraordinary encouragement given to arts and crafts by an aristocracy with high aesthetic taste, are all typical courtly phenomena. The wood carvers were the artists most highly honoured at the court, and even the kings thought it an honour on their own part to be carvers.

Above all, the reign of the ninety-third king, Shamba Bolongongo (1600—1620) lives in the memory of the Bakuba as a period of particular splendour. Shamba Bolongongo was not only a successful conqueror, he was also a wise ruler who championed the cause of peace, the love of one's enemies and lofty morality, and was venerated by the people as a noble example. At his court the best artists gathered from near and far. With his idea of having them carve a wooden memorial for him as the symbol of his ideals he founded the art of Bakuba statuary, for after him all the kings commissioned memorial figures on the same pattern: an idealized, exalted divine king, portrayed in a naturalistic round style, sitting on a pedestal in a cross-legged position, holding the wooden *ikula* knife as an emblem in his left hand and with the royal cap on his head. Each statue was endowed with a special attribute in order to distinguish the particular king.

We learn from Alfred Maesen that the dying king had his memorial statue set up in his camp, so that it would accept the non-physical part of his soul and give strength to the new king. Astonishingly, the Bakuba have produced little non-functional three-dimensional

V 1
Kifwebe mask. Basonge.
Painted wood, 60 cm.
Rietberg Museum, Zurich.

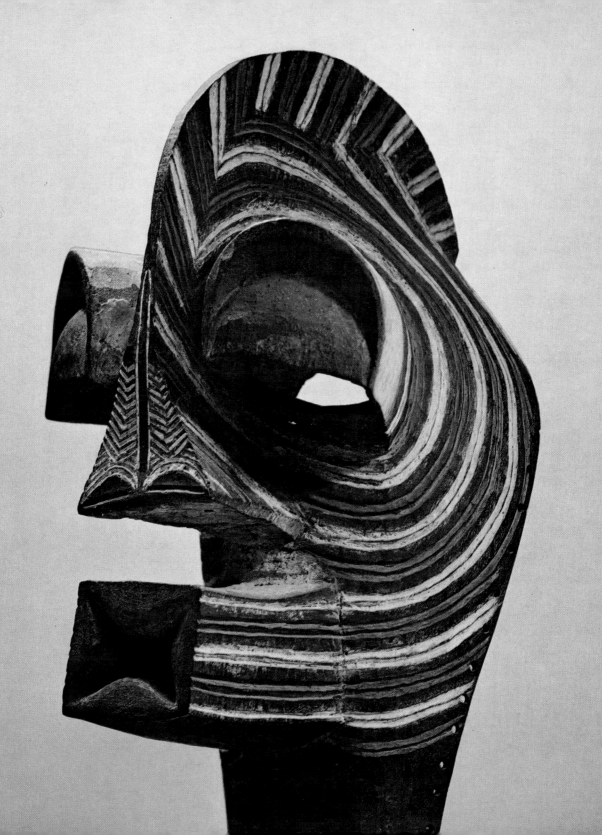

sculpture apart from their royal statues, while in the production of other ceremonial objects they display the greatest mastery. The expressive iron statuette in Antwerp is an extreme rarity.

The splendour of the court, the need for luxury and the refined taste of the aristocracy, their sense of beauty and decoration inspired every branch of related art, both in everyday objects and ritual vessels. Ceramics are uncommon but there are fine weapons, basketwork products and leather goods.

Amongst the most impressive are the wooden bowls carved in the form of figures. They were used for the ceremonial drinking of palm wine or for the poison ordeal. Function and ornament are always combined in a brilliant unity. For bowls and boxes the Bakuba like to choose themes from the animal kingdom: the beetle was called the 'head of God'; the crocodiles, the antelope or the thick skin of the crocodile contained power. One theme derived from basketwork is called 'belly of Woot' and refers to the fourth legendary king and culture-bringer of the Bakuba. Members of the *Yolo* society who were able to cut off an enemy's hand were allowed to express this fact by the carving of a hand. The decoration of the bowls displayed the rank of their owner; a ram's horn, for example, was restricted to kings and princes, because it refers to the myth and to supernatural power. The scars show the clan to which the owner belongs. *Tukula,* the red powder of the pterocarpus, was kept in ornamental boxes. The red ointment mixed from this powder repels termites, and was rubbed into the body; the dead were also painted with *tukula.* Many bowls carved as figures come from the Bakele and Bawongo. The Babinji of the Baluba style group specialize in tobacco pipes carved with figures. On the *musese,* the plush-like fabric woven from raffia, the basketwork pattern is applied in delightful variations. The women weave them on a hand loom, obtaining the plush effect by drawing loops of thread into the main weave during the weaving process and then cutting them off. The completed fabric is either worn folded as a cloak or used to decorate important dwelling rooms. Many of these cloths are embroidered. Some *musese* which reached Europe as early as the sixteenth century have been preserved.

The masks of the Bakuba and their neighbours, the Bakete, etc. are more a branch of popular art, although some of them are connected with the royal power. The *Mwaash-a-Mbooy* type, for example, represents the terrifying executive power of the police. Other masks appear in the initiation and funeral rites of the secret societies.

Three different forms of mask represent mythological figures:
1. Mwaash-a-Mbooy, or Woot, the first ancestor and hero who brought civilization, as well as the founder of the royal house, who married his sister. The mask is a decorative formation with a high peak, which symbolizes the elephant's trunk and thereby the royal power.
2. Mboom (Bombo), the brother of Mwaash-a-Mbooy and the ancestor of the initiation, who desired his brother's wife, is represented as a three-dimensional headdress mask with a heavy dished forehead, plated with copper foil.
3. Ngaady-a-Mwaash (Shene-Malula), the incestuous spouse of Woot, is represented by a somewhat flatter mask, completely covered with geometrical painted patterns, glass beads and cowrie shells.

The Bakuba masks are magnificent, imaginative and decorated with colourful additions such as copper, glass beads, feathers, cowrie shells, goat hair, cloth and bast.

V 2
Statue of King Mbop Akycen (*ca.* 1900).
Bakuba, Mushenge.
Wood, 55 cm.
Musée royal de l'Afrique centrale, Tervuren, Belgium.

V 3
Statue of King Kwete Peshanga Kena (1907).
Bakuba. Wood, 72 cm.
Danish National Museum, Ethnographical Department, Copenhagen.

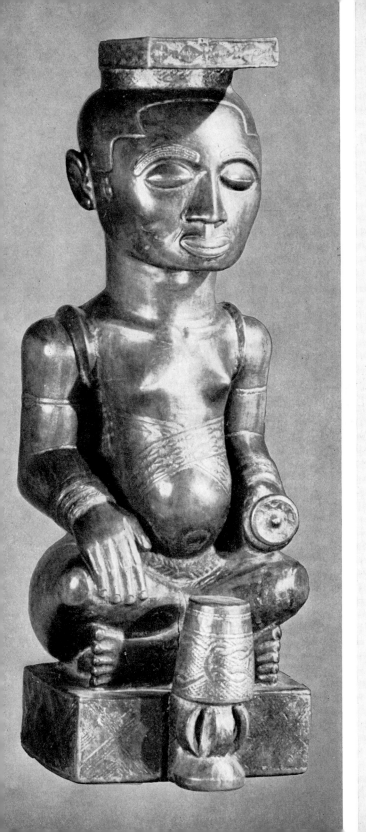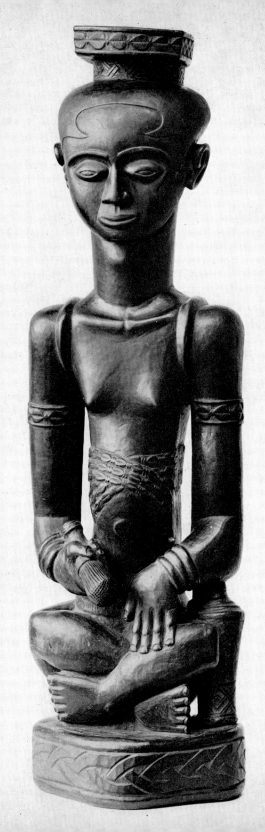

Their main characteristics are a wide head, the temple protruding to the side, a notched hair style or cap, eyes in the shape of coffee beans or spheres, surrounded by a row of holes in imitation of the eyes of the chameleon, circles centred on the bridge of the nose, a broad fleshy nose connected to a triangular or lozenge-shaped mouth by vertical lines; or again, lines following the pattern of weaving set with beads and leading from the nose to the chin.

We possess a few large statues of solemn appearance made by the *Ndengese,* northern neighbours of the Bakuba on the middle Lukenie. Alfred Maesen believes that they played a part in the powerful Leopard society, either at the initiation of members or as guardians of their graves.

The broad head with the royal cap and zig-zag lines at the side, as well as the circle on the bridge of the nose, are Bakuba elements. The lengthened body, decorated with scars, has no legs and rests on a pedestal.

The Basonge group

The Basonge group (including the Bekalebwe and Bena Mpassa) in the wide region between the Bakuba and the Baluba, between the Sankuru and Lomami rivers, has a distinctive position in several respects. According to tradition the cruel king Kongolo, who migrated from the north, founded the first Baluba kingdom in the fifteenth century. In 1585 Kongolo's kingdom was destroyed by the Baluba. In the midst of the matriarchal central Bantu culture, the Basonge form an enclave of patriarchal customs. It is interesting that their sculpture also departs from the round style of the Congo. The forms are sterner, cubist in feeling, unreal, and sometimes even aggressive, far from the lyrical charm of the Baluba style. The large eyes, in the shape of coffee beans, have a narrow slit to represent the pupil, the nose is triangular, the box-like mouth protrudes forward, or else is in the shape of a figure of eight on its side. The bodies seem to be composed of spikes, edges and corners. Most of the statues are still thickly covered with magical substances, plated with metal and decorated with cowrie shells, beads, feathers or snakeskin. They are fetishes in the true sense. In the Lomami region of the eastern Basonge area we find more and more masks of the powerful *Kifwebe* society. Their magical power is assured by blood sacrifices, which makes them effective against the most threatening events and troubles. With their parallel grooves, painted in alternating colours, and their eyes and mouths which jut forward, these *Kifwebe* masks are a fascinating incarnation of the supernatural.

The Basonge are also famous as smiths; they produce decorative ceremonial axes and throwing knives.

The masks of the Batetela — northwest of Lusambo — with their cubist forms and fine pattern of grooves, are similar to the Basonge masks.

V 4
Effigy drinking vessel. Bakuba. Wood, 19 cm.
Coll. J. Kerchache, Paris.

V 5
Drinking vessel in the shape of a head. Bakuba. Wood, 21 cm.
Coll. Hans Röthlingshöfer, Basel.

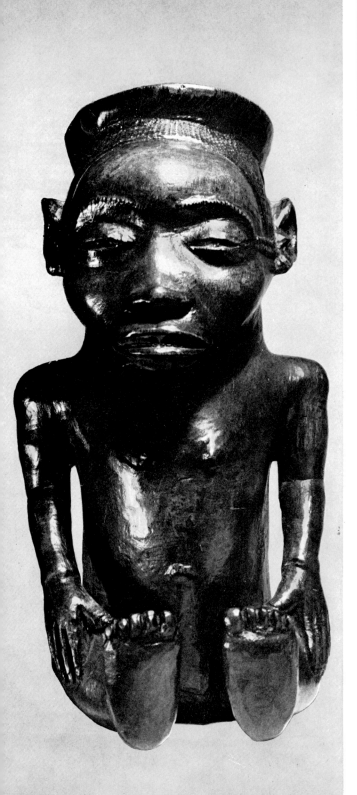
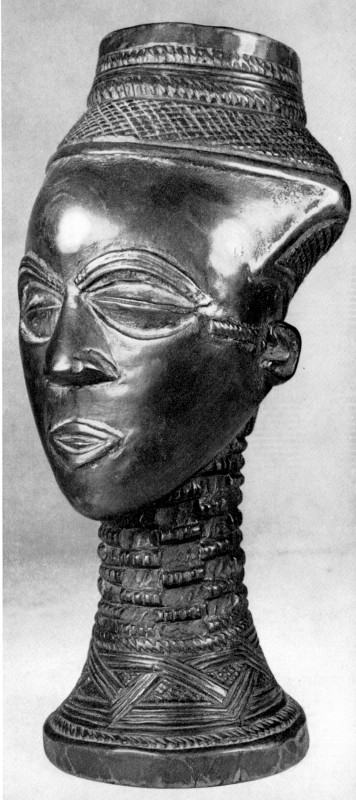

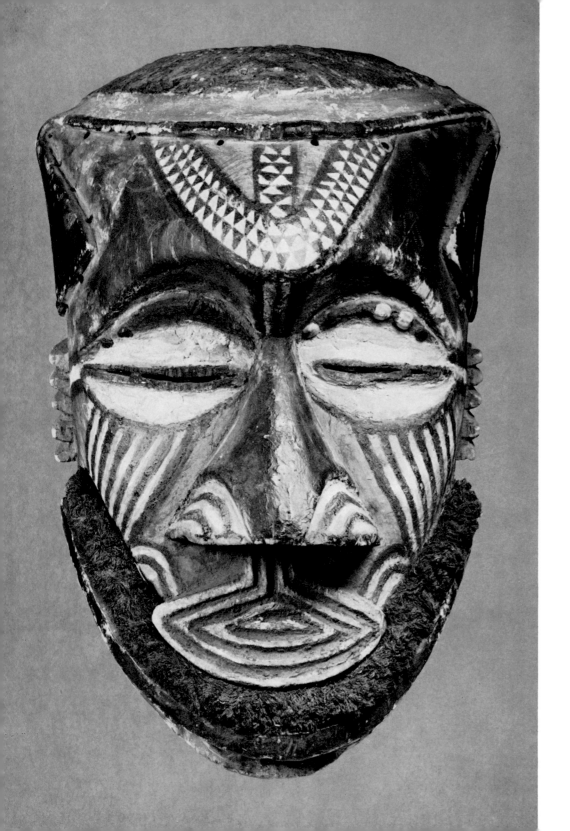

V 6
Large *Bombo* mask. Bakuba.
Painted wood, 43 cm.
Ethnological collection, Zurich.

V 7
Old *Kifwebe* mask. Basonge.
Wood with traces of white,
35 cm.
Rietberg Museum, Zurich.

V 8
Statuette. Bakuba, *ca.* 1515. Iron, 19.5 cm.
Etnografisch Museum, Antwerp.

V 9
Drinking vessel: head with ram's horns. Bakuba.
Wood, 20 cm.
Ethnological collection, Zurich.

V 10
Effigy drinking vessel. Bakuba. Wood, 23.5 cm.
Rietberg Museum, Zurich.

V 11
Drinking vessel: head with scar patterns. Bakuba.
Wood, 18 cm.
Rietberg Museum, Zurich.

V 12
Double drinking vessel. Bakuba. Wood, 15 cm.
Rietberg Museum, Zurich.

V 13
Lidded bowl with beetle motif. Bakuba.
Wood, l. 28.5 cm.
Coll. Hans Röthlingshöfer, Basel.

V 14
Decorated rectangular box with lid, used for
tukula ointment. Bakuba. Wood, l. 25.7 cm.
Prev. Coll. Epstein.
Coll. George Ortiz, Geneva.

V 15
Lidded box in the form of a basket with intertwining
pattern. Bakuba. Wood, 25 cm.
Rietberg Museum, Zurich.

V 16
Large headdress mask, *Bombo* type. Bakuba.
Wood with copper, glass beads, cowrie shells and
raffia, 28.5 cm.
Ethnological collection, Zurich.

V 17
Shene-Malula mask. Bakuba.
Painted wood, glass beads and cowrie shells, 23 cm.
Rietberg Museum, Zurich.

V 18
Effigy drinking vessel: large head on legs.
Bakuba. Wood, 20 cm.
Ethnological collection, Zurich.

V 8

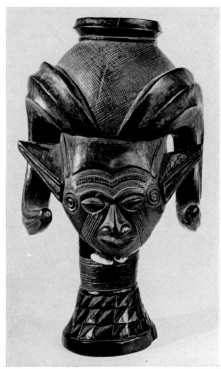

V 9

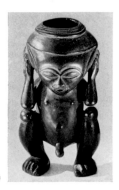

V 10

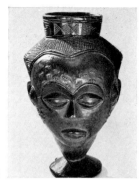

V 11

V 12

V 13

V 14

V 15

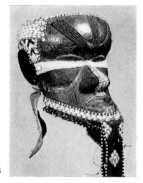

V 16

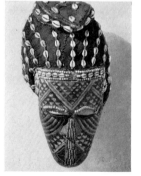

V 17

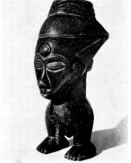

V 18

V 19
Drum with guilloche pattern. Bakuba. Wood, 130 cm.
Ethnological collection, Zurich.

V 20
Memorial statue of a chieftain. Ndengese.
Painted wood, 68 cm.
Ethnological collection, Zurich.

V 21
Musese, raffia velvet with guilloche motif.
Bakuba. Raffia, 50 cm.
Rietberg Museum, Zurich.

V 22
Mask with cylindrical eyes surrounded by small holes.
Bakuba. Wood, painted, 26.5 cm.
Coll. Dr. E.Hess, Oberwil, Baselland.

V 23
Hand with fingers bent inwards, a cross on the back
of the hand and a beetle on the reverse. Probably the
insignia of the military Yolo league.
Bakuba, Kasai region. Wood, l. 18.4 cm.
Musée royal de l'Afrique centrale, Tervuren, Belgium.

V 24
Female figure without arms. Basonge. Wood, 30 cm.
Coll. Maurice Bonnefoy / D'Arcy Galleries.

V 25
Fetish. Basonge.
Wood, horn, snakeskin etc. 31.6 cm.
Coll. Deletaille, Brussels.

V 26
Statue with long pillar-like neck. Basonge.
Wood, raffia apron, 54 cm.
Ethnological collection, Zurich.

V 27
Shield with mask in relief and geometric ornament.
Basonge. Painted wood, 77 cm.
Coll. J. Müller, Solothurn, Switzerland.

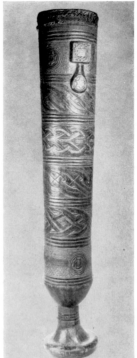

V 19

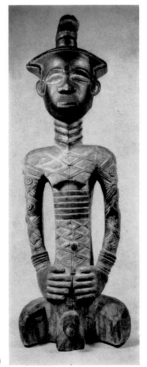

V 20

V 21

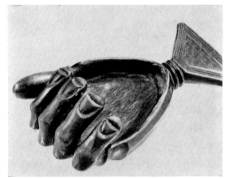

V 22

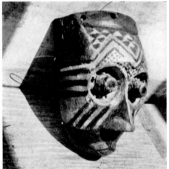

V 23

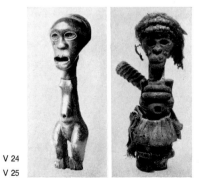

V 24
V 25

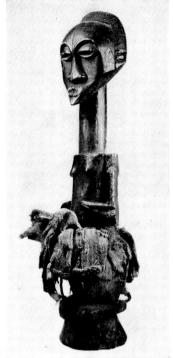

V 26

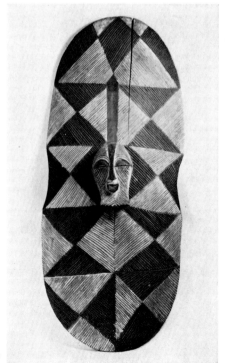

V 27

W The south-eastern Congo: the Baluba

Associated with the Baluba we have once again the conception of a great kingdom with a sophisticated court culture, which has given rise to one of the noblest and most beautiful styles of African carving. In 1585 the ruling class deposed the king of the Basonge; they united the different Bantu tribes of the wide region between the Sankuru and Lubilash (the upper reaches of the Sankuru), across southern Maniema and Katanga to Lake Tanganyika into a powerful military federation. The kingdom, weakened by internal political dissension, was conquered in the nineteenth century by the Batchokwe and Bayaka.

Many customs in the Baluba court point to the complex of the sacral kingship, an institution so important in Africa. Women have a high status. The matriarchal Bantu revere woman as the first mother, as a source of fertility, and as the guardian of cult objects. Thus the image of the first mother or of the female spirit *Vilye* is far more frequent that the most famous royal ancestors; and in every sphere of life carvings invoke the friendly, protective, helping power of the tribal mother. She is represented by naturalistic fully rounded bodily forms. We see harmonious proportions and gentle transitions, smooth joints, a spellbound posture and faces on which complete calm rests. And yet the Baluba style is not a unity. Over this wide area at least ten important sub-styles can be distinguished, which differ in their proportions and attitude, in their hair styles and in their scar patterns.

The famous classical Baluba style is the work of the Baluba-Bahemba, in Katanga, in the Urua country and between Lake Mweru and the river Lomami.

Its characteristics are a round head with a smooth vaulted forehead; a transverse band with short grooves across it separated from a coiffure which forms the outline of a cross. The eyes have the shape of coffee beans and there are tiny cat-like ears. There are horizontal lines about the genitals, while the surface is carefully polished and blackened. The basic effect is particularly delicate and poetic.

The style of the Baluba-Shankadi can be recognized from the hair style in cascade form. Here a particular artist seems to have set up a school, with enchanting compositions of figures forming headrests and stools, and a mastery of dimensions which is of outstanding artistic quality.

But in the north, in the village of Buli on the Lualaba in Maniema, a number of thrones supported by figures, free-standing figures and figures carrying bowls, point to such an individualistic artistic personality that commentators have come to speak of the long-faced style of the 'Master of Buli'. The heads and positions are dramatic and expressive.

In the case of the eastern Baluba group, the round style is confronted with the pole style of their eastern and northern neighbours. The result is an interesting modification of the round style into stern cubist forms and abstractions, particularly in the figures of the Wabembe (Kasikasingo) and Babuye. They have powerful angular contours, in the case of the Wabembe with a 'lantern-shaped' head in which face and forehead are at an obtuse angle to each other, and with large insect-like eyes. Amongst the Babuye the head is round.

The Wabembe also make completely abstract masks with eyes like stars, which give a telling impression of the unreality of the spirit being. The hair styles and decorative scars on the bodies

W 1
Headrest with two figures with cascaded hair-style.
Baluba-Shankadi.
Wood, 11.7 cm.
Coll. J. and R. Studer-Koch, Zurich.

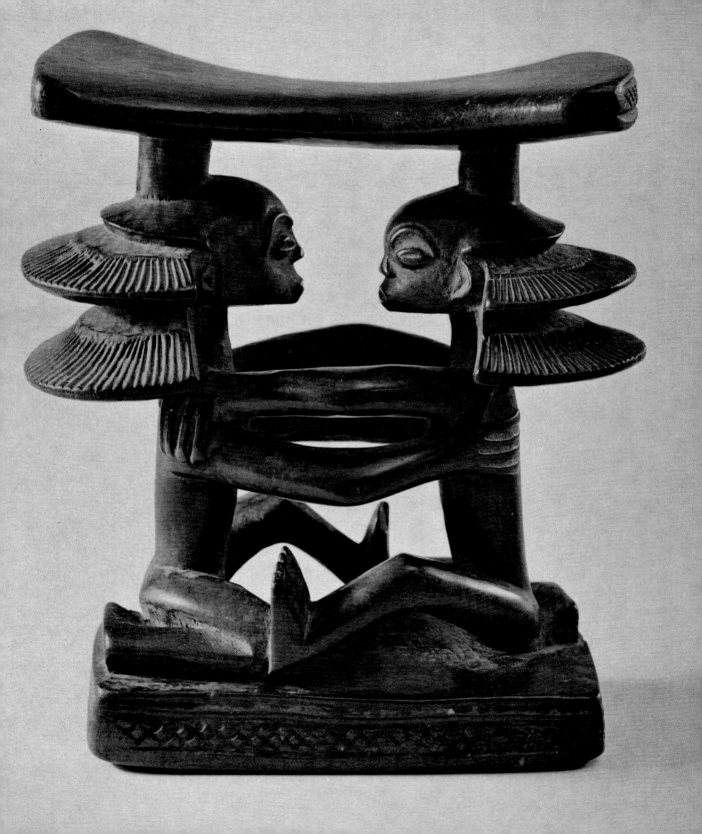

of figures are the insignia of the aristocracy.

The carving of the Baluba is so admirable because it succeeds in combining the image of the human figure in such a delicate and convincing way with functional objects. For example, a female figure will support with her head and arms the seat of a throne or a small neck-rest; it may top a sceptre, the chief's ceremonial axe or many other objects from the sphere of the cult and the court. The figure of the woman carrying the bowl, the 'beggar', is called *Kabila na vilye,* 'daughter of the spirit'. She is used by the medicine man to receive sacrificial gifts in the name of the spirits. This figure is used as an oracle, by laying an ancestor figure in the bowl, moving it about, and interpreting the answer from the way it falls. The *Kabila* figure is also used by a woman in childbed, who before her confinement sets up the bowl before her house as a silent appeal for gifts in kind and for the solidarity of her sisters.

The Baluba masks are rather few in number. They are mostly limited to the north-western region, where, as in the case of the Basonge, they are used by the *Kifwebe* society. Their surface is beautifully smooth or covered with a pattern of regular grooves, and they are hemispherical in form.

The works of the Baluba in ivory and hippopotamus teeth are extremely fine: neck-rests and amulets carry the image of the first mother who, bowing humbly — following the shape of the tooth — radiates a fine poetic feeling.

W 2
Ancestor figure. Baluba.
Wood, 26.5 cm.
Linden-Museum für Völkerkunde, Stuttgart, Germany.

W 3
Ancestor statue. Baluba.
Wood, 75 cm.
Ethnological collection, Zurich.

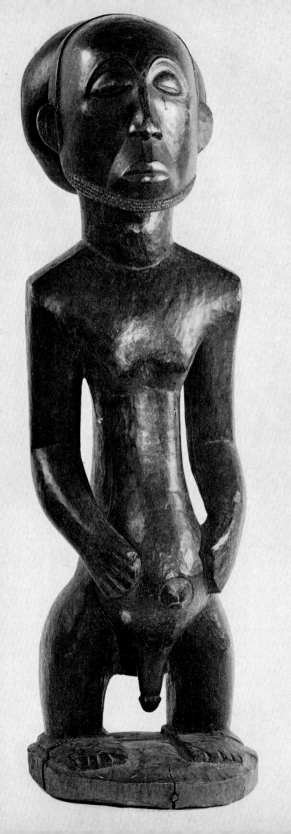
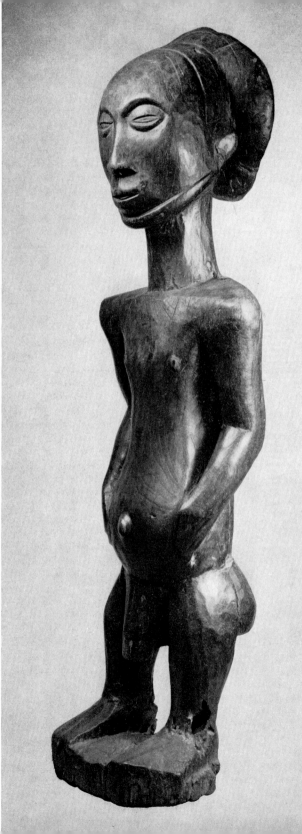

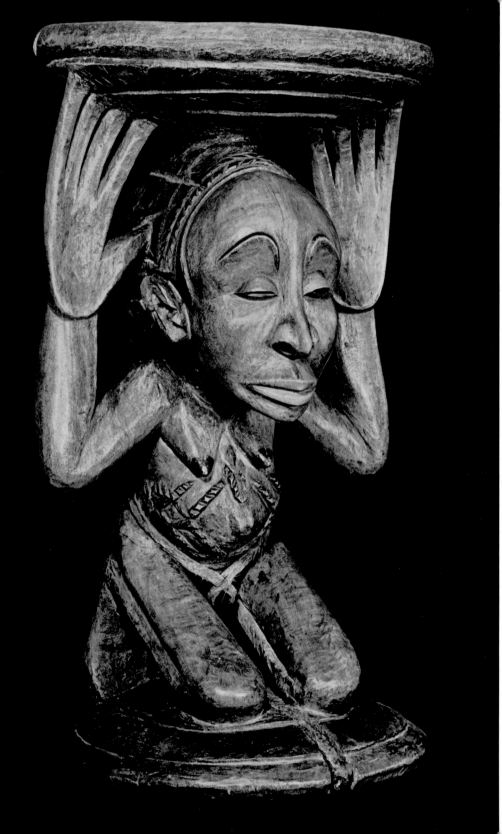

W 4
Chief's stool with kneeling
woman, work of the so-called
Master of Buli. Baluba.
Wood, 53 cm.
Linden-Museum für Völker-
kunde, Stuttgart, Germany.

W 5
Chief's stool with standing
woman, cross-shaped
hair-dress.
Baluba. Wood, 42 cm.
Coll. Hans Röthlingshöfer,
Basel.

W 6
Ceremonial staff with double
figure (detail). Baluba-
Bahemba. Wood, 161 cm.
Ethnological collection, Zurich.

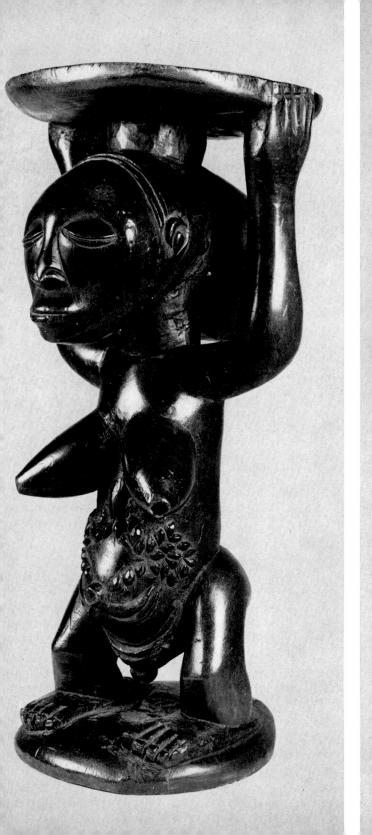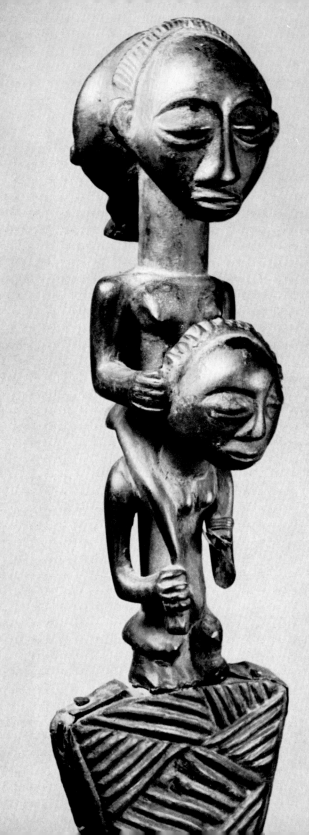

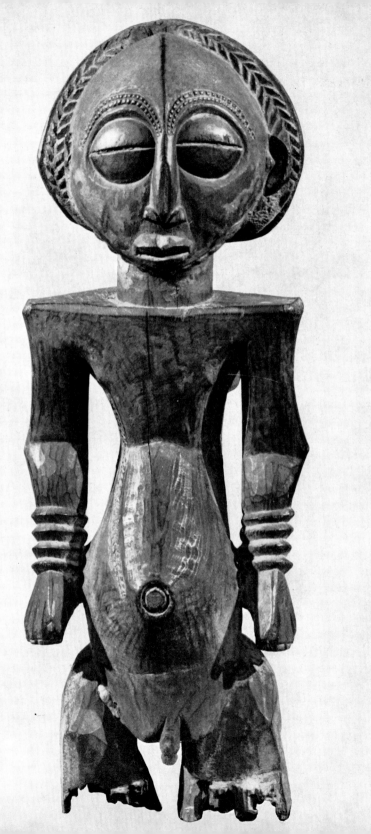

W 7
Ancestor statue of Adessa,
8th ancestor, grandchild of the
conqueror king Babuya from
Katanga. Kabambare region.
Wood, 79.4 cm.
The Museum of Primitive Art,
New York.

W 8
Headrest with the tribal
mother, Baluba-Bahemba.
Wood, 17.3 cm.
Rietberg Museum, Zurich.

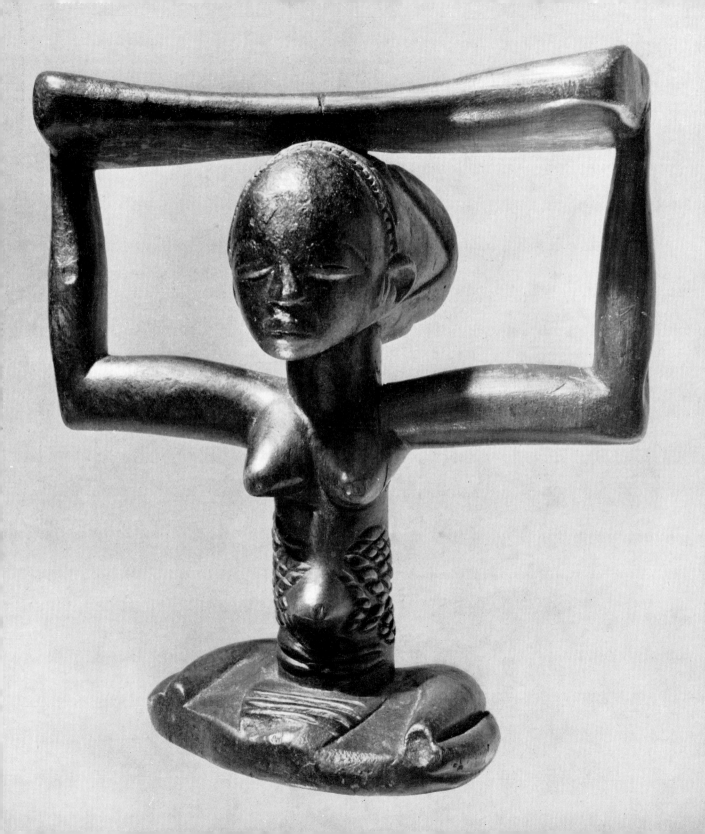

W 9
Ancestor statue. Baluba. Wood, 78 cm.
Rietberg Museum, Zurich.

W 10
Kneeling woman. Baluba. Wood, 46.5 cm.
Rietberg Museum, Zurich.

W 11
Two figures with dish. Baluba. Wood, l. 32 cm.
Coll. Hans Röthlingshöfer, Basel.

W 12
Ancestor statue. Baluba-Bahemba (detail).
Wood, 88 cm.
Etnographisch Museum, Antwerp.

W 13
Woman with dish. Baluba. Wood, 46 cm.
Ethnological collection, Zurich.

W 14
Tribal mother with scar pattern. Baluba.
Wood, 30 cm.
Coll. Jean Roudillon, Paris.

W 15
Cult vessel with head. Baluba (detail). Wood, 24 cm.
Rietberg Museum, Zurich.

W 16
Ceremonial staff with head, long-faced style.
North Baluba (detail). Wood, 144 cm.
Rietberg Museum, Zurich.

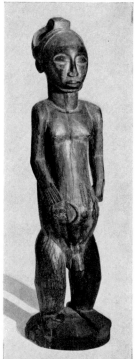

W 9

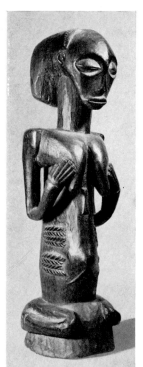

W 10

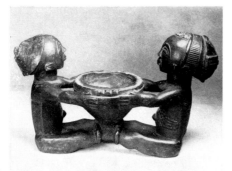

W 11

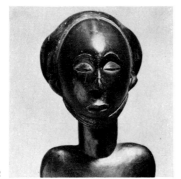

W 12

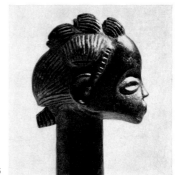

W 14

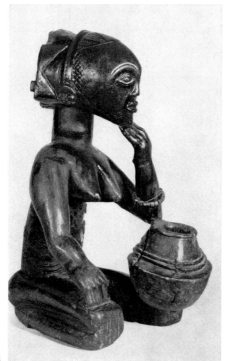

W 13

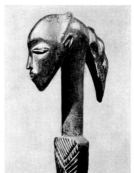

W 15

W 16

W 17
Ceremonial staff with figure. Baluba. Wood.
Ethnological collection, Zurich.

W 18
Ritual staff with abnormal spirit figure, long-faced
style. North Baluba. Wood, 130.5 cm.
Rietberg Museum, Zurich.

W 19
Chief's stool with pair of caryatids, work of the
so-called Master of Buli. North Baluba.
Wood, 54 cm.
Hessisches Landesmuseum, Darmstadt, Germany.

W 20
Head of a ceremonial axe. Baluba-Bahemba.
Wood, copper and iron, 36.5 cm (fragment).
Rietberg Museum, Zurich.

W 21
Amulet figure. Baluba-Bahemba. Ivory, 12 cm.
Rietberg Museum, Zurich.

W 22
Chief's stool with two standing figures. Baluba.
Wood, 40 cm.
Ethnological collection, Zurich.

W 23
Double figure. Baluba-Basamba. Wood, 21 cm.
Rietberg Museum, Zurich.

W 24
Round mask with beard. Baluba. Wood, 43.5 cm.
Ethnological collection, St Gall, Switzerland.

W 25
Ancestor statue. East Baluba. Wood, 63 cm.
Ethnological collection, Zurich.

W 26
Kalunga mask with large oval eyes. Wabembe.
Painted wood, 32 cm.
Private collection, Lausanne, Switzerland.

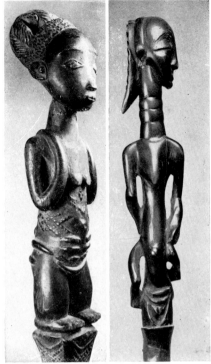

W 17
W 18

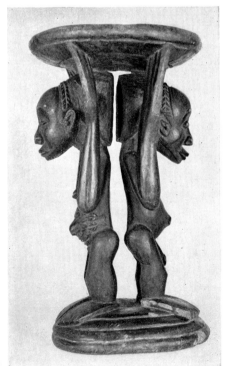

W 19

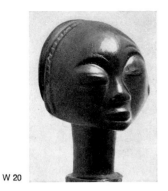

W 20

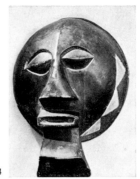

W 24

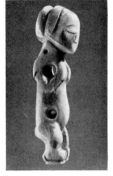

W 21

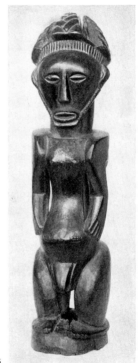

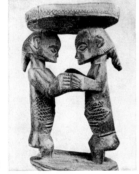

W 22

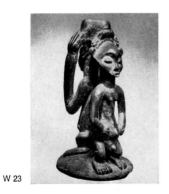

W 23

W 25

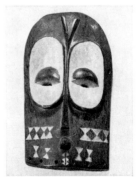

W 26

X The northern Congo

The difficult conditions of life in the northern Congo, covered with thick forest, are favourable neither to the formation of large kingdoms nor the development of significant arts and crafts. Only in the north-east are there a few oases of art: the Balega, Bapere, Bambole, Ababua, and on the very edge of the forest, the Mangbetu and Azande. In the north-west a few scattered styles exist, such as the Ngbandi, Tobgo and Ngbaka. The patriarchal tribes of the northern Congo show an inclination towards forms in the pole style.

The most important style of the northern Congo, that of the *Balega* people, is found between the great lakes and the River Lualaba. The Balega live in small villages in the tropical rain forest and are courageous elephant hunters. Their social life is determined by the *Bwame* society, to which everyone belongs. Depending upon one's bravery, the number of presents and payments one makes and the tests one has undergone, one can reach a high rank within the society. There are five ranks for men and three for women. A high rank signifies power and prestige and is a stimulus to increased endeavour. A man of the Balega finds his highest fulfilment when he is admitted to the initiation feast of the highest grade. This feast is celebrated with splendid dramatic presentations, the giving of gifts and singing. Then the power basket, which contains all the insignia of his family, is ceremoniously unveiled while special songs for the purpose are sung, and the mask and figures are ritually set out. They are made of ivory and elephant bones in the case of the highest *Kindi* rank. For the second highest rank, the *Yamanio* rank, they are made of wood. The sculptures are hand-ed down within the family for generations to relatives of the same rank. At the festival the masks are freshly painted with white *pembe*. The forms of the ivory figures express proverbs, or allusions to particular events. A figure with several heads alludes to the hunter who sees an elephant and looks back to call for help. To have several faces means to see everything, to possess omnipotence. Zig-zag forms refer to the man who runs but is called back; raised arms express lamentation at the destructive forces of witchcraft. For every figure the corresponding song is sung.

Their considerable requirements for secret society insignia inspired the Balega to produce delightful artistic creations, in a boldly abstract spiritualized style, influenced by their patriarchal culture towards the cubist style.

Their characteristics are large, simplified and solid forms, concave faces, often heart-shaped with a delicate mouth and a pointed chin, eyes in the form of a cowrie shell or as a point on a circle, often angular limbs, rudimentary bodies and dots or zig-zags as decorative patterns. Many small objects show considerable expressive force, while others display a naive but fresh primary style.

The large masks belong to the whole clan and are worn only at the initiation ceremony. Small masks serve as a sign of recognition for the members of the society and are worn on the arm or kept in the 'power basket'. The Balega also have animal figures, all of which are greatly simplified or schematic: especially dogs, but also chameleons, doves, elephants, snakes and the scaly anteater as the tribal emblem.

The ceremonial spoons carved from ivory and with decorative handles are particularly attractive. The material has taken on a warm, reddish patina from long use.

X 1
Initiation mask of the *Lilwa* secret society. Bambole. Painted wood, 45.9 cm. Musée royal de l'Afrique centrale, Tervuren, Belgium.

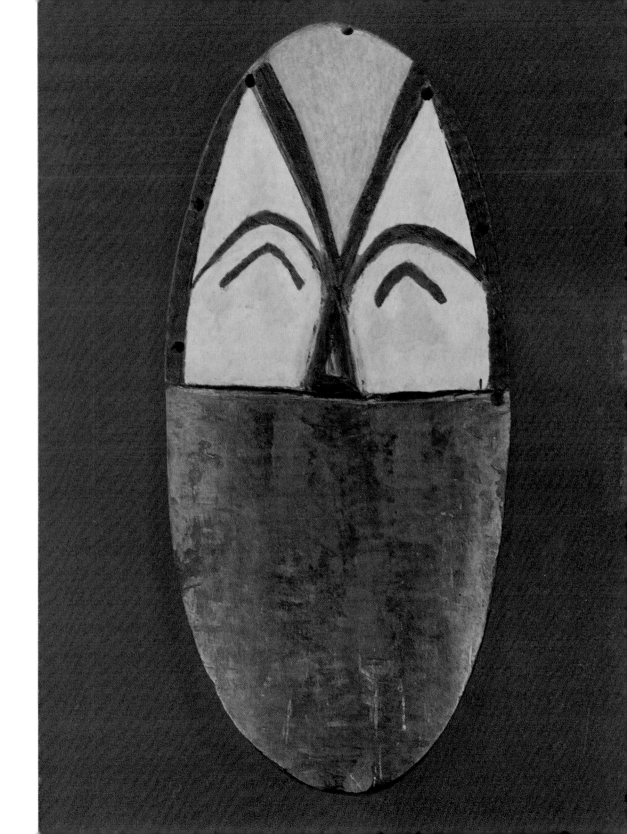

Wooden figures are rarely found amongst the Balega. A number of pieces betray the influence of the Baluba or Wabembe, but retain the subtle basic feeling which is characteristic of Balega art.

One phenomenon which comes from the *Bapere,* who live north of the Balega, is a distinctively stylized musical horn. In reality it is a human form resolved into spikes.

The *Bambole* — in the central Lomami forest round Opala — are hunters and farmers who are governed by the *Lilwa* society. The leader of the society and his assistants use figures as terrifying warnings. They are bodies which have been hanged or suffocated by smoke, and which demonstrate how an evildoer is punished, particularly one who betrays the secrets of the society.

The figures are strongly abstract, and have a heart-shaped, concave white painted face. A striking feature is found in the shoulders, which are taken forward in a complete arch above the breast — a detail which we have also observed amongst the Fang and Mitsogho. Little is known about the strongly abstract polychrome masks for the initiation rites.

The *Ababua* are a Bantu tribe who live in the jungle and swamp region between the rivers Likali and Aruwimi. Their art is not very different from that of the Mangbetu. Only in the masks which they use to bring luck in hunting and war do they display a style of their own. On drastically simplified forms white and black sections often alternate in a decorative and balanced way. A number of masks have a vaulted forehead, and sometimes a mouth with teeth or large ears in the form of a ring.

In the north-east, on the River Bomokandi, where the forest gradually grows thinner, there settled in the eighteenth century immigrant groups of *Mangbetu,* who set up a new kingdom. It was flourishing when the Sultan Munza received the explorer George Schweinfurth in 1870 in the pillared hall of his palace, fifty yards wide. Here again the culture of a court was the occasion of inspiration for a luxurious art. An unmistakable characteristic of Mangbetu figures is the way in which the back of the head is unnaturally long and narrow; this form corresponds to the ideal of beauty amongst the nobles. In order to achieve this lengthening of the back of the head, the heads of children were tightly tied with bast. The women also stiffen their hair with wickerwork to produce a basket-like formation.

The effect of the Mangbetu heads is extremely elegant. Their forms are naturalistic and display a delicate feeling. The Mangbetu are extremely skilled at combining functional objects, boxes, spoons, pipes, jugs, etc., in a harmonious way with figures and heads. The most beautiful are perhaps the *kundi,* the harps of the wandering singers. On top of the neck of the harp is a human figure, or else a long oval head. The strings, the thin ones of bast and the thicker of giraffe hair, above the beautifully curved, leather-covered sounding box, are sounded by plucking.

While it is the women who make the vessels for ordinary use, amongst the Mangbetu it is the men who manufacture the palm wine jugs in the form of figures. They are combined with human heads, the surfaces are decorated with chipped carving, and the hollow form is skilfully balanced with the handle.

The Mangbetu also show outstanding skill as smiths. They sell their complicated throwing irons, the *kpinga,* far outside their tribal region, especially to the Azande. The Mangbetu and Azande sometimes used to exchange artists, so that certain parallels exist within their styles.

X 2
Fine mask used as insignia of
the *Bwame* society. Balega.
Wood and white kaolin, 14 cm.
Coll. W. and D. A.

The *Azande* live in the north-eastern Zaïre and the adjoining areas of the Central African Republic, and in the Democratic Republic of the Congo, where the transition from forest to savannah takes place. They are people who have spread over a wide area. The Avengura, their ruling dynasty, have migrated in several movements since the sixteenth century from the central Sudan. They provided the kings for the various regions of the mighty state which reached its highest point in the second half of the eighteenth century. They carried on a cultural exchange with the Mangbetu. But as a rule the sculptures of the Azande were more abstract than those of the Mangbetu. The pair of figures shown recall, in the angular outlines of their bodies, certain ivory figures of the Balega, while the arch representing their shoulders is reminiscent of the style of the Bambole.

The Azande also decorate their harps with human heads or legs, and they wear strongly abstract human figures as the insignia of their *Inani* society.

From the region of the Azande and far beyond in the Ubangi-Chari area, and also amongst the Yangere, Ngbaka, Baramo, etc., we find huge slit gongs, which in a grandiose abstract style represent buffaloes or antelopes.

With regard to the isolated and less important styles of the north-western Congo, we shall content ourselves with a brief reference. The figures and masks of the Ngbandi, Ngbaka and Ngombe are usually bulky. The masks of the Ngbandi have round heads and those of the Ngombe long thin heads. Vertical, dotted lines of scars run across the forehead and nose. The holes for the eyes are often large and concave in treatment.

X 3
Musical horn in anthropomorphic shape. Bapere. Wood, 79.5 cm. Etnografisch Museum, Antwerp, Belgium.

X 4
Kundi, harp with double-headed figure. Mangbetu. Wood and leather, 55 cm. Rietberg Museum, Zurich.

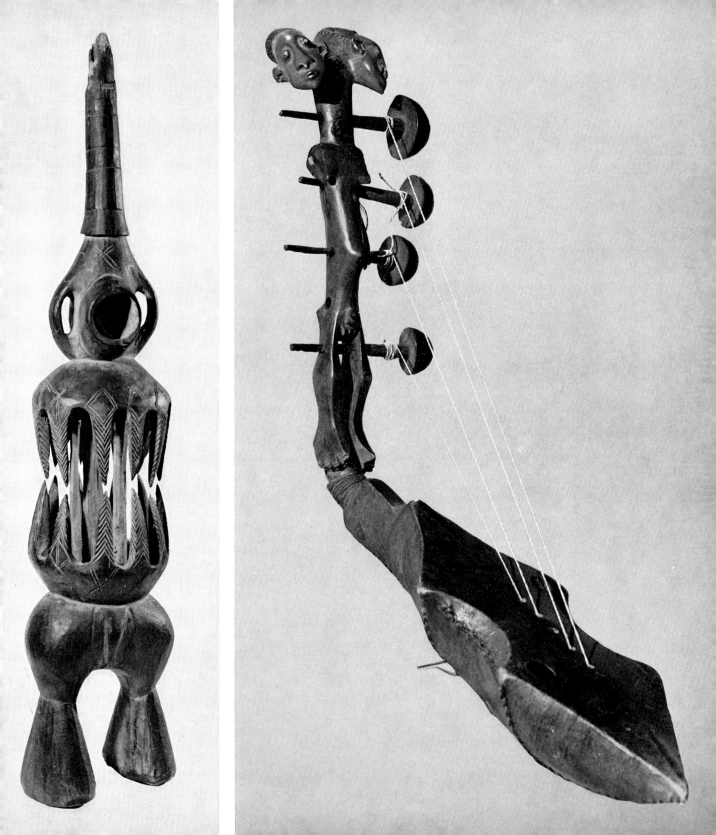

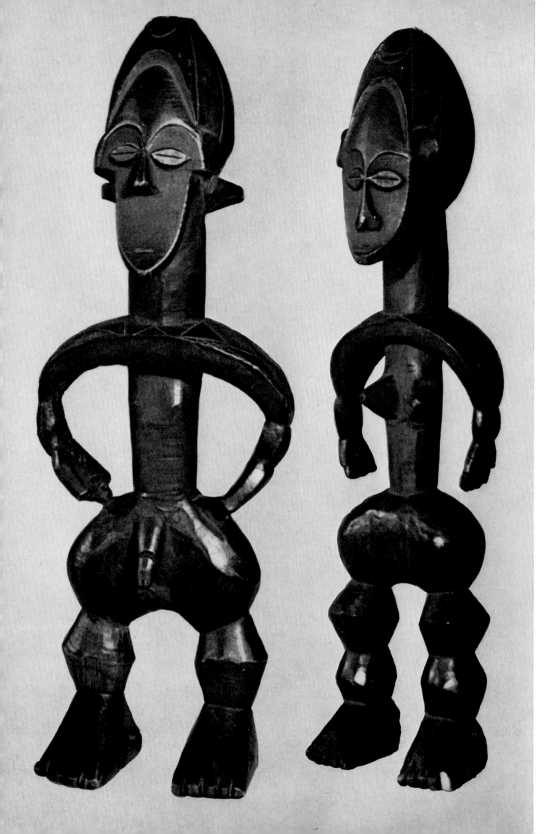

X 5
Pair of statues. Azande.
Wood, 34.5 and 35 cm.
Náprstek Museum, Prague.

X 7
Horned mask for the *Bwame* society.
Balega, Mobiri village, Manyema district.
Wood, white kaolin, 29 cm.
Rietberg Museum, Zurich.

X 8
Female figure for the blessing of children.
Balega, mouths of the rivers Luindi and Luama, near
Basheba village, Manyema district. Wood, 35 cm.
Coll. J. and R. Studer-Koch, Zurich.

X 9
Mask for the *Bwame* society. Balega. Wood, 23 cm.
Coll. Max and Berthe Kofler-Erni, Basel.

X 10
Composition of several heads. Balega. Ivory, 15 cm.
Coll. Charles Ratton, Paris.

X 11
Small head used as mark of the highest grade
of the *Bwame* society. Balega. Ivory, 5.5 cm.
Coll. J. and R. Studer-Koch, Zurich.

X 12
Small mask used as mark of the *Kindi* grade in
the *Bwame* society. Balega. Ivory, 5 cm.
Coll. J. and R. Studer-Koch, Zurich.

X 13
Kika, female figure in primary style. Balega.
Ivory, 22 cm.
Rietberg Museum, Zurich.

X 14
Double mask. Balega. Wood, painted white, with a
raffia beard, 20.5 cm.
Musée d'Ethnographie, Neuchâtel, Switzerland.

X 15
Statuette. Balega. Ivory, 14.5 cm.
Ethnological collection, Zurich.

X 16
Statuette with rudimentary arms. Balega.
Ivory, 10.5 cm.
Ethnological collection, Zurich.

X 17
Necklace with figure, animal's teeth and glass beads.
Balega. diam. 25 cm.
Coll. J. and R. Studer-Koch, Zurich.

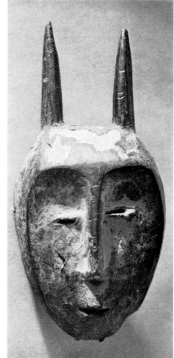

X 7

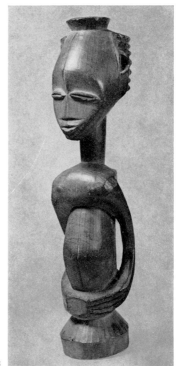

X 8

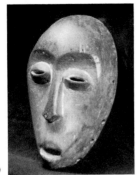

X 9

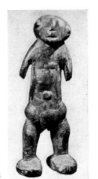

X 13

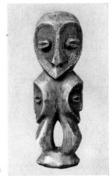

X 10

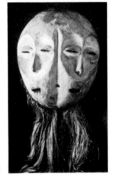

X 14

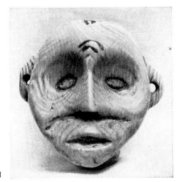

X 11

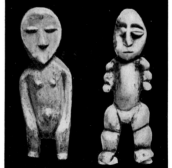

X 15
X 16

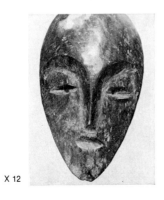

X 12

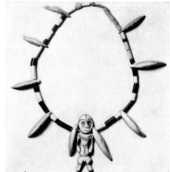

X 17

X 18
Spoon with decorative handle. Balega.
Ivory, 19.5 cm.
Rietberg Museum, Zurich.

X 19
Spoon with Janus head. Balega. Ivory, 25 cm.
Coll. Winizki, Zurich.

X 20
Male figure of the *Lilwa* society. Bambole.
Wood, 49 cm.
Ethnological collection, Zurich.

X 21
War mask. Ababua.
Wood, alternating black and white sections, 33.8 cm.
Musée royal de l'Afrique centrale, Tervuren, Belgium.

X 22
Kundi, harp with human head. Mangbetu.
Wood and leather, 98 cm.
Rietberg Museum, Zurich.

X 23
Jug with man's head over the circular handle.
Mangbetu. Terracotta, 37 cm.
Ethnological collection, Zurich.

X 24
Bark box in human shape.
Medje. Wood and bark, 65.3 cm.
Rietberg Museum, Zurich.

X 25
Abstract human figure. Azande. Wood, 33 cm.
Coll. Hélène Kamer, Paris.

X 26
Standing female figure patterned with tattocs.
Mangbetu. Wood, 62 cm.
Coll. Comte Baudouin de Grunne,
Wezembeek-Oppem, Belgium.

X 27
Pair of figures. Ngbaka. Wood, 45 and 41 cm.
Coll. Delenne, Brussels.

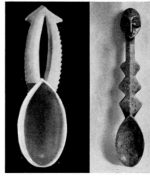

X 18
X 19

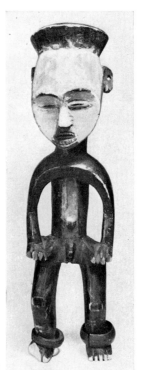

X 20

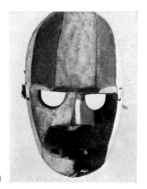

X 21

X 22

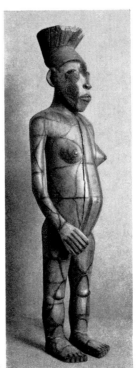

X 26

X 23

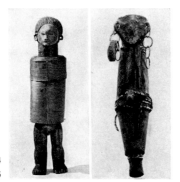

X 24
X 25

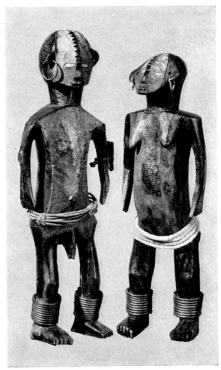

X 27

East and
South Africa

Z The Nile to Madagascar

From ancient times peoples crossed the steppe of East Africa and travelled along the chain of lakes towards the south: from 5,000 B.C. onwards these were the hunting bushmen races, some of whom no doubt are connected with the art of rock paintings. Later indications suggest that at the beginning of the first millenium A.D. the Bantu carried an early iron age culture (with the characteristic dimple based pottery) and that amongst them the first sacral kingship were to be found, the sources of which are to be sought in the Ethiopian and Nubian area.

In the late iron age, from the second half of the first millenium, there arose other large states with sacral kingship and a distinctively courtly culture, such as the pre-Wahima states in Uganda.

In the south of the continent also various empires developed in the course of the iron age Bantu migrations, and these are known as the Rhodesian civilization. In the south-east they reached their greatest achievement in the culture of Zimbabwe, Inyanga, and the associated Monomotapa kingdom of Rhodesia.

Negro agricultural cultures, in association with a belief in ancestors and spirits, and Hamitic or Nilotic rulers and the sacral kingship form a similar conjunction to that in the west. Despite this, East Africa produced hardly any sculpture of any account. Although everywhere that Negroes lived carving and modelling took place, in the east scarcely a single work was above the level of a primitive pole style sculpture. The only exceptions are reminiscences of courtly cultures such as the works of the Makonde group, an enclave of the round style in south-east Africa. Here and there we also find rudimentary sculpture in clay. We learn from Cory that this was used amongst the Wanyamwezi as illustrative material for the initiation school. Taken as a whole, the art of East Africa is so impoverished

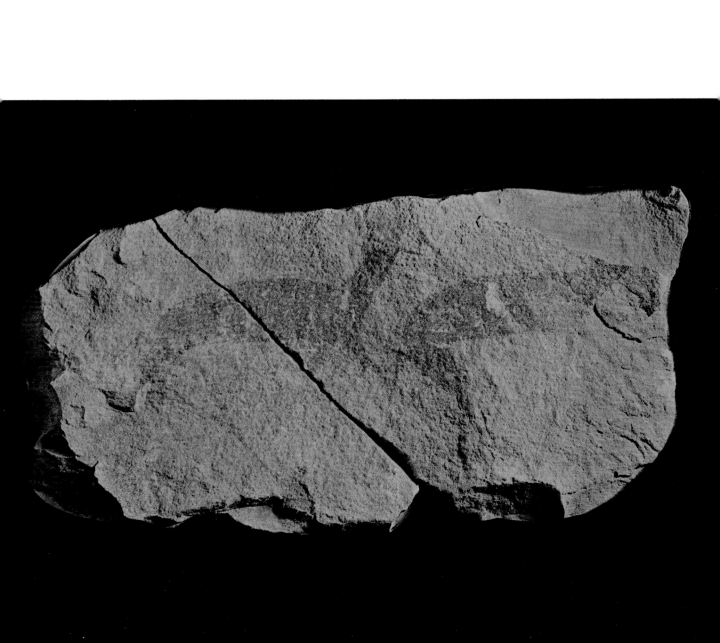

by contrast with the high civilization of West Africa that we can confine ourselves to a small number of selected examples.

The *south-eastern Sudan.* The northern part of East Africa is subject to Islam and of no significance for representational art. Not until we come to the tall Nilotes of the upper Nile region, the Shilluk, etc. do we enter the sphere of Negro art and discover traces of carving. To the south moist savannah begins; it is inhabited by Old Nigritic tribes such as the Bongo, Bari, Nuba, etc. The Shilluk have simple masks from gourd shells, while the Bari, Bongo etc. on the White Nile have ancestor figures and fetishes in a primary style, post-like figures with little variety which they set up in their houses or place on the graves and pour sacrificial libations over them. The Nuba have a certain reputation as potters.

The *region between Lake Victoria and the Rift Valley Lakes* of East Africa is a fertile mountain highland. Here Nilotic rulers dominate the Bantu, and the Wahima states flourished. Amongst the Watutsi (the Nilotic ruling class of this region) and Barundi we find most beautiful examples of basketwork, so fine that they are watertight. Their patterns swirl in rhythmically balanced zig-zag forms. The wooden vessels and tools are marked with fine burnt patterns. In Luzira (Uganda) prehistoric pots in the form of figures have been discovered. The Baganda wear cloaks of bark, with a stencilled pattern produced by the use of mud and a stencil, fastened over one shoulder like a toga.

In *Tanzania,* the fertile moist savannah west of Lake Victoria and Lake Tanganyika, the eastern Bantu have adopted many Hamitic practices. The Ethiopic Massai, nomadic cattle herders of the steppe, paint their leather shields with decorative tribal insignia and tokens of bravery and decorate their leather clothing, their milk vessels and ornaments with bright glass beads. Their iron lances are finely formed.

Amongst the eastern Bantu, such as Wasaramo, Wakerewe, Wadoe, Wagiriama, etc., we find a simple pole style sculpture representing ancestor and grave figures. The Washambala in Usambara, etc., set up rough figures as sources of power during times of sickness.

The iron animal figures from the kingdom of Karagwe are very elegant. A number of monumental pieces stand out amongst this series as the sole examples of the former courtly art. Amongst these is the throne of the Sultana of Buruku, of the Wanyamwezi. This is a chair, the back of which carries a human figure carved in relief, with a small round head looking out above the back.

Ethiopia

With regard to Ethiopia, we restrict ourselves to the art of the Negro tribes who live in the southern and western mountain region, because the highly developed art of the emperor's court belongs to quite a different sphere.

Alongside the Hamitic and Semitic ruling peoples live the negroid Konso, Gato, and Ometo, whose ancestor and grave memorials are made of stone and wood in the pole style.

The *Swahili coast,* the central coastal zone of East Africa, is strongly influenced by recent oriental civilization. From early times the Negro inhabitants had come to terms with the inroads of Arabs, Persians, Indians and Indonesians. From the tenth to the sixteenth centuries Kilwa was the flourishing trading metropolis of the Persian immigrants, and dominated the trade in gold as far as the kingdom of Monomotapa in Rhodesia.

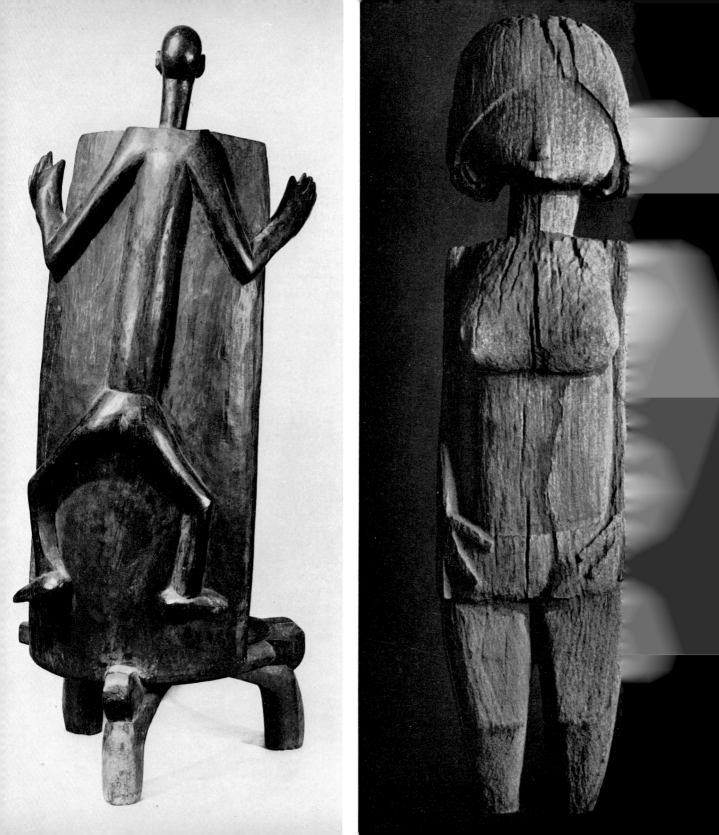

Asiatic influences and the dominance of Islam were largely responsible for the form taken by the decorative arts. Objects for everyday use from wood and noble metals bear the mark of the Coptic Nubian and Arabic Persian cultures.

The Makonde group occupies a special place in the East African area. It includes, amongst others, the following tribes: the Makonde, Mavia, Wayao, Makua, Wamuera, Matambwe, etc. They live between Lake Nyasa and the Indian Ocean, partly in northern Mozambique, and partly in southern Tanzania. In this enclave of matriarchal Bantu culture within a patriarchal area we can speak of a distinctive style. The privileged position of woman is complemented by the terrifying masked rites of the men.

Their works are in a round style, which must be seen as an offshoot of the art of the southern Congo, but less cultivated, and less 'courtly'. Indeed, it is sometimes of a rough and grotesque realism.

The sculptures represent the tribal mother and fearless warriors, the latter with beards; the female faces are distorted by the stretching of the top lip with a thick plug, and are often covered with tattoo lines, which have been drawn on the wooden face with wax.

Wooden breast plates complete the disguise of the masked dancers. A Makonde legend tells how the first man of creation carved a wooden figure which came to life and became his wife.

The masks include quite opposite types: a very simple and delicate type with a narrow nose, and a three-dimensional type with a grotesquely realistic fleshy Negro face. In the latter case the nose is wide, and the lips seem to be swollen. The female masks have the top lips stretched over a plug, and a scar pattern. We also find masks combined with animal elements, with long ears or horns.

Medicine and snuff is kept in the small and prettily decorated wooden boxes of the Makonde.

South-east Africa

Zimbabwe is rich in archaeological discoveries. Almost a hundred ruins between the Zambezi and the Limpopo, the remains of fortresses, temples, mines, cellars, baths, monoliths and terraces all bear witness to the flourishing kingdoms of the past, with a sacral monarchy, in which there was continual activity in metallurgy and in art. The whole culture is named after Zimbabwe, the most famous temple, lying fifteen miles south-east of Fort Victoria in the rocky hill country of Rhodesia. The architecture, the massive conical tower and the beautifully sweeping staircase of accurately dressed granite blocks, are creative masterpieces. Very little sculpture has been found: six magnificently stylized birds of steatite, stone bowls carved in relief, wooden bowls, and severaly formed vases in the shape of animal heads for preserving the internal organs of the ruler.

In Zimbabwe large quantities of copper were hauled out, bronze was cast and gold was melted. With the help of radiocarbon dating, imported glass beads, Persian faience and Chinese porcelain which were found in the ruins, it is possible to give some estimate of the date of Zimbabwe. The first early iron age settlement was early in the first millenium A.D. the beginning of the Zimbabwe culture was in the eighth or ninth century, and its greatest period, with the most important buildings in stone, was approximately in the thirteenth century. It is possible that the Wakaranga, who with their ruling aristocracy the Monomotapa invaded the Rhodesian plateau around the middle of the second millenium A.D., were responsible for the destruction of the

Z 4
Mask for puberty celebrations. Makonde, Tanzania.
Wood, glass beads and hair. 21.5 cm.
Linden-Museum für Völkerkunde, Stuttgart, Germany.

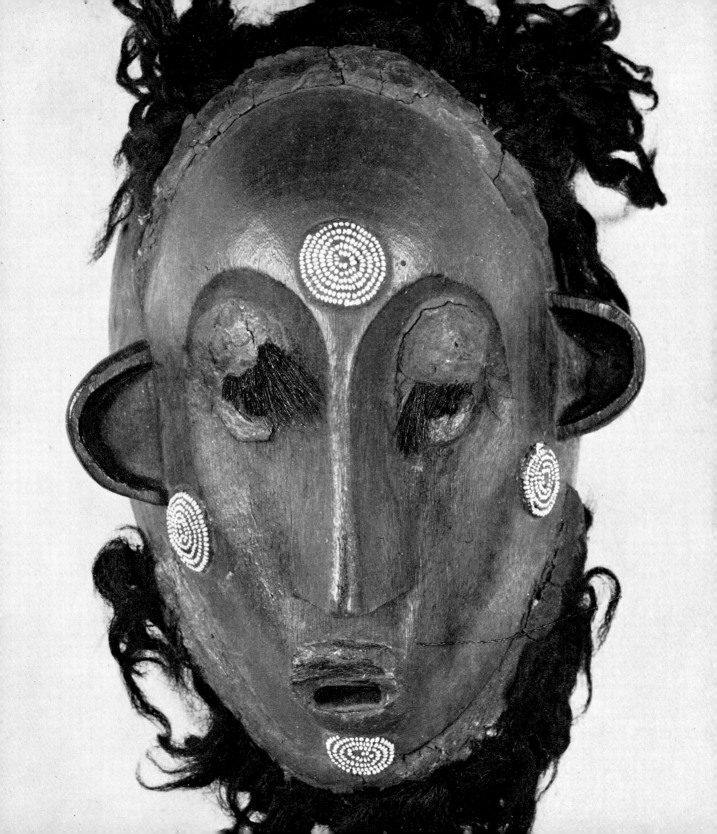

kingdom of Zimbabwe. In the sixteenth century the Portuguese explorers found the kingdom of Monomotapa already in a state of decadence. Monomotapa means 'lord of the mines'. He was a sacrosanct ruler who lived in the greatest splendour.

The Barotse

In the seventeenth century the Barotse overthrew the kingdom of Monomotapa and in their turn founded a kingdom on both sides of the Zambezi. A number of talented Bantu tribes practised the art of carving, for the need of their Hamitic overlords for beautiful functional objects was considerable — e. g. neck-rests, thrones, pipes carved as heads, baskets etc. Amongst the most beautiful are perhaps the lidded bowls of the Kwangwa, used for vegetables and meat, the handles of which are worked into the forms of stylized, cunningly abstracted human animal figures. For the ritual dances the Bantu manufacture wooden masks: the *Masubiya* with a divided forehead and crown of feathers, and the *Mambunda* with globular cheeks.

The connection with the royal courts of the Batchokwe and Balunda is obvious.

The *Basuto* are good potters, as can be seen from their animal sculptures in clay. In the south-eastern Bantu area high artistic standards have been attained: works in beads, leather and feathers, the drawing of iron and brass wire, and decorated wooden bowls with decoration in chipped carving all bear witness to a delicate aesthetic sense, by contrast to the figure carving, which never departs from a rigid pole style and in many cases is recent.

We show an ancestor couple carved by the *Wangoni* for the *Tonga*. Neck-rests supported by figures and other articles are made by the Wangoni.

Madagascar

Access to Madagascar is made extremely difficult by the powerful current in the straits between the continent and the island. For this reason, the civilization of the island looks more towards the East, and has largely been determined by Malaysian races, with an Indian and Arabian admixture. On Madagascar Negroes are in the minority and live in the backwoods areas: e. g. the Mahafaly and Antandroy in the south and the Tsimihety in the north. Nevertheless, their decoratively carved wooden *aloala,* grave posts from six to twelve feet high, are wholly worthy of our attention. They combine representational figures in a simple round style with meaningful geometrical ornamentation (much chipped carving, half moons, peripheral arches) which are clearly related to Afro-Arabian forms. The costums of the Madagascar Bantu reveal megalithic elements.

The *aloala* are set up in the large grave area *(valavato)* of a noble clan, together with numerous buffalo horns. The ornamentation and the number set up is related to the social rank of the dead person. The *valavato* are surrounded by stone slabs, with menhirs sticking up between them.

Aloala means 'shadow of death'; *alo* means mediator, the mediator between those who belong to the family and their ancestors. In the memorial the restless soul of the dead person finds a dwelling place, where it can be consoled and honoured by sacrifices. The *valavato* become shrines for the cult, which cannot be entered without the permission of the head of the family, and only in prayer and with libations. Old stories tell how human sacrifices were offered at the graves of great rulers: a king could not enter the next world without his retinue, nor without his wife and slaves. As late as 1912,

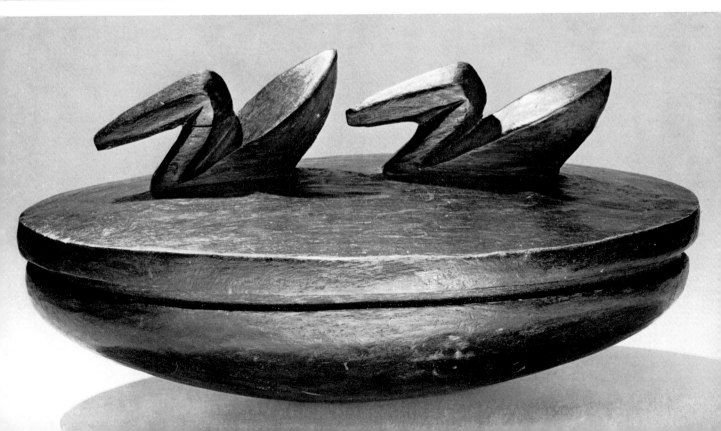

at the funeral celebrations of King Tsiampondy, sixteen hundred oxen are said to have been killed, as well as three slaves, whose heads were laid under the coffin. On the grave building, nearly fifty yards long, thirty-six *aloala* were set up and six hundred ox skulls set up in rows *(see* Décary, 1962).

Rock paintings

We conclude our survey of Africa's art by looking at the rock paintings which are spread throughout the steppe and deserts of northern, eastern and southern Africa. They were created over a period of ten thousand years, largely by non-Negro peoples, nomadic hunters and shepherds. There are places where pictures different in content, different in style and different in technique are found together and even over one another, so that there are great difficulties in deciding which were painted first.

The earliest examples are probably the powerful paintings of wild animals in the rock overhangs of North Africa (Oran, Fezzan, Tassili, Hoggar, etc.). Many of these rock paintings are drawn in the same way as in the Franco-Cantabrian style, while many can be compared with the style of the Levant.

In the fifth millenium B.C. large herds of cattle begin to appear on the rock walls. About 1200 B.C. we find chariots of the Cretan and Mycenaean type, and galloping horses make their entry. When the camel appears, the rock paintings can be dated in the historc period of Berber and Arab times.

The rock paintings of East Africa (Uganda, Tanzania, Kenya) are attributed to people similar to the Bushmen, who once roamed as bold hunters through the wide spaces of the savannah, and in the course of time reached South Africa.

It was Bushmen too who carried the Wilton and Smithfield cultures of South Africa, which are manifested in rich paintings and rock carvings. Their origin lies within a very lengthy period: the oldest are almost seven thousand years old, while the most recent come from our own time. The paintings are found throughout Rhodesia and the Transvaal, Natal, Lesotho, the Orange Free State and Cape Province. In South-West Africa they extend as far as the famous Brandberg.

As little as a hundred years ago it was quite possible to watch Bushmen painting and to record their rich mythological visions. It is not, however, out of the question that a small proportion of the most recent rock paintings were painted by or for Bantu tribes.

It is difficult to decide which of the rock paintings are the most admirable: the charming, marvellously dynamic animal and hunting scenes in a naturalistic style (in the Drakensberg etc.) or the high stylized scenes which represent cultic actions of a symbolic kind and seem reminiscent of ancient Egypt. Leo Frobenius, who calls them the 'cuneiform style' has tried to interpret them on the basis of the traditional myths. In certain pictures he believes that the act of killing the king can be made out. This would imply a connection with the important complex of the sacral kingship, the startling phenomenon which has been of such decisive importance for the fortune and prosperity of Africa and also for its art.

We have at least learnt to know, to understand and to admire the art of Black Africa. But we are only at the beginning: the mystery of its genius is still far from being exhausted.

Z 7
Ancestor pair, part of a
grave post, *Aloala*.
Madagascar. Wood, 80 cm.
Coll. J. Kerchache, Paris.

Z 8
Memorial heads. Konso, Ethiopia.
Wood, 47 and 42 cm.
Ethnological collection, Zurich.

Z 9
Mother and child. Figure for a roof. Galla, Ethiopia.
Terracotta, 49 cm.
Ethnological collection, Zurich.

Z 10
Bird. Karagwe, Bukoba, Tanzania.
Sheet copper, l. 34 cm.
Linden-Museum für Völkerkunde, Stuttgart, Germany.

Z 11
Bull. Karagwe, Bukoba, Tanzania.
Iron, l. 24 cm.
Linden-Museum für Völkerkunde, Stuttgart, Germany.

Z 12
Vizulu, seated woman with dish.
Washambala, Usambara. Wood, 45.5 cm.
Ethnological collection, Zurich

Z 13
Mask. Makonde. Wood, reddish colouring, 22 cm.
Ethnological collection, Zurich.

Z 14
Bull with enormous horns. Basuto.
Terracotta, l. 13.2 cm.
British Museum, London.

Z 15
Headdress mask with human face. North Mozambique.
Wood, 51 cm.
Museum für Völkerkunde, Berlin.

Z 16
Mask with long animal ears. Makonde.
Wood and raffia, 59.5 cm.
Museum für Völkerkunde, Berlin.

Z 17
Mask for puberty rites, with lip-plug and wax
tattooing. Makonde. North Mozambique.
Wood, wax, 21 cm.
Rautenstrauch-Joest-Museum, Cologne.

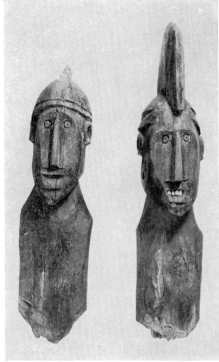

Z 8

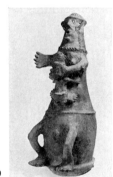

Z 9

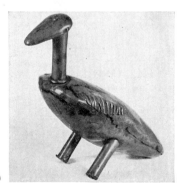

Z 10

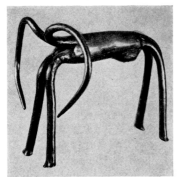

Z 11

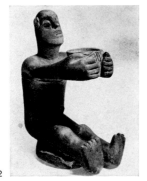

Z 12

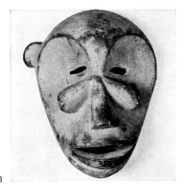

Z 13

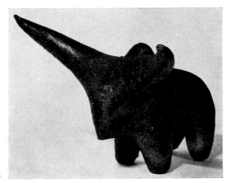

Z 14

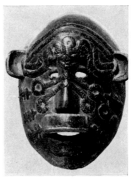

Z 15

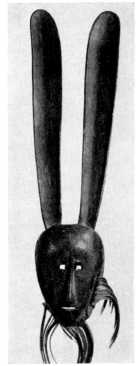

Z 16

Z 17

Z 18
Headrest. Mashona, Mozambique. Wood, 13.5 cm.
Ethnological collection, Zurich.

Z 19
Headrest in the form of a rhinoceros. Wangoni.
Wood, l. 26.5 cm.
Museum für Völkerkunde, Berlin.

Z 20
Lidded bowl with lion handle. Barotse.
Wood, l. 44 cm.
Musée d'Ethnographie, Neuchâtel, Switzerland.

Z 21
Staff with monkey. Barotseland.
Wood, total length 81 cm, monkey 12.5 cm.
Coll. Winizki, Zurich.

Z 22
Bird. Madagascar. Wood, 44 cm.
Coll. Duperrier.

Z 23
Standing couple, man wearing a wax head-ring,
sign of age and dignity.
Wangoni-Tonga. Wood, 68.5 cm.
Rijksmuseum voor Volkenkunde, Leiden, Holland.

Z 24
Decorated drinking vessels. Bushmen of South-west
Africa. Ostrich eggs, engraved and painted, 15 cm.
Ethnological collection, Zurich.

Z 25
Aloala, grave post with female figure and zebu.
Mahafaly, Madagascar. Late 19th century.
Wood, 146 cm.
Rietberg Museum, Zurich.

Z 26
Aloala with zebu (detail). Mahafaly, Madagascar.
Wood, 230 cm.
Coll. E. Storrer, Zurich.

Z 27
Mother with child. Part of a grave figure.
Madagascar. Wood, 116 cm.
Coll. Duperrier.

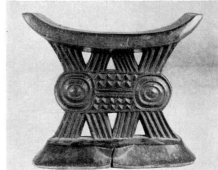

Z 18

Z 19

Z 20

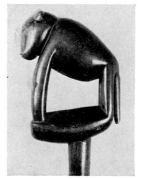

Z 21

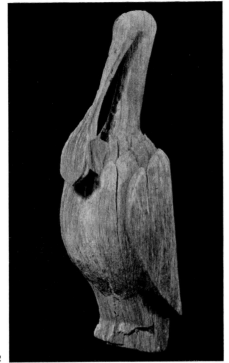

Z 22

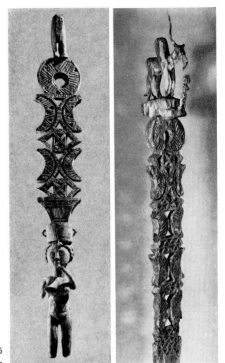

Z 25
Z 26

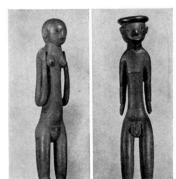

Z 23 a + b

Z 24

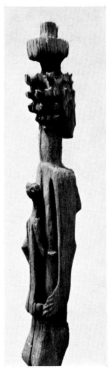

Z 27

Select bibliography

General

African Ideas of God. Pub. *Edwin W. Smith*. London 1950.

Allison, Ph.: African Stone Sculpture. London 1968.

Anspach, E.: African Tribal Sculpture from the Collection of Ernst and Ruth Anspach. The Mus. of Prim. Art, New York 1967.

Baumann, H.: Vaterrecht und Mutterrecht in Afrika. Zeitschrift f. Ethnologie 1926.

Baumann, H.: Afrikanisches Kunstgewerbe; in: Bossert, Gesch. d. Kunstgewerbes, Vol. II. Berlin 1929

Baumann, H., Thurwald, R. and *Westermann, D.:* Völkerkunde von Afrika. Essen 1940, out of print. French edition available. Les Peuples et Civilisations de l'Afrique. Paris 1948. New edition in preparation.

Baumann, H.: Nyama, die Rachemacht; in: Paideuma, Vol. IV, 1950.

Baumann, H.: Afrikanische Plastik und sakrales Königtum. Munich 1969.

Baumann, H.: Die ethnologische Beurteilung einer vorgeschichtlichen Keramik in Mittelafrika; in: Pub. in honour of E. Jensen. Munich 1964.

Beier, H. U.: African Mud sculpture. Cambridge 1963.

Biebuyck, D.: (Ed.) Tradition and Creativity in Tribal Art. Berkeley and Los Angeles 1969.

Bodrogi, T.: Afrikanische Kunst. Vienna, Munich and Budapest 1967.

Davidson, B.: Urzeit und Geschichte Afrikas. London—Hamburg 1961.

Davidson, B.: Afrika. Geschichte eines Erdteils. Frankfort/Main 1966.

Delange, J.: Arts et peuples de l'Afrique noire. Introduction à une analyse des créations plastiques. Paris 1967.

Dias, J. et al.: Escultra Africana no Museu de Etnologia do Ultramar. Lisbon 1968.

Einstein, C.: Afrikanische Plastik, Berlin 1915.

Einstein, C.: Negerplastik. Munich 1920.

Elisofon, E.: Text by Fagg, W.: Die afrikanische Plastik. Cologne 1958.

Fagg, W.: On the Nature of African Art; in: Mem. and Proc. Manchester Lit. and Phil. Soc. 1953.

Fagg, W. and W. a. B. Forman: Vergessene Negerkunst. Afroportugiesische Elfenbeinschnitzereien. Brunswik 1960.

Fagg, W. and Plass, M.: African Sculpture. London 1964. (Pictureback)

Fagg, W.: Afrique, 100 tribus, 100 chefs d'oeuvre. Paris 1964.

Fagg, W.: Tribes and Forms in African Art. London 1965.

Fagg, W.: The Art of Central Africa. Fontana Unesco Art Books. Milan 1967.

Fagg, W.: The Art of Western Africa. dto.

Fagg, W.: African Tribal Images. The Katherine White Reswick Collect. Cleveland Museum of Art. Cleveland 1968.

Fagg, W.: African Sculpture. The International Exhibitions Foundation 1970. USA.

Frobenius, L.: Die Masken und Geheimbünde Afrikas, 1898; in: Nova Acta, Leopoldina, vol. 74/I.

Gabus, J.: Art Nègre. Neuenburg 1967.

Gardi, R.: Unter afrikanischen Handwerkern. Bern. 1969.

Gerbrands, A. A.: Art as an Element of Culture. Leiden 1957.

Gerbrands, A. A.: Afrika, Kunst aus dem Schwarzen Erdteil. Recklinghausen 1967.

Griaule, M.: Arts de l'Afrique noire. Paris 1947.

Hefel, A.: Der afrikanische Gelbguß und seine Beziehungen zu den Mittelmeerländern, in: Wiener Beiträge, Jg. 5, 1943.

Herrmann, F.: Die afrikanische Negerplastik als Forschungsgegenstand. Berlin 1958.

Herrmann, F.: Afrikanische Kunst aus dem Völkerkundemuseum der Portheim-Stiftung. Berlin, Heidelberg, New York 1969.

Herold, E.: Ritualmasken Afrikas aus den Sammlungen des Náprstek-Museums in Prague. Prague 1967.

Herskovits, M. J.: Background of African Art. Denver 1945.

Heydrich, M. and Fröhlich, W.: Plastik der Primitiven. Stuttgart 1954.

Himmelheber, H.: Negerkunst und Negerkünstler. Brunswik 1960.

Himmelheber, H.: Die Geister und ihre irdischen Verkörperungen als Grundvorstellungen in der Religion der Dan; in: Baessler-Archiv, NF vol. XII, 1964.

Huet, M. and Fodeba, K.: Les hommes de la danse. Lausanne 1954.

Kjersmeier, C.: Centres de style de la sculpture nègre africaine, 4 vols. Paris 1935—1938 (and Copenhagen).

Krieger, K. and Kutscher, G.: Westafrikanische Masken. Museum für Völkerkunde Berlin. Berlin 1960.

Krieger, K.: Westafrikanische Plastik I to III. Berlin 1965 and 1969.

L'art nègre. Présence africaine 10/II. 1951, Paris.

L'Art Nègre. Exposition. Dakar—Paris 1966.

Laude, J.: Les arts de l'Afrique noire. (Livre de poche). Paris 1966.

Laude, J.: Musée de l'Homme. Paris 1967. Arts primitifs dans les ateliers d'artistes.

Leiris, M.: Les nègres d'Afrique et les arts sculpturaux. Unesco, Paris 1954.

Leiris, M. and Delange, J.: Afrique Noire, la création plastique. Paris 1967.

Leuzinger, E.: Africa. Art of the Negro peoples; in the series Art of the World, Methuen. London 1960.

Maesen, A.: Styles et expérience esthétique dans la plastique congolaise; in: Problèmes d'Afrique centrale XIII, 1959.

Masterpieces of African Art. Brooklyn Museum catalogue. New York 1954.

McNaughton, P. R.: The Throwing Knife in African History; in: African Arts, vol. III/2, 1970.

Meauzé, P.: African Sculpture. London, Lausanne 1965.

Millot, J.: La Collection Léonce-Pierre Guerre; in: Objets et Mondes, vol. II/2, 1962.

Nuoffer, O.: Afrikanische Plastik in der Gestaltung von Mutter und Kind. Dresden 1926.

Parrinder, G.: West African Religion. London 1949.

Paulme, D.: Les sculptures de l'Afrique noire. Paris 1956.

Pedrals, D.-P.: Archéologie de l'Afrique noire. Paris 1950.

Perrois, L.: Gabon, culture et techniques. Libreville, Gabon 1969.

Plass, M.: African Tribal Sculpture. Univ. Mus. Philadelphia 1956.

Radin, P. and *Sweeney, J. J.:* African Folktales and Sculpture. New York 1952.

Ratton, Ch.: Masques africains. Paris 1931.

Robbins, W.: African Art in American Collections. L'Art Africain dans les collections americaines. New York, Washington, London 1966.

Schmalenbach, W.: Die Kunst Afrikas. Basle 1953.

Schweeger-Hefel, A.: Afrikanische Bronzen. Vienna 1948.

Schweeger-Hefel, A.: Plastik aus Afrika. Museum für Völkerkunde Wien, Vienna 1969.

Steinmann, A.: Maske und Krankheit; in: Ciba-Zeitschrift No. 89, 1943. Basle.

Sydow, E. von: Die Kunst der Naturvölker und der Vorzeit. Propyläen-Kunstgeschichte I. Berlin 1923.

Sydow, E. von: Handbuch der Afrikanischen Plastik, Vol. I. Berlin 1930.

Sydow, E. von: Afrikanische Plastik. Aus dem Nachlaß herausgegeben von Gerdt Kutscher. Berlin 1954.

Tempels, P.: Bantu-Philosophie. Heidelberg 1956.

Trowell, M.: Classical African Sculpture. London 1954. 2. Ed. 1964.

Underwood, L.: Figures in Wood in West Africa. London 1947.

Underwood, L.: Masks of West Africa. London 1948.

Underwood, L.: Bronzes of West Africa. London 1949.

Vatter, E.: Religiöse Plastik der Naturvölker. Frankfort/Main 1926.

Wassing, R. S.: African Art, Its background and Tradition. New York 1968.

Westermann, D.: Geschichte Afrikas, Cologne 1952.

Wingert, P.: The sculpture of Negro Africa. New York 1950.

Worringer, W.: Abstraktion und Einfühlung. Munich 1959.

Zwernemann, J.: Der Widder und seine Verbindung zu Sonne und Gewitter in Afrika; in: Anthropos, Vol. 54, H. 3/4.

West Sudan

Dieterlen, G.: Les âmes des Dogons. Paris 1941.

Dieterlen, G.: Essai sur la religion Bambara. Paris 1951.

Dittmer, K.: Die sakralen Häuptlinge der Gurunsi im Obervoltagebiet. Mitt. Museum für Völkerkunde Hamburg XXVII. 1961.

Goldwater, R.: Senufo Sculpture from West Africa. Cat. Mus. of Prim. Art, New York 1960.

Goldwater, R.: Bambara Sculpture from the Western Sudan. Museum of Primitive Art Catalogue. New York 1960.

Goldwater, R.: Senufo Sculpture from West Africa. Greenwich, Conn. 1964.

Griaule, M.: Masques Dogon. Paris 1938.

Griaule, M.: Dieu d'eau. Paris 1948.

Himmelheber, H.: Figuren und Schnitztechnik bei den Lobi, Elfenbeinküste; in: Tribus, No. 15, Aug. 1966, Stuttgart.

Holas, B.: Sculpture Sénoufo. Abidjan 1964.

IFAN, Notes africaines, No. 59. July 1953.

Laude, J.: La Statuaire du pays Dogon; in: Revue d'Esthétique. Vol. XVII/1 a. 2. 1964.

Lem, F. H.: Sculptures soudanaises. 1948.

Minotaure. Mission Dakar-Djibouti 1931 to 1933. Paris 1933.

Schweeger-Hefel, A.: Nioniosi-Kunst; in: Baessler-Archiv, NF, Vol. XIV, 1966.

Schweeger-Hefel, A.: Die Kunst der Kurumba; in: Archiv für Völkerkunde, Vol. XVII/XVIII, 1962/1963.

From Senegal to Dahomey

Bardon, P.: Collection des masques d'or baoulé de l'IFAN. Dakar 1948.

Bernatzik, H. A.: Äthiopen des Westens. 2 Vols. Vienna 1933.

Bernatzik, H. A.: Im Reiche der Bidyogo. Innsbruck 1944.

Delange, J.: Le Bansonyi du Pays Baga; in: Objets et Mondes, La Revue du Musée de l'Homme. Tome II, Fas. 1, 1962.

Dittmer, K.: Bedeutung, Datierung und kulturhistorische Zusammenhänge der 'prähistorischen' Steinfiguren aus Sierra Leone und Guinée; in: Baessler-Archiv. NF. Vol. XV/1, 1967.

Donner, E.: Kunst und Handwerk in Nordostliberia. Bässl. Arch. 23. Berlin 1940.

Fischer, E.: Künstler der Dan; in: Baessler-Archiv NF 10, 1963.

Glück, J. F.: Die Gelbgüsse des Ali Amonikoyi. Annual Linden-Museum. Stuttgart 1951.

Harley, G. W.: Masks as agents of social control in Northeast Liberia. Pap. of the Peabody Mus. 32/2, 1950.

Herskovits, M. J.: Dahomey, 2 Vols. New York 1938.

Himmelheber, H. and U.: Die Dan. Stuttgart 1958.

Himmelheber, H.: Die Masken der Guéré im Rahmen der Kunst des oberen Ca-

vally-Gebietes; in: Z. f. Ethnologie, Vol. 88/2, 1963.

Himmelheber, H.: Gelbgußringe der Guéré (Elfenbeinküste); in: Tribus No. 13, 1964, Stuttgart.

Himmelheber, H.: Wunkirle, die gastliche Frau. Eine Würdenträgerin bei den Dan und Guéré (Liberia und Elfenbeinküste); in: Festschrift Alfred Bühler. 1965.

Holas, B.: Masques Kono. Paris 1952.

Holas, B.: Mission dans l'Est Libérien (Mém. IFAN 14), 1952, Dakar.

Holas, B.: Portes Sculptées du Musée d'Abidjan. Dakar 1952.

Holas, B.: Note sur la fonction rituelle de deux catégories de statues Sénoufo; in: Artibus Asiae, Vol. XX, I, 1957.

Holas, B.: Cultures matérielles de la Côte d'Ivoire. Paris 1960.

Holas, B.: Arts de la Côte d'Ivoire. Paris 1966.

Kyerematen, A. A. Y.: Panoply of Ghana. London and Accra 1964.

Menzel, B.: Goldgewichte aus Ghana. Museum für Völkerkunde Berlin. Berlin 1968.

Meyerowitz, E. L. R.: The sacred State of the Akan. London 1951.

Paulme, D.: Les gens du riz (Kissi). Paris 1954.

Rattray, R.: Religion and Art in Ashanti. Oxford 1927. New edition 1959.

Rütimeyer, L.: Über westafrikanische Steinidole; in: IAE. 1901.

Schwab, G.: Tribes of the Liberian Hinterland. Pap. Peabody Mus. Vol. 31, 1947.

Staub, U.: Beiträge zur Kenntnis der materiellen Kultur der Mendi. Bern 1936.

Vandenhoute, P. J. L.: Classification stylistique du masque Dan et Guéré de la Côte d'Ivoire occid. Leiden 1948.

Verger, P.: Dieux d'Afrique. Paris 1954.

Waterlot, E. G.: Les Bas-Reliefs des bâtiments royaux d'Abomey. Paris 1926.

Webster Plass, M.: African Miniatures. The Goldweights of the Ashanti. London 1967.

Zeller, R.: Die Goldgewichte von Asante; in: Baessler-Archiv. Beiheft III. 1912.

Nigeria

Abel, H.: Poids à peser l'or en Côte d'ivoire; in: Bull. de l'IFAN, Vol. XVI/1−2, 1954, Series B.

Beier, H. U.: Festival of the Images; in: Nigeria 45, 1954

Beier, H. U.: The Story of Sacred Wood Carvings in One Small Yoruba Town. Lagos 1957.

Bowdich, T. E.: Mission from Cape Coast Castle to Ashantee. London 1873.

Carroll, K.: Yoruba Religious Carving. London, Dublin, Melbourne 1967.

Daniel, F.: The Stone Figures of Esie; in: Journ. Roy. Anthrop. Inst. 67, Vol. 1937.

Dapper, O.: Beschreibung von Afrika. Amsterdam 1670.

Dapper, O.: Umbständliche und Eigentliche Beschreibung von Afrika. 1671.

Egharevba, Chief J. U.: A Short History of Benin. Lagos 1953.

Eyo, E.: Guide to the Nigerian Museum, Lagos.

Eyo, E.: 1969 Excavations at Ile-Ife; in: African Arts, Vol. III/2, 1970.

Fagg, W.: De l'art des Yoruba. L'art Nigérien avant Jésus-Christ; both in: L'art nègre. Paris 1951.

Fagg, W.: Bildwerke aus Nigeria. Munich 1963.

Forman, W. and B.: Text by Dark, Ph.: Die Kunst von Benin, Prague 1960.

Fröhlich, W.: Die Benin-Sammlung des Rautenstrauch-Joest-Museums in Köln; in: Ethnologica, Vol. 3, Cologne 1966.

Fry, Ph.: Essai sur la statuaire mumuye; in: Objets et Mondes, Vol. X/1, Paris 1970.

Horton, R.: Kalabari Sculpture. Nigeria, Apapa 1965.

Leuzinger, E.: Die Schnitzkunst im Leben der Afo von Nord-Nigeria; in: Geographica Helvetica, Zurich/Bern 1966.

Luschan, F. von: Altertümer von Benin, 3 Vols. Berlin 1919.

Marquart, J.: Die Benin-Sammlung des Reichsmuseums für Völkerkunde in Leiden. Leiden 1913.

Meek, C. K.: The Northern Tribes of Nigeria, 2 Vol. London 1925.

Murray, K. C.: The chief Art Styles of Nigeria; in: I. Confér. Int. africanistes Quest II. Dakar 1951.

Murray, K. C.: Ekpu, The Ancestor Figures of Oron. Burl. Mag. Vol. 89, Nov. 1947.

Murray, K. C.: The Stone images of Esie and their yearly festival; in: Nigeria 37, 1951.

Pitt-Rivers: Antique Works of Art from Benin. London 1900.

Read, C. H. and Dalton, O. M.: Antiquities from the City of Benin. London 1899.

Roth, H. L.: Great Benin. Halifax 1903.

Shaw, T.: The Mystery of the Buried Bronzes. Discoveries at Igbo-Ukwu, Eastern Nigeria; in: Nigeria Magazine, March 1967.

Sieber, R.: Sculpture of Northern Nigeria. New York 1961.

Talbot, P. A.: Peoples of Southern Nigeria, 4 Vols. Oxford 1926.

Wescott, J.: Yoruba Art. Ibadan 1958.

Wescott, J.: The Sculpture and Myths of Eshu-Elefba, the Yoruba Trickster: Definition and interpretation in Yoruba Iconographie; in: Africa, Vol. XXXII/4, 1962, Oxford.

Willet, F.: Ife, Metropole afrikanischer Kunst. Bergisch-Gladbach 1967.

Cameroon, Gabon and Central Congo

Alexandre, P. and Binet, J.: Le Groupe dit Pahouin. Paris 1958.

Andersson, E.: Les Kuta. Studia Ethn. Upsaliensia. 1953.

German, P.: Das plastisch- figürliche Kunstgewerbe im Grasland von Kamerun. Leipzig 1910.

Harter, P.: Four Bamileke Masks: An Attempt to identify the Style of Individual Carvers or their Workshops; in: Man vol. 4, No. 3, Sept. 1969.

Labouret, H.: Kameroun. Paris 1934.

Lebeuf, J. P.: La plaine du Tchad et ses arts. Paris 1946.

Lebeuf, J. P.: Art Ancien du Tchad. Paris 1962.

Lecoq, R.: Les Bamiléké. Paris 1953.

L'habitat au Cameroun. Paris 1952.

Siroto, L.: The Face of the Bwiti; in: African arts, Vol. I/3, 1968.

Tessmann, G.: Die Pangwe, 2 Vols. Berlin 1913.

The Congo

Baumann, H.: Die materielle Kultur der Azande und Mangbetu. Bäßler Archiv II. Berlin 1927.

Baumann, H.: Lunda. Berlin 1935.

Bastin, M.-L.: Art decoratif Tshokwe. 2 Vols. Lisbon 1961.

Bastin, M.-L.: L'Art d'un Peuple d'Angola; in: Africans Arts from Vol. II/1 1968, in instalments.

Biebuyck, G.: Function of a Lega Mask. IAE 47/I. Leiden 1954.

Boone, O.: Carte Ethnique du Congo Belge et du Ruanda-Urundi. Museum Tervuren. 1954.

Burssens, H.: The so-called 'Bangala'; in: Kongo-Overzee XX/3, Brussels 1954.

Burssens, H.: La fonction de la sculpture traditionnelle chez les Ngbaka; in: Brousse No. 2, 1958.

Colle, R. P.: Les Baluba, 2 Vols. Brussels 1913.

Dupré. M.-C. and Delange, J.: A propos d'un masque des Téké de l'ouest; in: Objets et Mondes, Vol. VIII/4, Paris 1968.

Himmelheber, H.: Les Masques Bayaka et leurs sculpteurs; in: Brousse, 1913/1. Léopoldville.

Himmelheber, H.: Art et Artistes Batshiok; in: Brousse, 1939.

Kun, M. de: L'Art Lega; in: Africa-Tervuren XII, 1966, 3/4.

Larsson, K. E.: The Chair of a Chief. Göteborg 1967.

L'art au Congo Belge (Les arts plastiques), Brussels 1951.

L'art nègre du Congo Belge. Brussels 1951.

Les arts au Congo Belge et au Ruanda-Urundi. CID, Brussels 1950.

Maes, J.: Les figurines sculptées du Bas-Congo; in: Africa III/3, 1930.

Maes, J.: Die soziale und kulturelle Bedeutung der Kabila-Figuren aus Belgisch-Kongo. Paideuma II/6—7, 1943.

Maesen, A.: Les Holo du Kwango; in: Reflets du Monde 9:31—44, 1956.

Maesen, A.: Umbangu, art du Congo (L'art en Belgique III). 1960.

Olbrechts, F. A.: Les arts plastiques du Congo belge. Brussels 1959.

Scohy, A.: Ekibondo, ou les murs veulent parler; in: Brousse 1951, 1/2. Léopoldville.

Sousberghe, L. de: L'art Pende. Acad. Roy. de Belgique, 1958.

Torday, E. and Joyce, T. A.: Notes ethnogr. sur les peuples Bakuba. Brussels 1910.

Torday, W.: Notes ethnogr. sur des populations habitants les bassins du Kasai et du Kwango oriental. Brussels 1921.

Verly, R.: Les Mintadi. La Statuaire de pierre du Bas-Congo. Louvain 1955.

Walker Art Center: Art of the Congo. Minneapolis 1967.

Zwernemann, J.: Spiegel- und Nagelplastiken vom unteren Kongo im Linden-Museum; in: Tribus No. 10, 1961.

South and East Africa

Camboué, P.: Aperçu sur les Malgaches et leurs conceptions d'art sculptural; in: Anthropos 1928.

Caton-Thompson, G.: The Zimbabwe Culture. Oxford 1931.

Cory, H.: Wall paintings by snake charmers in Tanganyika. London 1953.

Cory, H.: African Figurines. London 1956.

Décary, R.: La mort et les coutumes funéraires à Madagascar. Paris 1962.

Holy, L.: The Art of Africa. Masks and Figures from Eastern and Southern Africa. London 1967.

Jensen, A.: Im Lande des Gada. Stuttgart 1936.

Kronenberg, A. a. W.: Wooden carvings in the South Western Sudan; in: Kush, 1960, Vol. 8.

Leuzinger, E.: Zwei Aloalos aus Madagaskar im Museum Rietberg, Zurich; in: Festschrift Alfred Bühler, 1965.

Lormian, H.: L'art malgache. Paris 1934.

Meiring, A. L.: The Art and Architecture of the Amandebele. South Afr. Scene Vol. I. Pretoria.

Trowell, M. and Wachsmann, K. P.: Tribal Crafts of Uganda. London 1953.

Urbain-Faublée, M.: L'art malgache, Paris 1963.

Journals and magazines

African Arts / Arts d'Afrique: UCLA, Los Angeles, African Studies Center, Quarterly.

Africa. Journal of the Int. Afr. Inst. London.

Annales du Musée du Congo Belge. Les Arts. III 1902–1906. Brussels-Tervuren.

Bulletin de la Société d'études camérounaises. Douala.

IFAN (Inst. Français de l'Afrique Noire): Mémoires, Bulletin, Notes africaines etc.

IAE (Internat. Archiv für Ethnographie), Leiden.

Journal de la Société des Africanistes, Paris.

Journal of the Royal Anthropological Institute, London.

Kongo-Overzee, Brussels.

Man, London.

Nigeria. A quarterly Magazine. Lagos.

Paideuma. Institut für Kulturmorphologie, Frankfort/Main.

Zaïre. Revue Congolaise. Brussels.

ZfE (Zeitschrift für Ethnologie.) Deutsche Ges. für Völkerkunde. Brunswik.

Plates

Serge Béguier, Paris: R 10.
Frau Prof. E. Bernatzik, Vienna: E 15
Zoé Binswanger, Les Antigues, Saint-Rémy de Provence: D 3, 14, 21, E 9, 17, 19, G 11, L 24, R 15, T 9, V 21, W 16, 21, X 7, 22, Z 25
Bordas, Clichy-Paris: Q 4
Michèle Bouder, Paris: A 10
Courtesy of the Brooklyn Museum, New York: Q 3, U 8
British Museum, London: K 26
W. Bruggmann, Winterthur: K 24
Roberto E. Castro, France: B 5
Chaccin, France: Q 6
The Cleveland Museum of Art: K 2, P 4
Jacques Culot, Brussels, H 1, 25, L 2, M 20, N 17, P 21, X 26, Z 3
Robert David, Paris: E 25
Henri Delleuse, Marseilles: B 23
Didoni, Linden-Museum, Stuttgart: K 15, N 16, 20, O 12, P 10, 26, S 2, U 10, W 4, Z 4, 5, 10, 11
Walter Dräyer, Zurich: A 11, 12, B 1, C 12, D 2, 7, F 24, H 4, 8, 21, J 6, 13, K 1, 8, 20, L 1, 11, 30, M 1, O 7, W 7
Hans Finsler, Zurich: F 5
Helmut Gernsheim, Castagnola: B 11, O 10
Ernst Hahn, Berlin: A 20, B 24, 25, 27, K 21, L 4, 25, P 14, S 11, T 6, V 10, W 9, 10, 15, X 18, 24, Z 6
André Held, Ecublens: A 3, 4, 5, 22, 26, 34, B 3, 4, 10, C 9, 14, 17, 18, 21, D 17, 19, E 6, 7, 24, F 6, 8, 17, G 1, 10, 21, 25, 26, 29, H 22, J 1, 14, L 31, N 2, 12, 30, O 1, P 1, 7, 11, 12, 19, Q 12, 24, R 13, 19, 21, 24, S 21, T 3, U 15, Z 27
Hugo P. Herdeg: A 24, E 26, Q 7, 13, 15, 18, U 16, 18, V 9, 18, W 24, 25, Z 20, 22
Hans Hinz, Basle (with permission of the Office du Livre, Fribourg): A 8, B 8, 13, G 4, 12, L 28
Walter Hugentobler, Neuchâtel: U 14
Vera Jislova, Prague: B 15, E 5, G 17, X 5
Aimé Kerchache, Paris: A 14, 16, 17, 21, 35, B 21, D 6, 22, F 12, 26, H 5, 7, 9, 27, L 3, 7, 10, M 3, 4, 5, 6, 7, 11, 19, 21, 26, 33, N 9, 10, 11, 13, 14, 21, 22, P 3, 5, 9, 22, Q 2, R 3, 4, 6, S 17, U 5, 6, V 4, Z 7
G. Künzi, Oberd./Solothurn: H 17, R 16, 20

Landesbildstelle Baden-Württembg.: W 2
Elsy Leuzinger, Zurich: L 16, M 29, R 12
City of Liverpool Museums, Photographic Department: K 4, 12, 23, O 17
Mardyks, Paris: R 9
Claude Mercier, Geneva: F 25, S 16
Claude Michaelides: Q 11, 22
Bernhard Moosbrugger, Zurich: C 8, D 5
André Muelhaupt-Buehler, Basle: F 9, P 23
A. Muller, St. Gratien: F 15, M 12
Musée de l'Homme, Paris, phototèque: A 1, 6, C 1, S 18, X 6
Musée Royal de l'Afrique Centrale, Tervuren: N 1, S 5, 19, T 1, 2, 4, 7, 14, U 17, 20, 21, V 2, 23, X 1, 21
Museu d'Etnologia do Ultramar, Lisbon: E 11, 12, 18, S 4, U 9
Denys Niedsgorky, Paris: R 23
The Nigerian Museum, Lagos: J 2, 3, 4, 5, 7, 8, 9, 10, 11, 12, 15, 16, L 12, M 9, 17, N 4, 6, 14, 18, 25, O 2
I. Rácz, Hilterfingen: D 20, E 10, W 23, X 13
Rijksmuseum voor Volkenkunde, Leiden: K 18
Helen Sager, Basle: L 16
Peter Schnell, Zurich: K 5, 17, 19, L 23
Sörvik, Göteborg: Q 9
Steinmetz, Germany: K 24, N 26
Dr. Wolf Strache, Stuttgart: K 29
Charles Uht, New York: L 5
Verité, jun., Paris: R 11
Ernst Winizki, Zurich: A 2, 9, 13, 15, 18, 23, 25, 27, 31, 34, B 9, 12, 14, 17, 18, 19, 20, 22, 26, C 10, 11, 15, 19, 23, 24, D 4, 8, 9, 11, 15, 18, E 2, 8, 16, 20, 22, 23, F 1, 2, 3, 4, 7, 10, 11, 14, 16, 18, 19, 20, 21, 22, G 2, 3, 5, 6, 7, 8, 9, 14, 15 16, 18, 19, 20, 22, 23, 24, 27, 28, H 3, 11, 12, 13, 15, 16, 23, 24, K 6, 14, 22, 25, L 9, 19, 21, 26, M 18, 22, 27, N 5, 28, 29, O 3, 4, 9, 13, 16, 18, P 6, 13, 15, 16, 17, 18, Q 8, 10, 14, 16, 17, 19, 23, R 1, 2, 5, 14, 18, S 1, 3, 13, 15, 20, 22, 24, T 8, 10, 13, 15, 16, 17, U 2, 7, 11, V 5, 6, 16, 19, 20, 26, 27, W 3, 5, 11, 13, 17, 18, 22, X 2, 8, 9, 10, 11, 12, 14, 15, 16, 17, 19, 20, 23, Z 8, 9, 12, 13, 21, 23, 24, 26
Wettstein + Kauf, Zurich: B 2, C 4, D 1, 13, E 1, G 13, L 22, U 1, V 1, 7, W 1, Z 1
D. Widmer, Basle: A 28, 29, H 14, 19, 20, K 10, 11, 27, 28, 30, L 29, M 28, V 14
Michael Wolgensinger, Zurich: D 16

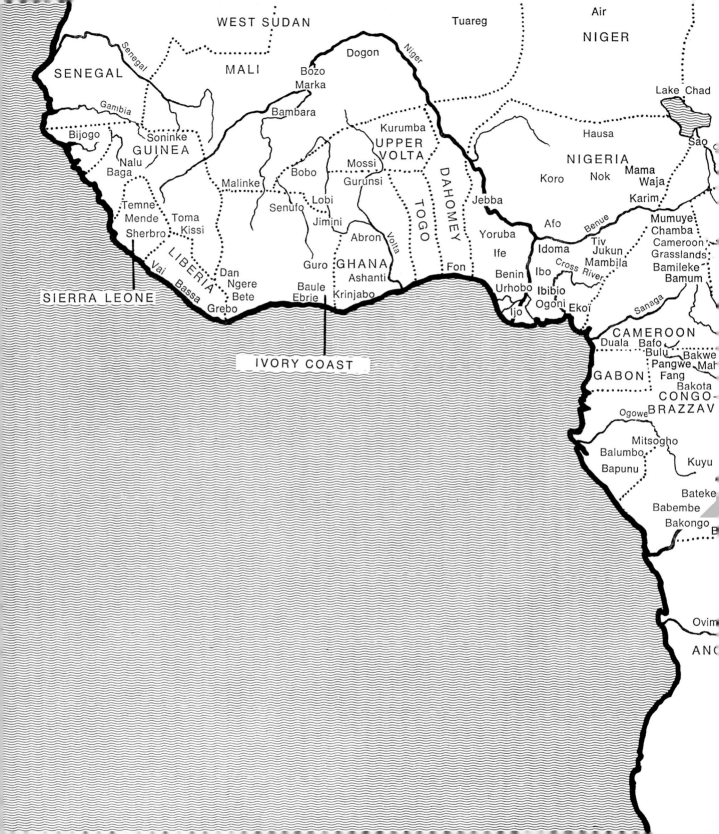

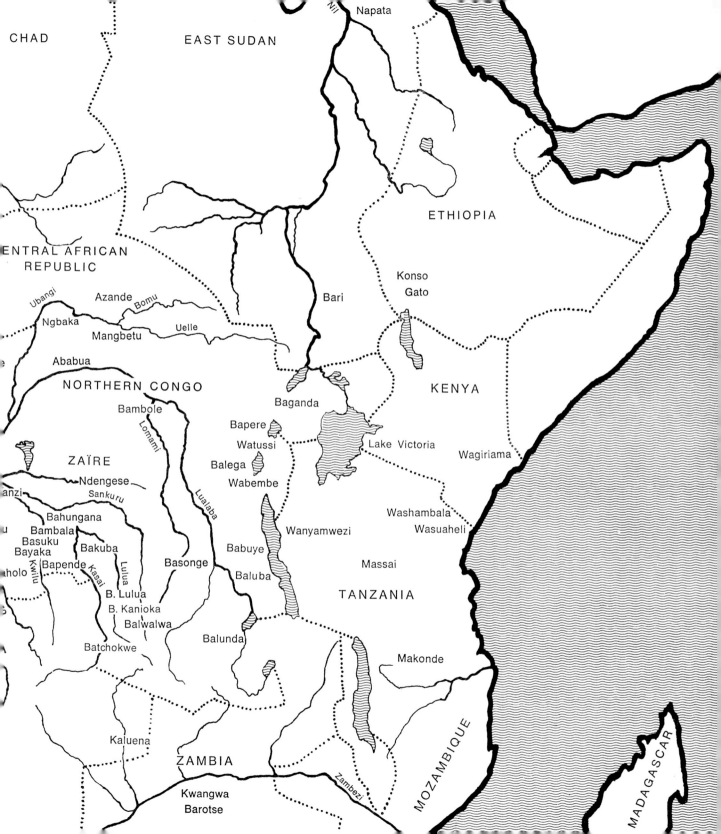

Index of countries and tribes

A

Ababua 276, 338, 346
Abron 56
Adamawa 204, 206, 222, 236, 248, 264
Aduma 262
Afo 206, 208, 210, 216, 220, 264
Agni 17
Alangoa 114
Ambete 262, 272
Angola 280, 292, 300, 302, 304, 308, 310
Ashanti 16, 17, 108, 110, 124, 126, 128,
 130, 132, 134, 136
Attie 110, 114
Azande 278, 338, 342, 346

B

Babanki 236, 248
Babembe 282, 284, 288
Babinji 312, 314
Babuye 324
Bacham 234, 240
Bafo 226, 232
Baga 17, 82, 86, 88, 90, 92
Bahemba 324, 328, 330, 334
Baholo 292, 294
Bahungana 292, 298
Bakete 302, 312, 314
Bakongo 7, 278, 280, 281, 282, 283, 286,
 288, 290
Bakota 248, 262, 264, 266, 268, 272
Bakuba 7, 16, 278, 312, 314, 316, 318,
 320, 322
Bakwele 248, 252, 256, 272
Balega 252, 336, 338, 344, 346
Baluba 7, 19, 278, 304, 306, 324, 326,
 328, 330, 332, 334
Balumbo 264
Balunda 7, 278, 292, 300, 304, 308, 354
Balwalwa 304, 310
Bamako 42, 44
Bambala 292, 298
Bambara 16, 40, 42, 44, 46, 48, 50, 52,
 56, 66, 82
Bambole 34, 252, 262, 276, 336, 338
Bamenda 222, 234, 236
Bamileke 12, 234, 236, 238, 240, 241, 342,
 344, 346
Bamum 236, 238, 246
Bangante 234, 236, 344

Bangwa 234, 242
Bankanu 280, 290, 298
Bantu 6, 8, 13, 276, 278, 316, 324, 338, 348, 350, 352, 354, 356
Bapende 292, 294, 296, 298
Bapere 338, 340
Bapunu 248, 262, 264, 270, 274
Bari 350
Barotse 354, 360
Barundi 350
Basalampasu 304
Bashilange *see* Bena Lulua
Bashilele 312
Basonge 278, 312, 316, 319, 322, 312, 326
Bassa 100
Bassange 206
Basuku 290, 292, 296, 298
Basundi 280, 282, 286
Basuto 354, 356, 358
Batchokwe 18, 300, 302, 304, 308, 354
Bateke 276, 284, 288
Batetela 316
Bauchi 208, 218
Baule 16, 19, 66, 108, 110, 112, 114, 116, 118, 120, 122, 128, 134
Bavili 278, 280
Bawongo 282, 312, 314
Bawoyo 283, 288
Bayaka 290, 292, 298
Bayanzi 284
Bekom 236, 238, 242, 244
Bena Kanoioka 304, 310
Bena Lulua 302, 307, 308, 310
Benin 7, 16, 19, 108, 144, 152, 154, 156, 157, 158, 160, 162, 166, 168, 170, 190, 236
Benue 204, 206, 208
Bete 100
Bijogo 82, 83, 84, 86, 88, 90, 92
Bini 160, 190, 202
Bobo 56, 58, 61, 62
Bongo 350
Bozo 46
Buguni 42, 44
Bukoba 358
Buli 12, 324
Bullom 94, 96
Bulu 232, 250
Bushmen 6, 348, 356, 360

C

Cabinda 280, 282
Cameroon 7, 13, 17, 152, 222, 252, 278
Cameroon Grasslands 222, 234, 244, 246
Cameroon Woodlands 224, 226, 232
Chad 7, 222, 224
Chamba 206
Chari 340
Congo 17, 19, 276, 278, 280, 352
Congo-Brazzaville 248, 252, 262, 264, 270, 282, 340
Congo-Kinshasa (Zaïre) 276, 292
Cross River 224, 227
Cush 7

D

Dahomey 108, 130, 132, 134, 136, 152, 170, 172, 174, 176, 182
Dan 12, 14, 19, 94, 98, 100, 102, 104, 106
Diula 56, 72
Djenne 24, 34
Dogon 13, 16, 22, 24, 26, 28, 30, 33, 34, 36, 38, 54
Duala 222, 226, 231, 232

E

East Africa 16, 348, 350, 356
Ebrie 114
Efon-Alaye 174
Ejagham *see* Ekoi
Ekoi 17, 18, 222, 224, 226, 232
Esie 17, 144, 148
Ethiopia 7, 8, 17, 348, 350, 352

F

Fang 248, 250, 252, 256, 258, 260, 338
Fante 130
Fon 132, 136

G

Gabon 248, 252, 262, 264, 266, 268
Galla 358
Ghana: old kingdom 22, 110, 124
Ghana: state 56, 72, 124, 126
Grebo 100
Guinea 17, 80, 96, 98, 100
Guro 110, 112, 114, 120
Gurunsi 56, 58, 64

H

Hausa 208, 210

I

Ibibio 204, 206, 208, 218
Ibo 188, 190, 192, 193, 194, 198, 200, 202, 206, 208, 226
Idoma 190, 206, 208
Ife 7, 16, 17, 19, 108, 138, 140, 142, 144, 150, 152, 154, 170
Igala 190, 206, 208
Igbira 206
Igbo-Ukwu 140
Ijo 188, 190
Ivindo 248, 250, 252, 262
Ivory Coast 16, 58, 66, 72, 98, 100, 106, 108, 110, 114

J

Jebba 144, 148
Jimini 72, 78
Jukun 204, 206, 208, 210, 216

K

Kaka 206
Kaluena 300, 302, 310
Kana *see* Ogoni
Karagwe 16, 350
Karim 210, 220
Kasai 276, 290, 292, 302, 304, 312
Kasikasingo 324
Kasongo 300, 302
Kissi 94, 96, 104
Konso 358
Koro 204, 210
Kpelle 100
Kran 14, 100, 106
Krinjabo 114
Kulango 56, 72
Kurumba 28, 54, 62
Kuyu 248, 262, 264, 270
Kwango 290, 292, 302
Kwangwa 354
Kwilu 284, 292, 298

L

Landuma 82, 90
Liberia 96, 98, 100
Ligbi 72
Likawale 252

Loango 278, 280
Lobi 24, 56, 58, 62, 64
Lower Niger 150, 158, 160, 164, 174

M

Madagascar 350, 354, 357, 360
Mahafaly 354, 356, 370
Mahongwe 262, 268, 272
Makonde 348, 352, 358
Mali 22, 24, 26, 54
Malinke 46
Mama 210, 214, 220
Mambila 206, 210, 220
Mangbetu 17, 280, 338, 340, 346
Maniema 324
Marka 46, 48, 50, 52
Mashona 360
Massai 6, 350
Mayombe 280, 286
Mende 94, 96, 104
Meroë 7
Minianka 17, 44, 50
Mitsogho 248, 252, 262, 264, 269, 274, 338
Monomotapa 7, 348, 350, 354
Mossi 54, 58, 62
Mozambique 358, 360
Mpongwe 248, 264
Mumuye 206, 214, 218

N

Nafana 56
Nago 132
Nalu 80, 82, 92
Napata 7
Ndengese 312, 316, 322
Ngbaka 276, 340, 346
Ngbandi 276, 340
Ngere 11, 98, 100, 102, 104, 106
Ngombe 340
Ngumba 250, 252, 258
Ngutu 226, 232
Nigeria 8, 19, 138, 172, 184, 220, 278
Nile 7, 350, 352
Nilotic peoples 6
Nile Valley 7, 22, 142, 156, 276
Nok 16, 17, 138, 140, 142, 148
Northern Congo 336
Nubia 7, 348, 352
Nuna 56

O

Obamba 262
Ogoni 204, 218
Ogowe 248, 250, 262, 264
Okitipupa 190
Ondumbo 262, 272
Oron-Ibibio 204
Ovimbundu 300, 302, 310
Owo 160, 168
Oyo 170, 174, 186

P

Pangwe 248, 250, 252, 254, 258

R

Rhodesia 350, 352, 356
Rovuma 6, 278

S

Sankuru 312, 316, 324
Sao 17, 222, 224, 230
Segu 42, 44, 46
Senegal 80, 90
Senufo 16, 44, 56, 66, 68, 70, 71, 72, 74,
 77, 78
Shankadi 12, 324
Sherbro 94, 96
Shilluk 350
Siena see Senufo
Sierra Leone 17, 94, 96, 98, 104, 160,
 278
Sobo see Urhobo
Soninke 90
South Africa 8, 348, 356
South-east Africa 7, 278

T

Tada 144
Tellem 28, 54
Temne 7, 94, 96
Tikar 234, 236, 238
Tiv 206, 214, 218
Togo 130, 170
Toma 96, 104, 106
Tundidaro 17, 24

U

Ubangi 7, 276, 312, 340
Udoh 160, 168

Uganda 348, 350, 356
Ughoton 190
Upper Volta 54
Urhobo 188, 200
Urua 324

V

Vai 96

W

Wabembe 252, 324, 334
Wagiriama 350
Wahima 348, 350
Waja 210, 216, 220
Wambundu 284
Wangoni 354, 360
Wanyamwezi 348, 350
Warega see Balega
Washambala 350, 358
Watutsi 6, 350
West Sudan 6, 7, 13, 16, 17, 19, 22, 82
Wobe 98, 100

Y

Yakuba 100
Yangere 340, 343
Yaure 118
Yoruba 12, 16, 17, 94, 132, 140, 170, 172,
 174, 176, 180, 182, 184, 188, 206

Z

Zaïre see Congo-Kinshasa
Zambezi 352, 354
Zambia 300
Zimbabwe 7, 348, 352, 354